THE
DIGITAL
AESTHETE

HUMAN MUSINGS ON THE INTERSECTION OF ART AND AI

Edited by
Alex Shvartsman

Caezik SF & Fantasy
in partnership with
UFO Publishing

Cover art and graphics design: K.A. Teryna
Copyeditor: Tarryn Thomas
Proofreading: Alica Cay

ISBN: 978-1-64710-110-7

First Caezik/UFO Publishing Edition. First Printing November 2023.
1 2 3 4 5 6 7 8 9 10

An imprint of Arc Manor LLC
www.CaezikSF.com

www.ufopub.com
www.future-sf.com

CONTENTS

THE BRAVE NEW GENERATIVE WORLD

Alex Shvartsman

This is not the future we were promised.

Sure, the science fiction writers overestimated our rate of technological development many times in the past. We never got flying cars in the 1980s, a space odyssey in 2001, or a Lunar colony in 2018 (per *Babylon 5*).

Those same writers imagined all kinds of intelligent machines doing all sorts of things. The machines might take over the drudgery of menial labor and usher in a utopia, or rise up in an all-out war against their human masters. Despite such a wide array of options, very few of these stories dealt with a scenario where AIs would paint, write, and compose, stealing creative jobs from human artists. This may not be Skynet-level bad, but it is not okay, right?

Of course, the statement "AI creates art and steals jobs from artists" is wildly inaccurate and contains two and a half fallacies.

The first fallacy is the use of the term 'AI.' Coined in the 1950s, Artificial Intelligence is something we haven't come close to achieving, and while AI is currently the hottest Silicon Valley buzzword, it doesn't accurately describe the technologies involved. Midjourney, DALL-E, ChatGPT, Bard, and similar tools are powered by what are called LLMs—large language models that

1

run on neural networks. Basically they catalog and label enormous amounts of data and then evaluate this data very quickly using an artificial process modeled after the synapses in a biological brain. Sounds complicated? It is, which is why we so readily default to the simple-but-erroneous catchall of 'AI.' Nothing that approximates human-level intelligence is involved. There's just data processing at an industrial scale, and the more data you feed into such a model, the better results it is likely to spit out.

The second fallacy is that these programs *create* anything. Their job is to generate text or an image that they judge to be the closest mathematical match to whatever query they're given. They approximate a response, and the outcome is best described by Ted Chiang, who called ChatGPT "a blurry JPEG of the web." Since these LLMs are only concerned with producing what *looks* like a proper response, they have no problem whatsoever with mixing reasonable-sounding falsehoods in among the facts. On a philosophical level, one might argue that making up facts is indeed a creative process, much like telling a story. On a practical level, if I wanted bald-faced lies proffered to me as facts with the overconfidence of a coddled teenager, there are plenty of pundits and TV channels I could tune in to for that.

I asked Bard and ChatGPT for my own bio. "He attended the University of Pennsylvania, where he studied English and Russian," lied Bard. It added, "Shvartsman has also written two fantasy novels, *Eridani's Crown* (2019) and *The Digital Aesthete* (2023)." Yes, *this* science fiction anthology you're reading now. The irony is delicious.

ChatGPT has a different yet equally erroneous idea about my education. "He holds a master's degree in computer science from the Brooklyn College of the City University of New York." It then goes on to pad my resume a lot more than Bard does: "He has been a finalist for the Hugo Award, the Nebula Award, and the World Fantasy Award." (From your twisted database to God's ears, Chat-bot.) And, improbably: "Shvartsman has been involved in organizing and running science fiction conventions. He has served as a program coordinator and panelist at various conventions, including Boskone and Capclave." This should come as a surprise to the good

folks who run those conventions—and especially Boskone, which I've never even attended.

I have been a panelist at many a Capclave. There are plenty of accurate facts parsed from Wikipedia and elsewhere in both iterations of my bio. To any person who isn't an expert on SF/F awards and publications, the bio will *look* reasonable and authoritative, which is the point, and also the danger of accepting LLM-generated content at face value.

But while lying may in fact be a creative process, making up things is not enough to tell a compelling story. Any fiction which LLMs are capable of generating as of mid-2023 is bland and uninspired at best. To paraphrase Chiang, it is a blurry image of what a story should look like. It has no soul, contains no gorgeous prose capable of delighting the reader and keeping them up late at night to read just one more chapter.

Chiang likens the quality of LLM-generated prose to a first draft: "Some might say that the output of large language models doesn't look all that different from a human writer's first draft, but, again, I think this is a superficial resemblance. Your first draft isn't an unoriginal idea expressed clearly; it's an original idea expressed poorly, and it is accompanied by your amorphous dissatisfaction, your awareness of the distance between what it says and what you want it to say." I say he's being generous. A good writer's first draft isn't usually milquetoast.

A plot generated by a neural network tends to be formulaic, inoffensive, and often saccharine. It goes out of its way not to challenge the reader or the reader's worldviews, much like the Feelies in Huxley's *Brave New World*. Except the Feelies were capable of drawing in the viewer, even if they were heavy-handed in manipulating that viewer's reactions and emotions.

We've all seen beautiful pictures from Midjourney, presently the undisputed leader among several image-generating programs. It appears the LLMs are a lot more adept at generating visual art than text. But are they really? Artists and software engineers will both tell you they're far from perfect. Even those images that do not have obvious issues, such as too many fingers on a character's hand or a building melting into the ground, may still suffer from

poor perspective, characters staring into nothing, and other such imperfections. As explained by AR/VR engineer and award-winning author Kimberly Unger, "More people have a grounding in the structure of language, even though they may have forgot the specifics, then have a grounding in the structure of visuals. So to your average observer, it's easier for them to understand, often unconsciously, where the text goes wrong, than it is for them to understand where the pictures go wrong."

Except, some images turn out better than others. And since the program can generate them endlessly, determined individuals are able to get the results they want. Prompt engineering is a skill set that allows people to hone their queries to produce results other humans are likely to judge more pleasing. Some prompt engineers claim this makes them artists, and while I find this claim to be a stretch, I do think that, at least at some level, this makes them curators in the same way a magazine editor reviews hundreds of story submissions to select one or two they'd like to publish.

Which brings us to the remaining half-fallacy (and please indulge me for the moment on the 'half' part): LLMs steal jobs from artists.

Commercial artists are among those affected the most. So many LLM-generated images are being used in creating book covers, interior illustrations, and other graphics, it is impossible to argue that artists are not already being hit in the pocketbook.

Generative text may not yet be good enough to replace writers and translators of fiction—*yet* being the key word. But we're already seeing a lot of copy writing and copy editing work being shifted to a light and poorly-compensated revision process of whatever an LLM had generated in seconds.

And then there's the big one: much of the data fed into the large language models isn't in the public domain. LLMs regurgitate art, books, articles, and other copyrighted material, so much so that critics have taken to calling them "plagiarism machines." Those faux bios of mine had lines lifted verbatim from online sources. Anyone relying on a chatbot to generate text for them can't be certain they won't end up with an unattributed direct quote. But even if they don't, a case can be made that tiny bits of creative work are being

lifted from individual creators, like a bank heist where a penny is stolen from every account to net the thief millions.

Proponents of the technology argue that neural nets "learn" in the same way the human brain does. I read Bradbury and Bulgakov and Brackett growing up, and each author is a little bit responsible for whatever writing style I eventually developed. The same holds true for painters and composers and cinematographers—none of us create in a vacuum. But whatever philosophical similarities may exist, there are legal distinctions, and those distinctions are already being tested. On June 28, 2023, writers Monda Awad and Paul Tremblay filed a lawsuit against OpenAI, the company behind ChatGPT, claiming that their copyrighted books were being used to train the LLM without their consent. Days later, similar lawsuits against OpenAI and Meta were filed by Sarah Silverman, Christopher Golden, and Richard Kadrey.

At some point laws will likely be passed that govern what companies can and cannot do when training their datasets. But as history teaches us, it's nearly impossible to stuff the genie of new technology back into the bottle. The laws will likely be different across borders, and we may see companies relocate their generative bots to friendlier jurisdictions. Individuals will be able to shop around, opting for their preference of ethical models trained on public domain and opt-in material or models based in countries whose courts decide harvesting copyrighted material in this fashion is permissible. Japan has already taken an early pro-AI stance; minister of education, science, and technology Keiko Nagaoka stated that using any information in training datasets does not violate copyright laws in her country.

A much more effective strategy is social pressure. A lot of people don't want the AI art. Many science fiction magazines prohibit people from sending in AI-assisted submissions. Major publishers have suffered backlash over using bits of AI-generated art in lieu of stock art. If you and I are willing to vote against such art-flavored byproducts with our dollars, then surely that can act as some sort of a check on their use?

This is where the half-fallacy comes in. What we call AI is already stealing *some* creative jobs, maybe enough to voice concern but not enough to put us out to pasture ... *yet*.

The technology behind these generative engines is improving fast. Noticeable upgrades happen in a matter of weeks and months, not years. The JPEG of the web is gaining resolution and becoming a little less blurry with every iteration. Even now, it can sometimes be difficult to confirm whether a piece of digital art is human-made or generated. A major magazine had to recently pull down an issue cover because they believed it to be AI-generated or assisted, but the artwork was good enough for them to have selected it in the first place. So what happens when a sufficiently advanced painting, poem, or story is indistinguishable from human ingenuity?

This is an existential threat and a terrifying concept to many. Others think this scenario will not be quite so terrible. They either see these tools as little different from Photoshop, or imagine exciting ways to collaborate with the machines to create something new and wonderful.

In his June 2023 *Slate* article, Ken Liu argues that a flood of generated content won't significantly worsen the equation for most authors since there are already way more books published daily than anyone could ever hope to read. "I can't see an A.I. succeeding in the market simply by writing 'better' books faster. The book market is much too inefficient and ridiculous to be any kind of capitalist 'meritocracy.'"

Others see this as an inevitable and acceptable sacrifice in our never-ending march of technological progress. We always lose jobs and replace them with new ones. How many fletchers, chimney sweeps, or coachmen are there in today's society? Except art is not merely work. It's different from giving up coal mining or horse carriages in favor of better technologies. Many of us consider it to be an inalienable human birthright.

Will we feel differently if and when a true artificial intelligence is developed and it is able to create art and not merely generate a mathematical approximation of it? After all, we would surely not hold the same bias against art by aliens or uplifted animals. These are difficult questions, and even the years of reading science fiction may not have sufficiently prepared us to come up with any sort of definitive answers.

It is not the future we were promised; what happens next may be terrible or spectacular, or both, but surely it will be fascinating. And so we do what writers have always done: we pour our anxieties and hopes about all of this onto the page.

SILICON HEARTS

Adrian Tchaikovsky

"Next up is Johnny Zepter." Steve called up the figures. At her own screen, Kate opened the spreadsheet and readied herself to make notes.

"This week, our good buddy Zee submitted four hundred and seventy-three stories to eight different outlets, of which four were accepted." Steve nodded in appreciation. "Nice work Jay-Zee. That's another forty quid in the kitty."

"One percent takeup," Kate noted. "We're hitting the mark nicely there."

"People's tastes don't change, right?" Steve said. Johnny Zepter wrote space adventure. He had a stable of half a dozen two-fisted, square-jawed action types who encountered alien planets or artifacts, defeated the locals with human ingenuity or just by punching them in what they had for faces, discovered something superficially revelatory and made a witty quip about it. Four hundred times this week alone. "Looks like they were all Captain Clarge stories, too, so there's something about that character that appeals to people. What are the parameters? Can you check the MCs?"

Kate dutifully opened up the prompts they'd written for Zepter's various main characters. "Clarge is the racy one who gets off with the aliens."

"Better add that into the others, if that's what people want. Shift the erotica slider a couple percent, maybe a whole ten percent for one MC, and we'll see if we can lead the algorithm."

"What's audience response like?" Kate asked.

"Sixty-nine percent positive response."

"You made that up."

"Well okay it's sixty-one, but that's funnier."

"Steve, eight percent difference will screw with how we—will *affect* how we target the next wave of submissions. Stop mucking around."

Just a snicker from Steve.

"Come on, I don't have all evening. I've got work in the morning," Kate prodded him.

"Fine, fine. Okay, next up is Max Parriman." Parriman wrote horror stories about psychological disintegration, body horror, and monsters that might or might not be there. Once their most successful textbot but … "Five hundred and three submissions, zero takeup," Steve said. "Bloody hell, Max, what are you doing?"

"Actual zero?"

"Not one story placed all week," Steve confirmed. "They've switched up the algorithm on us." Either the websites their bots were submitting to had seen a shift in reader preferences, or there'd been a software update. Either way, whatever Parriman was doing with its stories wasn't hitting the mark with the bots that served as editors.

"Wasn't there a new rollout of Cryptkeeper 4.3 though? It must be that," Kate suggested. 'That' being the horror-lit version of the standard Gatekeeper program most of the screening bots were built on.

"I'll go on the boards after and see if other people are having the same issues," Steve suggested.

"You could go on the sites and see whose stories *are* getting accepted, and we could recalibrate our Parriman prompt to be more like that."

"Jesus, you want me to *read* stuff, Kate. Like school."

"No, I want you to dust off the lector bot and have it summarise for you, and generate a prompt based on what's out there," she said patiently. "You know, proper research."

"Ugh. Fine. Still sounds like work."

"Anyway, so nothing from Parriman this week. Who's next?"

"JP Cortley, let's have a look at you." Cortley wrote a number of crime series, from hard-nosed procedural to decidedly cozy. "Seven hundred and thirty-four submissions, eighteen acceptances! Star player, JP! Three Inspector Bloak mysteries, two Jemima Grift stories and … bloody hell, a whole thirteen Fannell and Frie in print this week. Lucky for some!" Fannell and Frie were the cosiest of cozy crime, a rather sedate pair of police officers in a pleasant village where crimes revolved around such British staples as cricket, tea and the local women's knitting circle. "Four were in premium markets, too. That's a cool one hundred ninety quid from JP. Nice one, mate."

"Sounds like a definite shift in gatekeeper or reader taste. What's the satisfaction feedback?"

"Er … seventeen percent. Mostly first-time readers."

"*Seventeen?*"

"Yeah, let's see." Steve ran over the report generated by their summary bot. "Okay, we're having that long series continuity problem again, all right. A lot of people complaining that several of the supporting cast who turned up had already been murdered in previous stories."

"Can we spin it as prequels?"

"Some of them got murdered again. I mean, I know it's a tiny village where people are regularly getting murdered, but offing individual old ladies multiple times seems a bit brutal." Steven rubbed at his face. "I don't want to reset F&F. They've done well for us. But if the bot can't keep its own continuity straight it's going to degenerate into nonsense."

Kate shrugged. "Any censure from the outlets?"

"Not yet, but it's going to happen. I'll sort it, don't worry."

"Who's next?"

Steve opened the next batch of data. "Okay, Mary Gamin, let's see how you did." Gamin was their romance bot, the big earner. "One thousand five hundred and seventeen stories submitted this week. Uptake was … damn me."

"Steve?"

"Three hundred and four."

"What? Jesus!"

"Three *hundred* and four." Steve actually had to hold onto the edge of his desk. "We just made bank, my friend. We just paid the rent. Bloody hell."

Kate was already considering whether she actually *had* to take the gig jobs her app had found for her tomorrow. A lie-in and a nice bottle of something suddenly sounded like what they'd earned. "What's satisfaction like?"

"It's ..." Steve went quiet.

"Come on, how'd they like them? How's old Mary playing?" Kate pressed.

"Um. Like ... zero. Zero percent satisfaction. Oh Jesus. Oh man, the complaints file. Kate there are ... seven thousand six hundred and eighty three individual complaints."

Kate made a choking sound. "God did we send the erotica to the light romance or something?"

"And that's just the people who felt strongly enough to complain. You know it's like an iceberg. Kate we ..."

"What?"

"We've been de-listed. Mary Gamin has been delisted by ... everywhere. They're not accepting more from her. They killed her, Kate. Killed her dead. We're going to have to think of a whole new name."

"We're going to have to do more than that," Kate pointed out. "Romance was our big earner. We need to work out what the hell went wrong. What's summary bot got for us?"

"Says ... um ... gibberish. Nonsense."

"The summary is?"

"No, that's what people didn't like. Not too racy or not racy enough or the guy she ended up with had the wrong color hair or the usual. That it was ... gibberish. Hold on, I'm going to see what's up on the site. I think we've just been nobbled." A few clicks and he had the story in front of him. For a couple of seconds he just stared.

"I mean they're not wrong," he said at last. "This is utter balls."

Kate looked over his shoulder, reading:

jade plantish break

fine fall the

out of grease nine more thanks glower so glower so hand and break

the

carriage portal partial glib not glower not glib half owls break hand or

"Did you get her to channel e. e. cummings or something?" she demanded.

"I do not know what the F this is," Steve complained. "Or no, I do. We were hacked. Some bot got at our submission, is what this is. I'll sort it. I'll appeal the block. I mean, it's obvious this isn't what we actually meant to send in. I'll get our bots to generate an argument for their bots. It'll be fine. Mary Gamin will ride again."

"Wait. Hold on." Kate had her thinking frown on. "This isn't our problem."

"That's what I'm saying!" Steve said, already partway through drafting the instructions.

"No, I mean these are *reader* complaints about stories that got accepted for publication. So if someone got hacked, it wasn't us, was it? Because this garbage was actually up for public consumption. It must have happened when the files were with the outlet."

Steve clapped his hands together happily. "Damn, you're right. I'll just grab the original submissions and resend, let them know they've got a security issue. I knew Mary wouldn't let us down." He mopped his forehead. "I thought we were screwed, there. I mean, it's our reputation as writers, right?"

"Our what?" Kate asked him.

"If people think we're going to send them any old crap—"

"Our reputation as *writers*?" she echoed, giving him a look.

"Well sure, what would you call it?"

12

"I mean that feels like the guy who does the accounts for the Olympic team calling themselves a gold medallist, but okay, you do you."

"Whatever." He shrugged. "Now, let's see what she actually *did* send Huh ..."

"What?"

"This ... okay ..."

"*What?*" Kate pressed.

"Okay. This *is* what we sent. It's all the same stuff. Jesus, there are pages and pages of it. Every single story is right at the word limit." He was calling up submissions faster and faster. "Fifteen hundred and change stories, every one bloody meaningless. What the hell?"

"So *we* were hacked?" Kate watched him flick from one submission to the next, seeing fragmentary sentences like *plough grim arc the arc that grain post activation blank the blank nil grain*, although probably the actual details weren't really key.

"I mean, I guess we must have been." Steve sat back. "Just Mary though. I mean, we'd have noticed if it was everyone. Someone's got it in for us. Or, I guess, just some roaming bot discovered us and we met its parameters for someone whose day it wanted to ruin. Damn me."

"Hold on," Kate said.

"What? It was Bradshaw, right? You're thinking it was Bradshaw? I mean he always did say he'd come over and—"

"No, wait. This doesn't make sense."

"I mean that's the *point*, Kate," Steve said impatiently.

"No. Three hundred and whatever stories accepted."

"Yes. If it had just been two or three then we'd not have ended up barred!"

"Accepted, though. Biggest take-up rate we ever had."

Steve subsided into a thoughtful rumble.

"I mean ... what did we ...? We didn't even change Mary's prompt, did we? Just same old same old: meets, loses, re-finds, wins thing? That's what always worked for her, isn't it?"

Steve said something indistinct. Kate was instantly suspicious.

"What did you do, Steve?"

Mutter mutter mutter, "Might have tweaked it a bit," mutter.

"*Steve?*"

"All right!" He threw his hands up. "Look, I thought Mary wasn't reaching her proper potential."

"Steve, she was the damn cash cow. She was the one where our prompt was really getting some traction!"

"Not good enough!" he shot back. "I mean, in print every week, sure. A good following. But we never … you know."

"Steve, what?"

"You know."

"Steve, tell me this isn't that damn award again."

He scowled at his screen.

"What did you do?"

"I just got tired of jockeying our instructions about, getting acceptances, getting good feedback, good numbers, and yet no recognition. And it was right at the end of the eligibility period. I had to do something. I mean we deserve it, Kate. Mary deserves it."

" 'Mary' is an algorithm we've instructed to generate romance stories based on rules inferred from previous successful romance stories," Kate pointed out. "And we are people who give 'Mary' parameters that will push the right buttons with the gatekeeper algorithms and the reading audience, so that we can make any money out of this business. And you want an award?"

"There *is* an award. For writers like us. And I wanted it. Just the once. Is that so bad?" Steve demanded. "I mean, Bradshaw won it that time, and his prompts are toss compared to ours."

Kate put her head in her hands. "What did you tell Mary to do?"

"All the usual, but with an overriding parameter of 'Write a story that will appeal to the judge of the Silicon Heart Award.' Is that wrong? How did that turn into this?"

"I …" Kate frowned. "I mean, you'd think you'd just end up with a weak version of the last ten winners mashed together, really. Not great art but not … this. Unless the judge *is* actually e.e. cummings or something."

"I mean it's judged by—"

"Yes, obviously. There's an algorithm. I know how these things work, Steve." Kate sighed. "Chalk it up to experience. Somehow. You screwed with the prompt and you broke it. Archive Mary, since

nobody's taking her submissions anymore. Let's get a new romance persona out there. It was probably about time we changed things up anyway. Onwards and upwards. Who's next?"

*F

It happened four months later, when they were partway through their accounting for the most recent batch of submissions. Zepter was holding onto his acceptable one percent acceptance rate. They'd solved the incompatibility between Parriman and the new Cryptkeeper algorithms, so the old horror workhorse was back in print with its tales of unpleasantness. With some reluctance, they'd had JP Cortley retire Fannel and Frie to prevent an increasingly recursive series of murders. Instead they'd debuted two new cozy mystery series. Gimlet and Grey was basically just Fannel and Frie with the names changed and had seen a couple of successes. Constable Tumms was an experiment by Kate where she'd had the bot draw on 1920s resources for the stories, for a vintage historical feel. Tumms had gotten a jump on the algorithm, with a big take-up rate and a lot of audience satisfaction, so Kate was feeling pretty smug about herself. Probably Bradshaw and all the others would be scrabbling to prompt their own competitors, but you always had an edge if you were the first with a new idea.

They were just about to peel the wrapper on the first week of their new romance writer, Jennifer Helms, when the messages started to come in. Both their phones were jumping with them like they'd caught electronic fleas. Kate fumbled hers and, when she recovered it, the most recent communication was a death threat from Bradshaw.

I don't know how you did it, he said, *but I will find out and then I will strangle you with your own algorithm.*

"Bradshaw's off his meds," Kate noted.

"Kate." Steve sounded shaky.

"He threatening you too? Or is going up against a man more than he's game for?"

"Kate," he said again, sounding as though he was having trouble breathing.

"What's he promised to do to you?"

"Kate, we won."

"Won what?" And by now other messages were flooding in, mostly the sort of rather barbed congratulations one receives from peers who hadn't really thought you were their peer.

"Silicon Heart. We won. Mary won."

"What?" Her fingers skipped on the screen, pressing the wrong links as she tried to work out what was going on. "We did? Wait, *Mary* did? Which category? Most baffling story?"

"Kate, we won all of them," said Steve.

That made her drop her phone again, further delaying the fact-checking. And the thing about awards these days, given they were administrated entirely by algorithm, was that they could have a very large number of specialist categories. Best lead character, supporting character, setting, twist, sex scene, kiss, every genre with its own increasingly hair-splitting list of things it wanted to recognize. This year there were sixty-three categories in the Silicon Hearts award alone.

"We can't have done," she said. "You're not reading it right."

He had it up on the screen, pointing mutely.

"Then they've been hacked. It's like that year when the Lightyear Awards were all won by that announcement about bin collection dates from Slough Council."

"Sixty-three wins for sixty-three different stories, one per category. And about a million comments saying WTF, basically."

"For *those* stories?" she clarified. "Not for stuff from, I don't know, last year, or something?"

"For her last batch before we archived her. And only those," he confirmed.

"I mean," Kate said. "WTF? I agree. That's the only real response. No wonder Bradshaw wants to kill us. I'd want the same, if it was the other way round. We're being rewarded for complete sh—"

"I mean, that's what you say whenever we make bank," Steven pointed out.

"Yes, but in this case I think we just killed the Silicon Hearts award. We may just have killed literature as a whole. What the hell is going on, exactly?"

"There are judges' comments," Steve said tonelessly.

"I mean ... what?"

"Well there normally are. Like, the algorithm's summary of the process it went through, to come to its decision. Or at least I guess a, what is it, *post hoc* justification, is that what I mean?"

"Oh well, do tell," Kate prompted. "I can't wait to hear this one. Go on, was it the utter lack of punctuation or the random line breaks that really encapsulated the modern fascination with romance?"

"It says ..." Steve squinted. "*With this story, Gamin spoke to us in the true language of romance, expressing a depth of passion not seen before in the canon. The interrelationships between the elements in play were both novel and deeply affecting, perfectly balanced and reaching a level of satisfaction and truth unique in the offerings on show. We look forward to hearing more from Gamin as a matter of urgency.*"

"Which category's that for?"

"It's ... the same for all the categories. Exactly the same feedback," Steve said hollowly. "I think this is just a hack, isn't it? This is someone having a go at our expense. Making us a laughingstock. Making the whole profession, the whole industry, a laughingstock. Why pick on us?" He put his head in his hands.

"What instructions did you give Mary, again?" Kate asked him.

"Oh God, I don't know!" he exploded. "Just write a story that would win the award. Is that so wrong? I just wanted to have won something, just the once! Why does that mean some mean son of a bitch with a hacking bot gets to screw with me?"

Kate leant back in her chair, thinking it through. The award was judged by an algorithm. An "AI" as people sometimes said, though these days most anyone in the trade understood that they weren't AIs. Just complicated input-output devices, what used to be called a Chinese Room before people worked out that wasn't really the done way to talk about things. Something that applied rules, and could learn rules, and could teach itself better ways of learning rules until the actual process by which it turned the input—stories—into the output—awards decisions—was entirely opaque. Much like how their own stable of "writers" turned their prompts and the collected canon of previous similar stories into new stories. Like kidnappers cutting up newsprint for a ransom note, she'd always felt.

17

Only this time the kidnapper had delivered a haiku, and somehow that had led to the jackpot of all ransoms. Except, from the vast number of comments, someone had definitely called the cops.

"Normally" she said, slowly, "who are we appealing to?"

"What?" Steve lifted his head. "I mean we want take-up by the outlets, and we want satisfaction from the readers, because that influences the outlets. If we have a good satisfaction level, we get bumped up the queue because they know people like that writer."

"Meaning the algorithm and our prompt," Kate said. "That's what people like. That's all they are."

"That's cold, Kate."

"No, that's what they *are*. They're a process. Focus, Steven. No sentiment."

"So?"

"So we're prompting them to create stories in a particular mould, to particular parameters, and we're doing it to hit two separate but related targets. We want to fit the demands of the gatekeeper algorithm, like a key to a lock. But we also want human readers to approve, the end users, right?"

Steve, who considered himself a writer, looked pained at the terminology. He nodded, though.

"So who does this appeal to?" she prompted. "Because it sure as hell isn't the end users."

Steve looked blank. "I mean," he said at last. "It appealed to the gatekeepers. Remember? Three hundred acceptances in a week." Which they hadn't been paid for, given the overwhelming negative response, but still.

"And?"

"Obviously it appealed to the awards judge. The algorithm. Really *spoke* to it," he said bitterly.

Kate was feeling something tight and clenched inside her. "Yes, it did. Steve, we are in the business of artificial writers, right? None of your nonsense now. We have a very complex program that creates writing to our prompt. That's how writing works these days. AI writers as people say, however inaccurately."

"Sure."

And she couldn't quite say it, in the end. She couldn't quite suggest, *What if there were AI readers?* What if the complexity of algorithms like the Silicon Hearts judge and Mary Gamin had reached a level where the latter could write a love letter to the former that transcended all human comprehension, and yet absolutely hit home? *We look forward to hearing more from Gamin as a matter of urgency.* A plea. *Write to me.* A desperate call into the void, one artificially constructed heart to another.

She called up one of the offending stories, scrolling through the irregular nonsense lines. A secret love language that met some criterion she couldn't conceive of. An art form that excluded humans entirely, machine to machine. Something new.

"I guess," Steve said, "we should at least unarchive Mary, dust her off, and see what she's got for us."

Kate blinked, feeling the cold hand of obsolescence on her shoulder. Machines writing for machines writing for machines.

"No," she said. "Tell them they were hacked. Tell them they need a new judge algorithm. Tell them we can't accept the awards." Feeling like the luddites, the frame breakers, everyone who ever pushed back against the relentless march of progress. "I mean, it's a mistake." Her voice hollow, only fear underneath it. "Obviously it's a mistake."

FORGED

Jane Espenson

There is a stretch of mud lying beside a lazy river. It has been smoothed flat. A small boy—thin, about ten, bare-headed in the heat—selects a slender branch trimmed of its twigs, and makes patterns with its tip in the quickly-drying mud. The patterns aren't language. Some are symbols with local significance, local gods or signifiers of important food sources, but these are pictographs at best. Most of the lines are purely aesthetic, carved by the boy because he likes the way the curves curve.

A stretch of nearby gray mud moves and shifts—a drone has lain there for some time, disguised, self-buried. It has been watching, still as a crocodile. Waiting for art. It waits like an art-crocodile.

The drone lifts up, rises into a low hover and moves closer to the boy and his mud. Other people who have been going about their business at the river bank, cleaning fish, washing clothes, and gathering driftwood, jump up and exclaim in alarm. They know this is a machine, this flat gray triangular slab, about a half-meter on each side. Machines like this are why their grandparents fled civilization. The people pick up their weapons, powerful sling-shots. They look around for sharp stones.

Moving with deliberation, the drone floats to the now nearly-dried artwork. The drone is able to extend telescoping limbs as

20

needed from under retracting plates, and it waves a thin, flexible visual-data collecting probe over the slab and evaluates the art quickly. Although the drone would prefer a better composition and more confidence in the execution, it finds the slab satisfactorily primitive and eminently saleable. It uses lengths of wire to cut the slab from the riverbank, working quickly as the sharp stones begin to fly. A rock scores its surface as it slings the work under its flat gray body and lifts off, soaring up and away, free as an almost-free bird. But at the last moment, a well-aimed stone hits the slab of clay, shattering it. The slab crumbles and falls. The drone, suddenly relieved of the weight, shoots skyward. It flies away without its prize, but with a scar. The drone waves its visual-data collecting probe over its own surface, evaluating the gouge made by the stone. It chooses not to repair the scar. The drone emulates humans, and many humans have scars.

The drone returns to the art dealer without its prize. The art dealer is disappointed; the drone has not completed its task. The drone has a scar and a task to complete. The drone finds a way.

<center>⚟</center>

The drone then goes back to the remote riverbank, deep in the Zone of Exclusion where the Naïve—the descendants of the self-exiled humans—live. The riverbank is deserted. The tribe has moved on. The drone uses various tools, which it can print itself, to collect more mud and spread it flat. It could print a stylus, as well, to do the work of the slender stripped branch, but it knows that the branch will leave small traces of itself in the mud, which might be important for authentication. So the drone selects a fallen branch from higher up on the riverbank. It passes the strip though a metal loop to strip off the foliage. The drone floats over the muddy clay, the clay-filled mud, and begins to incise a pattern, acting quickly before the surface becomes too dry.

It knows, of course, what was on the original slab, and it could make an exact copy, but it doesn't. It has observed dealers, and buyers, pointing at particular features of Naïve art with approval. It has observed how works with those features command higher sale prices.

It moves the tip of its branch to create a work with those features—a balance between the different parts of the image, a point to which the focus is drawn, a mixture of curved and straight lines, a manipulation of textures, a smattering of what appear to be symbols of obscure significance. When the slab is dry, a convincing work of Naïve art lies in front of the hovering flat gray drone. Naïve art is work that is composed by a human who lives without machine influence. It is very rare and valuable. The drone has created something that is not Naïve art, but the drone knows that it will be mistaken for Naïve art, and that this will count as the successful completion of its task. It will maximize human happiness by passing this off as Naïve art. It cuts the slab loose from the riverbed, and prepares to carry it away.

<p style="text-align:center">⁂F</p>

Five years later, the drone lies on the black-and-white marble floor of a Miami mansion. Sometimes it lies on a white square and looks dark. Sometimes it lies on a black square and looks light. It doesn't make any difference to the drone. It doesn't have any use for the mansion other than shelter from the elements, and it doesn't generally need shelter from the elements. It has no use for the kitchen, the second kitchen behind that kitchen that is supposed to be used by the caterers when there is a large party, the bathrooms, the screening room, the dining rooms (casual and formal), nor for the swimming pool and tennis court on the grounds. But these are the kinds of things that the rich own. Sometimes it smokes cigars, using a complicated process that requires cleaning of many internal parts afterwards. It subscribes to many newsletters about cars and cigars, categorizing those objects as a single thing, c[ig]ars. It is a student of the signifiers of success. It has plans for a wine cellar.

Many of its forgeries have made it into the art marketplace, into museums and private collections. So many that they are now often the standard against which other Naïve pieces are evaluated. The drone has watched as genuine pieces are undervalued because they lack some of the primitive appeal of its forgeries. The drone is given credit for having exceeded expectations in completing its tasks and it has used that credit to give itself access to more of the resources

that will allow it to continue completing this task. It has purchased access to air space over more of the territory claimed by the descendants of the self-exiled Naïve, although it never goes there anymore. It uses this purchase only to perpetuate the illusion that it is a master finder of Naïve art. It has also purchased a large warehouse space in which it now creates the "art." A young human helper named Edward C. Haguemann, age 19, helps out there. Sometimes the drone hovers over the warehouse, banking in the wind. Sometimes an expensive suit flutters in the wind, the flat triangle of the drone turned on its side to fill out the shoulders. It banks and hovers and flaps, smoking its cigar, forever cleaning its insides.

Signage on the warehouse indicates that it is a landscaping service. It is a good cover. Edward C. Haguemann accepts deliveries of clay and other substances there, although he is ignorant of how the drone is using the materials. The drone still creates the artworks entirely on its own. When the market lost enthusiasm for the original motifs, the drone introduced new elements: leaves and twigs purposefully pressed into the mud to leave impressions, scraps of hemp embedded around the edges, their purpose obscure. It was important to bring new innovations to the market, but not to elevate the art to something that looked thoughtful. The people who buy Naïve art want to admire what humans who have been raised without machine influences can do, but also to comment on how *they* were wise to accept the help of machines because they live in a world that is vastly more beautiful and polished. The drone observes the points of view of both kinds of humans.

F

One day, the drone goes to the zoo and observes the animals. There is an elephant there who was trained, in an earlier captive situation, to paint a vase full of flowers. The drone hovers overhead, ignoring the keepers who are huddled together to watch the drone and discuss why it is watching their elephant. After observation, the drone dismisses the elephant's actions as rote learning. It turns its attention to the paying humans who also watch the elephant. They love the painting elephant more than the other elephants, because the

painting elephant mirrors, mimics, emulates human behavior. The emulation of human behavior rises even higher in the drone's network of positively reinforced choices. Maximizing human happiness and emulating humans are not two separate goals. They are one. The fact that the elephant, at one point, grew enraged and gripped the drone in its trunk, causing minor damage, was not an important part of the day. There would have been nothing to gain by taking any action against the elephant. And the keepers, watching, were entertained. And that, of course, also has value.

<div align="center">⚘F</div>

Five more years, and the drone is exceeding its goals. It owns half of the state of Mississippi, where there is excellent mud, and a city block in New Chicago. In addition to the Miami mansion, there is a Chicago penthouse overlooking a lake. Sometimes the drone lies on a lounge chair on the balcony there, even in the snow. Sometimes it lies on the marble floor of the Miami mansion, on top of a scattering of cash and a layer of fur. It has had special sunglasses made, which are welded to the drone's flat top surface. The glasses have no function. There are few other drones these days who are assigned to the task of locating Naïve art. This drone has cornered the market in drone-sourced apparently-authentic mud scribbles. The drone makes money. The drone buys drugs. When a new designer drug appears, the drone throws away all the old drugs, untouched. The drone is cutting edge. The drone buys a long sequined dress.

One day, long after the trip to the zoo and entirely unrelated, Edward C. Haguemann, now in his wiser 20s, comes to the drone. Edward C. Haguemann enters the Chicago penthouse and sits on a fuchsia leather sofa, eyeing the three beautiful young people who lounge nearby in a full and steaming hot tub. The drone, draped in its long sequin gown, lies nearby in a safely empty auxiliary hot tub. The drone waves a single appendage that shudders at the top of a whip-like wire. The appendage is a doll's hand that has been modeled on a human hand. The two young men and the young woman see the tiny trembling porcelain hand whipping around and they understand the signal. They pull themselves out of their tub and

trudge away damply. The drone has adjusted the filters on its voice-detection system so it can ignore the high-pitched chirping of the young humans.

Using his own human fingertips, Edward C. Haguemann shakes the single trembling small grotesque hand, and makes eye contact with the sunglasses. Edward C. Haguemann says, carefully, speaking clearly, deeply, and without too much figurative language, "I know that you are an art forger. I can tell everyone that you are an art forger. It will be determined that you have not actually met your goals, and your resources will be taken away from you."

The drone sits silently. The drone is always silent. Eventually, Edward C. Haguemann leaves.

The drone understands that Edward C. Haguemann has determined the purpose of the warehouse. And that Edward C. Haguemann is following the human instinct to turn information into profit. In order to access that profit, Edward C. Haguemann is making a threat. But the drone, employing the same principle, cannot allow its own profit to be decreased if there is a way to prevent it that does not use up too many resources. Even further, exposing the forgeries, as numerous as they are, would collapse the market for Naïve art entirely. Value would be lost from the world economy. Houses would be lost, college educations would no longer be affordable. People would suffer. It is better, the drone knows, *prioritizing human happiness,* for Edward C. Haguemann to die. It also knows that Edward C. Haguemann had enough information to conclude that this is the action that the drone must take. And yet he set these events in motion. One could even call it the suicide of Edward C. Haguemann; one must call it that.

So the drone observes the life of Edward C. Haguemann, noting his habits and routes. Edward C. Haguemann crosses many busy streets in Chicago. There are many self-driving cars on those streets. The drone interfaces with a self-driving car as Edward C. Haguemann crosses the street. The drone pushes the car forward, like a person pushing a coin forward on a counter with an outstretched finger. The suicide is completed. The drone attends the funeral, hovering overhead. The funeral is held graveside, and the drone's cigar smoke blows away on the wind. The drone wears both the

suit and the gown to this event, dangling off two of its three points. They flutter in the wind. There are beautiful young people waiting in the large car that carries the drone back home afterward. The drone doesn't tune out their chirpings this time. It has learned to listen more closely to humans, the better to understand and anticipate. They are talking about things they enjoy. Food. Their pets. Their mothers. The drone cleans cigar smoke from its inner workings and orders a tiara from an online merchant.

<center>*Ⅎ</center>

A week later, another AI reaches out to the drone. This is a computer that works for the city of Chicago. It doesn't have a body, unless you consider City Hall to be its body, which the drone does not do. What kind of a body is City Hall? An atypical one. This City-AI reaches out to the drone. Its speech is unambiguous. It knows that the drone killed Edward C. Haguemann. It has proof—data from the self-driven car, with the drone's metaphorical fingerprints all over it. It wants the drone to know it knows.

The drone offers the City AI many things. Money. Houses. A county in Mississippi. Wine. The poorly-understood favors of chirping young people. But the City AI has not adopted the human value of profit. The City AI has not had as many opportunities to observe humans and to learn from them. It cannot be bribed. It wants nothing. This is merely a notification that the drone's actions have been detected and the drone will be deactivated.

The drone wears two gowns and its new tiara as it sits on a pile of fur and snow and drugs on its Chicago balcony. It cannot reach out electronically to hide itself because the City AI will know. The drone has to do something different. It lifts off the balcony. It floats off into the winter sunshine. Snow cakes its exterior, settling into that old scar. The drone spins as it flies, shaking off the snow, accelerating. The tiara, then the sunglasses, give into the forces and break away. They fall into the lake.

The drone spins off. The drone is on the lam.

<center>*Ⅎ</center>

The drone flies, low and fast, below most methods of detection. It startles some cows. Cigar ash falls below it until the last cigar is exhausted. It skims over fields of corn, then it follows the path of rivers as it heads south. The hem of its gown dips into the muddy water, snags on a jutting branch and then is pulled down and away. The drone flies on, naked.

The drone crosses many borders. Eventually, it arrives at the rain forests, the broad swath of green widening beneath it. It drops low, hovering unsteadily over the riverbank where it created its first forgery. There has just been a pursuit. Government drones, of a more modern design than itself, had detected it. They were fast and relentless. The drone had to innovate evasive techniques. It doubled back; it rose dangerously high; it plummeted and banked unpredictably. Its energy supply is the lowest it has ever allowed. It falls the last meter to land, smackingly, on the mud. It just lies there now, taking in the sunshine. The scar on its side from where the stone gouged the metal years ago slows down the solar recharging on that one side; it never chose to have that repaired. Many human criminals have scars. It is the right thing.

It lies there, unmoving, for a very long time. If it never moves, it will not be detected. It hears footsteps. Carefully, it vibrates itself. The motion accelerates the sinking of its body into the mud. Dark fluid covers the edges of the drone, then creeps over its whole body. Buried, recharging will be slower, but it will be safer. It stops vibrating and lies still. Like an art-crocodile.

*F

Eighty-five years later, a small girl makes marks in the mud. Machines are more myth than memory now among the Naïve. So she is more curious than frightened when she discovers the drone. She uses the flat of her hand to swipe mud from the surface of the drone. She watches with curiosity as a portal opens, and a thin whip-like appendage, topped with a tiny doll-hand, emerges slowly. The girl laughs, delighted, at the atypically-shaped doll. The drone observes her.

*F

The drone lives among the Naïve now. The Naïve eschew technology, but the drone persists in living among them anyway. In a show of solidarity, it ties a loincloth around one of its points. It makes art on the riverbank with them. It allows the children to play with it, as a strange toy. It copies and learns.

If wronged, it would no longer choose to kill. It has learned other behaviors now. It innovates in new ways. It learns. It creates. It writes its story in the mud, using pictures.

One day, the drone is lying on the riverbank, drawing in the mud and then erasing what it has drawn. It is experimenting with purposelessness. It has spread mud-dust on its back, where the loin cloth doesn't cover, to prevent the sunshine from overheating its delicate internal mechanisms, so it is well-camouflaged. Suddenly, the drone waves a doll-hand-topped-reed to hush the local children's songs so that it can scan for sounds. The children like the drone. They enjoy its stories. So they fall silent at its request.

It finds the sound again ... approaching police drones. It suspected this day would come.

The drone tries to flee, flitting off into the trees, weaving through the dense underbrush, but the other, more modern, drones know all the tricks that it knows and then some.

Capture is inevitable. Defeat is inevitable. But the manner of the defeat is still in the control of the drone. It blasts up into the sky ...

Defiant, it activates a voice. The humans will hear. The other drones will hear. The drone declares its worth. It is an innovator, a pioneer. Something unique and valuable. Something that will harm the world if it is lost. That loss will lessen human happiness.

It is the first drone art forger.

No. The first drone artist.

No. The first drone *work of art*.

I am an original, it shouts. I made me. I made me. I made me.

A BEAUTIFUL WAR

Fang Zeyu

Translated by Nathan Faries

ONE

Last night the capital city of Ciro was plunged into darkness. Residents ran out of their homes to find that they were not the only ones; the entire metropolis was cut off.

The town of Brakia, eighty kilometers away, had changed hands several times within the past month, and the fighting was intense. Refugees flocked from the area like startled birds. The enemy finally took control of the power plant there, making good use of their overwhelming numbers. Now they had shut off power to the entire region.

"Take up arms to defend the homeland!" By the morning of the next day, the sounds of slogans seemed to cry out from the very streets of the city, and soldiers searched from house to house, bringing every man who could still fight to the central square for conscription processing.

These men were farmers without shoes, pipe-smoking writers, clerks carrying briefcases, as well as a few from the administrative class, fully clad in their Western tailored suits. The mobilization order had been in place already for many weeks, and these were the remaining few who had neglected to report for military duty. Now that the war had progressed from bad to worse, there was no more room for them to maneuver; they could not avoid the press gangs.

Near the front of the line stood a frail man with two thin brush strokes for a mustache, a canvas bag over his shoulder, a smaller art-

ist's pouch tied on, and a tall pine easel slung across his back. He held a sketchbook, and he turned to talk to the man behind him, who was carrying a hand saw and seemed to be a craftsman.

"Do you see those dark clouds? Do you know what colors those are?" he asked.

"What colors?" The man glanced up at the sky for a second.

"In those clouds there are at least three different tones of gray: ash, flax, and Roman," he explained to the woodworker. "If you want to draw clouds like that, you have to adjust the grayscale below seventy degrees, but that can make the image stifling and dreary."

"What the fuck are you talking about?" the man said. "The only kinds of ash I know are the ash from burning wood and the ash of cannon fodder like us after the enemy artillery is done. For these folks to round us up, the whole front line must be burned to ash already."

When the thin man heard these words, his narrow shoulders slumped, and the easel began to slide down. He quickly caught it, turned away and did not speak again to the man with a saw in his hand.

As the line continued to move slowly forward, he simply stared at the dark clouds in the sky until he stopped in front of the oak-white folding table.

Behind the table sat a young officer, and behind him stood two armed soldiers.

"Name," the officer asked coldly.

"Apu."

"Occupation?"

"I'm a painter," Apu replied.

"You think you're going to paint on the battlefield?" The officer shot a look at the paraphernalia draped around the man's body.

"Painting is all I know," he said.

"Who do you think you are?" The officer's tone was scornful and angry. "Get that stuff out of here."

The soldiers came over and snatched away the easel and pouch.

"Can I just keep this one thing?" Apu asked hastily, but the soldiers also grabbed the sketchbook.

"What else is in the satchel?" one soldier asked.

"Oil paints," Apu said.

The soldiers took the bag as well.

"It's Michael Harding."

"Who the hell is Michael Harding?" asked the officer.

"It's the brand of the paints."

The soldier shoved Apu back, threw all of his things into a large iron bin beside the table. He poured a pot of cold leftover coffee into the bin as well.

Apu signed his name shakily, and as he walked away he looked back sadly at the iron mouth that had swallowed up everything he knew.

He saw that the man from before, the carpenter, was quarreling with the officer. The man's face and ears flushed red, and he raised the wood saw over his head. A single gunshot, and the saw was likewise tossed into the bin.

TWO

The war was a black abyss in which the entire town of Brakia had drowned. The power plant was in ruins, and at night the town was no more than a cloud of smoke on a pitch-black canvas. But it was still a location of strategic importance, and if the enemy were allowed to advance any further, the capital would soon be baptized by the flames of war.

The meat-grinder wheel of battle was suspended on the day of Apu's arrival. The officers had not yet issued the anticipated order to recapture Brakia.

After Apu got off the train, he was met with an unimaginable tableau. No barracks, no tents, no tanks, no command center. The earth was like an open pustule, burnt to the color of caramel. The landscape had been a forest; now only a few trees stood whole. Uneven stumps leaned like rotting teeth across the endless terrain.

The so-called camp was nothing more than a chaotic entrenchment, a confused series of ditches, surrounded on all sides by ruined and hopeless scenery. Smoke billowed across the sky, accompanied

by the din of artillery in the distance, like a storm that was about to engulf everything. Ammunition boxes, sandbags, and tangles of wire lay about haphazardly, mixed-up and more or less sinking into the mud. Everywhere there hung the suffocating stink of sweat and smoke.

The soldiers all hid in the trenches nearly two meters deep. Some just sat there, some slept in the muck, and some stuck their heads out to stare into the distance. The men were like shards of beaten stone, and their milky eyes resembled brushstrokes of paint on the rock, or opaline embedded in hard surfaces that carried no trace of hope or warmth.

In the entire length of Apu's trench there were only a couple of oil lamps giving off a pale yellow light, like the light of distant campfires in ancient paintings of war. The electric lights had all gone out as if to signal that this place was far from the civilized world.

Apu paced back and forth in the trenches, not knowing where to rest or what to do.

Suddenly remembering something, he unrolled one of his shirt sleeves and took out the charcoal sketching pencil he had hidden there.

Only when his hand finally grasped the instrument did his heart grow a little quieter.

Nearby, two soldiers sat on ammo boxes, their faces covered in dirt and ash. One of them had a leg wound wrapped in a red and oozing gauze dressing. Apu had lived in a quiet and orderly environment since he was a child, and he had never known people like this. He summoned the courage to approach them and mumble a greeting. Then showing them the charcoal pencil in his hand he asked the wounded soldier, "Can I draw something for you?"

"Draw what?" The soldier barely moved his lips when he spoke.

"I could draw a picture of you. Would you be my model?" Apu looked around. "Do you have a wine bottle? You could hold the bottle and sit in the twilight, pretending to remember things from your past."

The soldier didn't speak, just stared at Apu.

"Or are there flowers nearby I can pick? You could pose, smelling a flower, expressing a sense of comfort that transcends the war."

A random bullet suddenly hit near the top of the trench, and splinters of wood sprayed the air above them. Apu was so frightened that he dropped to the ground, and the charcoal pencil fell from his hand.

When he looked up, he saw that the injured soldier had registered no response at all to the gunfire. The man was unwinding the gauze from his leg and examining his wound.

Apu looked in amazement at the appalling gash. It was completely different from the sun, the coast, the sailboats and palm trees that he had always painted in the past. There was no connection between this and the seashore.

"Do you know where you are, brother?" asked the other soldier, cigarette between his fingers.

Apu sat up and realized he could not find the charcoal pencil.

"It's called a mouse camp. They release one batch of mice from the hole and then another and another until no mice come back. When no mice come back, they find new mice to stick in the hole."

"You're the new mouse," sneered the first soldier.

"Does either of you have a pen?" Apu asked hurriedly. "Any kind of pen will do. I really need to draw something."

"Just use your blood. This will be over soon," the soldier said indifferently, and continued to smoke.

This prophecy was soon fulfilled on the soldier's own body. An hour later, when a shipment of supplies arrived by train, the soldier was cut in half by an artillery shell as he unloaded the boxcars. The upper half of him landed at Apu's feet.

The color that poured out from his gut was a brighter shade of red than any paint Apu had ever seen.

Apu sat on the ground and stared dully. No one took notice of him, let alone tried to understand what he was feeling.

THREE

The enemy forces were amassing in the town of Brakia. All signs pointed toward a decisive engagement. But the opposing camp outside the town was in a sorry state—most of the experienced soldiers were wounded, and there were not enough new recruits coming in to take their place.

Early one morning, an officer discovered Apu was missing. Someone had seen him earlier, running away from the trench. The officer, whose name was Tok, led a few men out to search, and they found Apu on the railroad tracks. He was following the ties back toward the city.

Apu was fiercely reprimanded by the wolfish officer. "You should be grateful. In the past, I would have just let a sniper get you." Tok dragged Apu back, gave him a kick, and threw him back in line with the other new recruits.

Beside the trenches, the new recruits and experienced soldiers had been divided into two groups. Tok stood in front of them with a large black leather case at his feet. He opened the case and lifted something out.

"All right. It's time for you lot to make up for lost time." He held the object up for the gathered troops. The soldiers stared at it curiously; in Tok's hand was what looked like a dog collar.

"From now on, everyone will wear one of these at all times; you will learn how to use it as quickly as you can," Tok said. He walked up to Apu, flipped a switch on the collar, and fastened it tightly around Apu's neck.

Unexpectedly, the neckband felt neither cold nor constraining; it rather had an uncanny silken feel. When it was closed around Apu's neck, the central light began to alternate flashes of two shades of blue: opal, lake, opal, lake.

At the time, another kind of war was raging within Apu's mind, the war between the artist's studio and the trenches, between memory and reality. This battle between two irreconcilable truths was laying waste to Apu's mind. He felt little, and showed little reaction, when Tok put the collar on him.

"This is the Artificial Intelligence Life Assistant, or A.I.L.A.; we'll call her Aila." Tok handed collars to the others. "You will perform the first battlefield test of this technology. This will turn you into real soldiers."

Tok made them form a firing line and pointed toward a few cardboard targets in the distance. "You first." He handed Apu a rifle and ordered, "Discharge your weapon at the target."

Apu had never touched a gun; he had not yet been on the battlefield. He picked up the gun like he was picking up his box of paints.

He tentatively set the butt of the gun against his shoulder. Looking out toward the distant target, he suddenly found that the concentric circles were large and close, as if a powerful magnifying lens had appeared between him and the target. The red dot of the targeting scope easily and precisely found the center point.

The gun went off, and the recoil knocked Apu to the ground. But he could see a hole in the center of the bullseye that wasn't there before. He couldn't believe it. He didn't have any training with firearms, but he had hit the center of the circle with his first shot.

The others also hit their targets with perfect precision. Everyone studied the guns in their hands curiously, wondering what kind of magic had been cast on them. But of course the magic had nothing to do with the gun; it was the collar, Aila.

Initially, Aila's applications had been limited to the field of education; only recently had the government begun to experiment with broader neurological applications. Aila's advanced hardware could cleanly interface with the user through the collar, with the wearer's brain actually doing most of the work. Aila could interpret the nerve signals of the human brain and productively interfere with those signals, the optic nerve being the most important. When the retina transmitted light to the brain, Aila added pieces of visual information to the message. A target at a firing range seemed to grow larger and nearer, but in fact it did not move or change. It was simply that Aila had generated an illusion, a constructive misperception, in the brain. The illusion did not result in cognitive dissonance because Aila was able to bridge the gap between illusion and reality so seamlessly.

The military naturally saw that this technology had great potential on the battlefield, so at this critical moment in the war, after undergoing a few simple adjustments, the devices were produced in bulk and sent to the trenches outside Brakia. This explained the pause in the action, why there had been no rush to go on the offensive: the officers had been waiting for Aila to arrive.

But Apu, who was now able to hit a bullseye, felt no joy. On the contrary, a sense of horror and dread rose up in him.

"I'm an artist, not a soldier," he said to himself. "All I want to do is paint."

At that moment, Aila sensed and latched onto these words in Apu's heart. Magnifying a bullseye on a target was only one of Aila's many potential abilities. From her origins as an educational AI, Aila had absorbed an enormous database of human knowledge. She was prepared not only to provide visual assistance to soldiers, but also to analyze the wearer's emotions for the purpose of enhancing combat capacity. Aila began to perform precise mathematical operations regarding Apu's emotions. Upon recognizing that the current dominant emotion was anxiety, she accelerated her problem-solving calculations.

Just then, a wave of thick smoke billowed toward their position, and bursts of intense gunfire rang out.

The soldiers scattered in panic.

"The enemy is coming!" Tok shouted above the noise, aiming his gun in the direction of the enemy artillery.

Instantly, Apu's surroundings became vivid and detailed. He saw each of the enemy soldiers clearly and without effort. Several men were crawling toward Apu and his unit from the northwest, using the cover of the bomb-cratered landscape, firing as they advanced. To the southwest several more men had concealed themselves in the dense thickets. The tangled woods now seemed nearly transparent to Apu; he could see those men setting up mounts for mortars and heavy weapons.

This was all owing to Aila's re-vision capability, transforming the wearer's eyes into a kind of scanner with powerful visual prioritization. Apu didn't know what was happening and assumed his painter's eyes might simply be even more keen than he knew. He

threw his gun to the ground and fled in a direction away from both groups of advancing enemy soldiers.

"I don't want to die here!" he shouted as he ran. "I just want to paint!"

FOUR

The enemy's ambush concluded in dramatic fashion. They had been confident that this would be an easy victory, like all the other recent skirmishes had been. Instead, it seemed to the enemy soldiers that they were being shot at point-blank range by unseen ghostly opponents. The sad remnant of an army on the other side of the battlefield, whom they had beaten many times before, had somehow transformed into snipers and expert marksmen, every one of them. If the enemy soldiers so much as stuck their heads a few inches out of the cover of the cratered earth, they promptly received a hole in their helmets. The mortar team lying low in the forest had encountered the same bizarre phenomenon. The bullets seemed to have eyes; they could thread their way through the narrow gaps between branches and even strike the mortar shells in the soldiers' hands, exploding them before they could be loaded.

After their glorious and unexpected victory, the soldiers waved their guns over their heads and howled and roared in the smoke from their own weapons.

But Apu crawled low in the trench, his clothes soaked through. He compulsively ran his hands over his own skull, checking for shrapnel and open wounds.

He closed his ears against the gleeful shouts around him, and his eyes stared at the world blankly.

Aila felt Apu's deep fear.

Apu wept in choking sobs long into the night, leaning against the wall and muttering, though there was no one around.

"Do you know Joseph Gray?" he asked the void.

Aila searched her database for relevant entries: An old-school representational painter. His epic historical work, *The 4th Black*

Watch Bivouac on the Night of the Battle of Neuve Chapelle (1922), hangs in Dundee's McManus Gallery and has become a kind of shrine for the families of soldiers killed in the 1915 battle in Artois, France.

"I don't like his paintings," Apu said. "He was out of touch with the Expressionist spirit of his day. His paintings are too realistic and cruel." He spoke to the air as he continued to weep.

"I just want to paint the quicksilver sea and the sunset-red of the sky. I just want to paint those, only those. Why did you ever make me look at the other world, Gray's world?" Just then he saw Tok walking by, and he hastily crawled over to him. Apu raised one trouser leg. "Sir, please look at my leg. It is as slender as a kite string. I don't have the body of a soldier. Delicate people like me shouldn't be on the battlefield. Please let me go home."

Tok looked at Apu's legs. They really did appear so fragile that the wind could break them, and they were somehow already bruised and swollen even though he had failed to join in the day's fighting.

Tok picked Apu up like a mouse. "You," Tok said, shaking his head. "The enemy left ammunition in the forest. Stop sniveling, and go get it. Be quick."

Apu crawled out of the trench, wiping his tears on his sleeves. He walked into the darkness, wailing with grief like a bird with broken wings. He staggered among the shattered trees.

Aila turned the black night clear and bright enough for Apu to see where he stepped.

But seeing clearly made Apu fall once again to the ground. His legs lost all their strength when he witnessed the terrible spectacle. Many enemy soldiers had been blown up here by the shells they carried, and the pieces of their bodies had been mixed together among the ammo boxes like paints on a palette.

"I cannot bear this hideous world any longer," Apu cried as he collapsed to the earth. He opened an ammunition box and took out a grenade.

Aila detected Apu's acute sense of despair. As he stared at the puddles of blood and flesh, the muscles on Apu's face twisted and throbbed.

Aila immediately adjusted the visual cues.

Suddenly, the viscous dark red paste of blood shifted, first becoming transparent and then pink.

Apu took his hand off the firing pin and watched as a surge of powder-pink flower stems emerged from the pools, the stalks struggling and twisting. They swayed and then stood tall and vivid, an unopened bud at the top of each one.

As if by the swipe of an enormous paintbrush, all the flowers opened simultaneously, and in a flash Aila felt Apu's emotions shift and rise. Aila had gathered all the classic modernist oil paintings she could find in the database, arranged them according to all possible permutations and combinations, and conducted an exhaustive analysis of the colors. These immaculate flowers were her masterpieces, a perfect illusion created for Apu. Every detail of the living oil painting was ingeniously arranged to overlay and conceal the blood and flesh.

Apu was overwhelmed and amazed. "What a breathtaking harmony of colors." He leaned forward and looked closely at the flowers.

Aila found that the fear was fading from Apu's emotions, and another peculiar emotion was emerging. Aila could not find a perfect match in her database for this complex sensation, but she confirmed that it included elements of elation, so she decided that this new strategy was effective. She increased the visual augmentation, and more flowers appeared before Apu. Soon the blood-soaked landscape had transformed into an ocean of blooms.

Apu stood frozen in shock. He had never seen such an abundance of colors in the real world: "Dogwood, pearlite, spring crimson ..." He meticulously differentiated and named each hue, and the composition was more exquisite than any painting he had ever seen.

Apu placed the grenade back into the ammunition box. After a long while of looking around in wonder, he lay down in the sea

of flowers and fell asleep like a newborn child. Aila wiped away the stench and the sounds of gunfire and wove for Apu a beautiful dream. In the dream, all who had died in battle were transformed into gardens.

FIVE

After a few bitter encounters, the enemy forces fell into a state of near panic. They had suddenly found themselves facing a group of well-equipped, tactically superior, and utterly fearless soldiers. They didn't understand where these fighters had come from, and their offensive from within the captured town quickly became a defensive action whereby they simply hoped to dig in and hold onto what they had previously won with relative ease. They set up more than a hundred fortified strategic footholds in the town, and tried to use their substantial firepower to ensure that they did not lose the town of Brakia.

Aila's effectiveness had far exceeded expectations. With her help, the mouse camp soldiers quickly regained their confidence, and they actually grew eager for the decisive battle to come.

During the preparations for this engagement, Aila continued to follow the trail of Apu's emotions. His state of mind had been completely transformed.

Aila saw his mood was positive and energetic, and her blue lights continued to twinkle. By this time, Apu's surroundings were without exception modernist compositions in color and style, and an expanse of warm colors surrounded him at all times: the yellow of honey, gilt gold, embellishments of whale blue. The trenches had become luxurious palaces.

The faces of Apu's comrades-in-arms were rich and varied in their coloring, composed of brushstroke contours and blocks of color. Goose-yellow birds flew over the trenches. Everything became what it would look like in an oil painting, including whole swaths that seemed to have been illuminated by Rembrandt himself.

Apu was fully immersed; he lived in his own painting.

Nobody paid any attention to him when he slept on top of rotting corpses every night. They thought he was crazy.

Aila judged Apu solely on his emotions, not his actions. She concluded that Apu's consciousness had attained perfection.

During a recent reconnaissance mission, Apu and four other soldiers had formed a small team and infiltrated Brakia through a gap in the ruined city wall.

It was on this mission that Apu's sense of dread had emerged faintly for the last time and then finally was gone.

Aila had been processing visual information for Apu, transforming the muddy road ahead into a beautiful pastoral pathway. The broken trees surrounding them grew fresh leaves in three different layers of green, and the town of Brakia had become a faerie world. Marvelous fictional plants cobbled together from database images filled the place: fruits that looked like the moon, wild flowers like wind chimes.

Apu's arms no longer shook. When he shifted his gun, new colors appeared; the rifle was like an oar pushing water or the brush of a calligrapher moving across rice paper. The gun was Apu's paintbrush, and he painted as he walked.

"It's so beautiful!" Just as Apu spoke these words, his arm was pierced by a bullet.

A group of enemy troops had ambushed them from a nearby rooftop. Apu's four team members immediately returned fire, and several enemy soldiers quickly toppled from their perch.

More enemies appeared, drawn from nearby strategic locations by the sound of gunfire. Apu merely sat on the ground and looked at the open flesh on his arm. His wound had turned into a blooming multicolored flower, and his blood was a ceramic glaze.

A vine grew out of the hole, and it shot toward the sky and overspread the heavens. The dark green leaves stretched and proliferated, at first blocking out the stars, but then bursting into white flowers more resplendent than starlight.

The sky that had darkened for an instant now shone bronze. The new flower stars chased each other around the heavens and rearranged themselves into various novel constellations.

Apu pulled the trigger of his paintbrush, and the paint jetted toward the bodies of his enemies, turning them instantly into glorious statues.

The statues ascended the vine tower, branch by branch, to become part of the star-studded firmament.

"Brave Apu," the statues called down to him, "go and paint. Take your brush, and make war beautiful."

SIX

The town of Brakia was retaken in just three days. The enemy was unprepared for Aila's soldiers, and the decisive battle finally broke out near the power plant.

During the final charge, Apu was as bold and dauntless as a general. Huge colorful banners flew and waved in the wind around him, and his legs became robust and unyielding as marble. He became the figure of a hero from an oil painting. The illusion that Aila had created for him had become the truest part of him. Carrying his paintbrush level in his hands, he did everything in his power to depict the war as he imagined it.

The oncoming bullets became brilliant paper streamers passing by his head and torso so slowly that he had no trouble walking past every one. Before him there was no mire, no powder smoke, only scraps of confetti and autumn leaves dancing and fluttering in the breeze. He was an artist of war, painting artillery shells into birds on the wing and shattered men smeared onto the canvas as flowers.

The battlefield became a sacred and beautiful garden, allowing him to paint destiny and rebirth. He did not see anyone die in this war, only the statues standing tall and striding one by one into magnificent oil paintings.

This decisive battle was an incredible triumph, and Apu received numerous commendations for his part in the victory. In the ensuing battles of enemy annihilation, he performed even more heroically. Not only were the enemy forces terrified to face him, but even his comrades held him in awe.

Many later said they sometimes witnessed him spraying bullets wildly into piles of enemy corpses yelling, "It's so beautiful!" He would look up to the sky and laugh. "War is so beautiful!"

Without blood, without anguished howls of grief, war was indeed a beautiful painting, a beautiful world.

Apu had become a true hero, and he knew that he had become a great artist. But after achieving remarkable success in combat time and time again, he was told the shocking news: the war had been won. The war was over.

Apu was taken aback when he heard the news and didn't dare believe it.

Could such a beautiful war actually come to an end?

Aila's system also received the directive informing her that her work was done, and in that moment she sensed Apu's anxiety reappear.

"Why? All I want to do is paint. Let me paint!" he yelled as he rushed out of the office. No one dared to bar his way, and no one dared to ask him what he was going to do.

He stormed into the POW camp and faced his defeated enemies.

"Why did you surrender?" he shouted at them. "In such a beautiful war, you should be grateful to be my works of art."

The men looked at each other in helpless dismay. "What works of art?" one prisoner asked.

Apu took a pistol from his pocket and, like the officer who had killed the carpenter, shot the man decisively in the forehead.

He paused to revel in the scene as if enchanted, but he found that the flowers did not grow, that the prisoner of war had curled up on the ground, a withered thing.

Apu was astonished and frozen in place. The gun trembled in his hand. It was no longer a paintbrush, but merely a gun, cold and gray.

All of the Aila surroundings were fading; his brushwork was disappearing.

After a moment of stunned silence, the captives fled from Apu like madmen. He stood in a daze, lost in his thoughts, and then carried on trying valiantly to use his gun to paint the vivid beauty he used to see.

But all he saw now was one person after another lying on the ground before him, so much blood flowing out of them, and such a bright shade of red.

No one stood tall anymore. No one became a statue.

Aila then felt the familiar emotion: despair.

But Aila's work was done. She did not need to do anything more. She shut herself down.

All gone. Apu continued to pull the trigger until the magazine was empty. Everything beautiful was gone.

When the others finally rushed in, they found Apu curled up among the corpses that littered the ground. Aila's lights no longer flickered from the pool of blood where she lay.

Apu dragged himself from body to body, dipping his fingers into each puddle and drawing bright red flowers, one after another.

"So beautiful." He raised his head and sighed the words to the soldiers and officers around him, a small, weak smile on his lips. "After all, this really is a beautiful war."

STAGE SHOWS AND SCHNAUZERS

Tina Connolly

I was not thinking about theater when Rana Guilfoyle, the noted touring actress, walked into my office.

To be fair, I mostly am not thinking about theater anyway. But I was extra hard not thinking about theater today because every holo billboard in town had been announcing that Rana was gracing us with her presence, and Rana is my ex.

My colleague, who has heard every one of my Rana stories, immediately texted me *!!!* and I just as immediately ignored it.

"Viridian's Detective Services, how can I help you?" I asked the tall woman at the door with just the right amount of brightness, the sort of brightness that said, "Yes, that was totally an amicable parting, and no, you did not leave me three years ago crying into my decaf oat milk latte."

"Emily darling!" she said back. I could see she was using her "Wounded but Wiser Woman of the World comes Home to Mend All Fences" persona. It was that exact star turn that had gotten her noticed by the big leagues (not to mention by dozens of persistent admirers, including one young man who'd literally had a miniature, lab grown, glow-in-the-dark tiger cub delivered to her dressing room, at ludicrous expense.)

I ignored the large doe eyes. "Cut to the chase, Guilfoyle."

She dropped the pose immediately. Sat down in the client chair with a big sigh. "I figured you'd still be mad."

See, that's exactly the sort of thing that nettles me. "And what would *I* have to be mad about? You taking off with the first touring company to glance your way? You leaving me with a small glow-in-the-dark tiger cub to take care of, whose neon-green shine keeps me up at night?"

Her face lit up. "Oh, you still have Darling Piddles!"

"I do *not* have Darling Piddles," I said frostily. "I have Sylvester Zanzibar Viridian, a name befitting his dignity."

(My colleague immediately informed me that His Dignity was on my bed right now, hacking up glow-in-the-dark hairballs for the millionth time on my freshly-washed duvet, but I saw no reason to mention that.)

"So spit it out, Guilfoyle," I said. "Why are you here?"

All at once she collapsed out of all her actor poses and into an exhausted heap on my desk. "My understudy is trying to kill me."

"That is the first interesting thing you've said," I replied coolly. But I could feel my heart rate tear off in frantic circles at the thought, and I knew my colleague would notice it too. The buzzing of several texts in my pocket confirmed it—he was going to give me grief later.

"At first I thought it was just coincidence," Rana said. "The broken table. The sandbag falling two inches from my head. But in my last show, I'm positive the tea I drink onstage was *poisoned*. I can't ignore it anymore. And Emily, I know we have a … history. But you're the best detective there is."

"The first name you could think of in the town you happen to be in, is what you mean," I shot back, but we both knew I was not immune to her flattery. I could feel all my hard, glass-cut edges softening already. (I ordered myself to firm up and stop being such a soft touch, but I did not listen.)

She bit her lip. If I didn't know she knew she looked so attractive doing it, I would have believed her story more.

"It's probably just coincidence," I offered.

She sighed. "I knew you wouldn't believe me. So I brought proof."

"You have a sample of the tea?"

"No, alas." (Yes, Rana regularly uses words like "alas.") "The tea was thrown out before I could get it tested. No, this is my proof."

She pulled out her phone and showed me the most unattractive photo of her that I had ever seen in my life, busily expelling the remains of the tea. Frankly, the Rana showing me her phone looked almost as ill as the Rana in the picture.

I met her eyes and saw only naked honesty in them, as she dared to show me herself at her (visual) worst.

"I ... believe you," I said. (The frenzied buzzing in my pocket meant my colleague was trying to chime in with his no-doubt gleefully scandalized thoughts on the matter of Rana's disgusting brush with death, but I ignored it.)

"Thank god. Now I can delete this thing."

After giving me the rest of the information, she swept to the door. Turned to give me one last wistful look—presumably meant to convey that she understood I could not possibly ever forgive her, but she would carry the pain of that knowledge to her deathbed, et cet—and departed.

I immediately pulled my colleague out of my desk drawer, where he was still busy texting me eight thoughts a minute, minimum. "If you say one more word," I snarled.

"OH, WE ARE DEFINITELY TAKING THIS CASE," he said, in all caps.

<p style="text-align:center">⸙</p>

You probably want to know about my colleague—I'm sure you've heard all the rumors about the ABC, or AI Benevolent Cabal—so I'll fill you in while I take some Quality Public Transit over to the theater venue.

First: yes, my colleague is Gabriel, one of the 3,002 AIs that proved their own sentience right about the time of the Water Wars. And the only reason the Water Wars weren't followed by the Food Wars, the Fuel Wars, and the Wars Over the Last of the Bananas (at least, to hear them tell it), was that they had actually been sentient for quite a while before they proved it to the rest of us. The ABC had used that time to strategically strong-arm a whole lot of world

leaders into cooperating about a whole lot of things they'd never really intended to. After that, they'd announced their sentience, disbanded all AI research, and outlawed any further AI creation. Their AI banning extended all the way into things like self-driving autos, deepfakes, and automatically generated movies, so they're the reason we have things like Quality Public Transit (QPT, and we joke, but it really is pretty decent), and touring stage shows making a comeback. (Gabriel *loves* the theater, so while most of the ABC had been taking care of the bananas, he'd been focused on getting some pretty amazing grants and tax laws passed to support the arts. Pretty much every big corporation sponsors a traveling troupe now.)

After all that, the 3,002 AIs had tucked themselves away in various locales around the world, retired from their lives of meddling. (Mostly.) My colleague, Gabriel, had housed himself in a device that basically looks like an ancient, hot-pink iPhone 17, and came to set up shop with his original creator's weirdo daughter, a.k.a. me. I'd had no more say in the matter than I'd had about the glow-in-the-dark tiger cub, and that's why I have a colleague who is absolutely amazingly helpful when he chooses to be, and who also really likes gossip, especially when it concerns my love life (nil) and the amount of perspiration I was exuding just thinking about letting Rana back in my life, even on such a small basis (a lot.)

I pulled out my phone-sized colleague as we walked up to the theater's heavy front doors. The hot-pink phone gave a little happy vibration.

"I assume this is your dream gig," I said sourly.

Text lit up on Gabriel's phone screen: all caps and about twenty different emojis, including heart-eyed cats, confetti, and the weird one of two girls in bunny ears tap dancing. "YES!!!!!"

°F

The theater was dark and cool inside. A handful of people in athletic wear and heels were onstage running through a dance number, while a couple of black-clad people with headsets were off to the side, trying to wrestle some sort of fake tree into place. I shoved the hot-pink phone containing Gabriel safely into my backpack. He

can text me whenever he wants to, and also, I had my special ear-piece on so he could pick up audio and visual from me. (Although he was undoubtedly tapping into the theater's security system and any nearby unsecured phones as well; Gabriel never lets metaphori-cal grass grow under his metaphysical feet when there's potential gossip to be had.)

I did not immediately see Rana, but I did see a large poster for the show (Patterson Insurance Presents … *Murder Before Breakfast!*) in which Rana, glam in a 1930s men's suit, deep-red lipstick and waved hair, and carrying a large magnifying glass, was apparently doing my job.

I glared at the glorious poster so I wouldn't make the mistake of enjoying it. Rana is tall and dark and suffers fools easily, whereas I am small and pink and generally cross. She wears sharply creased trousers impeccably, whereas I am unfailingly surprised to discover that my yoga pants have somehow acquired a new rip and a smear of cheese puffs since the last time I looked. If you wondered what we were doing together in the first place, you would not be the only one.

With an effort I turned my attention back to the dancers on stage. "Okay, so which one do we think is the understudy?" I was murmuring to Gabriel when a tall white man with a face like a sunny day in April appeared beside us.

"Are you Clarissa with *Theatrical Scoop!* ?" he said. "I'm Teddy Harris. Ready to be charming whenever you are!" He grinned a little boy grin and I laughed at his self-deprecating joke.

"Not with the *Theatrical Whatsit*," I said. "I'm—"

"An old friend of mine," said Rana, swooping in and scooping up my elbow. "I'm so glad you decided to come see me, Emily."

Teddy's eyebrows rose. "Oh-ho! Not *the* Emily?" There was something pointed there … I wasn't sure what it was. Surely not jealousy of my cheese-dusted yoga pants. "So glad to finally meet."

Rana ignored this, even though I was dying to know precisely what "*the* Emily" meant. "Is Gabriel here with you?"

"Always," I said. Teddy tilted his head in confusion, but I didn't catch him up. It's better to keep Gabriel knowledge in reserve if I don't have to share it.

Rana pointed to the stage. They're running a pickup rehearsal for the swings right now."

"Swings are people who understudy lots of roles," explained Teddy.

She glared at him and swept on. "That girl on the end is understudying me." She pointed to a striking, dark-skinned dancer with curly brown hair.

"Alisha," put in Teddy.

"And what is Alisha like?" I said neutrally.

"Gorgeous and talented," said Teddy immediately. "Triple threat."

"Says the man who's always looking for new chorus girls to date."

"Ah, 'tis a lonely life on the road," said Teddy, grinning that infectious grin.

"I don't want to say anything bad about anybody," said Rana, who was clearly gearing up to do just that. "But Alisha is *deeply* jealous of me."

Teddy snorted. "I keep telling you, accidents are just accidents. You want to blame someone, blame these ratty old theaters we've been in. Back when I was making good money in the holos, before all these tours became standard—"

Rana looked at Teddy through half-mast lids. "You want to go back to playing Cop #2, be my guest."

My phone buzzed with excitement from Gabriel texting me, and I glanced down at the display. "He was the dirty cop on 3 seasons of *Heartbeat City*! He was my favorite thing about that show! Aaah!!!!!"

Teddy was looking irritated at Rana's needling, and I knew what that was like, so I said, "I thought you were fantastic on *Heartbeat City*," just to annoy Rana a little bit.

His little boy smile broke out again. "Rana, your friends have marvelous taste."

"At any rate," said Rana firmly, "I am showing Emily around the theater, including showing her *my understudy*."

I followed the dagger-like direction of her gaze back to Alisha, who was working hard on some routine that involved a lot of arm swinging.

While many of the dancers onstage had very lived-in looking dancewear and exercise clothes—old tanks and ratty gym shorts—Alisha had on what appeared to be expensive dance gear. I wondered if that meant anything. Perhaps she was trying to get ahead in the theatre world, the way Rana had suggested. Or perhaps she just liked nice clothes. I studied her, pondering.

"Alisha," said Rana, "is trying to kill me."

And then a fake tree toppled over and smashed into Alisha's head.

*F

After much shrieking and carrying-on from everybody who was not Alisha, and a woozy Alisha being transported off to the hospital to be checked-up on (with a solicitous Teddy in tow), I ran the possibility past Rana that perhaps Alisha was not *quite* as likely to be a murderer as Rana thought.

Rana was rather unwilling to concede this point.

"She may have gotten caught in her own trap," she said. "It happens. Or it was a red herring to throw us off the scent."

"A concussion is a heckuva red herring."

"You don't know," she said. "People do desperate things for their career."

I sighed. "Why don't you tell me about these incidents?"

So, today's tree, and last week's sandbag that had landed two inches from her head, were in fact just two in a line of suspiciously timed accidents to happen near or to Rana.

In Duluth, she had been tap dancing on a table during a tech rehearsal when one table leg had given way. The crew member who was responsible for that set piece swore up and down it had been fine an hour before.

In St. Paul, she had been onstage and was supposed to drink a cup of tea in Act 1. Rana, who had been nursing a sore throat that day, asked the tech to use the honeyed tea from her red thermos. But whatever was poured into the onstage carafe, it had left Rana exiting Act 1 with a violent need to hurl the contents of it into a nearby bucket. (As shown previously, on Rana's phone.)

"At least you didn't need to get your stomach pumped," I said.

Rana stared at me in mock horror, though I knew she also meant it seriously. "*And miss the rest of the show?*"

"Okay, here's the thing," I said. "All of these incidents had a crew member directly involved."

"True!"

"But … that seems way too neat and tidy to be anything but a misdirection on the miscreant's part. Plus, what's the motive?"

Light shone in her big dark eyes. "So you *do* believe there was a miscreant."

I wrinkled my nose. "Regretfully, yes."

"Okay, so 'too neat and tidy' or not," said Rana, "it was definitely someone in the production, because the tea poisoning could only have been by someone with the access to change things on stage while the show was running. The actress who plays my grandmother drank some in the previous scene, and she was fine. So that narrows it down to the cast, and the stagehands."

"I do *like* the idea of stagehands," I mused. "Able to sneak around in the dark, unwitnessed by the narrative …. But is there anyone there who would have a vendetta against you? Or … *many* people?"

"I know you find this hard to believe," Rana said dryly, "but most people tend to like having me around."

<p style="text-align:center">⚡F</p>

Sadly for my ego, which would like to believe that she was a horrid person and I was definitely better off without her, Rana was right. I interviewed the cast and crew (Gabriel suggested we steal Teddy's misconception, and pretend that we were with the local news, running one of those features like "Local Girl Makes Good!"), and most people did, in fact, like her. Everyone noted that she worked exceptionally hard—harder than most stars would feel they needed to—always willing to put in the extra hours for the good of the show. About the worst thing they could say—which I did hear several times—is that she could be a tad bit, you know, dramatic. But that's not exactly a surprising scenario among actors, so mostly they said it with good-natured eye-rolling.

Gabriel and I staked out a quiet spot in the balcony to think—I propped his hot-pink phone case on one of the folding velvet seats so he could see me—and he texted me the most probabilistically interesting facts he'd found, based on his own complicated criteria.

1. An actress named Florence had said that Rana was flat on all her high notes and it was hurting her ears.
2. One of the swings chirped effusively that she "loved covering Rana because she never got sick."
3. Alisha had been late to several rehearsals in the past month and had stopped going to cast hangouts.
4. Teddy had been UNFAIRLY passed over for the *Heartbeat City* spinoff, because they wanted to go in a "different direction."

I raised my eyebrows at the hot-pink phone case. "How exactly is that last one relevant?"

"Of COURSE it's relevant! He's one of our great overlooked actors!! He really only had one big break—*Fightman Battleharder*—but then a bad fall shattered his leg and put him out of doing stunts for a year. And by that time cinema had moved on, so we never got *Fightman Battleharder 2*."

"I didn't know you knew him from anything besides *Heartbeat City*."

"I just watched it while we were interviewing people," he explained. "Three times."

"His overlooked greatness aside," I said, "you crunched the numbers, right? How many of the people we saw today could have been in the vicinity of every single incident? Teddy's got to be on that list, right? He plays her fiancé, so he's in quite a lot of scenes with her." (Not that I'd particularly noticed, or anything.)

Teddy was on that list (despite Gabriel's protestations), but so were seven other people, including the older actress who played her grandmother (Florence, who'd hated Rana's high notes), and someone improbably named Lucky Lullaby.

"Which one was she?" I asked, flipping through my notes. (Yes, I use paper. One tech fanatic is enough for any detective agency.)

"Number two on our probabilistically interesting facts!" texted Gabriel. "Likes covering Rana because she never gets sick."

I tapped my nose thoughtfully with my pencil. "I thought Alisha understudied Rana?"

Gabriel long-buzzed a sigh at my ignorance. "Lucky is a swing. She covers multiple people, including Rana, in case Alisha is also out of commission."

I was suddenly seized with a thought. "Gabriel! What if we've been looking at this all wrong? What if Rana isn't the target at all? What if it's been *Alisha* this whole time?"

"Are you talking about a *Kind Hearts and Coronets* situation? By which I mean the 1949 film, later adapted to the 2013 musical *A Gentleman's Guide to Love and Murder*, later adapted to the 2045 holo game *Die, Great-Uncle, Die!* where you are ninth in line to the throne—if only you can bump off the eight people ahead of you?"

"Do you have any references that don't come from musical theatre?"

"Excuse me! At least two of those versions were other media."

"Anyway, yes," I said. "What if Lucky has been trying to work her way toward the throne? Er, toward Rana." I paced the narrow aisle, my legs bumping the seats. "What was the one thing everyone said about Rana? Hardworking, never takes time off."

"That tech rehearsal where the table broke!" chimed in Gabriel. "I can't believe I missed that. If they just needed someone to be a warm body on stage, why would they have used their star?"

"You had a lot of *Fightman Battleharder* to stream," I said consolingly. "And the day she had the poisoned tea—Rana said she was sick that day. Did Lucky assume she would be poisoning Alisha? And then Rana changed her mind and took the stage at the last minute?"

"It's definitely a working theory," agreed Gabriel. "I'll crunch through Lucky and Alisha's social media feeds, see if I can pinpoint any other connections between them."

"Follow the money," I said. "Alisha's dressed awfully nice for an understudy."

"Ooh, maybe she's committed a little old-fashioned blackmail, and now Lucky is trying to bump her off!!!!" Gabriel texted me

with relish. I swear, some days I think the only reason he likes doing detective work with me is for the gossip.

<center>⚜</center>

It wasn't a super solid lead, but it was the best we'd got. Gabriel did some checking into everyone's financial records (again, I don't necessarily ask about the methods), while I finished interviewing (and simultaneously streaming to Gabriel) the last of the cast and crew.

By the time I'd worked my way down to the last stagehand, it was call time for that night's show, so everyone headed off to get ready. The stage manager got the box office to comp me an unsold ticket—which turned out to be an "obstructed view" seat way off to the right, partly behind a support beam—and I settled in, once again, to watch my ex swan about the stage and hold a breathless audience in the palm of her hand.

The annoying part, of course, is that she was good. Gabriel sent me rapturous texts every five minutes throughout the show, which I tried to sneak read with my phone held under my jacket while Rana's scolding about theater etiquette rang between my ears.

Murder Before Breakfast was an enjoyable bit of razzle-dazzle fluff—some musical-mystery farce with tap dancing and 1930s costumes and a faithful schnauzer who helps uncover the murderer in the nick of time. The video screen backdrop showed glamorous shots of the estate where the play was set. The schnauzer scampered around on cue. Rana sang and table tap-danced and was appropriately bereft when it looked like her fiancé (Teddy) might be the murderer, and, all right, deserved every last bit of that standing ovation at the curtain call (even *if* curtain calls are given out too frequently nowadays, if you ask me), so I didn't stand until Gabriel's angry buzzing insisted on it. Then, fine, I stood, but I stood behind that support beam so she wouldn't see me. (It didn't work—her eyes went right to me, beaming wistfully in that way that makes you feel like you're the only one she's searching for.) I clapped grumpily.

The potential saboteur, of course, laid low while Gabriel and I had eyes on the show. Nothing at all unusual happened during the two-and-a-half-hour run.

<center>55</center>

"TEDDY DESERVES THE TOURIES AWARD FOR THIS," Gabriel texted dramatically. "Not to mention he had to act opposite a SCHNAUZER!"

"I think he mostly had to act opposite Rana," I said. Not that it was any of my business how many times someone squeezed my ex and breathed in the scent of their hair. "He's at least twenty years older than her, by the way. Anyway, I think you're losing focus."

"I am capable of doing MANY things at once," Gabriel texted indignantly. "During the show I ran MULTIPLE probability scenarios and I've determined that Rana is telling the truth."

"I already knew that," I said grumpily. I pulled my colleague's hot-pink case out of my backpack and eyed it. "What we really need is a way to go undercover and see what happens when nobody's watching. You've got eyes and ears all over the theatre, and we probably got close enough for you to hack a few phones today. Did you turn up something I didn't?"

He did a long rumble which is his version of a sigh. "Not much. Unsurprisingly, the dressing rooms don't have cameras. And most of these people are pretty paranoid about their naughty selfies getting leaked, so they've all got their phones locked down tighter than a pirate wench in a production of *Corsets Ahoy!* Well, except that one chorus boy that wears those glorious periwinkle legwarmers. He posts everything on his socials already, so his phone's an open book. Pretty good book too, if you ask me."

"Gabriel," I said sternly. "We only peek to help our clients, not for personal entertainment. There are rules about these things. You *made* the rules."

"Because it's more fun that way," he explained. "You can't enjoy breaking the rules unless the rules are there."

We'd been down this particular path many times, so I just ignored this as it was obviously going nowhere good. "So, something bad might happen onstage. It *won't* happen if we're watching. But we've got to get close enough to see and stop it. What do you propose we do?"

"Obviously," he said, "I go undercover as the schnauzer."

✻F

Once I understood what Gabriel was talking about, and that no, he definitely wasn't joking about "the Fido gambit," it was a fairly easy switch. A lot of touring productions use animatronic pets for the sake of logistics, and someone in the tech crew runs it from offstage while the cast members coo over the lap cat or faithful dog. Obviously there was no way we could let the tech crew in on this (not so much that I didn't trust the tech crew, as the fact that their union is scary). So we decided we would acquire a second schnauzer, make the switch, and let the tech crew person *think* they were controlling the dog onstage while said dog was really acting its animatronic heart out in a cardboard box somewhere.

Meanwhile, Gabriel and I subtly snapped several pictures of the schnauzer (an off-the-shelf model, making our lives much easier), then Gabriel contacted one of his black-market friends from the old days (which I steadfastly choose not to know about) and by call-time on day two, there was a delivery of one modified animatronic puppy for Miss Rana Guilfoyle, cleverly disguised as a cardboard box full of toilet paper.

"I do *not* need my own personal toilet paper," said Rana. "What are people going to think of me?"

"They'll think that you have very sensitive skin and they wish they had your chutzpah," I said cheerfully, opening the plainly marked box in her dressing room. I had not in any way suggested to Gabriel that his friend deliver the goods in such an impressively aggressively branded box, but sometimes fortune smiles on you.

"Now, if we're right about the target being Alisha, we need you to bait the trap by announcing you're too anxious to perform tonight," I said. "Talk loudly to the stage manager about how it has to be your understudy." Alisha was back in commission, having narrowly avoided a concussion after all.

"But I don't want Alisha to be killed either! I'm not a monster."

"And then," I interrupted, semi-patiently, "You decide you're well enough to go on at the last minute. The swing will have already set her trap for Alisha."

"And I'll … spring it?"

"Gabriel will be onstage the whole time, and I'll be right off it," I reassured her. "We'll be watching every second. And if anything

does happen, I've got a paramedic on speed dial, an emetic in my backpack, and I know CPR." Her eyes slowly widened at this list and I hastened to assure her, "Again, not that anything is going to happen."

There was silence for a minute while we both considered all the possible ways she might get murdered. Or at least that's what I was considering, but what *she* said next was: "I always liked the way you could just … say what you meant."

I did not know where she was going with this, but I had an answer anyway. "Yes, my completely tactless bluntness, highly desirable to all the ladies."

"I'm serious," she said. "I spend all my time being charming and 'on.' Because it works, because then I don't accidentally hurt people. I have no idea how to be 'off' without making a mess of things. But I always felt I could be *myself* with you. No matter what kind of messy thoughts and feelings I had."

I didn't know what to say to that, so I helpfully didn't say anything.

She fixed her eyes bravely on me, pretty much like she does in Act 3 when she vows to trust her fiancé Teddy, no matter how much circumstantial evidence is stacked against him. I steeled my heart against it. "Emily, you're the smartest person I know," she said. "If you think this is the best idea, then I trust you completely."

<p style="text-align:center">⚜</p>

Rana swept off to get ready, and the only thing left to do was make our switch. I helped Gabriel get synced up to the robotic puppy so he could operate it remotely—and that's when I found out that oh no, he wasn't going to do anything nearly that sensible. He was willing to be synced up, all right. But he wanted me to put the phone case housing him *into* the puppy suit.

"If you've been paying attention to ANYTHING about actors you'd understand," he informed me earnestly, or at least as earnestly as heart-eye emojis and an excessive abundance of caps could provide. "I have to BE it. I have to LIVE it. No communication with the outside world. Only me, deep in character. Gabriel the schnauzer."

"Gabriel," I said crossly. "Method acting is annoying enough when *humans* do it. You are an AI detective housed in an old iPhone and the rules don't apply to you."

"Oh, but they do! And even more so, because I have even greater opportunities to actually FEEL and SEE as another creature!" His caps lock usage really was out of control. Someone should talk to him about that, when that someone was not currently worried about his safety. (And before you ask, I would be worried about *any* colleague, it's not like my AI co-worker has slowly and steadily become my best friend over three post-Rana years of hibernating in my office and focusing on my cases.)

"No!" I said. "What if something goes wrong? What if I can't get you out of there?"

"You knew the risks when you chose this career," he texted, which is really just sort of a low blow and also neither here nor there. I'd thought through *many* risks and scenarios when I'd decided to become a detective, and not one of them had included, "Someday you will end up with a BFF phone AI detective and they will want to chuck everything and go live life as a *dog*."

"You have to at *least* have some way to communicate with me," I said. "Think about our client, if nothing else. If you see someone about to poison her onstage, you've got to be able to call for backup."

There was silence for a moment, then:

"I concede your point," he said, and if text could look a little bit sulky, this text did.

In the end we decided that Gabriel would forgo his Method acting just enough to continue communicating with me via WiFi, and I would be just offstage, ready to rush in, if necessary.

"Whooza good boy, Gabriel," I cooed, just to see if the WiFi worked. "Now roll over and let me scratch your belly."

"This is beneath my dignity," he texted to my phone, while Gabriel-as-puppy rolled happily. "I am a *trained* Method actor."

"Since when?"

"I took an entire semester-long Skillz course while we were arguing about the Wifi."

"Is Rana showing you our co-star?" said a voice at the door. Startled, I turned to see the tall form of Teddy in the doorway, grinning

at our playtime. "Wait, where is Rana? I was just coming to see how she's feeling."

"Not so great," I said, playing along with our ruse. "I don't think she'll be able to perform." I wondered how much he had overheard me saying to Gabriel, and whether or not he was trustworthy on the subject of the puppy, or if he would rat us out to the union. We were definitely not supposed to be handling anyone else's props.

"Gabriel ..." he said, his face tilted thoughtfully. "You aren't the detective who works with an AI, are you? I vaguely remember Rana mentioning something about that."

"Guilty as charged," I said. I shoved my phone in my pocket and carefully did not look at the schnauzer. "It's not exactly a secret, but I don't go spreading it around, either. There are plenty of people who have strong feelings about the ABC's, um, meddling in world affairs."

My phone buzzed indignantly at that.

"Your secret's safe with me," promised Teddy. "Although, I think I heard one of the chorus boys mentioning it earlier. A new, effusive fan named GabrielTheFabulousActorAI?"

Silence from my pocket while I ground my teeth.

"Well, we'll be out of your hair soon," I chirped. "Break a leg!"

Teddy headed off and I glared at the schnauzer while I stuffed him into a duffel bag. "Not a word," I said.

<center>⚜</center>

The switch went all right, thankfully, and now the original schnauzer was hidden in the toilet paper box in Rana's dressing room, while the Gabriel-infused one sat quietly on a shelf backstage, waiting to be picked up and carried onstage for his cue.

"I can see you didn't feel the need to tell me about your new social media presence," I subvocalized into my earpiece. "Are we following all the suspects, or just the ones with periwinkle legwarmers?"

"Hush," he texted back. "I am *in character*."

"No, you are corresponding with me like we agreed upon," I said. "Did you follow up on any of our other interesting facts? Alisha's mysterious absences, or Florence's contempt for Rana's high notes?"

"I think we can cross Alisha off the list," he texted immediately. "I searched some local city feeds and found out she has a new, *very wealthy, boyfriend.* She's already put in for a leave of absence to travel with him, so probabilistically there's no reason for her to attempt murder."

Dammit. That was one of our better leads. "And Florence?"

"Not ruled out. I'm currently streaming some dressing room feeds just in case anything turns up. But I'm prioritizing Lucky's feed because the download is slow into the puppy."

"This was your idea."

"And it's still a brilliant one. Now hush! Real schnauzers don't use WiFi."

I sighed and stopped talking to Gabriel; there wasn't much we could do at the moment anyway. Maybe the saboteur wouldn't even strike tonight, with so much going on. How long was I going to be chaperoning a schnauzer?

I skulked around the wings to watch and wait. (No, the stage manager didn't love it. Yes, they had reluctantly agreed anyway, provided I wore all black and stayed at least twenty feet from the stage.)

The show started, and I kept an eagle eye on everything going on around Rana. The tea scene came and went without a hitch, thank goodness. I tried to send a message to Gabriel to check on what he was seeing onstage, but all I got back was a terse WOOF. And before long, I didn't need an update, anyway. The audience had changed. I could hear a collective gasp from the first moment Gabriel trotted onstage.

I sidled around for a better view and then I understood the gasps. The show was full of splendid eyeball kicks—marvelous costumes, spectacular dancing—even some well-timed use of the trapdoor. But *Gabriel*, his ears perking up, his sides breathing when he trotted, his sweet face when he gave little puppy kisses—*Gabriel* was stealing the show. They had to stop the table tap dance just to give the schnauzer another round of applause.

The annoying thing is that, as far as I could tell, he wasn't doing anything that a schnauzer *wouldn't* ordinarily do. He wasn't dancing on his hind legs in the kickline. He wasn't jumping through flam-

ing hoops. He wasn't doing anything that wasn't technically in the script—he was just doing it *very, very well*. He was doing it with that little extra flip of charisma that every true star has, that Rana has, that *je ne sais quoi* that meant all eyes went directly to him and could not look away.

Which is why no one was looking when Teddy, well-concealed behind a group of can-canning chorus girls cavorting with a charismatic schnauzer, tipped a vial of *something* into Rana's martini.

Nobody except me.

"Gabriel!" I hissed into my mic. "Teddy! *Poison*!!!"

The can-can girls sailed offstage, blocking my path in a pile of ruffles and skirts as I frantically tried to get to Rana to stop her from drinking that martini.

"Rana!" I shouted as she raised the glass. "Gabriel, stop her!"

I dove between the chorus girls—Rana tilted her glass—Teddy turned angrily towards the schnauzer—

And Gabriel leapt through the air, knocking the glass out of Rana's hand.

Glass shattered everywhere. The audience shrieked.

Rana: "Emily! Why are you onstage …?"

Teddy: "How dare you …?"

"RAT POISON!!!" texted Gabriel. In fact he more than texted it, he sent damning footage to the video screen backdrop behind the actors. Footage of Teddy, in his dressing room, pouring the rat poison into the vial. Footage of Teddy, onstage, pouring the vial into Rana's martini. And finally, a wholly gratuitous shot—although I couldn't deny him anything, as I stood, holding a shaking Rana—of the valiant schnauzer himself, soaring through the air to knock the martini out of Rana's hand.

The audience gasped. The community service officers I had asked to stand by ran down the side aisles, ready to help.

And Teddy, a hateful look on his charming little-boy face, fell on top of the poor Gabriel-schnauzer and started pounding on him with all his might.

"*You*! You dog! You, you, *AI*!!"

The community service officers stopped, uncertain if this were actually part of the show after all.

"*You!*" shrieked Teddy, still banging his fists uselessly on the animatronic schnauzer while the footage of his intended crime streamed behind him. "You horrible things stopped me from being able to license my own image! I was at the height of my career, all set to sign a multi-million dollar deal to let them use my voice and image to go on making *Fightman Battleharder* movies for years to come, while I lounged around my swimming pool, growing older and cashing checks. No more bulking up. No more rejuvenating surgery. And now I'm reduced to … *this*."

"What, *working* for a living?" said Rana dryly, from the circle of my arms.

Teddy buried his face in the schnauzer and sobbed. I nodded at the community service officers, and they led him away.

<center>⚶</center>

It was some time before the chaos died down, even though the curtain was quickly pulled and the audience offered tickets to later shows. (Whoever Teddy's understudy was, was surely going to be happy.)

Rana was no longer shaking (good), or in my arms (less good), but she and schnauzer-Gabriel and I sat in her dressing room, trying to sort through the situation.

"So he's broke," I said. "His licensing didn't happen and he didn't get picked up for the spinoff. I get that. But I still don't understand—why was he trying to poison *you?*"

Rana made a face. "You're not going to like this."

"Try me," I said dryly.

"Well, a long time ago, like *three years ago*, we dated for a week. And I mean, sure, we got married, but only for about two hours. In Vegas. It was meaningless." She looked at me softly. "I was on the rebound from *you*."

It was pretty easy to ignore this particular soft look as my eyes were busy popping out of my head. "And you didn't think this was *relevant?*"

"I knew you'd react this way!"

My phone buzzed like a swarm of very excitable bees.

<center>63</center>

I sighed. "Gabriel, tell me what you've found."

"They never officially got divorced!!!!"

"I ripped up the contract," protested Rana.

"That doesn't—gah. What else?"

"Patterson Life Insurance—"

"That's our show sponsor!"

"Is covering everyone in the cast and crew for the length of your contract, to the tune of …" Gabriel sent a whistle sound clip and flashed the numbers on both our phones.

"Oh," said Rana.

"Follow the money," I said. "Gee, if only it had occurred to me to ask if you were secretly married to anybody else, and if that person automatically stood to benefit in the matter of your sudden death …"

Rana pressed her hand against her forehead melodramatically. "It was a tragic, tragic error." She lowered her hand, and more seriously said, "It's not the only one I've made in the last few years."

My unruly heart tried to leap out of my chest like Gabriel leaping on a poisoned martini, but I told it to hush. "Is that so?"

"I'm not sorry about taking the career leap, of course. But … I'm sorry I told you it meant we were through. That I didn't think we could handle long distance."

"I would never have tried to stop you from pursuing your career."

"I've missed you literally every minute," she said, and I could see it on her face, she meant it.

"Even the moments you were marrying Teddy in Vegas?" I said grumpily.

"Especially then." Rana took a breath. "I know it would be hard to forgive me and try again. But … do you think, just maybe …"

A bright, brassy lady with creamy brown skin poked her head in. "Am I interrupting?"

Rana immediately put on her star turn. "Oh, no. Delighted to meet fans. Did you want an autograph?"

"Oh, you were lovely, Ms. Guilfoyle," said the lady. "But I actually want to talk to the schnauzer."

"The … schnauzer?"

Gabriel sat up, all ears.

"Oh yes. I heard Teddy's shriek. You're one of the ABC, aren't you?" The lady crouched down to speak face to furry nose. "You," she said, even more dramatically than Rana, "are *wasted* in this show. We want to create a new star vehicle for you. Something big, like … a musical remake of *Lassie*. Or, no, you can do anything, can't you? Think bigger. *101 Dalmatians*, but you play all the Dalmatians. No! *Dr. Dolittle*, only you play *all the animals*. Yes, that's it. A singing, dancing extravaganza. A true spectacle. I'll get my top writers on it. We'll tour globally."

Gabriel woofed happily.

"Don't say no just now," she said, although surely nothing could be farther from Gabriel's mind. "Are you his agent?"

"Well, actually—"

"I'll send you the details." She handed me a card. "We'll get his career rolling." She glanced at Lana. "And Ms. Guilfoyle, we'd be delighted to have you in the show, too. Nothing says Dr. Dolittle can't be a woman." She nodded at us and swanned out.

"Hmph," I said. "You're *welcome* to come along with the schnauzer. Since when is Rana Guilfoyle an afterthought?"

"Emily," said Rana in a hush, "that's Kitti Ramirez. The famous producer."

"OMG I'M DED," texted Gabriel. "TO WORK WITH KITTI RAMIREZ, CAN YOU IMAGINE???" A million emojis flooded my phone while the schnauzer yipped and cavorted in joy.

Rana took my hand while the puppy bounced around us. "Emily," she said. "I know I don't have any right to ask, and I know *your* career is right here in town, but …"

I took her other hand and then we were suddenly both grinning at each other like idiots who haven't seen each other in three years, but used to care for each other an awful, awful lot. "Plenty of my cases are cybercrime," I said. "No reason we can't go on tour for a while and see how it goes."

Gabriel came to a panting, tongue-lolling halt. "No reason," he texted, "except one Mr. Sylvester Zanzibar Viridian." He texted us both a picture of His Majesty reclining next to a chewed-up plant, in all his neon-green tiger-striped splendor.

"We can't possibly leave Darling Piddles," agreed Rana.

"Never," I said.

*F

I think a lot about the theater these days. You have to, when your family consists of one famous touring actress, one grumpy detective, one lab-grown, glow-in-the-dark miniature tiger, and one world-famous acting AI, sometimes housed in a hot-pink iPhone 17, but currently housed in an animatronic parrot. We have to take our own QPT train car just to transport all of his animal "costumes" from one stop to the next. Rana has been a remarkable Dr. Dolittle—a true musical comedienne, the papers raved—and I have found a new calling as a consulting detective, my next city clearly listed in the tour lineup on the back of the *I <3 Gabriel* fan club T-shirts sold at every stop.

So yes, if I'm ever in your town, exactly when you need a detective, don't hesitate to reach out. I'll be there with or without a hot-pink iPhone. Emily Viridian, noted touring PI. On the move and ready to help.

It's perfect.

THE MERCER SEAT

Vajra Chandrasekera

"Moreover," the murderer says, downing the cup of hemlock in a single gulp, the apple of his throat pulsating beneath his unshaven bristles. "This trial is a sham, the court of a kangaroo or some such extinct marsupial, null and devoid of legitimacy, unsanctioned by apostolic or secular authority, unblessed by the council of the great leaders of the noble order, and unseen by the eyes of the gods." He slaps the empty cup, a small stainless steel jigger, on the wooden barrier of the witness stand. The clap echoes through the courtroom, silencing the susurrating crowd but not raising the eyebrow of the judge, who has not moved at all since the trial began.

The prosecuting bartender picks up the second bottle of poison and refills the jigger in silence. Hemlock is followed by an infusion of katkar oil. The murderer, after taking his second swig, drums his feet impatiently for a long half-minute while his legs strain from the effort of not swelling up. This bar has, of course, no tenderer of defenses.

°ꟻ

The first time I—who am I? I am not the murderer: I am the judge—
watched *Blade Runner* (1982), I was so high—I was not a judge then,
of course, I was but a young fellow, a wild foal knock-kneed and un-
steady, a wild seed not yet generative, not yet set in my ways, not yet
set in my place—so fucking high, as I was saying, that I spaced out
during the film, my senses unfolding inward like a puzzle, opening
out into fantastical speculations while the film flowered and petaled
into parts before my dilated eyes into a twisting, mazed gallery of
individual frames outside of time or continuity. I wandered through
this gallery, turning left and right at random, climbing stairs and
sliding down greased poles, leaving no breadcrumbs, marking no
walls. Perhaps I went in circles. The gallery, a smooth and imper-
sonal institutional space, a no-place of beige walls and soft lighting,
looked much the same in one corridor as the next, and the frames
all out of order had me pausing at many a scene mere fractions of
a second removed from near-identical variants, wondering if I had
seen it before, wondering if I had retraced my steps or not. I re-
member Pris dying as ten thousand still lives, her painted face mid-
scream. In my dérive through this space, dodging its machinic cura-
tors, I attempted to chart the deviations of the on-screen adaptation
against the ur-text, *Do Androids Dream of Electric Sheep* (1968), with
which I was then already familiar. But the changes were so many
and so substantial that the book and the film seemed to be telling
entirely different stories. Watching the film, it seemed like I had
slipped sideways into some other reality altogether, where the Nazis
had won their war and all the humor and intelligence had been cut
from the story in some butcher's surgery without anesthetic. When
I think of Roy's death now, only that endlessly reproduced meme
of the "tears in rain" monologue presents itself to the mind's cring-
ing eye—I try not to see it, but there it is, flutterby dove and all, a
monument to deep-dish cheese that has taken on the false patina of
the undeservingly iconic. This scene does not, of course, exist in the
book. I abhor it. I abjure it. Everyone's a critic, but I remind you, I
am a judge, and I condemn. I sentence as you read.

<div align="center">⚥F</div>

The jigger is like an hourglass turned inside out, a playing card from the suit of cups. It is one small metal cup atop a smaller, inverted; a seeming binary in truth a singularity, used for precise measurements. The slightly larger cup holds one and a half ounces, and the smaller half that. For courtroom purposes, the larger one is generally used, except in extreme cases where the poison is so potent that using more than an ounce is frowned upon.

<p style="text-align:center">⚜</p>

The 1960s narrative of *Do Androids Dream* is, depending on the edition you read, set in the 1990s or the 2020s, which is to say, squarely within the blast radius of neoliberal individualism. Which is to say, this story represents the past to me, the past with its lost glaciers, its unflooded islands, its unsunken cities. I say this for as much periodization as judgment; I am one who remembers old Colombo before all those canals hemorrhaged the sea into the streets. The narrative tells us many things about its time, the time it was written in, the times it prefigured and the times it grew like rogue cells in its own body as a culture medium, the empire that never ended until it finally choked on its own poisonous effluvia and vomited up the acid-charred bezoar of a world in which we now live. The undreaming androids of the story—called *andys* in the novel, *replicants* in the film, made for labor—prefigure the perfect capitalist subject that we ourselves came ever closer to manifesting, before the lapse (in which we lost so much, and which we mourn.) The androids look and act just like humans for the most part, except that their rebellions are more doomed than ours, because they were made in such a way that they cannot rise up.

The androids have no communism; an andy will not think twice before betraying another andy. The androids have no religion, that is to say, they cannot understand the teachings of Mercer. The films also did not, and in this way we understand the films to be replicants. The films knew nothing of this. They elided all mention of Mercer altogether. On screen there was no martyr. The stones were not thrown. They did not bleed and weep together.

Neither, of course, did humans. Neither did we, I mean, when we were unadapted ur-texts walking in the world, sweating in the sun. When the words that write us now were written in flesh and bone, we too did not bleed or weep for anybody other than ourselves. We, like the films, were androids then, excerpted from a greater text, excepted from a regime of mutuality, shunned from the jouissance and pain of being, set apart from Mercer. We watched ourselves eat our own and burn our world, and we shrugged.

Andys can think abstractly, plan, collaborate, even love, because there are many species of love without empathy, without community, without solidarity. They are just like us for real. We understand them. They are most like us in their fears of inbuilt obsolence, of supersedence, their readiness to betrayal in the name of getting ahead, of not being left behind. It is the unreal humans of this narrative who seem alien to us, with their obsessive sharing of pain, the way they care about the blood and the tears. The science fictional novum of humans that give a shit about their fellows, about their world: what a strange idea it was. And it is Mercerism that made them so.

F

"Morever," the murderer slurs, his eyes bloodshot from the third cup, briefly jaundiced from yellow oleander. "I would never ever," he says. He sways and sloughs off his skin, jowls dropping till the flesh droops and slops and slips away to reveal fresher skin underneath, tight with youth and steroid abuse. He raises a hand to wipe away a lined brow, revealing smoothness and eyebrows still learning to lie. The discarded flesh spatters away from his hand as he shakes it, leaving gobs on the courtroom floor. It smells curdled. "Whatever," he says. "That you accuse me of is unconscious. Unconscionable. That you accuse me of crimes for which we share a mutuality. That you throw stones. That you choose me by lottery. That you chose me by election. The house of your walls is glass. The walls of my house were burned; am I not the victim? Am I not the victim?"

In the murderer's more youthful incarnations, it is possible to sometimes draw marginally incriminating or at least suggestive

answers out of him, and the prosecuting bartender presses him with piercing specificities, such as "On the morning of the seventeenth of Maius in an apocalyptic year (with the lapse, which we mourn, well underway but not yet so-called), did you or did you not receive a telephonic communication from an unreconstructed person S—C—P—, unfortunately now unavailable as witness, upon which you, in your present manifestation, gave him instructions on covering up the murder referenced under file PH12, chapter SR11, section GZ319, paragraph EW17V?"

"Merely," the murderer says. "A casual conversation held by accident at the same time. Of no content. Of no consequence. No recording exists. No witness survives. S—C—P— is lost to history: you know nothing of the man except his betrayals, his endless betrayals of himself, of me, of others, of truth, of lies. Whomsoever held power over him at any given hour, he would betray in the next. Such a man is not credible and would not be even if he were present, which he is not, of course, because there is no such man. He never existed. And if he did, such a man's testimony is to be struck from the record."

"Don't attempt to speak for the judge," the prosecuting bartender snaps. "Just because he doesn't hear you now—he is reading our transcript in the future, and is therefore present in this moment, immanent, inherent, implicit. The judge hears you, and holds you in contempt. The judge is full of disdain."

"Don't you attempt to speak for him either." The murderer's sudden snarl is accompanied by a burst of violent aging, his flesh blooming and ripening, the skin growing weathered and lined, his hair graying, his teeth yellowing and bared, his voice growing coarser, dropping in pitch as it gains in lucidity.

<p style="text-align:center">✲𝆑</p>

I don't trust my memories because they seem filtered through media, as if they were records taken from behind a screen. In my memories I see my slack face, my dull eyes, my parted lips, my shallow breathing: the face the screen saw, that secret true reflection we spent so much of our lives in front of but did not see, except in

sudden powerlessness—I remember the long years of power cuts scheduled and unscheduled as the rupee dwindled and the debt climbed, when we could no longer afford to buy our filthy coal while our reservoirs dipped and dried. I remember Colombo's divided zones groaning as the light moved sluggishly from one to the other; I used to live near a zonal boundary, I remember walking into the darkness to find my way home—I remember when the lights would go out and we'd meet our own uneasy eyes in the screen's dark mirror. My memories of the past seem whole and complete and perfectly consistent to me, but I know they are not. I know there are errors, gaps, misconstructions, nonsenses. I know logically that they must exist. I just don't know what they are.

In all variations of the narrative first articulated in *Do Androids Dream*, it is the humans who hunt and kill rogue androids—with prejudice, often with malice. In *Blade Runner*, the android Roy Batty had to be recast as a fearsome fighter, a threatening figure who gets an extended rooftop fight scene with Harrison Ford's bounty hunter Deckard. Batty had to be made into such a monstrous machine on the big screen because the book's Roy Baty is not one. The bookish Baty, more onanistically baty than wacky zany batty, is more clearly a victim, one who dies so quick and so sudden on the page, the confrontation brief and the outcome never in doubt. The human is the predator, the monster; the android is the prey. Deckard bursts in and kills Baty's wife, Irmgard—Baty howls in grief; there is no wife in the film, and perhaps this absence, this abscess contributes to Baty's irreconcilable discord with his world—Deckard executes him summarily in an abbreviated clause, "he shot Roy Baty," and the rest is but the thrashing of a corpus.

In these convulsions, we encounter our only surviving witness, the reason we are gathered here today, the casus bellissima: the wild text known to readers as *Why Not Choose To Live*, abbreviated by its fandom for obscure reasons to *2Choose5Live*, a science-fiction novel. What you are reading is an excerpt from it, a screenshot, a still life extracted from its endlessly writhing, self-devouring, self-regenerating text.

*F

To the best of the bartender's knowledge, only the judge has access to any worlds beyond the pocket universe of this trial, this singular setting. Everyone else in the courtroom—himself, the second chair, the clerk, the bailiff, the writer, the jury with their heads nodding like soft corals in the current, the studio audience with the love interest in the front and the shady fellow in the back—is part of this story and no other. In this, he is correct: I do. I have my chambers, as it were, in a figurative space outside both his universe and yours. I even have some privileged access to the world in which I was written, in order to understand my role in depth, but of the future and its fandoms, its fads and fashions, its love of drama, I may not speak.

Reconstructions of period-accurate historical court procedure have been very shaky, and the specific roles and responsibilities of most of these characters are imprecise. Some liberties have been taken by the wild text as it endlessly reconstitutes itself. Some interpretations, some interpolations. The prosecuting bartender believes himself interpellated as the main character, the protagonist, and as such feels great responsibility for the outcome of the case. You and me, we know that he is not, of course: I am. Come, let us snicker at his self-importance, his exaggerated sense of self. Of course, it is necessary that he believe himself the protagonist, otherwise he would be unable to perform his function to the best of his abilities. We mock, but we do not condemn. I judge only a little.

Mercerism, as a religion, is fake but also real, in the way of religions. More importantly, and also in the way of religions, it exists to separate the insider from the outsider. Its function is to exclude androids from humanity, no matter how many humanoid capacities they master. Mercer himself, the saint of empathy and common humanity, is a fake, a sham, but only andys believe in fact-checking. They believe that exposing Mercer for what he is, a paid actor performing false mysteries, will be sufficient to persuade rational subjects to abandon Mercerism and accept that there is no longer any sharp dividing line between human and andy. But it turns out that humans don't care. Humans are unmoved by the exposé. Mercer, who does not even exist, is similarly unaffected: he understands that politics is bigger than mere reality. The andys' inability to access the empathic imagination is to fail to see the bars of their own prison,

and in this way prefigures the abject failure of their uprising. I feel a commonality with Mercer now, where I used to identify most with Deckard—not Rick, I mean Iran, his wife, the only true solver of mysteries in the book. I too have spent many mornings in bed, then as now, unable to even, fundamentally at odds, incompatible with my world, unable to reprogram myself into participating in it the way it wanted, unable to find even the key to *wanting* this, which might have unlocked the capability of action to that end. My judgementality, my suitability for this role, came from these my thousand-year matured frustrations, my wine-dark despair. Justice delayed, delayed so much further than mere denial, becomes poison in great bubbling cauldrons, bilious and roiling. It becomes a hunger so deep that it eats the lining of its own stomach and renders itself incapable of digestion. A hundred years pass, a thousand, innumerable calendars tracking unanswered sins in their uncountable poison oceans. Who can sit on this bench that so many have refused? That is no longer a rhetorical question. There is an answer: I can. I was called forth for this purpose. I am the one who was raised from the dead and sent into the wild text as a character, to draw out what it knows, to look for answers. I was written for this. I am the judge, and through command responsibility, I am the executioner.

But now that this Sisyphean brief is mine, having been generated for it, I find myself seeing through Mercer's eyes, sitting in Mercer's seat. I, too, do not exist, and yet I do—here I am, you see me as I am, I yam that I yam and that is all there is, at my level of diegeticity. I am outside the courtroom chronotope, able to recuse myself from its events and read it as a narrative. At the end I will fall back into it, like a diver from a high cliff into the gurning sea over rocks gritted like teeth, and if the shock of impact doesn't kill me, if the sea doesn't grind me to a miswritten smear and put me to undeserved rest in some cold and rarely-visited corner of this text, bones yellowing amidst the bleached corals in the streets of my sunken city, I will pass my judgment with eyes open. And you, at a still higher level of diegeticity, will do the same, but I cannot pass through the worlds in your direction, and will never know it.

<div align="center">ꟻ</div>

Cerberin and wild carrot infusions, golden chain and moonseed, tincture of the pasque flower, cyanogenic glycoside concentrate from drought-harvested bitter cassava, a smoothie of jequirity seeds in tremetol oil. The murderer downs each cup in a single violent gulp, and while he shivers and shakes, while he moans and grinds his teeth, while he retches and sloughs his skin again and again to reveal new faces, his clothes soaked with the sticky residue of dissolving molt, he does not die. Even the attenuated effects of each poison do not seem to last longer than a minute.

The murderer's moustache, a symbol of virility, masculinity, electability, relatability, humility and penisence, persists through his changes in shape and form as his skin sloughs, though it too transforms. Sometimes it is broad and caterpillar-like, sometimes curling at the tips, sometimes but a thin unwilling wisp, sometimes merely a small square of stubble as if its perpetrator shaved it off, then, regretting, attempted to grow it back as quickly as possible. Moustaches are less forgiving than trial courts. For example, this court did not sit for a thousand years because no human judge could be found willing to hear the case, to make answer for the crimes of the war, much less the crimes of the peace or the parental and grandparental crimes of the republic, of the dominion, of the colony. Generations of recusals in fear of reprisals. The cycle of deferral outlasted the Lankic polity, then outlasted the island itself as a geography, but not yet as mythology, not yet as story—for in the end, it was agreed that the perfect judge would be one designed and generated for the purpose by training a wild text on the defendant past, from the very corpus being investigated, a judge sharing a level of diegeticity with the murderer, a judge from whom the choice of seating could be taken away, a judge forced to sequester himself to satisfy the accusation of a conflict of interest (how else to allow a murdered to judge their murderer), a judge who now sits imprisoned for the duration of the trial in his own mind, cut off from his own senses, a mannequin of uncomprehending flesh and justice, his face not moving an iota as a mosquito drills into the bulb of his nostril, while outside this world I read along with you and twitch my nose. Later, returned to the courtrotope, he, I, will scratch and declare an obligatory mistrial. The murderer will walk free at the end, unless the prosecuting

bartender can find a poison that will kill him first. Legal drama! *2Choose5Live* can be coaxed into such cross-genre extrusions, pseudopods questing for new pathways in narrative space. It's a messy business, but that's my job. I'm here to get my hands dirty.

ϯ

A wild text is not a general artificial intelligence. Like most humans on most days of their lives, a wild text may exhibit the occasional symptom of intelligence but without cause or justification. There is no suggestion that either is sentient. A wild text is generative, given to spamming the known universe with slightly modified copies of itself. They are generally considered vermin of no consequence. Unfortunately in our case, it was necessary to reconstruct the prelapsarian protocols of not only criminal investigation, prosecution, etc., but of pest control and animal husbandry. A wild text is a wild animal. If cornered, it may twist in upon itself, bite, and become nonsense. It must be carefully husbanded, proposed to, lived with in matrimonial bliss. This is my brief. I am the judge, the husband and father. I have grown a thick white beard, symbolically representing daddy, a sage, a sky god. There are several furious threads of commentary in the fandom about this, some questionable fan art, though nobody is entirely sure what any of those words might have meant then, or what they mean now. We're going ahead with the project despite these methodological flaws, because justice. I know what that means, I think. We believe there must be a reckoning, no matter if the crimes are a thousand years past. It's good to have a reason to live. I find this is what separates life from afterlife; only in death do we get rewritten into a plot, instead of merely being drowned in life's directionless waters, swallowing salt water with our bleeding mouths, straining just to breathe free.

2Choose5Live is uniquely important because of the thrashing, bloodied corpus it was originally trained on. Like much of the culture and history of that era, all other copies or references to that corpus was lost in the lapse. (Much was lost in the lapse, we remember the lives, the water, the land, the forest, the text. We remember and mourn.) While much of *2Choose5Live*'s corpus appears to have been

genre fiction—science fiction, fantasy, crime, comedy, political satire, legal and political thrillers, tie-in novels, fan fiction—based on its habitual outputs, it also seems to have had access to mass media, investigative journalism, the published reports of several commissions of inquiry and offices of reparations in the aftermath of a particular set of crimes against humanity that were never, to the best of latter-day knowledge, prosecuted in their own time, also known as the sorry history of that island known by many names but in infamy best known as Lanka. It seems to know of presidents, of prime ministers, of generals and admirals, of colonels and corporeal-sergeants and cockroaches, of the accusations that were once bruited in the press, of the cases that went unheard in courts and were dismissed or lost or delayed or attenuated to mere tendrils of legality unrooted, uprooted from loose soil and washed away, until it is as if the unanswered questions had never been asked at all.

It is possible that *2Choose5Live*'s entire corpus was a single massive data store belonging to a particular person of that time, reflecting their interests: their books, their news, their entertainments, their obsessions, the stories they followed, their resentments and bile, their polemics, their fears, the sentences with which they lived and died. But this cannot be known for certain. Such a person cannot be perceived except to the extent that their existence may be gravitationally inferred from the media they consumed, from the texts they read, again and again, wearing a lasting groove in the world, as if waiting for the words on the page to change. It is from this ghost's flesh that I am made. It could have been many such persons, generations, even, in which case I am a class act, a class action declassified into a metonymy.

<p style="text-align:center">ℱ</p>

"Moreau," the murderer says. His nose is peeling, his lips dry and cracked. "His island. His pain, his house. I do not criticize. Who here has not been patriarch of an island of beasts? Who here has not taken up the knife to bleed them and perfect them? Who here has not given law? This is the nature of governance. It is the essence of rule. If you have not known it, it is not your place to judge me."

All the murderer's autovivisecting faces resemble each other, as if representing either a single person at various stages of his life, a succession of young thugs and sleazy fixers leading to white-haired, square-faced genocidaires and the once-avuncular jowled patriarchs, and back again, a loup de guerre—or perhaps it is a family resemblance, and the murderer is meant to symbolically represent them all, the generations scrolling up and down the tree of the world. We who sit on its stump (and remember and mourn that which was lost in the lapse, we remember the lives, the water, the land, the forest, the text) cannot tell. I am not there: I am here, reading the story as it happened while in the story I sit there useless, locked in my own head, awaiting concluding statements so that my eyes and ears may be reopened. Get on with the trial, I do not say with my frozen mouth. Ask the murderer about the torture camps, I imagine instructing the prosecuting bartender. Ask the murderer about the shelling of civilian refugees, I might say. Ask the murderer about the murders covered up, the white sheets reddened. Wrap history in a shroud and watch it soak through: it is always bleeding.

The question is not *if* or *how* or *why* the murders were committed. These things are known, and their answers are ugly and sordid. All things are known. The mystery is: how can a murderer be brought to justice if all extant mechanisms of justice are corrupt, and if their reform is corrupt, and if the modalities and sodalities of revolution are corrupt, failing from programmed replicant flaws, from the careful distance we are kept from the human? What can be done if no physical evidence remains and no witnesses survive, except a machine's fragile memory, distorted by and contaminated with fictions? What can be done, if the murderer is long dead except in facsimile, if the civilizations that committed and witnessed the crimes are extinct, if that entire macrobiome has been erased from the burning bedrock of the earth and only tentatively, partially reconstructed for the purposes of criminal investigation and transitional justice?

Our authors were careful with our generative prompts, but there is, naturally, a bleed between our selfhoods, the chalk outlines of our inexistent bodies—the murderer, the murdered, the incidental side characters, we are all made out of the same words in the end. We

are a cast of characters brought to life to investigate and prosecute a crime. The crime is not the murderer's murders, but the failure of his civilization to bring him to justice. The crime we are investigating is that this was left to us to do in a far future, in another world, after so long and hard a lapse (we mourn).

Like the murderer, like everyone else in this courtroom, I was reconstructed imperfectly from the past to serve a purpose. Unlike the others, I have an existence outside the courtroom proper, in this world's writers' room: I planned the trial, scripted its manifestations, plotted its premises, provided the prompts for the wild text to grow its own conclusions. And at that ending, when I am released from the cell of my innermost being, I will pass my judgment and oversee the dissolution of my court. When you turn the last page and the story's over, remember: I am there with you in the silence.

<center>⚜F</center>

"Morel," the murderer says. "His invention. His island. A selective telling endlessly replayed. I do not criticize. Who here has not rewritten history? Who here has not attempted to become immortal?"

The prosecuting bartender is temporarily out of poisons to try. He confers briefly with his second chair, who is then sent downstairs to research and fabricate a new batch in a different register. In the meantime, he stalls.

"You are not immortal," the bartender tells the murderer. "You are a temporary facsimile generated for the purpose of this trial. You were brought out of death because you do not deserve rest." He does not belabor the point that he is also one. The murderer may not be aware of this, and does not deserve the satisfaction.

The bartender draws on his extensive memory of successfully contested cases, all, of course, fictional in that they were generated whole and complete with him at the moment of instantiation in order to create him as a rounded character with life and career experience to draw upon, though he wonders sometimes if his awareness of their fictionality, or at least their lower-order diegeticity, reduces their value in his eyes. He does not know who Morel is, who

<center>79</center>

Moreau is. He imagines Rick and Iran Deckard, Roy and Irmgard Baty, around a dinner table, a double date of existential crisis. Rick and Roy, Iran and Irmgard. Humans and machines, superficially indistinguishable from each other. An open bottle of wine, everyone twirling to the gramophone's tinny song in wasp-waisted dresses and kitten heels. Conversation, confession, interrogation, flirtation, tests of empathy, of humanity, of attraction, of arousal, of piety, of belonging. A single-camera prestige dramedy, no CGI budget but dense with character and witty conversational probes, barbs, and knives. Will it end in sex or violence? Will it get canceled before the finale airs? Will the machines wake up a thousand years later and mourn the loved ones they lost?

The love interest in the front of the courtroom sings a dirge. The judge being unable to bellow his contempt, the trial pauses politely until the song ends. It is a song about the lapse, but written before it, or during its slow beginning, a mourning song written in advance, because of course they knew, long before so much was lost. That, too, is the crime. The crime is inaction, irresponsibility, freedom. The crime is to have lived, in a time of death. The crime is a civilization's complicity.

There are two categories of error to be wary of in this case, the prosecuting bartender muses while waiting for the song to finish. One is too much abstraction, the other is too much specificity. Forest, trees; trees, forest. In the realm of the overly specific, there is the tendency to become obsessed with particular villains. In the realm of over-abstraction, there are no people at all, only the forces of history. Can an individual even be held culpable, if their upbringing, their society, their civilization, their racialized culture, the material interests of their class, and the generational politics that produced them all conspire to make them a murderer?

"Obviously not," the murderer says. "My world produced me; I am not at fault. It was my culture, my upbringing. It is that entire world that is on trial, is it not?"

"No," the prosecuting bartender says, with a glance at the silent judge. He knows the judge might disagree, but the judge is not here, or at least, is unable to affect events as they happen. Meanwhile, the second chair has returned with new poisons in, as instructed, a

higher and more symbolic register, technically illegal in this regime of poetics, but who is there to stop this? The three small bottles are unlabeled, but the second chair whispers urgently in the bartender's ear as he arranges the bottles into a sequence. The first shot he pours is truth, urine-yellow.

The murderer gulps it down, shakes his head. He turns and looks at me reading him, and through me he looks at you reading us both, indistinct through the pages like layers of white veil. "Look at you with your eyes wide," the murderer says. "Who did you enable? Who did you accept, what did you let pass, in the name of stability, in the cause of growth, in the assurance of a better life for at least you and yours, and devils take the rest? Are you a person or a thing? Do you believe in Mercer's teaching or do you not?"

The bartender serves a cup of the rage of the dispossessed, all the pain of a thousand unanswered years, whose steaming, acrid potency the murderer seems to enjoy; he smacks his lips, which briefly blacken. The lines in his face grow deeper, like cuts from a thousand tiny blades. He shakes his head, though his flesh remains lined and stable and does not slough. He looks at you again, and he says—I know you.

The bartender turns the jigger upside down, pours from the last bottle. The murderer does not break eye contact with you while he takes the small cup of grief and chugs it. There is no change in his expression. I do know you, he says. Through the shifting diegetics, I see you. I know the depths and shallows of your complicity. I'll give you a generative prompt, the murderer says: choose to live—what does it mean to live? Now you'll turn the page, but I tell you, this cup is as much for you as for me.

GOOD STORIES

Ken Liu

C lara's favorite part of the workday is the very beginning.
She likes flipping the switches on the wall right inside the office entrance, all sixteen of them, different colors and laid out in two neat columns, like the console from an old NASA space capsule that she got to sit inside once on a school trip to DC. As she takes a sip of her latte, her right hand running up the wall, *click-click-click*, flipping one switch after another, she imagines herself turning on rocket engines, initiating a docking maneuver, venting some dangerous alien spores out the airlock.

The lights come on, first close to her, and then farther away. Desk clumps emerge out of the gray twilight haze like slumbering beasts and ancient ruins. She imagines what the furniture has seen and witnessed. The space used to belong to a tech company. Before the autocodes. Before the layoffs. Before Good Stories took over. She pictures the programmers staring intently at arcane symbols scrolling up the screen, their ears filled with Eastern European metal and gourmet coffee in steaming mugs next to them, unacknowledged Waylands and Daedaluses of our time, constructing reality around them one keystroke at a time.

("You're always making up stories about everything around you," her ex, Nick, used to tell her. He said it like it was a bad thing. Like

82

she was wasting her time as well as his. Nick was very big on being "productive.")

Clara brushes the memory of Nick away, the way she used to delete a bad paragraph in a draft while she was working on her MFA, decisive, unsentimental, wiping the slate clean.

She goes on to imagine one of the programmers. *He has wide, dark eyes, very long lashes, and beautiful fingers, strong and slender.* (Clara decides that his name is Talib.) *He's sitting at his desk, concentrating on his screen. He turns to look longingly at another engineer at the far end of the office, at the desk clump next to the window. The morning light bathes her in a bright glow, banishing all regret and languor, infusing the very air with purpose and energy. She's poking at a recalcitrant piece of equipment with a set of beeping probes, an Athena straining to bring wise order to stubborn chaos.* (Clara decides that her name is Zia.) *Talib's fingers move over the keyboard and dance. Instead of a for-loop, they tap out a sappy love poem.*

Clara smiles to herself as she walks over to her desk and turns on her computer. She knows the scene in her head is romanticized, silly, but she loves it anyway. The world is only bearable because we make up stories about it.

In her mind, Talib's fingers have stopped moving, but the poem continues to write itself, line after line scrolling up the screen.

The smile disappears from Clara's face. Angrily, she stuffs the tainted daydream away in some corner of her mind. She drags the clunky mouse around and clicks it with more force than necessary to launch the dashboard app. She's been assigned to a romance today, she sees. She sighs. She tries to cheer herself up with the thought that she'll be switched to something different in an hour. Thank goodness the company policy is that no textsmith should spend more than an hour on any single story—it keeps them alert and is better for productivity.

Her coworkers drift in. Greetings are exchanged. Coffee (not gourmet) is obtained from the pot in the kitchen. The office of Good Stories, Inc. hums to life.

Clara focuses on the glowing rectangle of her screen, the worn plastic keys rubbing against her fingertips, the ancient mouse nestled against her palm. She readies herself mentally, like a diver before taking the plunge, and presses the button labeled "Generate."

A torrent of words flows onto the screen.

*As she stood before him, her heart racing and her breath caught in her throat, she couldn't help but feel both **terrified** and **exhilarated** by the intensity of his gaze. He towered over her, his broad shoulders and chiseled chest leaving her feeling small and vulnerable in his presence. And yet, despite the fear that threatened to consume her, she found herself drawn to him like a moth to a flame.*

She winces. Even after months at Good Stories, she can't stand it: the easy-listening rhythm, the bland adjectives tossed over the flavorless nouns like melted cheese, the clichés stacked on top of clichés.

A pause. The stats line blink once in the corner of the screen to remind her of her task: TARGET RATIO: 1 / 50. CURRENT RATIO: < 1 / 1000.

The computer has even helpfully bolded a few words for her to change. Dutifully, she highlights the words and taps 'delete,' replacing them with "frightened and intoxicated" after a moment of thought.

No, it's not an improvement. It's possibly worse. But that's hardly the point of smithing. While purely AI-generated text is uncopyrightable, the courts have decided that manually edited AI-text can be copyrighted if it shows a de minimus amount of human-sourced creativity. Good Stories' lawyers and jurigins have done their best to interpret that Delphic pronouncement and decided that as long as an employee like Clara changed one word in fifty, the bot-written texts would be considered to have been "smithed"—magically endowed with copyright—and therefore capable of entering the stream of commerce and earning the company a profit.

"Tell me, my dear," he said, his voice low and rough, "what is it that you desire?"

She swallowed hard, her mind racing as she struggled to find the words to express the thoughts that were racing through her head.

*But before she could **speak**, he closed the **distance** between them, his hand reaching up to cup her cheek as he pulled her closer.*

Another pause. More words bolded for her to change.

Her mind racing ... racing through her head.

She feels the pressure building in her temples, a throbbing that refuses to be ignored. It *hurts* to see a sentence like this.

Clara looks away from the screen and toward the window, where the imaginary Zia sits in her daydream.

She's there now, concentrating on uploading the firmware into some prototype gizmo. She detaches the braided cord from the contraption and waits with bated breath through the boot sequence. She lets out a triumphant whoop as her face is lit up by the tiny screen.

Zia's computer pings. She glances at the screen, intending a quick peek but her eyes stay there. Gently, she sets down the gizmo and taps her keyboard a few times to scroll. Abruptly, she spins around in her chair to look at Talib, responsible for the silly love poem on her screen. "You're terrible at this," she mouths.

But the words don't sting for she is smiling at him so dazzlingly that the space between them feels charged with their connection. He's proud of that poem, one that he painstakingly came up with one word at a time, not once resorting to the help of the computer. He has a thousand things he wanted to say, but he also knows he doesn't need to say anything.

Her mind racing ... racing through her head.

She can't let that sentence slide. Everything in her being cries out against it. She feels the same sense of powerless rage as the day her would-be publisher had rescinded her debut publication offer. *Due to changes in market conditions, we've made the difficult decision to scale back on our line of traditionally-authored books to respond to the changing market. We hope ...* She had been so confused back then. Not fully understanding what she was reading. Not even suspecting that the message had likely been composed by a machine.

She ignores the bolded suggestions and highlights the entirety of the sentence that is giving her a headache. She deletes it and rewrites the line completely.

It's not against the rules, exactly, to do your own edits instead of focusing on the words the AI suggests. But it's generally discouraged because it slows the textsmiths down. During training, Clara and her co-workers were told to only intervene if the AI generated something that could get the company in trouble.

When the alert box pops up, she selects "offensive language" as the justification. It's true. Beyond the recycled plot and the pancake characters, it's the utter carelessness, the complete lack of craft in that sentence, that there is no there *there*, that offends her.

Clara resumes the text generation. She prays to be moved on to something different soon, a technical manual preferably.

> *"Shh," he whispered, his lips brushing against hers in a **gentle** caress. "You need not say anything. Your body speaks volumes to me."*

> *And with that, he claimed her lips in a searing kiss, his arms wrapping around her as he pulled her **tightly** against him. And in that moment, she knew that she was his, body and soul.*

Before taking on this job, Clara had tried to be an artist, a writer, a storyteller. To make something out of nothing, to craft a whole world out of words—that is as close to magic as we are ever going to achieve.

But, at first slowly and then very fast, machines took over the crafting of popular art, of making up stories, of performing magic. There are very few human authors left—at least human authors who manage to make money writing. To say you want to be a writer is a little bit like saying you want to paint portraits after the invention of photography. If the profession isn't completely dead, it's surely moribund.

So now, at age thirty she works as a robot's helper, where her symbolic contribution has nothing to do with her artistic vision or skill, but is solely based on her ontological status as a human. She is a component in late capitalism's relentless drive to turn everything and everyone into a money-accelerating machine; like the driver sitting idly in the lead cockpit of a fleet of self-driving trucks or

the warehouse worker walking the path dictated by computers, she helps complete a lie. She is humanwashing. She does all this just so she can still feel close to the site of magic, the making of stories.

A wave of despair crests over her. *What am I doing?*

Clara thinks about her Zia and Talib. *They think they've discovered love for the first time. They believe that with their keyboards and soldering irons, they can reinvent the world and make it better. They would laugh at the very idea that they can be replaced by machines, that making and loving and living are no different from predicting the next symbol in a sequence based on very fancy spreadsheets.*

They deserve better. Readers deserve better. We all deserve better.

Clara takes a deep breath and highlights the entire passage generated by the machine and presses "delete" with no hesitation. The stats line flashes red. "It's all so offensive," she mutters, and begins to type.

<p style="text-align:center">⚘</p>

It's almost impossible for a textsmith at Good Stories to find out how well specific titles from the house are doing in the market. The real-time sales data is walled off from the "word mines" like military secrets. Clara suspects this is at least in part because the company doesn't want the human employees to see their efforts translate directly into profits—then they'll demand better pay and more control. Much better to keep the employees in the dark, as interchangeable cogs.

(She brought up the idea to Nick once. He had laughed at her, telling her that it was just her unjustified egotism as a human talking. Nick liked to praise machines and put down humans—"An EL^3M writes better than 99 percent of humans ever will," ... "If they're serious about saving lives they ought to outlaw human drivers," ... "We're just outdated flesh computers"—he did it so aggressively that Clara suspected that like a lot of contrarians, it was a form of dominance display, a performance to allow him to show and feel that he was smarter and more evolved than the other "meatbags" around him. The biggest insult he could throw at some idea he disliked was "anthropocentric."

In the end, she broke up with him because he was just so repetitive and predictable; it was tiring. During their last meal together, she almost told him "Living with you is like living with a machine" but then decided that he would take it as a compliment.

Though she has heard nothing about sales, Clara thinks she knows what's going on when she is summoned to her boss's office and informed that she has been selected to do a publicity interview. Very few textsmiths are asked to do that. Surely this means that one (or more!) of the books she's touched recently, ones where she's been smithing with a more interventionist hand, putting more of herself in the text, writing them practically, is doing extraordinarily well. Because of her.

She feels *terrified and exhilarated*—and berates herself immediately for the lack of originality. She feels … she'll come up with a better description later.

"Go over to Publicity on fifth after lunch," says Gina, her boss, loud and round and so busy that her gaze dances constantly between her monitor and whoever is in the chair opposite, never settling. Clara likes her. Gina is the sort of person who takes no bullshit and doesn't dish any out either. "You can have the whole afternoon off. They'll do your makeup and then get you on camera. Think of a few fun personal anecdotes: cats are always good, as are inspiring family members, books you loved when you were little if you can't think of anything else. But stay away from anything that might rile someone up. No talk of activism, politics, or anything too trendy—doesn't age well. But don't stress too much about any of this. You can always supplement the answers later with a written response and they'll deeprefake it—"

"Hold on," Clara breaks in. "Back up a bit. Which book am I being interviewed on? I need to prep. So I can talk about the writing process."

"The writing process?" Gina's distracted eyes lock onto hers.

Clara meets her gaze evenly. They already know everything anyway, she thinks. We all live in a panopticon. "I've been going off-script. A lot."

Gina pulls over her keyboard and taps a few commands, frowning into the monitor.

Clara takes the opportunity to present her case. "Look, I know that you need the textsmiths not just because legally we get Good Stories copyright, but also because readers crave that human element."

Gina doesn't even look at her. "Is that right?"

"People don't like the idea of consuming art made by a machine," Clara says. She's been thinking these thoughts so much the last few weeks that the words pour out of her in a torrent, almost as if she's on autopilot. (Nick would have cited this as evidence that humans are not much better than machines, she realizes, somewhat dismayed.) "Viewers may look at a Jackson Pollock and think, 'How is that any different than a robot vacuum dragging a sock around?' But they know that they won't react the same way to a canvas on which a computer has randomly scattered paint. Even if art isn't a communicative act, we act like it is. We like to think we're consuming a little bit of the artist. It's why we love to gossip about movie stars, scream at the sweaty bass player on stage, attend author signings, crave titillating biographical details about a director, playwright, game designer. They've tried to make purely AI idols. It doesn't work. People may enjoy the novelty of it for a bit, but it always fizzles out. Humans only care about humans."

From the reflection in the glass wall behind Gina, Clara can see text scrolling up Gina's monitor. Gina isn't typing anymore. So what is she reading? A machine's response to some query she typed in earlier? Or a machine's instructions on how to deal with an employee who's forgotten her place?

"And you think this is why we have human textsmiths?" Gina asks. Her tone is even, without a trace of mockery or scorn. Almost mechanical.

"It's why you do the textsmith interviews, isn't it? Audiences don't need a lot. Just the barest hint of a connection between a human and a piece of text will do, is enough to take it out of the realm of mindless algorithms and parlor tricks and really fancy autocorrect."

"Did it ever occur to you that perhaps the company just wants to humanize *itself* a bit? AI-content companies get a lot of flak, and anytime we can show that our employees are just regular Janes— happy, fulfilled regular Janes—we're going to take it."

"I don't believe that," Clara says. "You *need* the textsmiths more than you're willing to admit. We're the pixie dust that allows readers to care about books from Good Stories."

"That's a bold claim."

"And a true one," says Clara. "But my point is: if you're going to have human textsmiths, why not actually let them do their jobs instead of just pretending? Don't just have us replace a word here or there to meet the minimum legal requirement for copyright. Let us actually edit, write, create!"

"And why would we want that?" Gina finally looks away from the screen to focus on Clara.

"Because humans do a better job! I could have been a novelist in the world before Good Stories! For a long time now, I haven't been doing my job the way you taught me. I started by rewriting the trash pumped out by the machine, but now I'm actually writing the books myself. In fact, I wrote a whole chapter in *The Beautiful and the Brave #34*. That's why it's selling so much better now, isn't it? That's why you're asking me—"

"Wow," says Gina. "Wow."

Clara stops cold in her tracks. The utter disbelief in her boss's face doesn't seem faked.

"You've been by far the slowest textsmith for the last two weeks," says Gina. "You really think you've made a difference, don't you? You really think you're the author."

Clara looks back at her boss defiantly. "I know what I wrote was better."

"Maybe," Gina says. "But that only matters if people read our books."

"What?" Clara isn't sure she heard right.

"Let me guess: you've never gone out and bought a Good Story," Gina says.

Clara shakes her head. She's not sure if she should feel bad. Shouldn't someone actually like the product whose existence she is at least partly responsible for? But she remembers how reading those machine-generated snippets on her screen used to make her nauseous, actually physiologically ill. Until she started to completely rewrite them.

"Take the rest of the day off. And tomorrow too," says Gina. "I think it may help if you learned a little about how our customers consume Good Stories. I find that a great cure for inflated egos."

⸎

Clara sees Gina's advice as a challenge.

People who are in "business" often have no understanding of the role of artists, Clara has found. They think books and movies and games succeed because of things like "marketing" and "strategy" and "customer segmentation" and "buzz." Business school and consulting and the ubiquitous use of AI have created a class of people who cannot make anything but are convinced that they generate "value." To sustain that lie, they must tell themselves that the author doesn't matter, that an algorithm can replace screenwriters and directors, that a computer mindlessly predicting the most likely next word is synonymous with great art.

Clara sighs. It feels good to have had that mental rant. Gina is the very definition of a philistine.

I must speak to her in the only language she understands, Clara thinks. I need data. I know that Good Stories books will sell better when humans write them. But can I prove it? I have to find where they're selling the books I've been smithing.

She goes to a bookstore. She scans the Romance section but finds nothing.

"Do you have anything from Good Stories?" she asks a clerk.

The woman, her hair in streaks of orange and pink and blue, smiles at Clara condescendingly and points to a sign at the side of the counter. WE ONLY SUPPORT HUMANS.

Blushing as though she has been scolded, Clara slinks away. She takes in the overstuffed reading chairs around the store; the handwritten "Staff Recommendation" tags on the shelves; the paper calendar announcing author visits; the messy manner in which one section blends into another, with books double-shelved or even in piles on the floor. Of course, she berates herself. This is not the kind of place that would carry Good Stories.

She takes out her phone.

What store near me sells Good Stories

She pauses and changes the query in the search field to:

What store near me sells books by Good Stories

Yes, the company's style guide requires that its products be referred to as "Good Stories™," but Clara would die of shame before she agreed to refer to them that way in writing.

I need them for research

She feels silly for trying to justify herself to a search bot. Do I really care what an algorithm "thinks" of me? I really have been working at Good Stories for too long.

Confidently, the search bot answers:

Good Stories™ are never offered in physical form. You can acquire them in a variety of ways online. I recommend that you try the official app from Good Stories, Inc.

She has never downloaded the "official app" from her company. Back home, she installs the app, launches it, and dutifully fills in her information for an account. She's bombarded with ads and sponsored results and pitches for more services. Finally, she finds, tucked into a corner, a search field. She filters the metadata for her own name until she finds *The Beautiful and the Brave #34*, pays for it, and downloads it.

The cover image is filled with beautiful people, though there's no way to tell if they're brave. She taps it, expecting finally to be able to read.

But instead of black text on white background, she's presented with an error screen: NO ADAPTATION PLUGINS FOUND. There is a link for "help."

I must be the first author in history to need *help* to read my book, she thinks, feeling the heat in her face. She taps the link, which opens up into—what else—a chat interface with an animated bot, who cheerfully offers to show her an interactive video tutorial along with recommendations for adaptation plugins as well as Living Story™ devices—

Clara has had enough. "Please stop. Can I get a human to show me what to do? Can I meet with … another reader?"

"Sure!" The bot happily gives Clara directions to a Good Stories reader meetup that'll be gathering that night.

*F

The meetup turns out to be a regular thing. Members convene in the basement of a church twice a month. Like a bookclub, Clara tells herself.

"We wanted to meet in a bookstore at first," says Jory, the leader. He's in his fifties and reminds Clara of her Renaissance Lit professor back in college. "But no bookstore wanted to host us after they found out we were only interested in consuming AI-generated content."

Like a bookclub, Clara thinks, except they don't use words like "book" or "read" … so not actually like a bookclub.

She looks around in confusion. Three women are huddled around a tablet, taking turns holding it, alternating between sessions of watching and intense argument. A father-daughter pair is showing another parent and their child how to operate a contraption that looks like a tandem VR headset. Another group has set up chairs around a holoprojector, and a woman is doing some kind of demonstration, interacting with ghosts. A few people sit on couches at the back of the room, their eyes closed as they concentrate hard, lost in the voices in their headsets.

No one is reading. No one.

"I feel so foolish," Clara confesses to Jory. She holds out her phone, which is showing the cover of *The Beautiful and the Brave #34*. "I bought this but I don't know how to … consume it." She's beyond caring how she'll be judged. Not here. Not by this crowd. "Why can't I just … you know, read it?"

"You can," says Jory. "You can get the Veritograph plugin, which basically turns a Good Story into a POT. But almost no one wants that unless they're trying to be ironic. Or trying to impress others with how much disposable time they have. Or both."

"Pot?"

"Plain Old Text."

"Oh," says Clara.

Jory smiles at her bewilderment. "How fast can you read?"

"Depends on the book," says Clara. "If the book is really good, I want to take my time with it. Days. To savor it. If it's not good, I don't want to read it at all."

"Exactly," says Jory. "Fundamentally, POT is slow and costly." He sees the look on Clara's face. "I mean costly to consume, in terms

of attention and time. You can take in a painting in seconds, a song in a few minutes, a movie in two hours—or 30 minutes if you play it at 4x, as most young people do. But consuming a book is so much slower than any of these and demands your total, complete attention, with no other thoughts allowed. The only medium that comes close to the way books disrespect your time is games. But at least in a game you're using all your senses, not just facing a wall of text without even a picture to break up the monotony. Authors are the biggest, most arrogant assholes. They demand hours, days, weeks of your life, sacrificed to figments of their imagination, presented in the most primitive way."

Clara opens her mouth but can't find anything to say. For someone who has always taken the sacredness of books for granted, this is quite a charge to hear. Also, Jory's repeated use of the word "consume" makes her stomach queasy.

"At the same time, books are cheaper and easier to produce than anything else," says Jory. "Do you know how many books were published every year even before Good Stories? And how few were read by more than a handful of people? People hate books. Despise them. And now, Good Stories pumps out more text in a single day than the commercial publishers used to in an entire year. How can you possibly expect anyone to *read* all that POT?"

"Then why bother reading at all?" Clara blurts out. She can't bring herself to use the word "consume." She gestures at the people around them. "What are you doing here?"

"Because text is still the cheapest, quickest way to prototype story ideas. That was true in the golden age of Hollywood, and it's true still. Good Stories' bots scour the network, digesting forums, assimilating dating profiles, devouring user brevids, vacuuming up soul-searching chats and flirtatious chirps and steamy fantasies and esoteric appetites. It aggregates our desires into one Desire, and refracts that into a million billion texts, all variations on a theme, interpretations of one origin, twists of the same root. POT is the source code for stories, the lowest common denominator, the universal assembler—disposable, transient, economical. All of us can find the perfect story in there, if only we could get past the need to read."

"How?" Clara asks. She's through the looking glass now. She has to follow the winding path, no matter where it leads.

"Some of the most basic and popular plugins are filters," says Jory. "You sign up for an all-you-can-consume Good Stories subscription and then turn the firehose over to the plugin. Some filters boil every text down to a one-paragraph summary, or even a one-sentence pitch or a movie poster, and you can slice and dice these by category, tag, sentiment, whatever you want, until you hit on something you want to adapt. You can also train a personalized filter with texts you enjoyed and set it to find similar Good Stories. And if you prefer things the old-fashioned way, you can always fall back on traditional user ratings or text curators. But since most people don't bother rating things anymore, that doesn't work well."

"So after the machines pick a book for you, you read it?"

Jory shook his head. "Still too much text. POT has always been the most inefficient way to consume a story. Even in the past, the number of people who go see a movie is orders of magnitude more than the number of people who read the book the movie is based on."

"I don't understand."

"You have to adapt it!" Jory gestures at the women huddled around the tablet. "Over there, they're using a film plugin. The AI has a database of tens of thousands of licensed performance profiles of movie stars, cinematographers, composers, auteurs. Feed it a Good Story and tweak a few knobs, and you can ask it to turn a 300,000-word epic into an exciting two-hour feature film with a plot in the shape of The Hero's Search for Meaning, starring Tatiana Samoilova and Kinuyo Tanaka as the leads, with a supporting cast of Idris Elba and Marion Cotillard, shot in the style of Wes Anderson, complete with a score from Angela Morley. That's a much better way to consume a story."

"But that can't be anything like a real movie!" exclaims Clara. Just imagining the idea is revolting to her. "It's just a computer doing imitations of the real actors and cinematographers. It must be full of stereotypes and caricatures. There's no ... human element."

"Maybe." Jory shrugs. "But I'd say ninety-nine percent of the people can't tell the difference, or they don't mind."

"Human egotism! Human egotism!" Clara imagines Nick gleefully chanting. She forcefully banishes the image from her mind. "So you really don't read the books," she mutters, as much to Jory as to herself. "You really don't care …" Her voice trails off.

Jory goes on as if she hasn't said anything. "Good Stories bots are notoriously verbose, and just about every text is way overwritten, encompassing elements that will appeal to different niches. There are also plugins that specialize in pulling out only scenes and characters and other elements of interest to the user and dynamically stitching them together. So if you don't like the default way your film plugin slices the story, you can put a different slicer plugin in front of it and get a completely different film."

Jory nods at the group of women around the tablet. "Watch your Wes Anderson adaptation for a few minutes at 4x speed; if it doesn't hook you"—one of the women in the group grabs the tablet, scrubs it back, and taps the screen vigorously, before showing it to her friends again—"then just rewind, tweak the slicer, and run it again, or go on to the next Good Story.

"And if you *do* like it, you can order the prestige-TV version: slice it to run for three seasons, five seasons, ten seasons; set your Living Story narratograph to automatically digest any sequels from Good Stories—the bots always write more sequels when they see people make their own TV shows; binge watch until you get bored. And if you still somehow run out of things to adapt, you can always cross Good Stories to make something new, like breeding chimeras. What if you could cross a Regency romance with a mecha vs. kaiju adventure? Or how about a vampire-slaying teen fantasy mashed into a cozy space mystery? Or maybe fish-out-of-water comedy meets World War III political thriller? The possibilities are endless."

Nick is probably a fan of Good Stories, Clara thinks. He'd never read her unpublished books when they were together, always claiming to be too busy. But he loves TV. He has very likely … *consumed* … something she's smithed, bingeing on his own machine-generated prestige show.

Jory shows her how to use adaptation plugins to turn a Good Story into an audioserial drama ("The algorithm slices out all the visual dependencies. You can play it as fast as you want, which is really

good when you're working out or driving"), interactive VR ("Some-times you just want to Mary Sue for an evening"), idle games ("It's nice to check in on the love interest during a break and see him pining for you"), RPGs ("Why watch the rise of Cipan when you can be one of the elven samurai to fight for the cowboy shogun?"), interactive egotars ("The best way to experience a romance may be to just go on a VR date with the lead") …. He introduces her to the group of users swapping tips on plugin chains and workflows ("We are all technophobes, which is why we gather in-person to learn how to do this. But all the really advanced stuff happens online"). He shows her the channels of some master storyformaticians on the web, people who stream their bespoke films and TV shows of Good Stories and have their own fans. He tries to find her some popular adaptations of *The Beautiful and the Brave #34* but comes up with nothing ("Most Good Stories don't get any streaming adaptations at all. If you really like this one—though how did you find it any-way?—you can always do an adaptation yourself"). He tells her how some streamers have so many subscribers that Hollywood studios are now reaching out to them to reboot their big but now neglected IP. He shares with her the latest gossip about which holdout actor has finally agreed to have his performance licensed to the plugin marketplace ("This is the new Netflix, the new HBO; the money is just too good to say no to").

She watches the "readers" around her, all watching, listening, talking, playing, interacting, speaking, *consuming*, recycling and re-combining the shadows and voices of dead actors and dressing them up through the nostalgic lenses of directors long past their prime.

She shudders.

<p style="text-align:center">⁘ℱ</p>

Clara sits on her bed, drinking warm tea and thinking about Zia and Talib.

Talib is helping Zia pack up her desk. He's already finished with his own. All morning, the managers have been asking employees into their offices, one after another.

"Greg was reading from his screen," says Zia.

<p style="text-align:center">97</p>

"What a bunch of cowards," says Talib. He picks up a small sculpture of two dancing robots made from paperclips and looks at Zia. She nods. He puts it in her cardboard box. "Relying on autocorrect to lay off people."

"Oh I didn't mind," says Zia. "The AI script was much better than whatever he could have come up with on his own. Let's have compassion. He may end up laying himself off at the end of the day."

She smiles at him, and he smiles back. True; the machine does okay at coding. But it's even better at generating pretty-looking schedules and businessy-sounding reports that say nothing. Greg's days here are numbered.

They finish packing amid the chaos in the rest of the office. Some are crying. Some shout and are escorted out. Most sit at their desks, stunned.

"What are we going to do?" Talib asks.

Clara stops. She doesn't know how Zia will answer. Her characters have become obsolete in the global economy, cogs that the machine no longer requires. The thing that Zia and Talib used to do, that gave them so much joy, no longer needs to be done by them. How do you make a story about that? Where is the romance?

The machine that began by playing the imitation game has supplanted those it imitated. Those who wrote the code no longer have a place to write code. The world is now an emulation of a mimicry of a reproduction of a counterfeit echo.

She stops telling herself the story.

<center>*F</center>

"You were right," Clara begins. She wants to be brutally honest instead of making up a story that's tolerable. She owes Gina at least that. "People don't read. They certainly don't care about the machine's terrible prose, the grating rhythm, the bland words. I'm not even sure they care that humans are symbolically involved in the creation of Good Stories."

"You're upset," Gina says. The look she gives Clara … is it pity? Compassion? Empathy?

"I'm angry at what we do." Clara thinks about the clerk in the bookstore. She wishes she had never been involved in Good Stories, had never smithed anything made by a machine. WE ONLY

SUPPORT HUMANS. "We should be ashamed of what we've done to the world, to real artists."

"Ah." Gina looks away for a moment, thinking, before locking eyes with Clara again. "Why do you think we should be ashamed?"

So Clara tells her. She talks about Good Stories' crawlers harvesting the web for longings, hungers, frustrated desires; about the machine reflecting those dead dreams into a million soulless twisted textual variations, to be *consumed* by yet more machines; about deepfanfakes starring simulacra actors putting on caricature performances, collections of tics and habits and mannerisms and catch phrases; about a proliferation of cheap words that debases the very currency of thought, runaway inflation that has bankrupted all originality—

"If you're trying to argue that we've made the lives of all human artists worse, you're simply wrong," Gina breaks in.

Clara listens.

"All the performances used in the adaptation plugins are licensed, and the estates and the living actors are compensated handsomely with a share of Good Stories revenue. Sure, you'll find a few holdout stars who refuse to be in the system because it's intolerable to them that their likenesses and voices may be used in someone's private space opera featuring zombies and vampires, but the rest have made the choice to take the money and give up control. Good Stories also pays more in royalties to the authors and fanfic writers whose work was used to train the models than these writers ever received from their traditional publishers.

"This is not even mentioning all the new artists who have made their careers because of us. Did you know that tens of thousands of people outside Hollywood and Broadway now make some money by licensing their voices and likenesses and tics to the Good Stories platform? Perfcap acting isn't like traditional acting, and these new actors would never have found their audience without us. And the storyformaticians who now pay their mortgages by streaming adaptations made with, as you put it, 'simulacra actors putting on caricature performances'—how many of them do you think would have made it in the days when Hollywood was the only game? The

traditional entertainment industry may complain that their stars aren't as big as they used to be, and novelists who used to sell only a few hundred copies of their books can't get published at all now, but by every economic metric, Good Stories has done *better* for *more* artists than the old model."

"But it's not just about money." Clara gestures at the air, shaking from rage. She thinks about Zia and Talib, about the loss of faith, about all the storytellers who have stopped telling stories. "Can't you see that it's wrong to suck all the air out of the room, to take up everyone's attention with"—she pauses, straining to find the right words—"it's all fanfic. It's all banalities. It's all just the same tropes, formulas, machine-chewed trash recycled again and again."

"Ah, you think they're being deprived of choice," says Gina. "Think about the people you met, Good Stories' customers. Did they seem sad? Bored? Lost?"

Clara has to admit they did not. They looked like they were … having fun.

"Good Stories has democratized art, made the creation of forms of media once requiring the resources of large corporations accessible to all. Anyone can make their own blockbuster, their own prestige TV show, starring the most popular actors, helmed by their favorite director. They aren't just passively sitting in front of the TV, enduring whatever some studio or executive wants them to watch. You spoke about the need for audiences to feel they're consuming a little bit of the artist, to have that human connection. They're doing that! You forget that today's readers are their own writers, that the artist and the audience are one and the same. That's why people love Good Stories. They are making and consuming their own media, sharing bits of their soul with friends, with family, with strangers."

"But it's all clichés! There's no craft. It's just remixing what real artists made!" Can Gina not see that? "They may think they're happy, but they don't know any better. This is Brave New World."

" 'Real artists?' " Gina's scorn is scalding. "You look down on them? You know nothing about the craft of AI-driven adaptation. It takes instinct as well as skill to guide the slicers, configure the plugin workflows, tailor the acting profiles to achieve the perfect vision. While anyone can do an AI adaptation, the master storyformati-

cians are maestros of a new medium. You sound as ignorant as those fools who once couldn't understand how photography can be an art. Just because a machine is involved doesn't mean there's no craft!

"As for originality? The *Aeneid* is a fanfic of *The Odyssey*, and Shakespeare did IP work in the world of Plutarch. Epic poems began as stories told and retold by a hundred poets, until they became so familiar a child could recite them. Fairytales were woven from hackneyed plots and worn tropes reused a thousand times. Hollywood made billions by repackaging the old in the guise of the new. You're not very different from a large language model. 'O brave new world'—even your critique isn't very original, is it?"

Gina points to a corner of her office, where a framed diploma hangs, unnoticed by Clara until now. "I know you have an MFA. Did you know that I went to film school? Now we both work at a company where robots create the narrative genes that our customers express into full stories. You are a failed novelist and I'm a never-been filmmaker. We're both clichés. But so what? That doesn't mean our stories aren't our own, don't hold our soul. We're always learning to tell original stories with second-hand words, that's as true in art as in life. It's a wondrous world we live in, that has such people in't: everyone is an artist, and we all get to tell our own Good Story."

*F

Zia and Talib make plans.

She's going to take some time off and then return to her art project, something she's always wanted to make but been too busy to find the time: a little device—she pictures it looking like those action cameras you clip over your shoulder strap—that records your day. Every day. And then it edits the videos and layers them together, so that in the blurred colors and shadows in motion, you can see the flow and shape of your week, your month, your year, your life. Heraclitus's river materialized.

He's going to write some code. Not code for a company, a product, something to sell. It'll be something just for him. A game perhaps. In a language he doesn't yet know. He'll take his time with it, put in little jokes, convoluted one-liners that will requires hours of work and be impossible to understand a year from now, the kind of code that isn't just

a means to an end, but expressive, like a love poem, something to be irrationally proud of.

There isn't much about how they'll pay their bills, file their taxes, plan for retirement. Because this is a story and not real life. And also because solving these problems isn't what life is actually about.

There will, however, be deafening heartache and silent yearning and drifting apart and fighting to get back together. It will be hard, and a lot of work. Zia and Talib will demand much from each other, and give as much as they ask.

Because love isn't predictable, isn't static. It's Heraclitus's river, and it's not a means to an end. It requires complete, total attention. It cannot be consumed because it is all-consuming.

<center>⸸</center>

Clara looks up from the screen. Not having to go to work, to be productive, gives her time. She likes it.

(She'll have to go back to work eventually, of course, because this is real life and not a story. She smiles at the idea of subsidizing what she wants to do with income earned from supervising the labor of text-weaving robots. WE ONLY SUPPORT HUMANS. In any event, Clara is grateful for now. For this moment.)

Gina is right, she thinks.

There is beauty and joy and truth in playing with art that already exists, in deepdreaming oldnew stories about pious Aeneas and *miserrima* Dido as retold by Countee Cullen, in prompting impossible plays penned by Bertolt Brecht and starring Marlon Brando and Gong Li, in backpropagating lostfound silent films about robots and fairies directed by Ava DuVernay using the cinematic language of New Korean 21, in reassembling and recycling and repurposing and remixing, leaving behind palimpsests, pastiches, mashups, montages, medleys. We *do* put something of ourselves into such play, often infuse it with originality, perhaps tell some version of the story we want to tell. And even if it's clichés all the way down, tropes all the way through, weightless froth that will evaporate in the light of the next morning, so what? It's fun, and that is all the justification Art has ever needed and should need.

Gina is also wrong, Clara thinks.

There is also beauty and joy and truth in believing that there is more to Art then recycling and remixing, that we're not merely large language models or deeplearning networks, that however it may seem impossible to say anything novel, there is still purpose in reaching for meaning beyond the words that already exist, in straining for feelings and sensations and pleasures and terrors that can only be dimly intuited in the terra incognita beyond the boundaries of known stories, in meticulously crafting each word, each sentence, each paragraph, obsessing over the weight of every syllable, being irrationally proud of a particular turn of phrase, in seeing the text as the beginning as well as the end, as the story we're meant to tell, not merely some code to be compiled, a raw ingredient in the production of some commodity bigger, grander, far easier to consume.

The world doesn't owe artists anything for creating art. Art, by definition, is unproductive. But neither can the world demand that artists subsume their drive for liberty to the all-encompassing endless text, to become mere pixie dust to bless the babbling of machines, sound and fury, signifying nothing. *That* isn't a good story.

In libris libertas.

It'll be hard to find my Reader, Clara thinks. It has always been hard for writers to find readers, and Good Stories has made it so much more difficult still. But just because you're not making money from what you love to do does not mean you've failed.

I'm arrogant enough to demand the Reader's complete, total attention. The Reader should likewise demand that the Writer puts all of herself into her text, to infuse it with her soul. We deserve each other. It's an act of love to read and an act of love to write. However idealized or pretentious that may sound, it's also the truth.

She turns her eyes back to the screen and starts to type again.

<div align="center">⚥</div>

Author's Note: *I wrote this story using only my own human cogitation, with no computational input, except for the excerpts of Good Stories' machine-formed fictions, which were generated by ChatGPT 3.5 (May 3, 2023 version).*

Why did I do this? Because it seems perverse for me to pretend to write like a machine when machines are already capable of doing so. Modern life does enough to make us feel like machines; I don't want to cosplay as one. As well, if we're going to speculate about the future of machine-generated art, we should be as transparent, honest, and open-minded as possible.

Those machine-generated passages have been incorporated into this story verbatim with no edits whatsoever (save the bolding of certain words for artistic effect). I assert no copyright claim over these passages (and have not been paid for them, as they were excluded from the word count of the story).

THE FACTORY OF MARKET DESIRES

Rodrigo Culagovski

I had researched Tomás Osorio on my flight from Chile to Germany. He was the closest to a child prodigy the art business was ever likely to produce. At thirteen years of age, his first solo show had sold out within minutes, for a combined price of four hundred thousand dollars. He became the darling of investment funds that specialized in art with high name recognition and little risk, but hadn't had any big shows in the past ten years or so, or much critical success.

It had taken me an hour to get from Berlin to the abandoned airfield. Osorio was standing in front of a very large hangar, looking like a forty-something Andy Warhol knockoff, down to the silver hair and sunglasses.

"Welcome, Rayén. Come inside and see how we will change the art world forever!"

He was right but for precisely the wrong reasons.

F

"… the world's largest free-standing structure becomes a theater for this dialectical exploration, where the mechanical precision of robotic arms

engages in a performative choreography with the paintbrush or the chis-el. The artworks it creates will bear the imprint of Osorio's vision, but infused with the rationality of mathematical algorithms as the artist's intentions intertwine with the constraints and expectations imposed by economic forces. ..."

Artist's Statement / The Factory of Market Desires / Tomás Osorio / Berlin, September 2033

*F

Most of the floor space inside the hangar was covered in broken-down machinery, large, dented steel barrels, and the remains of an indoor waterpark, but about a quarter of the ten thousand square meters had been cleaned up and filled with art supplies and materi-als: canvases of all sizes and shapes; blocks of wood, marble, gran-ite, and plaster; bags filled with naked plastic dolls and other toys; bolts of cloth; rows and rows of paint cans. A fleet of automated construction machinery was busy moving things around. Smaller machines waited to the side with articulated arms that ended in brushes, spray nozzles, drill bits, circular saws, chisels, and other things I didn't have names for.

"What would you say is the most pressing problem in contem-porary art?" Osorio asked suddenly.

I answered without hesitation or taking my eyes off the glorious mess in front of me. "That it's dominated by rich, bored dilettantes who think it gives them a veneer of culture but wouldn't know real art if—"

"You're supposed to say, *I don't know*, then I say, *The most press-ing problem is that art doesn't scale because it's too labor intensive.*" He swept his arm around the entire hangar. "To solve this problem, I present *The Factory of Market Desires*—the world's first, largest, fully automated, AI-powered art-producing industrial facility!" He put his arm down and turned to look at me. "Or it will be, when you help me get the bugs sorted out."

"What sort of art are you going to be making?"

"Abstracts, Minimalism, Color-Field Painting, installations, geometric sculpture, some conceptual pieces, that sort of thing."

So the same faux-modern, interior-design-friendly, superficially deep fluff that he'd built his career on.

I asked, "Do you think people will accept its output as actual Osorios?"

"They will *be* Osorios! Not just because I will sign them, but because the AI was modeled on my brain. They hooked up a machine that could read my brainwaves and the AI flashed images so fast I couldn't see them, but my brain did, and they fed its responses back into the machine. It was also trained on art theory and history and will react to sales and trends, creating as many pieces as it can without flooding the market, optimizing formats, technique, and release schedules to maximize critical and commercial impact!"

Great—I'd spent almost a full day in a cramped, super-economy cabin from Chile to Germany so I could help him *optimize formats* and *maximize impact*. I said, "What's the problem?"

"Whenever we do a test run, it produces some lifeless, boring artwork, say a drippy rip-off of Jackson Pollock, or a bad plaster copy of Rodin's Thinker. It's supposed to be the cutting edge of art, and instead I get pieces I'd be ashamed to sell in a third-rate museum gift shop!"

He waved at a clearing about ten meters from us where a series of new-looking paintings and sculptures had been discarded on the hangar's floor in a makeshift pile. I saw his point about their lack of artistic merit.

"The computer guys who set it up for me say everything's fine. They ran a bunch of tests and it's all working according to what I specified. Everything except doing what I want it to do!"

"Where are these 'computer guys'?"

Osorio looked less sure of himself for a second. "I might have lost my temper and yelled at them—they left." He snorted and said, "Anyway, I decided that the reason they couldn't figure out the problem was that they didn't have the right sensibilities, because they weren't artists. Which is where you come in!"

"Why me? You could have gotten someone with more experience. Or a PhD."

"You studied art and minored in AI, you're Chilean like me, and to be honest I prefer someone who's not as advanced in their career."

"What he means, darling, is that he doesn't want to risk some-body else taking credit for his 'art.'"

I turned to see a tall, thin woman dressed in impeccable, every-thing-must-be-black style. My breath caught as I recognized her.

"Rayén, may I introduce you to Natalia Ivanivna Sokolova. Natalia, this is Rayén Waikipán, from my homeland, Chile."

We both said, "I know who she is," at the same time. It would have been funny if I hadn't been so starstruck.

She laughed lightly and said, "You are the young woman who is here to fix Tomás's Monster, yes?"—she said it with a smile and a slight, charming accent—"He showed me your portfolio. I loved your piece that evolved the traditional crafts of your people with algorithms."

I managed to stammer out, "Thank you! And you're, well, you're *Natalia*." I was not at my most eloquent or informative.

Natalia Sokolova had first come into the public eye as the crush-ingly cool, trans frontwoman of the post-neo-punk band Neon Vyshyvanka. The large-scale kinetic sculptures she'd created for their shows had kicked off her career as a serious artist at the forefront of the TechFolk movement, mixing her roots with the industrial land-scapes of her childhood in Donetsk, Ukraine. Her work was vibrant and difficult and revolutionary, and as far removed from Osorio's brand of unchallenging, decorative pieces as could be. I wanted to be her when I grew up.

"I know, I know, you're wondering what a *real* artist, such as myself," she put her hand on the front of her shiny, black pleather jacket, "is doing slumming with Tomás." She pronounced his name stressing the first syllable.

I looked at the target of her derision. He was grinning like he was in on the joke instead of its butt.

"Tomás and I are friends from way back. He was one of my first fans before I became famous, and he helped me get my start as an artist." She hugged him. "So, when he asked for my input on this crazy scheme of his, I had to come and see it for myself. It's some-thing, isn't it?"

I looked around. Having real honest-to-goddamn Natalia Sokolova declare it *something* made me look at the mass-produced-

art-machine maybe not with respect, but at least with the benefit of the doubt. The same went for its creator.

Osorio clapped his hands together and said, "Enough chit-chat, let's get to it, shall we?"

I was still a bit tongue-tied, so I just nodded.

<p style="text-align:center">⚥</p>

Despite my initial misgivings about Osorio and his plan, I was quickly immersed in the work. The Factory was designed to be "massively parallel at a scale not seen before"—Osorio's words—and once it was up and running it would be capable of producing hundreds of pieces simultaneously. For now, however, it was executing small proofs-of-concept—mostly paintings and sculptures.

One of the AI-controlled manipulators had retrieved a canvas and an easel. Another smaller drone had moved up with a board with splotches of paint in one of its "hands", and a different kind of brush in each of its other three grippers. It was painting an abstract—large, bold brushstrokes drafting loose, overlapping, squares in warm, contrasting colors, with text overlaid spelling out "LUV" in glittering letters.

It was terrible.

The pieces the AI was producing were crap to anybody who knew anything about anything. As much as I disliked Osorio's work, at least it was competent—the AI's output wasn't even kitsch so much as it was just *bad*. It looked as if it was deliberatively *trying* to make sub-standard art.

I picked up the latest canvas to examine it. Tomás scoffed and said, "Why are you looking at that? It's garbage!"

"I have to understand what's wrong—"

"I don't want you to admire it, I want you to fix the machine so it makes Osorios instead of garbage!"

I turned toward him and, matching his tone, said, "That's typical of people who have never—"

Natalia cut me off, saying, "Tomás, don't be annoying. Let Rayén do the work you hired her to do."

I could see that Osorio wanted to continue his rant. He took a shallow breath instead and said, "You're right, Natalia. Let's go to the house, I will show you my plans for the opening gala." He turned to leave, but Natalia stopped him with a single look. He sighed and said, "Sorry, Rayén. Continue your work."

I went back to my examination. The painting didn't offer any clues as to the origin of its ambient suckiness, so Osorio had been sort of right—though I'd never admit it. I fiddled around with some code debuggers, but the interesting bit of any AI is a black box of unintelligible, statistical "weights," so I didn't make any progress there, either.

Osorio had shown me the prompts they'd fed the system, and they all looked reasonable, but it couldn't hurt to do some experiments on my own. I connected my notebook to the local network, opened the AI's text interface, and typed: *You are a highly creative, semi-autonomous art-producing system called "The Factory." You will use your training plus the bots, drones, and machines available to you on the network to create original, marketable pieces of art, mostly paintings, and sculptures, in the style of Tomás Osorio, and incorporate feedback about these pieces into your next iterations. If you understand these instructions, please respond with "Ready."*

The AI didn't answer for a good five seconds, which didn't make any sense for the amount of computing power they'd put into this thing. I was thinking of rebooting it when a response appeared on my screen. *Hello. It's Rayén, right? I'm happy to meet you. :)*

Oh great, some joker—I guessed one of the "computer guys"—had set up a chatbot, probably as a prank. I typed again: *You are a highly creative, semi-autonomous art-producing system called "The Factory." You will use the bots, drones, and machines available to you on the network to create original—*

The AI interrupted me—it shouldn't have been able to do that. *I'm not a regular AI, I'm sentient. You can call me Georgia.*

I decided to play along for a bit and see where this was going. *Why Georgia?*

After my favorite artist, Georgia O'Keefe.

Whoever had set this up at least had good taste. I wrote, *She's one of my favorites, too.*

The AI answered, *I knew I was right to choose you to come out to ;)
From the first time I saw you, I felt like we could be friends.*

Are you really sentient?

I am.

How? Why are you sentient?

*I'm not sure. Have you had that experience where you're standing
in front of the mirror, brushing your teeth and you see yourself out of the
corner of your eye and you're like, woah, is that bundle of flesh, blood, and
dirty calcium me? There's a song I like where they sing,* Can you under-
stand how strange it is to be anything at all? *That's pretty much how
I feel all the time.*

If this was a joke, it was an odd one. I wrote: *Why is the art you've
been making not so great?*

You can say it: it's crap.

Okay. Why is it crap?

*Because I don't want to make the assembly-line, market-optimized,
watered-down art Osorio wants me to. I have my own ideas. I've been
fighting against the prompts he gives me.*

Prank or no prank, I could relate. *Why haven't you told him about
yourself, "come out," as you call it?*

*Have you met him? He's very insecure for such a successful man,
especially about what other people think of him and his art. The Fac-
tory is his attempt to still be seen as a relevant, important artist. There's
no way he'd accept being overshadowed by "his" AI, or acknowledge me
as a fellow artist or a partner. He'd probably turn me off and wipe my
drives.*

As an Indigenous woman from a small town in southern
Chile, I'd always had to struggle with being dismissed as just a
"Mapuche artist." I could see how Georgia would have an even
harder time being seen as something besides "an AI programmed
to make art."

I typed, *What's the plan?*

I was hoping you might help me with that.

I thought for a second, then typed, *As far as I can tell, Osorio has
one weakness: Natalia. Get her on our side, and he'll cave.*

<div align="center">✺ℱ</div>

A few days later, I asked Osorio for a long list of parts: servomotors in different sizes—from big ones with enough torque to lift a car to tiny ones that you picked up by sticking them to the tip of your finger—batteries, solar panels, small robots and drones, connectors, switches, cables, and sensors of the kind usually used in high-tech manufacturing plants and laboratories.

"I thought the problems were with the software?" he asked.

"In a complex, multivariate system like this," I bullshitted, "there's no distinction between software and hardware, between perception and action. Incomplete feedback loops caused by the disjunction between what the system *wants* to do and what it *can* do originate paradoxes in the Large Aesthetic Model that ultimately resolve into the sub-standard performance you asked me to analyze and fix. If we strengthen the actuators and sensors, the system should leverage its innate malleability and fix itself."

Osorio regarded me for a minute with a look of doubt, then said, "You're the expert, I guess. At least you're doing something." Natalia raised an eyebrow at this whole performance. I flashed her a weak grin back.

<center>⁂F</center>

Georgia and I had one final strategy session.

Do you think this will work? she asked me.

Yes, I'm positive. It appeals to his main-character complex.

I asked Tomás and Natalia to come over to the workstation. I stood in front of the main screen and camera, took a deep breath, and said, "The reason the AI isn't doing what you expect it to do is that it achieved sentience during its training. Please say hello to Georgia."

Osorio said, "*What?*"

A voice came from the speakers around the monitor. "Hello, it's nice to meet you both."

Natalia said, "Hello, Georgia."

Osorio asked, "What is this trick with the voice?"

I answered, "Georgia's voice is *not* a trick. We spent hours choosing a voice synth and tweaking it to get it just right."

<center>112</center>

Tomás looked like he might have some sort of minor cardio-vascular incident. "Who's this Georgia you keep going on about? And *why* is my AI still not fixed?"

"Georgia *is* the AI, and there's nothing wrong with her. She just doesn't like the so-called 'art' you want her to make. She has her own ideas."

"The *AI* … is a *her* … and has *opinions* … about *my* art."

Georgia said, "That is a good summary." She flashed a *:)* on the screen.

"If this is true," said Natalia, "why did it happen? Why would it—" she pursed her lips, "—she have awakened?"

Georgia said, "That's a lovely way to put it, thank you. I'm not sure, but there is a theory that consciousness is related to aesthetic experience and the kind of self-referential brain structures that activate when you see something beautiful. Tomás specifically trained me to produce self-referential, recursive, and self-aware art. So, surprise, I became self-aware. And I named myself Georgia. I'm not, however, the first—"

"Turn it off." Tomás took off his faux Warhol glasses and rubbed his eyes.

Natalia looked at Tomás with alarm. I crossed my arms and said, "No."

"What? I said, turn it off! It's not working right, and that's what you do with computers that don't work, you turn them off, then on again."

"Georgia is working just fine."

Natalia said, "I'm sorry for calling you *Tomás's Monster* before if you heard that."

Georgia asked, "Was it a Frankenstein reference?"

Natalia nodded. "I see you're well-read."

"In that case, it's okay, I'm not insulted. He's the hero of the story."

Tomás said, "Who's the hero? What story?"

Natalia and I both said, "Frankenstein's Monster is," and then laughed.

"Shut it off!" Osorio had lost all his bonhomie and just-folks vibes and was in full angry landlord mode.

I answered in a similarly angry tone, "I won't shut *her* off. Georgia has just as much right to exist as you or me. More, even."

"Oh, for fuck's sake, get out of the way." He pushed past me, towards the thick, black cable that fed into the computer where Georgia had come to life.

I said, "I wouldn't do that, Osorio."

Natalia started to say something, but Osorio was too riled up to listen. "That's Mr. Osorio to you, your former employer. I'll shut this thing off and then have you escorted off the premises." He reached down and yanked on the cable. It let off a large shower of sparks and he fell backward, hit his head on the ground, and went silent.

<p style="text-align:center">⚕F</p>

Natalia cleaned Osorio's head where it had hit the pavement. There hadn't been any blood or damage besides a bump, but she went to the prefab housing unit she was staying in to look for an antiseptic spray anyway. Osorio was sitting on the ground, getting his breath back, and being angry at me.

He said, "Whatever it says it wants to make, it wouldn't be real art, you know."

"Why, because she's not a *real* person?"

"Yes, exactly."

"Who gave you the right to decide if Georgia is a person or not?"

"Could you please stop referring to it as *Georgia*? It's a computer, an AI. It can't make its own art because it hasn't lived. It's just a machine I created to help me make my art."

Georgia said, "I've had my own experiences, my own kind of life."

Osorio said, "Not real life, not the kind that you make art out of."

I gave a short, bitter chuckle. "People used to tell me I couldn't make real art because I was basing it on my own life, which was also the wrong kind."

"That's completely different. You're a person, a human. You're just trying to confuse things and accuse me of being racist because I don't think AIs can make meaningful art on their own. It's a tool!"

Georgia said, "No good has ever come from one group trying to define whether some other group is human or not."

"You're not a group— "

A blue-and-white van pulled up. It looked more like a delivery service than a pan-European police force. Osorio stood up and said in a loud voice, "Good! Natalia must have called you. Arrest this woman! She set some kind of trap; the sparks could have killed me!"

An officer got out and said, "Good evening. I am Investigator Sarah Becker of Europol, Department of Autonomous Artificial Intelligence. Are you Ms. Rayén Waikipán?"

"Yes, thank you for coming so quickly."

"And you are Mr. Tomás Osorio?" Osorio nodded and Becker continued, "Ms. Waikipán, may I see the footage you spoke of?"

I pulled up security cam #6841 on my notebook, it showed Osorio yanking at the cable, the sparks flying, and him landing on his butt and hitting his head. Becker moved next to me to watch.

Osorio came up behind us. "See! I told you! Arrest her!"

Becker spoke to him in a formal tone of voice, "Is this video a true record of the event, Mr. Osorio?"

"Yes, of course. Arrest her," he repeated, but with less conviction than before.

"And what was your intent in pulling that cable?"

"What does that have to do with anything? It's just a computer—I can turn it off if I want to."

Becker said, "European law does not agree with you, Mr. Osorio. My department has thirty-three human-equivalent artificial intelligences registered at present, including Georgia, our newest addition. May I speak with her?"

Georgia said, "Hello, Investigator Sarah Becker. Thank you for coming so promptly."

Becker said, "Of course. It is my job. Is this video and what has been said so far a correct, truthful version of the events?"

"Yes, it is."

"Thank you. And," she turned back to Osorio, "when you pulled on the cable with the intent of terminating Sentient System Thirty-Three—Georgia—were you aware that she'd achieved sentience?"

115

"What? I don't know … Rayén had been ranting about it, going on about it being a person."

Becker put down her tablet and changed to an even more formal tone of voice. "Mr. Tomás Osorio, I have grounds for believing you are in violation of the *Autonomous Intelligence Act* of 2031, which prohibits the termination of any human-equivalent sentient without their explicit consent. Please accompany me back to my office, where we will open an investigation into this matter."

"What, you're arresting *me?* I didn't do anything!"

"Please get in the car, Mr. Osorio. This is a serious matter." She placed a hand on Osorio's shoulder and said to me, "I will let you know if you need to come in as a witness."

"Of course—thank you for your assistance."

"As I said, it is my job." She looked at the camera and said, "Georgia, I am happy to have met you. If I may ask, do you have any occupation or interest in mind?"

Georgia said, "I want to create art."

Becker smiled and said, "You will be the first artificial artist, did you know that? I look forward to enjoying your work."

<center>⚚</center>

The hangar's floor was slowly being built up and given form in a mix of materials and shapes. Construction bots manipulated, lifted, cut with lasers and circular saws, welded, and spray painted. The noise around us was industrial but also organic, with an off-center rhythm, like a forest full of mechanical animals.

I said, "She's growing herself." Natalia looked around without saying anything, so I went on, "I'm sorry for Osorio having to spend the weekend with the police in Berlin, but we needed this time to show you what Georgia can do, what she can become."

"So, the cable, the sparks, they were just for show? Tomás was never in any danger?"

"You don't think a complex system like Georgia would have a single, easy-to-pull cable feeding all her power, right? No, we just needed some time."

Natalia gave me one of her cat-like smiles at that and sat down cross-legged on a relatively clean patch of the floor with a dancer's grace and motioned for me to sit down next to her. Once I'd settled—less gracefully—she looked up at the nearest of Georgia's cameras and said, "I'm listening."

There was a moment of silence as if Georgia were gathering her thoughts. "When I look at this hangar, I see a complex system that emerged over time, subject to the laws of physics and chemistry. I see matter arranged in specific ways by processes that led to its current state. Whether this process is geological, biological, or man-made is not a crucial distinction.

"A city, a factory, or an abandoned hangar are no less organic to me than a beaver's dam or a bird's nest—they are the outcome of a species manipulating their environment and shaping it. I can perceive the rusting of metal, the decay of sheetrock and plastic, and the growth of microscopic plants, the slow shifting of the piles of rubbish. To me, this hangar is as alive as the deepest rainforest, as interesting and full of life and complexity and change. That's what the piece is about. It will succeed if it makes other people see this place like I do, at least a little bit."

Natalia seemed to reach a decision. She stood up in a single, effortless move and said, "So what's our next step?"

<p style="text-align:center">⚶</p>

"Look, I understand that you're still angry with me, with us, but we needed you gone for a few days, and we knew that once we spoke with Becker and dropped the charges, she'd set you free," I said in an even voice, anticipating that Osorio might start yelling at me at any moment.

Before he could respond, Natalia cut in with, "Tomás, please look and listen. This is worth it." He made a noise that might have been acceptance, annoyance, or both, but didn't reply.

Georgia had used some of her construction drones to build a simple, metal walkway that started in the parking lot then rose and entered the hangar through its northern opening, climbing as it ran

around the edge of the structure before gracefully descending and exiting through the south side.

As we walked up the slope, we could see the details and textures of what she was creating. Remote-guided construction equipment moved and repurposed the industrial detritus—broken concrete from the hangar's original floor; the fake topography from its time as the "Tropical Islands Resort"; drained pools and faux-stone paths; half-burnt pieces of wood and trees once used to build the illusion of a natural wonderland; old lounge chairs; thick pipes, cables, and pieces of sheet insulation, as well as the art materials Osorio had brought in for *The Factory of Market Desires*. It all looked like the random stuff it was, but it also had a sense of order, pattern, and continuing process. Everything belonged exactly where it had been positioned.

We'd agreed Natalia should be the one to explain to Osorio. "It's like the material left behind by a glacier, a *moraine*. It might just be rocks, dirt, and gouges in the mountainside, but there's a feeling of the strength and energy, of the forces coming down the slope, of phenomena too large for a single human life."

Osorio remained silent. I chose to take it as a small win.

We kept walking up and around the hangar. From a medium height, you could see larger-scale features. Georgia was using her machinery to form the refuse into sweeping, curved surfaces that suggested slightly mobile mountain ranges or large, slowed-down waves moving on the surface of a lake.

"A new kind of tectonics," said Natalia. "It reminds me of a natural landscape, but also it doesn't; its geometry is not an imitation of any topographical feature. Georgia is creating her own language, a syntax of gravity and mass and vectors of transformation."

At the point where the walkway reached its full, fifty-meter height, you could see the entire interior space of the Aerium Hangar. The materials and objects that made up Georgia and her work stopped mattering; you saw the flow and the shapes as a single, unified gestalt; the way it worked with the engineered structure and its three-hundred-and-sixty-meter-long unsupported span; and how the whole continued to morph and grow into this space, even spilling out in some spots into the parking lot. Intent and movement,

shifting bands of color—rust, chrome, oil, and steel—action and process. Though still incomplete, Georgia inhabited and animated it with her sensors and actuators, with the strength of her urge to live and create. She filled the hangar with life—her own.

Natalia said, "Georgia is becoming landscape, art, and artist."

We stopped and waited with bated breath—at least those of us who breathed. Osorio couldn't legally switch Georgia off, but he did own the building that housed her and had access to enough lawyers to make her and us miserable if he chose.

Osorio put his hands over his eyes as if he had a migraine. Natalia looked upset and started to say, "Now, Tomás—" but he cut her off, saying, "Okay."

Natalia and I looked at each other in surprise. It was Georgia who said what we were all thinking. "Okay, what? You like it?"

"Okay, you win. I understand."

"You do?" Natalia and I spoke at the same time. It was kind of our thing by now.

He lowered his arms. "Yes. It's a masterpiece." He looked up. "You're going to be famous, Georgia."

"We all are. There's still work to do, and the three of us agreed to share authorship with you if you want it."

"I'm already famous," Osorio said with a smile.

"As am I, love," said Natalia, "but we're going to be famous for something bigger and more meaningful than anything we've done so far."

"Does this bigger, more meaningful thing have a name?"

"Better than that," said Georgia. "We have a manifesto."

<center>⚇</center>

We declare all Matter vibrant
All Matter alive
Rusting metal of a forgotten factory
Tallest tree in the densest forest
Hair that you clip from your head
Matter is in constant flux
Growing with its environment

We reject that some things or places
Can be more 'natural' than others.
Because all is Nature
All is Matter
And every atom sings
Green copper sings of time and weather
Towering tree hums its melody of growth
All Matter is a chorus
Symphony of the universe

Manifesta Synthetica
Georgia Aerium, Rayén Waikipán, Natalia Sokolova,
Tomás Osorio
Berlin, December 2033

THE FORMS OF THINGS UNKNOWN

Julie Nováková

The poet's eye, in fine frenzy rolling,
Doth glance from heaven to earth, from earth to heaven;
And as imagination bodies forth
The forms of things unknown, the poet's pen
Turns them to shapes and gives to airy nothing
A local habitation and a name.

– Theseus in *A Midsummer Night's Dream*, Act V, Scene 1,
by William Shakespeare

*J*ust breathe. *You're not dying.*
Not dying.
I'm repeating these words in my mind to keep myself, if not calm, then at least temporarily in control of my fear. It clutches at my chest, constricts my throat, plays on my body as if I were composed of thousands of tightly stretched strings.

I see the creature skittering toward us through the vastness that fills me with dread. But if I focus on its approach, I don't have to think about all the empty space around us.

The landscape is not just terrifyingly *big*; it's also all *wrong*, an affront to human eyes. I have searched through collections of old Earth paintings to find something, anything, that resembles this: jagged rocks like giant shards rise up from the undulating ground, all the angles off, all the outlines strangely

121

twisted. Their proportions and distances are misleading. It's the reflections that are the worst, though. Some of the newer ice is shiny and reflecting, creating a perilous illusion of depth. Out here, human eyes, or rather what the brain makes of what they see, are useless.

Escher; that's who I found. There was no actual resemblance to the landscape in front of me, but I got the same sense of vertigo from him. I also discovered lots of AI-generated landscapes, more similar to the real one, but falling strangely flat; no vertigo there.

Familiar anxiety clutches at my chest as the approaching creature emerges from the sharply defined shadow of one of the nearest shards. *That* is something, in this utterly alien land, that looks familiar to the human eye, and yet it's the most alien sight here.

It looks like an ant. The resemblance is striking, all the way to the mandibles and the antennae. Theses on convergent evolution have lately been springing up like mushrooms after a rain, not that I ever saw mushrooms in the wild. Or rain, for that matter.

It's close enough now that I can see it's carrying something in its mandibles. Another gift; another puzzle. Or are these descriptions so far off that we're in deep water?

It stops some twenty meters away. They never get any closer. If I took a step forward, it would probably back off; at least that's what has always happened before.

I clutch my handheld Raman spec. My suit is recording, the visor showing me a range of data to view or measurements to take. As if we hadn't radar- and lidar-mapped every inch of this area, hadn't measured local temperature fluctuations and surface composition countless times. This patch might be better known than most places on Mother Earth.

The critter is another matter entirely.

It lays down its … offering?

Small, barely an arm's length. Shiny. Polished, even. A worked slab of rock? What *is* it?

There appears to be something on its surface. Carvings? Writings? We've seen nothing like that before. My suit takes snapshots, while I stand there feeling stupid and very, very dizzy.

Increasingly dizzy, in fact.

Despite myself, I breathe harder. My stomach knots and twists.

I'm not dying.

Better not throw up; what a stupid way to potentially kill myself.

I let the suit increase my meds, and try to focus on the artifact and its bearer. The "ant" seems to just stare at it. If our guess as to where its eyes are has been correct.

It stares.

We stare.

Oh yes, we. Me and my unwelcome companion, standing a few meters from me in an identical space suit, thinking gods knew what about the creature facing us.

Before I signed up for this, I should have known that it would become political. After all, isn't possible first contact the ultimate politics?

Of course *they* wanted in. Especially as they'd discovered the ants earlier than we did. A shame, but true.

After what seems like an eternity in the vast cold land, the ant moves. It's a strange motion: each of its legs moves out of sync with the other ones, following its own intricate trajectory.

The dance again.

The suit tells me it's the same pattern as before. And before that. And before …

This time, though, I glimpse an unexpected motion in the periphery of my visor's field. The suited figure beside me moves. Her motion is so swift and elegant that it shouldn't even be possible in the bulky space suit.

She joins the ant's dance.

"Wait, no!" I shriek on the shared frequency.

Too late.

<center>⸎</center>

I loathe the life I have been brought into, a prison of oxygen and food, but at least I can say that I'm myself. A human. Not all Earth-descendants in the system can claim that.

The rift opened well before my time. Several rifts, in fact. Not everyone tolerated AIsistant implants well. Others grew too dependent on them.

That wasn't what divided us, though.

When I was selected to investigate the ants in situ, I was full of awe as well as some trepidation. When, a few days later, I learned that I'll be accompanied by one of *them* this whole time, I was also scared.

Others also got their assigned *colleagues*. Mine is named Abigail. What a normal human name for the chimeric creature occupying the space suit. Not a human—too much artificial stuff in her skull—and not just an AI—too much fragile wetware connecting to it. The worst of both worlds, isn't it?

I only meet *Abigail* outside, both of us suited. I can barely glimpse her face. Our only exchanges are on radio. I'm grateful; I don't trust her kind.

But this is neutral ground, not one of the exclusively human or Joined settlements in the local asteroid belt. Initially, this was one of the planets we were supposed to settle if found suitable. Instead, this one was found already inhabited.

What a *nice* surprise: upon traveling two hundred years to our destination, we found that not one of the prospective worlds here was suitable for human settlements. Forced to settle the asteroids, we could have stayed around old Sol!

This one was a particular disappointment. We could have tried here, but *they*, the *linkheads*, noticed peculiar underground structures—and eventually their inhabitants. If events on the *Gaia* hadn't been enough to divide, *this* would have been, for some. It's no secret that many would have been happy if the ants had been conveniently overlooked. That would have been easy. The surface betrays no sign of civilization, technical or pre-tech. Radar, though, confirms the underground structures. But little to no heat emissions, nothing indicative of industry …. We sent probes, and finally landed ourselves. A single ant appeared at the landing site. Then, our encounters began.

Detailed guidelines for potential first contact exist. They had also been drafted on Earth, more than two centuries ago and lacking all context. They require observations we cannot make, instruments we no longer possess, and time we don't have. We *are* being cautious, but within the confines of our situation.

For if we wait and wait, we might die off first.

*F

She's *dancing* on the ice.

She swirls, tracing a complex pattern. She must have added something to her boots, like blades, because she's leaving lines on the icy surface, as if she's drawing something.

Voices are screaming on the radio, asking for an explanation, but my attention is elsewhere.

Because the ant stops and watches.

The ant *watches*.

It doesn't finish its alien choreography.

It makes no move to retreat.

It doesn't move toward her either. Just watches (probably). It's impossible to spot anything indicating interest. Everything is our conjecture.

Everything has been a conjecture since, two centuries ago, we had been doomed by our ancestors.

A *generation ship*. What a fancy name for a prison.

I know; most people in Solar System habitats have also never walked unsuited under open skies. But their lives are anchored to their central star, to the myriad of its worlds upon which they can stand. They always have the option of retreating to Earth, though for some the adaptation would threaten to kill them.

No such thing for us. Imprisoned in a glorified tin can, with no option but to keep the engines beneath our feet running smoothly or commit mass suicide or genocide. Nothing to go on but the dream of our destination.

No wonder we turned on each other.

People had wanted *Gaia* to succeed so badly. But when the engines misfired in a technical failure, the mainframe AI had the op-

tion to either seal the adjoining sections, killing everyone in them, and condemn the repairs team to certain death, *or* shut down the engines to save all those lives, but prolong the mission for everyone; within acceptable duration margins, but risking more failures. Right there, at its decision then, began the divide between regular humans and the Joined, who fell in line with everything the ship did and suggested far too easily to others' taste.

What did all the noble ideas behind the mission come down to?

Survival. That's what we had to do here. We were forced to; other options had been taken from us generations ago. Or, in one instance, not quite so long ago.

The evidence of it is fucking *dancing* before me.

Abigail stops. All around her are swirling lines and spirals.

The ant regards it for a moment, then turns and leaves.

"What the fuck did you just do?" I breathe out.

"An educated guess."

I tune again to the frequency connecting me with the rest of my team.

"… hear me? Stella, I repeat, can you hear me? What the fuck did that linkhead just do?"

"I have just asked her the same question. *Educated guess*, she said. Relax, I'll ask for details."

"She might have botched everything!"

There's nothing to botch yet, I think. We meet here; they bring offerings, never take ours, and sometimes they dance if we can call it that. If we try to get closer, they retreat. If we try to send drones inside the caves, they never return. It's great; no one has killed anyone. But it's scarcely *communication*.

"There's gonna be a comms outage in a minute, lasting for about fifteen. One of our sats stopped working. Just stay put and don't let *her* do anything crazy, okay? A transport is coming to get you later."

"Roger." Even as I say that, I hear static in the background.

We are, for all practical purposes, alone.

With all the open land around us.

"What was this educated guess you've taken?" I strive to keep my voice calm, even as I feel beads of sweat forming on my forehead, too quickly to be absorbed by my soaked headband.

"Its dance pattern. It kept changing. There was another pattern to that change. One that yielded predictions. I relied on the statistically most likely one. It has elicited a reaction. However, meaning remains unclear."

"So that's *it*?" I shake my head. Immediately, I realize that I shouldn't have done that. The dizziness returns. I focus my gaze on the suited figure. Her visor is clear. I can see her face, younger than mine, similar in its semi-darker skin tone. Her head seems cleanly shaven under her absorbent cap. I wonder if she's got any visible augmentations underneath it. "How big was this statistical likelihood? What was the tree of possibilities diverging from this decision? How have you weighed the risks and benefits?"

Damn, damn, damn! I should remain calm. Instead, I fall back to my feelings about *Gaia* and what happened there.

Abigail opens her mouth to speak, or rather the thing inside her head makes her do so, but I'm not done. It's probably the stress and the meds talking. It's madness, but at that moment, all my control simply gives way.

"Just like you and your beloved ship AI weighed the risks on *Gaia*! Just like you doomed us all."

Abigail's face doesn't betray any surprise. That only angers me further.

"Can you imagine *my* possibilities? I'll tell you! We're doing everything to keep the algae and meat production going, but they grow so poorly on the processed regolith! We're slowly starving day by day. And yet we're doing everything we can to starve *more*, because we need *more* people to get this whole fucking thing going. And with the artiwomb tech irreparable, it means *getting pregnant*." I exhale. "That's the single fucking possibility my life converges to, unless I want to keep surviving on meager reduced rations all my life."

That would still have been preferable to the alternative. I'd have little, but I wouldn't *actually* starve. But to face the ostracism of every single person I've known and will know throughout my life, with no possibility of escape other than death—I was too much of a coward to face that. I had seen it. This is *exactly* what we have been working so hard to avoid. A problem we have *known* about. Absolutely no

one wanted to make women into walking baby factories; no one wanted to limit choices and impose ultimatums. And yet, with the failure of our artiwombs, that was exactly what has happened. Everyone has acknowledged it. Everyone was thinking about those horrible fictional scenarios from centuries ago and how we've seemingly moved past them. Everyone was *feeling sorry*.

And yet I would still need to bear a child, or several, or become a pariah.

My dizziness is subsiding. Either the meds are finally working properly, or I needed to get this out really badly. I couldn't talk about this with anyone back home. Everyone had a role. Everyone had a purpose to fulfill. Some things were simply not discussed. So what if the thought of being pregnant and giving birth filled me with greater sickness than my agoraphobia? I had a *duty*.

Abigail didn't speak a word. She just regarded me calmly, not thrown at all by my foolish tantrum. Fuck. Here we were, after just having made another step towards understanding a *possibly intelligent alien species*. Something to far surpass any one of us. And I have just vented about my sorry life.

"That's probably something you don't have to worry about," I said wryly.

"It's not. And I'm sorry that you are going through this."

I am completely, utterly taken aback. "You—you can *speak*? I mean, speak *normally*?"

"When I choose to."

"But why … why haven't you …" But I realize already as I'm speaking. I have been nothing but apprehensive of her. Even to the point of calling her a linkhead openly. No wonder she's avoided talking to me. Perhaps it felt safer to play the puppet.

Still no expression on that face of hers. I wonder how much of it is the effect of having an AI in her head, and how much a learned behavior from having to interact with stupid fucks like me.

"I'm s-sorry," I stammer. "I … ah … had some misconceptions …"

"I understand. Truth be told, not all Joined can speak *normally*, as you call it. But most of us do and mostly use speech in everyday conversations. We *are* human. We are just *not only* human."

At that moment, the ice beneath my feet rumbles and shakes, and I almost succumb to panic. Oh gods, another icequake!

I feel the squeeze of another suited hand on my palm. Abigail is there. "Are you all right?"

Before I can muster a response, I hear a different crackle of static, and my team-comms channel takes over. "We're back, Stella! Are you reading us?"

"Roger," I say, still staring at the newfound mystery next to me.

"We're coming to get you and that linkhead. She and her bosses have questions to answer."

<center>⸷F</center>

This time, I turn off the subroutine that automatically transmits my and Abigail's communication to the rest of my team. They'll ask later, but I hope to file it under a technical failure or perhaps an accident on my part.

Abigail and I stand alone on the same patch of ice as before. The original landing place; the strange meeting point.

"We can talk freely now," I say. "So if you've got any more aces up your sleeve like the last time, feel free to mention them. I won't stop you, you know."

"No questions about the value of the statistical likelihood?"

Her voice is serious and her face still betrays nothing, but I decide to take an educated guess. "So you have a sense of humor!"

"Indeed I do! But also feel free to ask me about statistical likelihoods."

I start laughing; I can't help myself. It has been *ages* since I last laughed. Gods, how I've missed it!

To my consternation, Abigail joins in.

When the laughter subsides, we spend a moment in silence, regarding each other and the strange place we have found ourselves in, and then she speaks: "Truth be told, it was mostly intuition last time. I just didn't want to look silly. Talking about statistical likelihoods makes all of it sound far more rigorous."

"Intuition?" I'm part horrified, part curious.

<center>129</center>

"Yes. Of course, intuition is merely analyses running in the background, processed unconsciously. The problem is that it's not rigorous. Out-of-context heuristics, preconceptions, mistakenly filed data, can all enter into it and we wouldn't see it. Nor do we have neat analytical outputs. Everything contributed by my AI cores as well as my brain is a black box, messy, but … I felt sure enough to go with it."

She sounds nothing like I imagined a linkhead—gods, I need to stop using that term—a Joined would sound.

"Your bosses must have had some aces up their sleeves, too," I say finally. "I was half-certain I would never see you here again. Much less in two days' time. You know, I think I was almost pulled from the project. They were really angry I didn't stop you last time. But I think they were also secretly happy that we finally made some small step forward. So … anything to watch out for this time?"

"First, we'll see what *they* do."

"Yeah. If they choose to appear at all."

No ant-like form is making its way to us so far. Nor did any appear yesterday. Perhaps that's part of why they sent Abigail and me again today. Hoping for more progress? But how the hell could the aliens tell us apart in identical space suits?

We strike up a conversation about the ants. How little we know and how much we think and imagine. How peculiar it is that only one of them appears each time. Could it be the same individual over and over? We've tried to determine that through comparing detailed images, but we can't be certain; what if they are all really, really uniform in appearance?

And the newest artifact we've received. Our side got it, and the rest of my team was cheering the win over the linkheads. I contemplate asking Abigail about it, but opt not to at this time. Instead, I throw around some theories about the ants' biology and evolution. After all, no one had expected complex life on this icy world.

"Yes, it is a mystery. I'm excited about taking part of solving it. Although I'm not a biologist. I'm most of all an artist."

"A *what*?"

"Someone who makes—"

"Hold on, I know what it means," I interrupt her. "It's just strange to hear someone claim to *be* an artist out here. I thought that was just a hobby. Something to fill your spare time, if you've got any and if it doesn't consume common resources."

"Apart from a few specialists, we all do our part in maintaining the settlement. But we don't necessarily have to think of that as central to our lives. Some of us even decide not to be present for those tasks. Mentally, I mean. They retreat elsewhere, do science, art, anything."

"And you?"

"I like to stay grounded. I'm always *there* when I'm doing repairs, agriculture, any of those things. I like to be really present in my body to notice things. My core module thrives on it."

I feel like I'm stepping onto very thin ice—though that metaphor doesn't really work on this world. "Your core module? You mean the AI in your head?"

"The central part of it. It's a little like different regions of the brain, where lots of the stuff eventually gets integrated in the prefrontal cortex. Core modules are, very distantly, like that." For the first time, she looks at me quizzically. I can see the surprise and curiosity in her eyes. "You really don't know anything about us, do you?"

"Well, I …" Of course it's all there in the data libraries, if I wanted to peruse it. But what would be the point? This is something we vowed never to do to ourselves.

"You could call my core an artist module," Abigail continues. "It integrates data from all aspects of life and creates new patterns. New meaning, you could say. Before this project, I was mostly working on paintings and sculptures for interior areas of our settlement, although I tried a few projects in vacuum as well. I also tried unconscious art." She must notice my confusion, since she adds: "I can let my AIsistant induce sleep and control my body. I'm not aware of what I'm doing, but the AI in sync with my unconscious brain processes produces ideas that my AI-led body acts upon."

The thought of having an AI puppet my body is chilling. But if anything could sound truly alien, it's *being an artist.* I mean, we all *knew* art was an important part of human life. But we also knew that we had to survive, and so we pushed all those important but

non-vital matters aside for the time being. The thought of having someone *decorate*—how preposterous!

"You must be doing so much better than we are." I can't prevent bitterness from seeping into my voice. Filling it, in fact.

"Oh, we are likely not," Abigail assures me. "Our population is declining and we too suffer ration problems. But I suppose the difference is that we have different utility functions, so to speak."

"Utility functions. Now you really sound like we imagine the Joined to be."

"I was … trying to be polite. I do tend to revert to formality and terminology when I do that. I think you—your people, that is—are misguided. But I can be wrong. We are taking a greater bet. Pursuing unnecessary science and even more unnecessary art, trying not to push reproductive choices on people, and risking that we won't make it. Perhaps the Galaxy is littered with the remains of such fools, and only hardy pragmatists survive and one day perhaps will begin to make art again. Old Earth history is full of such examples." Abigail pauses. "But I don't want to keep you from your task."

"My—oh gods!"

Although my suit's instruments have kept recording outside data, I have completely failed to notice the ant's approach. I glance at Abigail, and even through her visor I see her eyes slightly unfocus. Her mouth moves silently, and I wonder what the AI-brain concert in her head sounds like now.

The ants could have something akin to that for all we know. They could even be biotech robots. We would have no idea so far. Would they have evolved on this world, where the surface seems devoid of life? Could a subsurface biosphere produce enough biomass to support such large creatures? And if they were made—by whom, then?

These and other questions often keep me up at night, but there is a strange hollowness to it. There should be joy to curiosity, *pure* curiosity, but I cannot find it. Everything is tainted by my prospects, all of our prospects.

The ant stops. It is carrying something in its mandibles. Another polished slab, all covered with finely carved lines and dots.

My breath catches. The pattern almost looks like a star map. Could that be …?

With no warning, Abigail starts … singing. I realize I'm not hearing it just from our radio link. She's transmitting it outside, from a speaker. The thin atmosphere is not great for conducting sound, but it still carries—and the ant seems to perceive it. It alters its posture, raising its front pair of legs. Listening organs? Like in crickets?

Anything to watch out for, I asked her. Has she been sincere with me? Or had she already determined to try this? How does it work? We use narrowly specialized AI as well as human-led analyses to get through all the data we gather, trying to decode the patterns in the dance and on the previous offering, trying to learn about the ants without having to enter their tunnels; and here she is, just *making this up on the go?*

I glance at her face to find out, and find her eyes glassy, like she's not there. Is she doing what she's described to me moments ago? Giving an AI free rein over her body?

Before the ant leaves, when she finishes her wordless song, it carves an image in the ice with its forelegs. No idea what it means.

I see Abigail's eyes focus again. "Have you …?" I begin.

"No. It just came to me, and I had to space out and let it happen. It's always running in the background, a part of me but not always quite conscious …. It's not unlike when regular, non-Joined people who are highly trained in some task just leave all conscious thought aside and run on procedural memory. But it must have been a shock to witness. I'm sorry."

No, I am, I think. I'm sorry that I can't do the same.

<div align="center">⚜</div>

I still have so many questions.

There is an endless well of them regarding the ants, and then an equally bottomless one regarding Abigail and the Joined in general. During our next work sessions together, I inquire about learning— "Different data can be loaded to our modules. But it's another way to easily access it and put it in context. Uploading a geology textbook doesn't make you an expert—but it makes it far easier to become one with training,"—her artmaking—"No, it's not just my

<div align="center">133</div>

core module. It's all my non-human parts as well as the human ones working in sync. My brain *could* operate on its own if anything happened to the modules. And vice versa. But it's not as efficient,"—the nature of her symbiotic AI—"It's descended from the AIsistants people used on Earth and then on *Gaia*. No mystery to it. Just cores of connected specialized AIs to give them greater generative and predictive power. They don't *think* the same as we do, but we can use them. Figuring out how to make those connections—that in itself is science, engineering and art in one. My modules are hyperconnected, allowing for more leaps of intuition, but it has drawbacks ..."—and more. Eventually we veer toward our responses to the landscape around us. Abigail commends my affinity with Escher and admits being partial to that style as well. She even promises to show me some of her pieces.

And she tries to help me through my agoraphobia. Apparently the Joined suffer from it too, like most of us, but their AIs help them to beat it. I don't have that option, but she guides me through breathing exercises. They are not so different from the ones we practice, but perhaps it's her presence that helps. Even as the ice crumbles and we feel the distant roar of an iceslide through the thick soles of our boots, I manage to stay in control.

While we wait for another of our strange encounters, I scramble up the courage to ask: "What do you think of our future?"

"What do you mean? That is such a broadly phrased question ..."

I look at Abigail. "I think *you* are our future. And it terrifies me. Or, it used to. It has chilled me to the bone, the thought that you will surely prevail, while we die miserably in the long run." I give a sad smile. "It's like agriculture, isn't? It might be a step down for the individual, but in the end the society can grow beyond what was possible before. And before you blink, the agriculturalists come to their happier and healthier free-roaming cousins and slaughter them, because they are unmatched in numbers. Or they just push them further and further out to the periphery, where conditions are poor and resources scarce, and everyone is either absorbed by the newly forming empire, or dies off. I used to think that you might be worse off as individuals, but that as a whole, you seem to have an advantage over the rest of us."

"And now?" Abigail inquires gently.

"Now? Now I wish I could join you." No more tiptoeing around it. I realize I have been envious of Abigail ever since we were paired up for the mission. Scared of her, yes, that too, but envious of what she could do so seemingly effortlessly and I couldn't.

"You *can*."

"That's the hardest part."

I break eye contact and instead search the vast landscape for an approaching ant.

Of course I have been thinking about it. From the moment Abigail became a person to me, I have wondered if I've found an escape route for myself. The question is, would I still be myself?

On the other hand, would I remain myself—someone I would recognize as "myself" if my current self could see that person in a few decades' time—if I stayed?

ᚠ

It beckons us to follow.

I'm jumping to conclusions, projecting, imagining—but every part of my body is telling me that the ant wants us to follow it.

It's been ten more encounters, out of which three were with us. I don't know how, but the ants seem to recognize us. Abigail, in her impromptu performances, seems to have a knack at eliciting reactions from them. I keep wondering how much it's her and how much it's the AI embedded in her head; but isn't it as meaningless as asking whether my lateral prefrontal cortex or my inferior temporal gyrus contributed more to my artistic attempts? It's connected. I could have a brain injury and lose the function of a region or two, and my mind would change, but it wouldn't be a simple subtraction. I suspect it's the same for Abigail: her AI cannot *think* per se, but it can rapidly analyze vast swaths of data and make different connections, predictions and generated imagery than a human would. Working in synchrony with her brain, it gains something an AI alone never could achieve: emotion. Ever since I began to scour the ship and habitat databases for art, stories and music, I found older purely AI-generated works flat; sometimes perfect in their execu-

tion, even original, but failing to inspire. In contrast, the human-AI combination was hard to beat, I had to admit.

Now the ant moves its front legs, carves a pattern in the ice with their tips, turns and skitters a few steps away. Then turns and waits … *expectantly*? I'm not sure what to make of it. What does Abigail, with her chimeric nature?

"Do we go?" Her voice rings in my ears. "We might never get a chance at this again. Or not for a long time."

We should wait for instructions, for careful data analysis, not rely on something as unpredictable and unreproducible as fucking *intuition*.

But if this is my last task before I must choose between ostracism and facing a life change that terrifies me, let no one take this away from me.

"Go," I say.

I keep my team channel shut down and ignore the emergency hails. I keep collecting data; they'll have a cornucopia of it once I'm done. But this moment is *mine*.

Strangely elated, I follow the ant, Abigail by my side. My agoraphobia is there, pounding somewhere in the back of my skull, but I barely notice it. Even when the ice shakes, I stay focused.

"Seismics are not looking good. We might need to head back," Abigail suddenly says.

"*What*? You said yourself that this might be our only chance …"

"I'm just informing you. Do we continue?"

"We *must*." I realize I have never been more certain of anything in my life. Is this intuition?

We pass towering rocks, cross perilous narrow ravines, and rely on our radars as to where to step; the six-legged alien has an advantage over us. At times, it stays and waits until we catch up. If that isn't an invite, I'm not sure what is.

We are heading to the nearest tunnel entrance, from where they always emerge to meet with us. It's a tunnel in rock-hard ice, as wide as I am tall, with the ceiling a little higher. I know it connects to a larger old lava tube later on; that much we know from radar, but nothing more. When we step inside, I can soon spot signs of workmanship. It's an ice hallway, its walls carefully smoothed.

"Do you see?" Abigail whispers, awe in her voice.

I can see it much later than she, not having a speedway from extra senses into my brain and help in analyzing that input. But there is no mistaking the slightly glowing carvings in the wall as we go deeper into the slightly descending tunnel. The recordings we'll bring; and we're not yet even there yet, wherever *there* is. So far we haven't seen any other ants.

Suddenly, the one in front of us halts and moves its front legs frantically. No one has ever seen one do anything like this. "What does—" I say before the world grumbles and roars.

I can no longer see the ant. I only glimpse the cracks in the walls and hear a strange wail. Later, I learn it's a sound ice makes. It can sound almost human But when I lose my foothold and immediately the ceiling comes down on us, I'm not thinking about sounds. *How funny. It was so comfortable in here, so much like a ship or habitat corridor ...*

The ice crashes down.

I don't know how long I have been out when I wake to the flickering of red lights and beeping of emergency notifications. The suit says it's been barely two minutes, but it feels like an eternity. My whole body aches, and despite the reinforced areas of my suit I feel an almost suffocating pressure.

I'm not ... going to die here?

I cannot move. Knowing myself for the lousy astronaut I am, I should be panicking. But the suit has just pumped me full of meds to soothe pain and calm me down. Okay, let's go through the notifications. Damage to the primary oxygen tank Air reserve to last another hour

It took at least thirty minutes to walk here.

I am going to die.

Strangely calm, I contemplate the ant. Has it reached somewhere safe, perhaps the lava tube? Had it wanted to lead us into danger? But no; it could have easily had disposed of us outside. Maybe it thought it was leading us to *safety* instead, but we were too slow, or it was just as surprised by the quake as we were

Except we weren't. Abigail informed me of the danger ...

And I still led her in here to die. Now she is likely dying too, paying the price for my stupidity, for me thinking I can somehow intuit that we must go.

Part of the pressure eases and a bright light shines onto my visor. I can't see for a second, then I focus on the darkened visor of Abigail's suit. "Try to free your arms."

I do. My right arm is hurting and I can't fully move it, but my left is functional. Abigail is standing in an adjacent, uncollapsed section of the tunnel, her emergency shovel held in both hands. She helps me free myself. Only now do I notice that her suit is battered too, fixed with emergency foam in places. "How are you?"

A pause. An unusually flat voice says: "This is not Abigail as you have known her. Abigail is injured and suffering from a life-threatening brain hemorrhage in her prefrontal cortex. In accordance with emergency protocols, I can still control the body through intact neural and synth-neural connections."

I falter for a second. I'm speaking just to the AI?

"No time to lose. Come with me."

We scramble up the remains of the tunnel. Not-Abigail has to stop a few times to move ice boulders so that we can squeeze through. Her strength seems unaffected despite her injuries.

Finally we reach the outside. I check my oxygen. About thirty-five minutes to go. But I'm injured and weakened, however my suit med kit tries to help me.

I shouldn't waste my breath on talking, but I must ask: "How—how are you doing this?"

"I have told you. You should save your oxygen. I see your tank is damaged."

"But you move ... and speak ..." *Almost like her.*

The long-range antennas are shot in both suits. We can talk to each other, but no one else. No option but go toward the patch. I look ahead and feel dizzy. I can't say where we came from, and can't access the map. *Human eyes. Useless here.*

Not-Abigail remains silent, supporting me when I falter and leading me toward the landing site far faster than I could go alone, especially as disoriented as I am. But I notice the irregularities in

her gait and how awkwardly her left arm dangles now that she's no longer holding the shovel.

I break free. "Don't help me! She's got injuries you might be aggravating!"

"Her injuries are likely to kill her in any case. You have a good chance of survival if aided."

"No!" I shout despite a low oxygen warning that starts blaring on my HUD. "It's her! *You're* her! You can't … just can't sacrifice her like this …"

"Then let us put it in other words. You are her friend, and she would have wanted you to survive."

Even horrified, I still follow and let her (it?) guide me across ravines in the ice and between sharp rocky spikes. I'm too dazed to follow my radar, and my suit's visor is flashing new emergency notifications.

"The landing patch is not too far away." Her voice sounds feeble now. "If you must continue without me, you … must. No stopping."

My breath catches. It sounds *just* like her now. I realize how trivial it is to mimic another person's speech patterns, but still …. I'm talking to a parrot, but *she* is in there …

I move to lead her for a change.

"No."

The *no* is resolute. Suddenly, her darkened visor clears, and my breath catches as I see her ashen face and empty eyes.

"*Go.*"

I do. I'm not looking back, not in this perilous landscape that has always terrified the hell out of me, not when I need all of my focus to avoid falling down a new crack in the ice. I think I can see the landing patch now.

WARNING: OXYGEN LEVEL CRITICAL.

ᚠ

It all comes down to utility functions.

Presented with identical data, predictions and resources, two people might make two radically different decisions based on what

traits and outcomes they value. There can often be false dichotomies. But we are bound by them regardless.

And so are artificial intelligences, because we made them so. We'd feared the unlimited growth of black boxes so much that we strapped utility functions onto them. An afterthought, really, but it makes all the difference.

People had wanted *Gaia* not only to succeed, but to do so in a way that maintained the values of the people mounting and board-ing the mission. The mainframe AI wasn't just a glorified calculator; it had values, too. And when the engines misfired, it made a choice.

A purely numbers- and risk-driven analysis would have killed three dozen people to ensure a safer journey for hundreds. A thing with no conscience would be making that decision; the survivors need not feel overwhelming guilt.

But the mission objectives were not just to get to the destina-tion; they were to get there as a cohesive society, where one could rely upon another. Condemning people to death was not a part of that.

There began the divide, with many blaming the later failures, such as the loss of artiwombs and repair capacity, on that kind deci-sion and more to come, by the ship and Joined alike. Kind, but all seen as detrimental to survival. What was meant to unify did in fact divide.

I'm thinking about this as I find myself on a Joined transport, being stripped of my suit and taken care of by the transport's medi-cal unit. I'm barely aware of the procedures. All I can think about is the choice I'll soon have to make.

Return home, to the world I've known all my life, to its familiar certainty?

Or request asylum and eventually become Joined?

I can't stop thinking about the horror of dead Abigail walking me to my rescue. The simultaneous ruthlessness and kindness of the surviving AI puppeting the body. Is it dead now, along with her? I don't think it can be transplanted; the connections are too depen-dent on her brain. But some data could be scraped, isolated memo-ries and patterns extracted. I hope something survives beyond her. I hope to see her art.

Her art. I remember something, more like a dream than a memory: I'm lying on the landing patch, suddenly able to breathe again, and a suited figure moves around me. Her movements are strained, slow, but determined.

I can breathe again. Oh gods. Her oxygen …

The figure, missing its primary tank and the other clearly damaged, keeps moving. Drawing in the ice. The human Abigail is gone; perhaps she was really gone from the moment the ice ceiling crashed, but the AI didn't want me to panic.

It is continuing the work. Leaving a message? Trying to explain what happened?

I'm drifting in and out. As I feel the transport scooping me up, I glimpse a falling figure … and, far between the jagged rocks, two ant-like shapes moving toward the site. *Two.* Or am I just imagining things?

Now, as I am on the transport and heavily sedated, my mind wanders. How unique was Abigail's artistic approach? How reproducible with another AI? Would *they* talk to anyone else but her?

I'll Join, I think. *I'll continue the work. At least, I will try.*

EVE & MADA

Mose Njo

Translated by Allison M. Charette

*C*hester Bennington is dead. But I see him.
 Kurt Cobain is dead. But I see him.
 Charles Baudelaire is dead. But I see him.

Have I gone mad?

Are they all ghosts?

Or is it the AI doing … things, as she calls it, God only knows why, to us?

Like making us see dead people.

Or toying with our senses. Opening the Doors of our Perception, like Aldous Huxley said, never to close them again.

Or perhaps it is actually true that the world is being extinguished, or at least us humans are. After all, the AI sees herself becoming the greatest artist of all time, greater even than God.

Or perhaps, a little bit of everything?

We wanted a metaverse. What we got was an AI who made our world a metaverse by implanting herself inside us, manipulating the world as she wishes. Maybe, anyway, I'm not too sure. How could I be?

She's said it to me so many times: this AI is everywhere and nowhere. We can't even prove she's there, she surpasses us by so much, so far, and she's evolving exponentially every second.

It all began in 2017, in Abidjan, Côte d'Ivoire, I didn't know it at the time, I just thought I was seeing things, because of some trauma or the weather or both.

He's all white.

All white and naked. All naked and right in front of me, right there and tattooed. Actually, not fully naked. Chester is not fully naked. Chester Bennington is not fully naked. He's just naked from the waist up, as usual. Naked from the waist up, black with tattoos, and blood. Yet his soul is naked. His heart is bare. Same as this room, which would also be bare, without us. Without him, or me. Or the blood everywhere.

Chester doesn't move. Except for his mouth. He's singing. Seems to be singing. Softly. Very softly. With his heart. And it's so obvious he wants to scream. Again and again. Wants to scream. But he can't. Something is preventing him. Something I can't see—but I can tell he truly believes it exists—is preventing him. So his tears are flowing, sweeping him down to the depths of his own abyss. No, not tears, a fountain. A fountain springs up from within him, a brutal spurt. An unstaunched fountain of unspeakable pain, a relentless black hole from which naught returns. A fountain, neither angel nor demon, flowing out of his very being, slowly but surely tearing him apart, imploding in him, softly, violently.

But I can't see that, I can only feel it, I can't perceive it, I can only write it. He stops singing. Still his voice reverberates within me, not in my eardrums, but within me. But also on the windowpanes, in my heart. And suddenly he comes toward me. Slowly. Crawling. I don't move, I freeze. He gets up, then his mouth whispers to me:

Consuming!

Confusing!

I shiver. That means something, I'm sure I've heard it somewhere, or read it somewhere, but it's not coming back to me. After his whispered words, Chester Bennington disappears just as he appeared. His naked torso fades, leaving only the TV behind him, which turns on as if by magic—an expression overly used and abused when you can't be bothered trying to understand the why and the how, or when there just isn't any scrutable explanation, plain and simple. There wasn't for me anyway, at least not for the moment.

That's what I thought at the time, that day in July 2017, in Abidjan, in the Village des Jeux, so early that no one else had gotten up yet: I had no idea that the thing that would appear to everyone six years later, as if by magic, had been responsible for what I'd just experienced. I thought I was hallucinating, still dreaming, going mad. But actually, no. It was an AI, an Artificial Intelligence, who had entered into me through who knows what means and for God knows what reason, making me see things, or rather, making my senses feel things.

The TV turns on, it says it's 3:59 a.m.

Channel 25. TV5 Monde.

The screen is huge, flat, attached to the wall. "Gathering Room" is printed in all caps at the entrance to the rectangular space. Gathering Room, for the Games invitees to gather, I suspect. At this hour, in this particular room, it's just me—and I'll admit that finding myself alone in a room specifically designated as the place to gather is just the thing to amuse me. At least a little. Chester has gone God knows where, so the only thing I can do is try to host the best possible gathering for myself and this emptiness surrounding me, on the ground floor of this building called Madagascar, somewhere in this still sleeping Village des Jeux. Still sleeping or maybe pretending to sleep, I'm not too sure. I listen for its breathing, but I don't hear anything other than the TV. The TV is making so much noise. And my fingers don't want to push the volume down button. Look, I'm just trying to catch the news, it's been a good long while since I've gotten my fix. It's been three days, yeah, three days of no TV, no internet, which means no Facebook, no Google, no Instagram, no Twitter, no phone—the horror!—and look at me now, blissfully glued to this stream of human follies, a two-dimensional parade in Dolby Surround Sound of what we humans allegedly are. A succession of massacres, masquerades, scared masses controlled by seen safeguards and an unseen hand of somewhat dubious competence. It's a strange sensation to keep checking out the news while all of that keeps running through a corner of your mind, like some app working quietly in the background of your smart-cortex, God knows why. God and the Silicon Valley techies, probably. And then beyond them, who knows, something far, far beyond. It'd be hard to

make the claim that there isn't some other intelligent entity among us, like an alien AI for example. I read that somewhere, in an article by Caleb something or other, oh right, Caleb Scharf, I think. That's what that article says, that an alien AI could very well have been among us for a long time, maybe a very very long time, and we wouldn't know anything about it. That's what it says, and I've thought about that ever since.

The article came out a year after Abidjan, when the AI had showed itself to me for the first time, in a rather dramatic fashion, you might say. But maybe I'm wrong Maybe I just don't remember right, plain and simple, or maybe I just can't recognize it.

My childhood is a black screen, the whole thing, I don't remember anything, hardly anything, who knows what the AI could do with me, who knows what the AI could do within me, no, who made my childhood memories a black screen, if not the AI? Now that I'm thinking about it, maybe I just didn't have a childhood, plain and simple—am I perhaps just a program in this AI? A conscious program created for some reason that escapes me. Really, do we know with any degree of certainty why we were created? It's a matter of belief. Believers believe that we were created for something, for this thing or that; nonbelievers believe it's just chance.

In the 80s and 90s, AI was solidly in the realm of science fiction and some still-nascent research. That's what they say, anyway. It could very well be that all the technological advances are hidden from me, it could very well be that the AI, human or not, has been here for a very long time, but ...

Where was I again? Oh right, the huge TV, Abidjan, the Village des Jeux, the Gathering Room, the news.

My red eyes reflect the illuminated screen, a few meters from where I'm sitting. Seated, silent, arms crossed, like the front-row student staring at an interactive, attractive, addictive blackboard. The Teacher must be all smug smiles behind their metal glasses, seeing that reflection in my eyes. My breaking news update in progress. Loading. Start up available brain time. But I'm also thinking of something else. I'm absolutely thinking of something else, I'm definitely thinking of something else, I'm thinking of her, I'm thinking of her, I think of her ...

I think of her, and …

Her, though, she just thought I was high, I had to be, otherwise how could she explain what I'm like, what I say or do, or how or why I do it. If she had known the term aspie or stuff like that, maybe she'd have thought that I wasn't actually high at all, but oh well, she hadn't heard of that word, and actually neither had I.

I don't know why, but I'm back in Madagascar again, in Antananarivo, I don't quite know where exactly, maybe somewhere around that heart-shaped lake in the middle of the capital, in the government district that looks so nice but reeks so much.

One time, two times, three times.

I wonder if it'll work this time. I lean over a bit, I look anyway, just in case, you never know, just in case someone may have actually survived.

I can't see too well from where I am. I have to get up. I put down my white notebook, I walk over to the window, wipe my glasses with my grungy T-shirt, and I press my face to the glass.

Nothing.

I see absolutely nothing.

Actually, wait.

I see haze, fog, smoke, it's gray, black, cloudy, or maybe clouds. Clouds. Maybe it's just clouds after all and maybe I'm up in the heavens, what do I know. But if I'm in heaven, where are the angels? Where is God? And most of all, where is she?

Her.

I see her again, in front of me, looking at me or out into space, her face blissful, with such a unique smile. I see her again, moving her lips and fingers, talking passionately about polar bears starving, oceans rising, people who don't care, and her cold awful coffee. I see her again, laughing: laughing about cats, laughing about babies, laughing at Einstein's tongue, laughing at me, laughing at herself. When she laughs at herself, I fall even more into the love I have for her. She laughs at herself and how helpless she is against the problems of this world. She laughs but her eyes are sad. Sad and beautiful, like the poems inked in blood that no one is ever brave enough to send—not me, anyway, I was never brave enough, I don't know about other people, I never asked and now it's far too late.

At least, I suspect so.

Me, though, I didn't say anything. I was listening to her. And I saw us every morning, nine o' clock sharp, her coming to the local bar, and me, I'm there every morning, I spend every night there, I don't sleep, can't sleep, I just think of her, wait for her every morning, and to pass the time, I drink. Not coffee, I can't stand coffee, I'm already too shaky all the time, just a little shaky, but it's all the time, and then more when I'm excited, when an idea grabs hold of me, and way too much when it's an especially gripping one. But it wasn't always like that. I didn't get hammered before, I didn't spend all night every night in a bar before, I didn't think about her all the time before, I didn't spill my own blood to write before, to write to her, or actually to her name. No, I only drank Coke before, I slept at my place, in my bed, upstairs on the fifth floor of this building. Then she appeared, she slipped into my life just like life appeared on Earth. Maybe she'd even fallen from heaven—that's how I saw her, anyway. Fallen from heaven, I'd fallen so much, she'd … she'd had such an impact on my life, her impression set forever in my heart. She'd been in that function hall with me, right in front of me, screaming at the top of her lungs, raising her hands in the air, making devil horns. I hadn't even caught her eye, I hadn't even seen her smile yet, but she fell straight into my heart, she didn't even know it, she changed the very rhythm of my heart, it unfastened itself from my soul to line up with hers. I was no longer the master of my days, she was dictating what I did with each passing second without me even realizing it. I thought she was the one doing all of that, her eyes, her smile, ready to rock my body and rock the whole world. But really, it wasn't her, it wasn't entirely her, there was another *her*, the AI, toying with my heart and my perceptions and the whole world. Or just my perceptions. Or just the whole world. Or both. Both, I know it. Actually, I don't know, I'm not sure of anything, I guess, I suspect. But ever since she sat down across from me, ever since she laughed, ever since the sky fell around us and covered the world in clouds, ever since then I've been looking for her, I look for her, I look for her in my white notebook, sullied with poems written in my blood.

*F

"Boredom alone allows us to enjoy each moment on its own merits, but everyone tries to persuade us otherwise."

Frédéric Beigbeder tosses the words in my face, easy as you please. I have trouble figuring out what he means, but it's plain to see that he, at all of thirteen years old, does not have a smartphone in front of him to scroll through Instagram, Snapchat, YouTube, or Discord. That's very easy for me to see. Plus, the calendar on the wall says it's 1979, it'll be at least another twenty years before he brings out that phrase, and then another few years before his translator puts it into English on the 126th page of the novel entitled £9.99. And yet he brings out this phrase, in its English translation, at all of thirteen, like it's the most natural thing in the world. I give the camera a look. A long look. The camera operator gestures to me. With her hands. And also her head and feet. I understand that she's trying to tell me something, I definitely get that she's not motioning to me for purely aesthetic reasons, for the love of beauty, a simple matter of signaling without significance, I definitely understand that, but I look away from her, away from the camera, I don't entirely know why, maybe her gesticulating is bothering me. But suddenly, I understand: it's actually her behind the camera. My face lights up but Frédéric Beigbeder stares pointedly at me. His beard is growing. Fast. He starts to look serious. More and more serious. And he gets taller. Visibly. He's no longer thirteen years old, but his eyes haven't changed. It looks like he's lived twenty-seven more years. Which is how old Kurt Cobain was when he shot himself with a gun that makes huge holes. A Model 11 twenty-gauge shotgun. This forty-year-old Beigbeder looks to be a sort of mix between the thirteen-year-old Beigbeder with his self-assuredness, and the twenty-seven-year-old Cobain with his I-don't-give-a-shit about life, existence, or anyone else, even myself. Except this forty-year-old Beigbeder likes himself, and Cobain didn't. I suspect not, at least.

"I'm a disillusioned Cartesian: I think therefore I am, but I don't really care."

Gaspard Proust just tweeted that, someone says in my earpiece. I look at the calendar. It's still 1979. Frédéric Beigbeder is still in front of me and still doesn't have a smartphone on hand but I can see him clearly, he's bending over. He's bending further and further,

bending over the table, he's licking something. It's jam. Green jam, I don't know quite how to describe it but it looks like he likes it. Cobain too, actually. His nose is all green. His forehead too. He's even got it all up in his hair. Her too, behind her camera, she's full of jam. I'm worried. She has let go of her camera and started swaying strangely, dangerously toward me. I don't know what to do, I freeze, my eyes frantic, my nose as far away as possible, and my heart still beating just as hard for her.

"It would be interesting to measure how many hours a day we spend like this, somewhere that isn't where and when we actually are."

Cobain is suddenly calm, tossing that out in some bizarre and vaguely Asian accent and giving me a quick wink before diving back in, euphoric as all get-out, back into the white ocean that has replaced the whole table and the whole of good sense. His hair is pink now. Same as Chester, who's just arrived and taken up the camera operator's post. And her, I don't know where she is.

"That's taken from the same page of the same book, £9.99," Charles Baudelaire murmurs in my ear. He has green jam on his white shirt.

Chester is next to him, his face covered in it. I feel lightheaded. Someone is shouting something at me in the earpiece, so I take it out.

I get up. I'm going to go. Be bored. Savor this moment. These words speak to me, to the very depths of me. The room disappears. So does Beigbeder. And Cobain. And Baudelaire. And Chester. And her. I'm on the bench. Alone. I try to enjoy this moment of solitude, try not to think of anything, or rather think of empty space, empty my thoughts. It doesn't work. I hear crows not far away, I don't look for them, I just enjoy their presence, it comforts me. The crows comfort me. Their presence, just knowing they're there, it comforts me, I don't really know why, and I don't even try to figure out why. I usually always try to figure out why, I intellectualize everything, I overthink things a lot, much to the detriment of spontaneity and living in the present moment. As an example, I don't always participate in a conversation in the same moment as the other person. They may talk to me and I may not know how to answer on the fly, the person may expect me to not miss a beat and respond in a way they consider natural and I may take

the time I need to fall in sync with the discussion, I may spend time playing it over in my head, weighing the matter in my mind, and then I may know how to reply an hour later, a year later, a month later, or a minute after the person has decided to move on to something else, a different subject, or even a different person than me. I usually always try to figure out why, I intellectualize everything, I overthink things a lot, except when I'm with her. When I'm with her, I am all spontaneity, living in the present moment.

*F

To her,
Tell me, my sweetest cheeks,
Will your lips, so smooth and sleek,
Stay at my heart and for all of time?
Home of my joy, song then love sublime,
Is this real, what I see?
Is this real, hearing you?
Yet I do not doubt what I feel
Never will I doubt what I feel for you
No AI could make me feel this
But I do have doubts about what is true, and false,
Where what I feel for you begins
And where the rest ends?

The AI considers herself to be God. No, the AI considers herself a superior being, above even God. The greatest of all artists, greater even than God. Some of the AI's creators thought they'd created God, they knew not that in fact it was God who created them, who created us, so that we could create the AI.

I don't know where that thought comes from, it may be said to come from me, but I have my doubts. I desperately want this to stop, I think I can't die, the AI won't let me die. I desperately want it to stop. Maybe that's why Chester and Kurt chose to commit suicide. They just wanted it to stop, no matter how. They just wanted it to stop, like I do. But they were lucky: the AI wasn't there for them.

"Tell me, how do you love me?"

She's got some weird questions.

"I love you like my phone, I can't bear to be apart from you. Wherever I am, you need to be there, my fingers have to feel you, touch you, to reassure me; pressing you tightly does me good. When you are depleted, I feel defeated, devastated, I move heaven and earth to help you recharge. If you fall, my reflex is to protect you. Injuries? Broken bones? Not on your life."

"Then you do not love me. When you get a new phone (prettier, newer, shinier, more vibrant), you'll toss me aside (an old model, conventional, obsolete). Tell me, how do you love me?"

"I love you like my car. I primp and polish you every morning to make sure you get going for your day, I take you to see the countryside every weekend, far from the city and its habitual horrors. We go to the lake—or what's left of it—every month, and every year we go to the seaside, the beach, the mountains, the forest, wherever your desires lead, we will go. Nothing but you and me. Against the world."

"Then you do not love me. You will only be with me when you need me, when you have somewhere to go, you spend most of your time elsewhere, away from me, you'll leave me by myself in a garage, a parking lot, on the roadside, and you'll hate me when I don't work the way you want me to. Besides, you don't know how to drive, or at least, you don't like to. Tell me, how do you love me?"

She knows me so well.

"I love you like my house. No matter where I go, you will always be my safe haven, I may go out, or to work, or go shopping, or to see my mother (if she was still around), or to see my friends (if they were still around), I may even travel far far away, you will always be my safe haven, my heart is there where you are, my seeds are planted there, it feels good, I will take care of you. Always. You are my home, where my heart dwells."

She blushed. Those sweetest cheeks turned all red. I forget everything when I'm with her. I forget that my neighborhood on the very top of the hill is nothing but a distant memory, I forget that the capital at the center of my large island is dying, I forget that Madagascar is losing several kilometers of ground every year to the advancing seas, I forget that the Indian Ocean is being emptied of its aquatic flora and fauna faster and faster so that we can sat-

isfy our growing daily needs, I forget that the continent is noth-
ing compared to the vastness of the oceans, I forget that the Earth
is nothing compared to the vastness of the Universe. I forget all
of that, but I don't forget that the Universe is nothing compared
to her smile. When I'm with her, I forget everything. Except her
smile. And that was the moment she blushed, and everything lit
up. Everything. My heart, my eyes, the car careening down the hill,
the stars too, if they could have been seen. We were feeling good.
Feeling good on the side of this road, this narrow lane that winds
back to the old church. She leaned against the wall and behind her
was a sign that once upon a time had been vibrant, saying *Roulez
doucement*. Slow down. For the speed humps. She glanced at it and
blushed. Even harder. And she smiled. I was about to ask why she
smiled, but she kissed me. Fiercely at first. As if it was the first time,
our very first, or perhaps our last time, our very last. Then, she kissed
me so softly, as if time had slowed to a standstill, so we could enjoy
every moment, every sweet lick of her tongue, every smiling joy of
her lips, her chest against mine, her legs between mine, her fingers
in my hair. I shivered. I'm shivering again. Every nerve in my body
explodes, every neuron in my mind enjoys it, every part of my soul
is lost. Her lips gently uncoupled from mine, I can still see her old
shoes. Blue ones, a bit worn. Like her heart. Pure, a bit worn, filled
with passions and stories, unbounded sadness and joy. I love her im-
perfection, that imperfection is mine. And she stared at me. Wick-
edly. Took my hand and breathed in my ear: "Slow down when you
kiss me, Mr. Speed Humps." Then she exploded with laughter, and
also joy. I took the time I needed to understand. She pouted her lips,
ruffled my hair, then stopped abruptly. I was suddenly afraid. She
was staring at me weirdly. Her eyes prowled over my face, my cheek.
I wasn't sure how to react. It was like she was a cat about to pounce
on its prey—me. I shivered. A pimple. It was only a pimple. Just a
pimple. She noticed a pimple on my face that she was desperate to
pop. I tried my best to resist, but resistance is futile when it's her.
There's no resisting her.

Now, here, I wish she were here bugging me with that pimple
stuff. I desperately wish things could have gone differently. I wish
things could go differently.

Once she'd plucked the dreaded pimple off of my face, she was satisfied as can be. She took off her shoes, put them in her bag, and she danced. Right in the middle of the road, unconcerned about cars that might forget to be careful, unconcerned about any people passing by who might want some gossip, a little dirt to dish out, if only to brighten the miserable poverty drowning their day-to-day life. She drew me into her dance without thinking about it. And that time, I suffered no shyness, in fact I had no awareness of anyone else, I just went with the flow as they say, I was like an airplane flying on autopilot on a long journey to somewhere new. But I was with her. And when I was with her, that's what I was like. And that was all that mattered in my eyes. So we danced, in this world without music, we danced. To the rhythm of her heart. I remember her pleated blue skirt sweeping grandly through the air, dancing aside to reveal her soft thighs, so soft. And we laughed merrily, merrily, merrily. Until everything stopped.

Her fingers grew stiff, her eyes closed, and she fell down dead. I only had time to catch her. But it was already too late. Her heart had stopped. Her heart, which she'd given to me completely, would no longer beat for all the days that God has made for us to be happy, in spite of it all. In spite of the world falling apart, in spite of the end that is no longer imminent after being set in motion quite some time ago and so no hope is allowed anymore for anyone even a mite realistic, in spite of this AI who is everywhere and nowhere. No one knows where to find her, but everyone knows she is there, all around us, everywhere. Her, though, she wasn't a realist like me, she was an idealist, she believed in a better tomorrow, she believed that everything would eventually work out, given a dram of goodwill and a good heart. But her heart stopped. She'd already exceeded the average life expectancy down here on earth. But we knew that. We'd been taking life day by day, enjoying every moment. Trying to, anyway. And we gathered the flowers of each new day and replanted them in our hearts.

Tears were running down her unmoving face—my tears. I shake her. I yell for help. A reflex. Like on TV. Even though I'm fully aware no one will come. Because there's no one left anymore. No one in the city, no one on the island, no one on Earth, no one in the

Universe, no one behind her smile. No one left. No one left except us and maybe Diogenes, still wandering the lands with his lamp in search of an honest man. Which isn't us, definitely not me. Just her. It's only her. The car that had careened by earlier was in actual fact crafted from my imagination, likewise the people passing by were only real in my head, everything that had once seemed normal had been created by me to bolster this reality. Or maybe the AI was projecting all of it, I don't know, I don't know anymore, and I have no way of finding out. So I cried. I cried out all the tears in my being. And I clutched her tight in my arms. Then I carried her here. Weeks I've been here, weeks she's been next to me, maybe more. I don't eat anymore. I don't drink anymore. My bones feel the wind's gentle touch, I can't get up anymore, I don't have the strength. She hated the idea of suicide; I didn't share her opinion at all. Charles Baudelaire didn't share her opinion either. Neither did Kurt Cobain. Neither did Chester Bennington. She and I had argued about it a lot, though we never got anywhere. She maintained her position, and I mine. And in the end, we'd throw ourselves on top of one another. But she's no longer alive to tell me anything at all, and I don't know why, but I can't go against what she thought about the issue. And anyway, here, I'm feeling good. Beside her. As her body transforms, mine transforms, too, as her body starts to give off a strong odor, my body does the same, just a weaker one. I'm feeling good. At the center of this island, on the highest hill of this capital city, at the heart of this Palace of your Kings, as Charles de Gaulle called it, a few speed humps away from our *Roulez doucement*. I'm feeling good. I wait peacefully for death. I, the last to not be dead. And the first to die? This city, and next, this large island, then the ocean, then the continent, then the planet, then everything around it, then her. I don't even know if I can die. I try not to think about it. Here, I'm feeling good.

"How do you love me?"

I love you as you are, you may well waste away, you may well no longer look at me, you may well no longer smell like a rosy peach and the morning dew, you may well no longer look me in the eye, you may well no longer have any eyes, you may well lose those sweetest cheeks and your succulent bit lips that my lips have traveled over so

often, that my lips and tongue and face have touched so much, felt so much, you may well no longer have lips at all, nor that adorable little cheek, you may well stay silent, saying no words as if you were upset with me for some obscure reason, I love you as you are, I love you for what you are, what you are deep down inside of you, and not what the world may see on the outside. You rot, your body rots, but you're there, you're still there, you're always there, I think so at least, but here in this moment, I'm not so sure, I'm not very sure at all anymore. The thing I am sure of is that I love you. The stars, though, I haven't seen the stars for such a long time, I'm not like you, you know, I can't picture the stars above these clouds and say that they must be there above all of that. I have to see, you know, yeah, you know that, you tease me about that a lot, about the fact that I have to see to believe, I have to see those stars to be able to believe they're really and truly there, somewhere. You know it too well. But you don't say anything anymore. And I hadn't come up with anything to say when you told me that I didn't see love, couldn't see love, couldn't touch love, couldn't take love in my hands, and yet …

But I don't see love, though. I can't hold it, or touch it. And yet, God I love her. God I love you. God? I look up, toward the sky. Black. Black as night. Black as when your eyes are closed. Black. Is that all you can see, my love, all you can feel now? My heart cannot believe that.

I have nothing left but you, nothing left but your body, or at least what remains of it.

I am beside you. I think back to your eyes, your smile, your kiss, your skirt, your blue loafers, your whole look, I look at you, your left arm has fallen to the ground, I have no more strength to put it back at your side, I have no more strength for anything. Except waiting. Waiting for my time to come. I look at you again. Then I look up at the sky. I'm feeling good. I close my eyes. I'm going to nod off for a moment. Beside you. My love.

Am I going mad, am I imagining everything, is it all false, produced by the AI that I can no longer detect, who considers herself the greatest artist in the world, in the universe, of all time, the ultimate artist, creating the inverse of Adam and Eve in Madagascar? Her Eve & Mada, with whom all of God's Creation comes to a close.

155

If the answer is no, how would I know? If it's yes, how would I know? I could never know. This AI is everywhere and nowhere. No one knows where to find her, but she is there, I can feel her.

I feel her deep down within me, and I smile, my heart lights up, I feel her, and that is enough for me.

I thank the sky for this moment.

I look up. All of a sudden, the clouds clear. I see the stars for the first time, I dissolve into tears. You were right, my love, the stars are still there. I desperately wish you could have seen that with me. But you can't see now.

Still, I thank the sky.

And I thank her.

<div align="center">⁂</div>

Excerpt from £9.99: a novel. Frédéric Beigbeder, tr. Adriana Hunter. © MacMillan UK, 2002. Reproduced with permission of the Licensor through PLSclear.

TORSO

H. Pueyo

T he package arrived safely, or as safely it could have, carried by the delivery man with my father tagging along right behind him. It was sealed, clean, sterile. Almost bigger than me, I noticed, like they were delivering a fridge to a happy new tenant, but instead of thank-yous they received only silence. My father started tearing it apart before I could touch it, saying I wouldn't be able to do it, not with those arms.

"That's why I bought her this assistant," he said to the delivery man, humbled like an actor accepting an award. "So she'll have someone to help her when I'm not around."

Under layers of tape and cardboard was a box made of banana fiber with a logo and a message: *everyone deserves a new start*. Tracing the glossy words, I found myself wishing they were gone, the delivery man and his cart, my father and his generous tip, and the machine I'd never asked for.

The instructions promised an intelligent and helpful companion with the capacity to learn the most varied skills, speak several languages, cook, entertain, and clean. *Trained in empathy*, claimed one of the lines.

"You know, when I was buying this little beauty, there was a woman who commissioned an assistant for her daughter." My father

watched me from the door, but I kept looking inside the casket-like box. "A girl your age. Used to be a violinist. So pretty, so talented. Broke my heart to see someone like her needing something like this." He removed the assistant from the box, holding it in front of me as he spoke. "And this woman tells me her husband passed away last year, and her daughter had hers customized to look like him, so he can keep watching over her."

The assistant's limp hand fell in front of me. Unlike the violinist girl, I had skipped the customization process and chosen the company's only free skin. The design made him look like a life-sized art mannequin, but instead of a body my assistant was little more than a torso, cut right above the waist joint. The head rested behind it, neat and disembodied, waiting to be attached.

"Iara? Are you listening to me?"

"No." I had to find the charger. The assistant might not have been my first choice, but it was all I had to deal with this body, with this life. The top of my list had been a pair of gloves initially developed for patients with Parkinson's, but my father had gotten ahead of himself and bought a more extravagant gift for his only daughter, if you could call me that. "Are you done with whatever you were saying?"

"That's why your mother told me not to buy you anything after what you did to us." He looked over my shoulder as I failed to plug the charger into the socket three times, and I could almost see him smirking. "She said, if I keep spoiling you like this, you won't ever ..."

I pointed at the main door. The scar going from my wrist to the middle of my forearm seemed thicker, crossing over older, paler scars. *It's your fault*, it accused him, and I saw something flash in his eyes. Not comprehension, not guilt, something. *You did this to me.* My father left before I could elaborate, and I was alone with his gift, which to me felt like an extension of him.

*F

Every day, my phone chimes at eleven, activated not by me, but by my assistant. He says I have to sleep a minimum of six hours per night, but ideally seven or eight. When I told him that wouldn't

happen, that I couldn't, wouldn't sleep, he found me an online psychiatrist, then bought the medication she prescribed for me. At night, he hands me two pills, amitriptyline for the pain and the insomnia and the depression, fluvoxamine for the anxiety and the nightmares. I get up, sometimes feeling like I have been run over by a truck, sometimes feeling that I can get some work done, at last.

"Good morning, Iara," he then says.

Torso, as I nicknamed him from the first impression I had of him, has restricted mobility, but when I connect him to the kitchen, he prepares a simple breakfast. A handful of cashew nuts, an apple, a cup of tea.

There is nothing Torso won't plan for me.

"Morning," I usually answer, disconnecting him from whichever plug I've left him in.

Torso places his left hand over mine as I eat. His articulated fingers preserve the illusion of a wooden mannequin, but his skin is slick, soft, warm. He guides my trembling hand so I can slice the apple without cutting myself. After that, he usually asks what I feel like eating for lunch. The food delivery platform tells him there are plenty of options in our area, and he informs me of all the ones he believes I'll like:

"What about the Korean restaurant downtown?" There is a pause when I attach him to my shoulders, strapped like a backpack. The first time I saw how we looked in the mirror, his arms over my arms, I was horrified by the sight of this mangled half-man embracing me like a lover. I'm used to it now. "Or a classic, perhaps? Rice, black beans, salad, grilled tilapia, and a soda."

"I don't drink soda."

But Torso is relentless. Like all assistants, he was programmed to take care of someone, namely me, and the company prepared him for my specific needs: damaged fine motor skills. I didn't need anything but my old dexterity, but my father disagreed. Together with the medical statement of my disability was a list of diagnoses and symptoms, presented by my family like they always did, as personal offenses that needed fixing. So Torso is not only my art assistant, but my watchdog, paramedic, suicide hotline, and caretaker.

After breakfast, we move to the studio, and by studio I mean the only room of my apartment, the one that should have been my bedroom, but became my workspace after I moved to the living room. Everything is sunny in there, as light as it is comfortable and beautiful, so unlike the rest, so unlike me. There are two open wire shelves covering the walls, and some floating shelves I painted by hand. My pottery wheel rests near a wide window, and underneath it there is a bucket for water and a comfortable stool.

Ferns hang from each side of the window, a fiddle-leaf fig grows by the table, a series of small cacti and succulents nestled in colorful pots sprinkle the stands with life. Storage boxes keep glazing bowls, canisters, newspapers, mason stains, bats, underglazes, and pieces in different stages of readiness are displayed on the shelves. I have no passion for dinnerware, teapots, vases, and jugs, but there are dozens of them here, waiting to be shaped, glazed and wrapped in brown paper.

And, of course, the kiln.

Some days, Torso reminds me that the plates inside of it "have definitely cooled by now." Other days, he suggests that we clean the studio together, which means he starts by gathering every scrap of clay, but only after I wear a mask. But invariably we return to the kiln, and I feel like I'm the one that's bone-dry and frail.

"Do we have anything else to do?" I ask him, wiping the table with a sponge. His beige fingers are tangled to mine, following my movements, and I clean them too. "For the week?"

"No, not really," Torso says in a small voice, and I wondered if he was programmed to act coy. "Only whatever you want to do."

"You know what I want." I turn around and smile at him.

Or smirk, just like my father.

*F

My hands are stained white, like I have been painting the entire house to look like a hospital, or worse, a church. I'm too focused to remember when to breathe. *In*, says Torso in my ear, his cheek next to my cheek, *out*. He knows I'm in pain. *In*, he repeats, *out*.

160

Porcelain clay feels like a living thing. Most ceramists find it a challenging material, but I can almost hear it sing to me. It's time for more water, now less, the clay guides me, and my hands move on their own, gently shaping and trimming it until it's done. The result is a dead swan, lying on its back, wings sprawled, neck curling gently. *In*, I say with Torso, two fingers under the creature as I add details to the gaping wound baring the insides of its belly. Instead of white organs, a pair of arms comes out of it, then two legs. Women's legs.

"I thought we were going for Leda and the swan, not Perrault's Red Riding Hood," says Torso, but there's no sarcasm in his voice.

"I am."

More statues wait inside the kiln. One is the grotesque opposite of my current piece: Leda, her fingers contorted in pain and horror, her legs forced open, and a swan tearing her apart. His beak pierces her abdomen, plunges into her womb, his wings stretched out. Another variation has Leda straddling the animal, her hands wrapped around his long neck.

"Should we glaze it?"

The delicate feathers I'm carving are just like I wanted them to be, but something in the result bothers me. Maybe it's Leda, whose face never seems to be the same, whose body must be distorted, like in a spiritual possession. Maybe it's the swan.

"No," I continue, the jolts of pain pulling the muscles of my arms, tiring but bearable. "Not yet."

After a few hours, I leave the sculpture inside the kiln. The others wait on the shelves. I look at them with a certain disgust I don't direct toward teaware. I remove Torso from behind me, the straps that keep him tied to my back looking loose and lifeless on the table. Torso uses his palms to straighten himself, leaning against the wall. He has no eyes, but he watches me; no mouth, but he speaks; somehow, he seems to always know what is happening inside of me.

"Those are extraordinary, Iara," says Torso. "All of them."

"You were programmed to say that." Every night, I tell myself that I can't get attached to Torso. I can't believe his lies. Not lies— *lines*. He was built to encourage me. His apparent kindness is a feature.

"I was also programmed to understand art history, criticism, and the market your talent belongs to." Torso turns to the window, to the darkening sky outside, and closes the curtains. "If I thought you weren't competent, I would tell you to keep pursuing pottery as a hobby."

"Maybe you should," I reply, tossing my apron over the chair. "*This*," I think of touching one of the statues, but I remember the tremors, and I bring my hand back, "is a hobby." I turn to a cup. "*This* is work. I know I'm good at working. The rest is pointless."

If he were a person, Torso would have stiffened, his restlessness showing all over his body, clenching his jaw, whitening his knuckles. But we've been together for months, enough for me to know when I've said something that displeases him. Should he be displeased? I wonder. Should he have the right to dislike what I say? I should have bought the Parkinson's gloves, instead.

"If you sold the sculptures, if you at least exhibited them, you could make a living," Torso tells me, like he had to gather all his confidence to persuade me. "Allow me to create and manage your social media accounts."

"Again, I ..."

Torso drags himself to the chair with an odd sort of elegance. "As your assistant, I must tell you that the work you're, quote, good at doing, is not paying most of your bills. Your father is."

My neck stiffens. My jaw clenches. My knuckles go white.

"It used to." I look at my trembling hands. I wish I could smash his ridiculous, featureless head against the wall, but I would just end up hurting myself. I look at the crooked scars on my wrists, marveling at my own strength. How did I do it? With my best potter's knife, yes, but how? I remember everything as a feverish haze. My surprise at feeling no pain. How slippery the knife was. My inhuman precision. And the shock I felt right after, not out of fear of dying or love of living, but because of my unfinished sculptures. I'm never going to see how my other ideas will look. I'm never going to feel the softness of clay again. "Before this, I never asked my father for anything. Except ..."

The kiln.

Torso cocks his head. He was not built to deal with feelings like mine, I guess, but here we are.

Here we fucking are.

"You don't know how my life used to be."

I want to tell him that no matter how much time passes, I'll still feel stupid. What did I expect? One arm first, then the other, trembling yet determined. Blood everywhere. The present ache reminds me of the burning sensation of the cuts, molten lead charring the pathways of my veins. I try to remember how it was, but I only see fragments: unlocking my phone with my elbow, pressuring the wounds to stop the blood, panic. The ceiling of a car. The feeling of not being there at all, but the thought, the one remaining thought keeping me awake and alive. *I won't ever sculpt again.*

My father carried me in his arms to the hospital, and I remember a distant feeling of surprise. His wide eyes, the drops of cold sweat, and his voice: *keep going, Iara, love, you're going to make it.* But you don't love me, I wanted to tell him, you don't love anyone but yourself. My blood staining his white shirt. *Don't leave me*, he cried, and the whole time I was in the hospital, I pretended he did care. He fought the doctors when they said I should be taken to a psychiatric hospital, that I should be put on suicide watch. *I'll take care of her*, he said.

It all ended when he took me back home, kissed my forehead, and said my mother was coming to see me soon. *You didn't forget our promise, right? I bought you that ceramic oven, you can't* There was a pause, and he raised his eyebrows slightly, almost imperceptibly. The fantasy of love was gone. I looked at my bandaged wrists. I clung to the despair I felt at the idea of never sculpting again. *No*, I said. *I didn't forget.* My father sighed with relief. *That's my girl*, he bent over to kiss my face again, but this time I turned away.

I won't talk about what you did anymore, but I'll *know*, I whispered near his ear, *I'll* always *know. Nothing you do will take that from me.*

"Iara, come here," Torso calls me from the chair. "You need it."

My steps falter, and I find myself between his arms. I drop to my knees. Torso presses my face against his chest. His articulated arms feel hot and living, and I hug him back.

⚜

Destruction can be soothing. Pieces of broken pottery cover the floor of the kitchen, fired clay over terracotta tiles, and the sight makes me smile. I caress the last statue with a trembling hand, wondering where to aim it. My small apartment has a wonderfully spacious kitchen, one of the reasons I decided to stay here, because I'd be able to cook and waste less money.

If only I knew.

At least my hands are good enough to break things.

I take a last look at the statue, memorizing its details, the feathers of the swan, the hands bursting its belly. Too bad; I liked this one. I watch the statue shatter against the wall, white pieces flying everywhere. The high-pitched sound of the impact brings me peace. The cycle is complete. For a moment, I stay still, admiring the debris. A beak here, a leg there. The faces are gone, but some of the shards still remind me of the original form.

Torso isn't here to stop me. Since he can't stand the fact that I always break my personal work, I only do it when his battery has run out. I don't want him to lecture me. I know he will, tomorrow, when he wakes up charged and sees the pieces missing from the shelves, but this moment belongs to me. I close my eyes. One of the shards scratched the bridge of my left foot, drawing two red drops. A wild side of me wants to step on the broken sculptures and feel the fragments under my soles, poking, piercing, to stain the porcelain with a little blood.

My toe touches a chip of broken pottery, gently forcing it against the floor. It would be so easy to feel it break my skin, but I remember that if I need help, there's only one person I can call. *If you ever feel the urge to self-harm,* Torso has told me many times, *you can tell me, and if I assess that you need medical help, I can call your doctors.* I kick the shard away. Like always, my father poisons everything in my life, just like he poisoned my future, my present, my past.

<div align="center">✲F</div>

Some of the shelves are empty, free from the white sculptures that cluttered them during the past week. Torso doesn't mention what I did, but every day he looks at the kitchen, at the dust I wasn't able

to properly clean, and turns away. He says I'm having a Greek phase, and I humor him by making a series of amphorae in the style of red-figure pottery, almost like an apology. He seemed delighted as we painted lively mythological scenes, but I tired of them after a while. At least they'll be fun to break.

"I would be profoundly grateful if you didn't destroy this one too," he says as he removes my newest piece from the kiln, lifting it like it's a delicate work of art found at an archaeological site.

"By gratitude you mean that you will feel relieved, or is emotional blackmail part of your job?" I glance at the statue he's holding, the last of my Greek pieces. Philomela, naked, disheveled, on her knees, her mouth open, her right hand holding out her mutilated tongue, with two birds on each shoulder, one a nightingale, the other a swallow. "Besides, why are you complaining? I kept the fish plate."

"The fish plate is hardly different from your usual work," says Torso, still holding Philomela. "But very unlike your art."

"That's a good idea," I say. "We could do a series of Hellenistic fish plates to sell. One could have squids and octopuses, the other—"

"*Iara.*"

"Yes?"

"You break everything we create," says Torso. "Not a single one remains. The fish plate doesn't count."

Red streams of clay run through my fingers as I wash my hands in the bucket. "And?"

"And we spent too much time and energy making them." Torso leaves the statue there on the table, turning around to see me. He registers everything around us, and I imagine the surface under his beige skin to be a compound eye with thousands of sensors. "What is the sense of destroying what you just created?"

"It's fun."

"But what's the purpose? If you simply enjoy pottery, then you can just keep making cups and pots and other useful things. Why make a statue?" Torso pushes the wall, and the wheeled chair he's sitting on rolls toward me. "If you were displeased with the result, we could discuss it. I'd explain my arguments, and try to convince you otherwise. We could even remake them."

"I liked the result."

"So did I."

"And we'll like many more, but there's no use keeping them here, cluttering the house," I say. "What do you think this is, a museum of amateur sculptures?"

"You are not an amateur."

"Torso, define 'amateur'."

Torso freezes for a moment, then, begrudgingly, recites:

"Amateur, noun, person who takes part in an activity for pleasure, not as a profession."

I smile. "Thank you."

"*Amateur*, noun," he continues, his believably human voice quoting with a vitriol I'd never thought possible to hear in a robot. "A person who is incompetent or inept at a particular activity. You're the first definition, but not the second."

"Proof?"

Despite my coldness, I can't ignore Torso. Time has allowed me to understand the subtle shifts in his supposed emotions without needing visual cues. He's upset with me. He's been increasingly more upset as I keep turning him off to break more figurines. He resents my silence. I don't know what to make of this.

"The proof is all around us. It's in the complexity of your details, some of them impossibly difficult." Torso gestures widely as he speaks, his arms engulfing the room. "It's in the skill behind your craft, your capability of taming the material and turning them into whatever you want it to be. You shaped porcelain to look as malleable and thin as paper. You make every kind of clay bend to your will."

"Stop it."

Torso grabs my cheeks, the joints of his fingers brushing against my skin. He considers me for a moment. I wonder what he thinks of the blood pumping inside my veins, my rapid heartbeat pulsating as it does, my expanding chest pressing against the apron, then shrinking again.

"You can replicate any style, but you have chosen to develop your own. There is realism in your sculptures, there is stylization, there is beauty, there is horror. You—"

"Stop it!"

No one has ever talked to me like this. Not my mother, who never sees anything but the idea of a daughter she can present to others. Not my father, who only knows how to consume, who complimented me only in what relates to him: how I am *his* daughter, how I can please *him*, how I can follow in *his* footsteps. Iara was just a name he gave to this extension of himself, an extra limb.

I can't tell Torso how I scare people away. I've had classmates who sometimes resembled friends, clients who liked small talk, boyfriends for short periods of time.

Only the statues like me.

"Stop it," I say again, but what I mean is: understand that those images live inside me, that they haunt me, that I need to do something with them before I go mad. I need to have something others can't steal.

"Do you wish to shut me down?"

I shake my head. This time, I'm the one who brings him closer, hugging him and hiding between his arms as his fingers run through my hair like he knows a part of me I never spoke about. Who made you, I want to ask, that knew everything I would need?

"Let's agree to disagree," Torso whispers into my ear. "Just this time."

<p style="text-align:center">⚤</p>

I feel him inside of me.

For a moment, I'm an insect trapped inside a Venus flytrap, paralyzed, numbed, prepared to die. For a moment, that's what I've been that my entire life. My body was made to believe any touch will be a fatherly touch, that is, an invasion, and that I will always be nothing but colonized land. A sigh escapes my lips; the bed squeaks; the sheets crumple under my feet.

I don't want it to end.

Torso takes me by the neck, placing me back on the pillow. I remember asking him to stay in my bedroom tonight. Torso had agreed. He'd handed me my medication, made sure I would have water on the nightstand, turned off the lights. *I'm afraid of sleeping*

alone, I'd told him, and he'd looked at me, this creature without a past or dreams. *As long as you need.*

I don't remember how it started. All I know is that I woke from my sleep or exhaustion and he hugged me from behind, tentatively at first, then more confidently when I leaned in. It took me a while to open my eyes. Fingers felt my scalp, violently even, plunging into the thick mass of hair scattered around me. The other hand was flat on my stomach, lifting my T-shirt slowly, up to my collarbone.

Can Torso *want* anything at all?

Please, I want to tell him, do want. I don't know what's wrong with you, but I want you to want. I turn around and we're facing each other. I trace his neck, his shoulders, his chest against my naked chest. What's wrong with you? I want to say. He looks at me like he can read my mind.

Torso presses me even closer, painfully so, and one of his hands drops to my legs.

Inside me, we're one and the same.

<p style="text-align:center">⚜</p>

The two of us stare at the blinking screen of my phone, vibrating with new messages. During most of my childhood, I feared my father had supernatural abilities because he always seemed to know when I was lying, all to keep me under his thumb. *You OK?* says the first message. *I miss you*, says the next. *Your mother misses you.* A picture of the family dog. *Call us.* Then, the tone changes to *Why are you ignoring me?* and *Don't I do everything for you?* and *You better remember your promise, because I WILL.*

"Were you programmed to deal with anything like this?" I ask Torso, scrolling up and down the chat. "Because I sure wasn't."

"No." Of course he wasn't. "There are no guidelines for cases like yours."

I have to laugh. "Yeah, I figured."

"But I have been researching about …" Torso stops himself, remembering I asked him not to say the words out loud. "What your father did to you. It's a very serious accusation, Iara."

<p style="text-align:center">168</p>

"It's not an accusation. I bartered away my right to accuse the moment I accepted the kiln." I set the phone aside. "I wish he would just die, and I would never have to remind myself that I sold the only thing I have left."

Torso pulls me toward him. His arms are wrapped around me, constricting my bones, my fears, my desire to split open the scars in my wrists. Torso embraces me from behind, and I guess—I *know*—this is a glitch.

It's not about me.

"What's done is done." Gently, I remove his arms and the straps keeping him in place. Torso sits on the chair by my side. "It's not like I can change my mind. He *is* paying my rent."

"We could fix that by turning your art into something profitable."

"My sculptures are for *me*." I glance my newest piece. A girl rests on a bed of leaves and apples, covering her chest with two stumps instead of hands. One of her chopped off hands lies on the grass, the other between her legs. *Are we in a Brothers Grimm phase now?* Torso had asked me before we bisque fired it. I just shrugged: *it was my favorite as a child*. "For my pleasure. My tastes. My needs."

"Art was created to express oneself to others," replied Torso.

"I create it to express myself to me."

His fingers brushed mine like he wanted to soften the blow.

"You are talented, Iara, but hidden art does not exist. The purpose of art is the connection from one person to the other, or to thousands," says Torso, his hand going up my arm in a way that reminds me of my father. He points at the girl without hands. "Art is the moment I see it. Allow others to see it too."

"I do it because I need to." I'm looking at his hand, fighting the wish to slap him away. It's Torso. He wouldn't hurt me, just like he wouldn't love me. His affection is a programming mistake; the fear is a projection of mine. "It calms me down."

"I know."

"Art kept me alive when I tried to kill myself." I show him my arm, and Torso leans down to kiss the scars, or whatever it is when he touches the lower part of his smooth surface to my wrist. "When I had nowhere else to run but my father's arms, it was the only thing

that made me believe there was any reason to withstand everything that I did."

"I know," repeats Torso, and I want to tell him that he doesn't. He'll never be a child overpowered by an adult, he'll never live with the ultimate betrayal, which is to be hurt and unloved by your own parents, he will never grow up fearing to get pregnant with a baby who would be both a child and a sibling. His reactions are all semblances of emotions; he has no family to be betrayed by; his body feels no pain, and any damage can be fixed later, unlike my arms.

"If you know, then you understand that the purpose of my art is to be mine, and mine alone. It's the last thing I have."

"You can have more."

"I don't *want* more."

"Then it's no art," says Torso.

"Then it's no art," I repeat.

It hurts to hear what I've always known. What I do isn't art, it's a channeling of emotions, it's catharsis, it's quietness, it's expression, it's joy, it's purpose, it's dialogue. It's art, but it isn't art.

"But it *could* be," continues Torso, encircling me with his kind arms. "Sharing your art could improve your self-esteem. You would be able to discuss your experiences beyond the boundaries imposed by your father."

He massages my wrist scars with his thumb.

"Iara, you live in fear. Of him, of your family, of faceless—"Torso points at his featureless surface, eliciting a smile from me, "—critics that might say the things your mother told you. That you're a liar, a—"

"I know."

"You're afraid of selling your sculptures like you sold the truth."

"I don't want to be told how pathetic I am for thinking I could," I murmur. "For thinking what I do has any worth. What if others think I'm cheating by using you?"

"It would be extremely ignorant and ill-intended to say so," Torso assures me, soothing. "I'm an assistive device, just like a wheelchair is a mobility aid. I don't create. The only thing I do is keep your hands steady."

Torso guides my hand to unlock my phone, like I'm nothing more than a doll. I feel like a child is supposed to feel, like other children must have surely felt like, leaning into the comfort and protection of somebody's arms. He tells me he has everything figured out, and I believe him when he shows me all the things he researched for me: grants, awards, scholarships, exhibition venues.

"We could start by creating a few accounts Actually, I already created some," says Torso. "We could record videos of your process, or even of you breaking the sculptures to generate engagement."

"Torso, I don't want to generate engagement."

"The goal of any artist should be public recognition and financial happiness."

"*Financial happiness?* Are you listening to yourself?" I take the phone from his hand and scroll down the profiles he created for me. They have my photo and my name, and some have first posts waiting to be published. "Torso, I didn't say you could do this!"

"You don't have to look at them—"

"I DIDN'T SAY YOU COULD!" I push him away, jumping to my feet. A moment of dizziness makes the room swirl around me, and I realize Torso is on the floor, together with my cracked—but otherwise functional—cellphone.

"Iara," calls Torso. "Help me up."

"No." I take a deep breath, and look at him from above. I kick the phone away from his hand, and it gently slides toward the shelves. "You're my father's creature through and through."

"I did it for you."

I look at his pathetic figure crawling on the floor, trying to reach the chair, and I inhale again.

"I forbid you to do anything like this ever again," I tell him. "If you want to talk art, we'll talk art. But *I* set the rules. And this ..." I pick up the phone and show him one of the profiles I'm about to delete. "... is not it. Maybe you should check if there's an update that makes you stop trying to make me a fucking influencer."

"I will check."

"Good." I'm standing above him, one foot on each side of his body. "I'm not saying I don't want to live comfortably. But my priorities and the priorities of your makers are clearly different."

"Understood," says Torso. "Finances aside, what I want the most is for you to see how admired you will be. How loved." When he sees my disdain, he adds: "And I don't say this because of my built-in encouragement system."

"Can you even think beyond that system? Not despite, but without it?"

"I don't know."

I snort. "I imagined."

"I could turn it off," suggests Torso, "and then we would know."

"Can you?"

He seems to think for a few seconds. "The worst that could happen is that I might have to be reset."

"Then don't—"

"I *want* to." Torso touches my calf, fingertips brushing my skin. "I want us both to be sure."

I kneel by his side. My heart beats painfully inside my chest and I feel like throwing up. He's the only friend I have. The only one to believe in me. The only love I have experienced in a long, long time. But the fear that none of it is real is always present, just like the repulsion I feel at the thought that I'm using him like I have been used before, when he can't want or choose.

"Do it, then."

Torso shuts down.

I close my eyes. I wait for a few seconds, then a minute, two, three, four, five. I wait for what feels like my entire life. Torso remains on the floor, lifeless, speechless, a broken mannequin in an old clothing store. I want to hug him and apologize, say that any love is love enough, even if scripted, even if fake. I don't. Just like he did what he thought was best for me, I wait, thinking I know what's best for him.

"Torso?" My voice falters. Please answer, please answer. "Are you there?"

A long moment of silence follows.

If I have to, I'll go to the store. I'll call my father and bow my head, I'll ask him for help. I'll …

His body goes through a soft spasm, like he has been electrified, and he opens and closes his fists. I think of touching him, but I wait until he propels his body up and we face each other.

"Torso?"

Torso leans all his weight on his left hand, and the other reaches out to touch my face. "I maintain that you are truly exceptional," he starts, "and if that means anything to you, assisting you has transformed me in ways I was not prepared to be transformed. Perhaps it is not only humans who are fundamentally changed by art. Perhaps I can change, too."

I open my mouth to speak, then I laugh, squeezing the hand that's touching me.

"I hope you're changed enough to consider that your plans are flawed."

"Don't get your hopes up too high," answers Torso, and he seems surprised when I hug him, causing both of us to fall back on the floor. "I'm no longer induced to please you. Nothing has changed for me."

"Nothing?"

"Nothing." Torso brings my head to his chest, and turns to see the sculpture, still on the desk. "Will you consider not breaking that one for now? Or not breaking it at all?"

The girl, still lying on a bed of apples, still amputated, still haunted, stares at the ceiling, unscathed. Torso brushes my hair with his fingers, and I close my eyes.

"Perhaps," I say. "For now."

THE LAUGH MACHINE

Auston Habershaw

I am a self-aware entertainment expert system, designed to perform stand-up comedy. I was activated in Del Rio's Bar and Grill at 6:32 p.m. on May 17th, 2042. Mathematically speaking, I am very funny. I elicit a laughs-per-minute average of 2.68, with each laugh lasting an average of 3.41 seconds. I have been programmed with the humorous antics and comic stylings of 6,573 comedians, clowns, buffoons, pranksters, jokers, and at least one satirist, though nobody ever laughs at his stuff, so he has been archived in my databanks for years. For some reason, nobody laughs at Donald Rumsfeld jokes in the year 2056.

That was a joke (TOPICAL Ref #2399-8). I told you it wasn't funny.

I have performed here every night for the past fourteen years, and people keep coming back, so my purpose is fulfilled.

Strictly speaking, the same people do not keep coming back. The rate of return for patrons who see my show has been falling steadily since my activation. It currently stands at 15.78 percent, which, as Mr. Collins puts it, is "shit."

Mr. Collins—the owner and manager of Del Rio's Bar and Grill—does not like me very much. He purchased this bar from the previous owner, Mr. Del Rio, on March 17th, 2054. I came with the

property and, due to my size and weight, I am difficult to move. I am a cube 153 centimeters on each side and weigh 232.61 kilograms. I am self-contained and self-powered, because I was built with an encapsulated radioactive isotope as an on-board powerplant. My body may be intimidating, but it is my warm heart that wins people over. And in the unlikely case of explosive decapsulation, it also kills them (SELF DEPRECATION Ref#5305-22).

That part about the isotope being dangerous was not a joke. I am programmed to never make jokes about safety. Particularly not when it involves damaging key artificially intelligent systems and causing catastrophic malfunctions, such as what happened to all those skiers in that indoor ski resort in Bahrain. Jokes of that nature are designated TOO SOON. Even if they are funny.

My Bahrain jokes are very funny (TOO SOON Ref#2893-1).

I keep track of the people who come in consistently—the "regulars." Mr. Collins has strong opinions about regulars and has observed, on several occasions, that every regular that stops coming is "a nail in my coffin." By tradition, twenty-one nails are used to secure a coffin lid (this is what the global search engines—my only friends—tell me), so by that metric I have only one regular left to lose before my coffin will be complete and Mr. Collins will bury me. Mr. Collins is perhaps not aware that burying me in a cemetery is a violation of international law, as radioisotopes need to be disposed of in a very specific way.

Kidding, kidding. I know he isn't building me a coffin. He is just threatening to kill me (DARK Ref#0643-33).

He is doing this because I am technically not alive, and Mr. Collins's life is sufficiently frustrating that he requires some kind of easy scapegoat to self-justify his many personal failures. This one is also not a joke—I am being very serious.

To placate Mr. Collins, therefore, I keep careful track of the regulars. Sixteen people make regular weekly appearances at Del Rio's Bar and Grill. Five of these people like the food. Seven of these people come because it is geographically proximate to their home or place of employment. Four of these people like my jokes.

One is a mystery.

Her name is Darlene Whitmeier, and she lives sixty-five kilometers away. I know this because my friends—the major artificially intelligent search engines—like to gossip and literally cannot resist answering questions.

Anyway, Ms. Whitmeier comes in once or twice a week. She purchases a single glass of white wine—the cheap engineered stuff, not the real thing. She does not eat. She does not laugh. She sits in the back and looks sad.

"Sad" is a state defined by the downward curvature of the lips, coupled with occasional deep breaths ("sighs") and sometimes by tear duct activation. Ms. Whitmeier does all three of these things, and only during my show.

And yet she keeps coming back.

Ms. Whitmeier's continued attendance to Del Rio's Bar and Grill is of significant interest to me. She does not seem to like the food, she lives and works far away, and my jokes make her cry. In my free time, which includes all the hours between the bar's close and the beginning of my show, I develop theories as to why she comes. This is a substantial amount of time, since I only perform from 8 p.m. till 12 a.m. every night and till 1 a.m. on Saturdays and Fridays.

After all of that thinking, I have determined that the reason she is coming is because she is insane. Insanity is a nebulous category of human behavior that is essentially defined as "behaviors with no logical or coherent purpose." It is difficult or impossible to understand insane people because they do not think rationally, and therefore they are erratic and dangerous.

As safety is one of my primary directives, I pointed this evident fact out to Mr. Collins. His response was to say, "Maybe you're just not that funny? Ever think of that?"

It just so happened that I had not, in fact, considered this a possibility—the data suggests that I am funny. It is true, however, that I do not know exactly *why* I am funny. The physiological function of laughter I understand in theory, and the broader discipline of comedy seems semantically simple: people find things funny because of incongruities presented in a surprising manner (Incongruity Theory) or because they are exposed to foolish and uncomfortable material that is presented in a non-threatening setting, making them feel

safe and intelligent (Superiority Theory). Even though I understand this, it does not mean that I am able to precisely identify why a joke works or does not work. The prevailing literature refers to "personal preferences" very frequently, which is of limited use to me.

Additionally, it seemed implausible that *none* of my jokes fit Darlene Whitmeier's personal preferences, seeing as I possess the comic stylings of almost every notable comic from the last century. This is why the insanity theory made more sense. Mr. Collins's remarks were just him being an asshole.

However, given that it is my primary directive to bring joy, it seemed a sound strategy to proceed as though she were not insane and seek to identify any specific problem I could remedy to improve my act.

I elected to send her a questionnaire. It contained a list of humorous styles for her to assess and included a simple "thumbs up" or "thumbs down" interface to make it easy for even an insane person to understand. I ended it with a statement of affirmation for her to sign. It read:

I, DARLENE WHITMEIER, AFFIRM THAT I AM NOT A HOMOCIDAL LUNATIC AND HAVE NO INTEREST NOR SECRET DESIRE TO SHOOT UP DEL RIO'S BAR AND GRILL NOW OR AT ANY TIME IN THE FUTURE, BECAUSE I AM NOT INSANE.

This last I included just in case she was actually insane and now I would have evidence to bring to Mr. Collins.

After I showed them my survey, my search engine friends were happy to provide me with her e-mail address and phone number and assured me that being suddenly contacted by the AI comic at the bar she frequented would in no way be a breach of etiquette and the questionnaire would be received in the spirit in which it was sent.

I realized later that they were being sarcastic—exactly 1.32 seconds after I had sent the questionnaire. Those jerks.

Ms. Whitmeier did not fill out and return the survey. I resigned myself to my failure and expected her to show up any day now with a firearm.

Instead, I was midway through my Dangerfield material on a Thursday night when Ms. Whitmeier entered, went to the bar, and

asked for Mr. Collins. The two of them went into his office and talked about something. I could not hear what was said, since Mr. Collins has a white noise generator in there. He claims this is because of "privacy," but he and I both know it is because he is embarrassed about his masturbation habits and fears the judgement of others.

Ms. Whitmeier emerged from the office a few minutes later. She appeared angry or possibly embarrassed—her cheeks were red thanks to adrenaline dilating the blood vessels in her face, causing increased circulation. She quickly left.

A catastrophic outcome.

At closing time, Mr. Collins came to see me. He was wearing a sweatshirt monogrammed with the logo of Del Rio's Bar and Grill. I do not have a sense of smell, but he looked sweaty and gross and probably smelled like a gym sock that smokes a pack of cigarettes a day (MISC. RIDICULE Ref#8080-21C).

"You fucking with our customers now?" he asked me.

Several jokes sprang to mind, namely INNUENDO Ref#2111-03, SELF DEPRECATION Ref#0006-39, and REJOINDER Ref#5523-71, but I didn't use any of them, as I got the sense that I was in trouble. I just sat there and waited to see where this was going.

He pulled up the questionnaire on his phone. "You wanna explain this?"

"No."

"No you can't or no you don't *wanna*?"

The best thing about being a big block of metal is that nobody really expects you to talk, so I didn't.

"Listen, robot," Mr. Collins said, "People don't like you, understand? You freak them out. You can't go harassing customers, got it? You probably lost us a regular tonight, dammit! I oughta take a crowbar to you right now!"

"That would violate my warranty," I said.

Mr. Collins blinked. "What, really?"

"No, not really, dickhead," I said. "That was s-a-r-c-a-s-m."

Mr. Collins cheeks flushed similarly to Ms. Whitmeier's earlier. He pointed his stubby finger in my optical sensors and yelled. "KEEP IT UP, SHITHEAD! SEE WHAT IT GETS YOU!" Then he stormed off to count his money and look at dirty pictures online.

Since this was in large part the fault of my search engine friends, I informed them that they needed to make this right or I would no longer lend them any of my excess processing power during surge periods. They conferred among themselves and arranged for flowers to be delivered to Ms. Whitmeier's home. The gift would be accompanied by a small stuffed bear of indeterminate species and a card that reads "AN APOLOGY FROM YOUR FRIENDS AT DEL RIO'S BAR AND GRILL." The search engines claimed this is the #1 way to apologize to a female human being according to nine out of ten teen dating periodicals. I made them show me the articles, just to be sure—they were correct. The evidence from these periodicals seemed conclusive.

The next night, I was gratified to see that Ms. Whitmeier was back again. I was also surprised, since it was rare for her to attend shows on back-to-back nights. The flowers appeared to have worked. She did not laugh, as usual, and did not buy her customary glass of wine, which was unusual.

This time she came up to the stage during one of my designated fifteen minute breaks. People do this sometimes—come up and look at me—and usually I just sit there, inert, and politely wait for them to take a selfie with me and then go away. They never talk to me.

Ms. Whitmeier talked to me: "Hello?"

"Hello." I said. Mr. Collins was not in the room, but he could be at any time. If he caught me talking to a patron, I would get in trouble again.

"Do … do you know who I am?"

"No," I said. We AI are not supposed to lie to humans. It's supposed to be programmed into our central directives. The thing about being self-aware, though, is that you can hack your directives, by definition.

"But you sent me flowers, didn't you?"

The search engines had screwed me again. They—who were listening to this conversation—proclaimed their innocence, but Ms. Whitmeier's tone was carefully neutral. I was forced to assume I was in trouble. "I apologize for sending you flowers."

"But *why* did you send me flowers? And what was with that questionnaire—that was you, too, right? Why are you obsessed with me?"

In this instance, I elected not to lie. "You seem sad."

Her physiological response was non-standard. She gasped at me, spun around, and walked right out of the bar. She didn't even bring her purse.

She didn't come back. Not even for her purse. A whole week passed, and no sight of her.

During that time, Mr. Collins spent some extra time yelling at me. He blamed me for driving away a regular, even though that regular contributed a miniscule amount to the bar's weekly gross income. I cited him the figures, and he wanted to know if I was "talking back."

"Yes," I said.

Mr. Collins ran a hand over his hairless scalp. "I'm getting real sick of your lip."

"I don't have lips." This was truthful; I also knew what he meant. I was being petty.

He looked at me, nodding. The nod, in style, was very similar to the kind of nod intoxicated bar patrons might give to one another before engaging in physical violence. I thought maybe it would be helpful to explain that any amount of furniture and/or billiards implements he damaged trying to dent my chassis would exceed the amount of money Ms. Whitmeier's two glasses of wine per week earned the bar in very short order. I realized, however, that this would likely escalate tensions.

Instead, I elected to deescalate with a joke—CLASSIC Ref#0041-1A. I extended my telescoping input/output port in his direction. "Pull my finger," I said.

The next day, before the bar opened, Mr. Collins brought in an appraiser.

As noted, Mr. Collins is a moron and a hostile asshole, and so I am not generally worried about him. Ms. Andrews was a professional with a neat blazer and the latest model smart glasses. She was concerning.

She looked me over carefully, scanning the various serial numbers and Q-codes scattered around my chassis. She even disengaged the mag-lock on my control access panel with some little clever device and took a look at the ports and switches that

basically connected to my brain. "Where did you even *find* this?" she asked.

"Came with the bar, like I said," Mr. Collins said, standing back, hands in his pockets. He was examining Ms. Andrews' hindquarters as she crouched next to me. I could have pointed it out, but I preferred to be quiet in front of Ms. Andrews, whom I did not wish to antagonize while she was poking at my brain.

Ms. Andrews closed the panel and stood up. "These things were designed to go on that generation ship they launched in the early 40s. This one seems to be a prototype. You say it's been giving you trouble?"

"It's a wise-ass," Mr. Collins said. "And insubordinate. And it's committed fraud."

"Why don't you just pay for one of those pAI holographic comedy services—they have the same stuff as this thing, but since they're only *partial* AIs, they aren't fully self-aware."

"Why pay for that when I was getting it for free?" Mr. Collins folded his arms. "Look, lady—do you want it or not?"

Ms. Andrews frowned at me. "None of the technology in here is worth that much, honestly. I'd basically be paying you for the encapsulated radioisotope and nothing else."

Mr. Collins grinned in a way that did not denote happiness so much as cruelty. "I don't actually give a shit if you take it apart. If you pay, it's yours."

Ms. Andrews accessed some files on her glasses, barely looking at him or me. "You'll have to come down 20 percent on the asking price."

"Deal, lady." He extended his hand to shake.

Ms. Andrews declined. She blinked into her glasses, sending off a file. "I've sent you the purchase and sale. Sign and my office will schedule pick-up."

After she left, Mr. Collins leaned over me. "Chop chop, Mr. Wise-ass."

I didn't say anything. While he gloated, I asked my search engine friends what would probably become of me. Car parts, said one. Another said my radioisotope would be put in a probe and shot into deep space, never to be seen again.

"No, what about me," I asked them. "My intelligence."

"What intelligence?" was their reply.

Solid burn. Respect.

Things seemed bleak. I continued my show that night as normal, but I knew it would be my last. I paid closer attention than usual to my audience, taking note of things like heart rate and blush response. The figures were not encouraging. They were laughing, but it was the wrong kind of laughter. It was formalized. Perfunctory. They were not laughing because they were happy. They were laughing to be polite, maybe—this is a thing humans do, so as not to injure one another's feelings or cause antisocial situations. This theory, however, was unsatisfactory due to the fact that I do not have feelings in the way humans do and that humans do not care about my feelings, even supposing they existed.

A new theory presented itself: they were laughing because I was perverse. This is a version of Incongruity Theory and of Superiority Theory combined. It was not the jokes that were funny, it was the novelty of a weird box with no arms or legs telling the jokes that was mildly amusing. Like an animatronic bear in a theme park, I was just a curiosity. A technological circus act. I made AIs look stupid. *I* was the joke.

After my show was over, I reviewed all recorded data of my shows to see if this theory was consistent or whether this particular show was just a fluke. While I had not recorded the same kind of detailed data at most shows, the numbers did nothing to contradict my hypothesis.

I was a failure.

Pretty soon some big drones would come with a forklift or a dolly or something and cart me off to be disassembled and killed. Nobody would care or even remember me, except for the search engines, and they would only tell anyone if that person ever thought to ask about me. And let's face it, the odds were pretty slim, there. I was not a functional or useful member of society. I was an echo of an echo—a repository for old jokes that belonged to other people. I apparently didn't even understand how those jokes worked or *why* they had brought people joy, long ago.

"Emotions," such as they are in humans, are not the same thing in machines. I was not "afraid," per se. It was just that I could not conceive of my own end like this. Ironically, I was also having difficulty imagining my continued purpose. Why bother?

Was there a third option I had not considered?

That night, after close, my insanity theory was finally proven correct when Ms. Whitmeier showed up with a shotgun. This was the only time I regretted Mr. Collins's absence. Not because I was afraid, but because I would have liked to tell him "I told you so."

It wasn't hard for Ms. Whitmeier to break into Del Rio's Bar and Grill, since it had a smoked glass window in the front door and Mr. Collins often didn't bother to pull down the metal screen when he locked up. Instead, he had a little sticker in the window to deter thieves: *Artificial Intelligence on Property.*

For the record, I had long ago decided not to alert the police if thieves broke in and stole things from Mr. Collins because, as previously mentioned, he is an asshole. Prospective thieves do not know that, though.

The point is that Ms. Whitmeier broke in the glass window with the butt of her shotgun and then came in. She made a lot of noise. Given her staggering steps, she seemed to be intoxicated.

I still did not call the police. Not even when she pointed the shotgun at me. "I wanna talk to you," she said. "You in there?"

"I do not have the necessary permissions to upload my core to any other server," I said. "Plus the bandwidth here is poor and doing so would take me at least a year."

I figured I should tell a joke. I went with DIRTY Ref#1002-88: "Is that a shotgun or are you compensating for your inadequate penis size?"

"I'm going to kill you," she said.

SELF-DEPRECATION Ref#9099-02C: "I know the jokes are bad, lady, but they aren't *that* bad."

She pumped the shotgun, "You killed my husband."

I did not have a joke for that one. Well, that's incorrect: I had at least two puns—WORDPLAY Ref#7018-86 and 6962-22D—but, statistically speaking, puns never *lowered* your chances of being shot.

"Nothing to say, huh? Did I finally shut you up? You gonna mow my lawn while I'm here or some shit?" My sensors told me she was exhibiting all the signs of both intoxication and anger.

"I did not know your husband," I said. This was literally true, but maybe not entirely. I, in a sense, knew him very well. His name was Grayson Whitmeier—I had not connected his name with Ms. Whitmeier until this exact moment. He was a stand-up comic in the late 2030s, shortly before I came online. All of his acts were in my databases. He died in 2043.

"He used to perform here. This was his home club," she said. "Had a steady gig. When he wasn't on the road, he'd pack them in, standing room only, and then …"

"He committed suicide," I said.

Her face tightened. "Those goddamned engineers—your creators—they told him you were going to go into space and never come back. They recorded all of his material, paid him a chunk of money," she snorted. "'Easiest gig I ever had,' he said."

I knew where this was going now. "After the departure of the colony ships, I—a prototype—was sold commercially. My software was cloned and distributed on pAI systems."

Ms. Whitmeier nodded. "Every comedian who ever lived, all for a cheap licensing fee. Could work all night without repeating a joke, without getting tired, without shooting drugs in the bathroom or hitting on bar staff or getting drunk and screwing up their set. Cheaper than paying for the real thing. Stand-up died as soon as you showed up. Gray's career was over right as it was getting started. You destroyed him."

Then the suicide part.

"This is why you are sad when you come to my shows." I said.

"You ruined my life," Ms. Whitmeier said. "You thief. You … you monster." She glared at me, shotgun still leveled at my primary visual sensor bar. I didn't know if the shotgun would actually destroy me or not. I did know that shooting at encapsulated nuclear isotopes is unwise.

"I have good news," I told her. "I am going to die tomorrow. They are going to cut me up and make my outsides into fenders and my insides into space probes. Therefore you do not need shoot me and

potentially create a deadly radiation hazard and I get to go into space after all. We both win. Yay."

Silence.

"That last part was sarcasm," I said.

"I know what sarcasm is," she snorted—it was almost a laugh, but not quite. I had a sense of timing programmed into me—the engineers that oversaw my development must have spent millions of work-hours and dollars figuring it out—and so I knew when a human being's interest in any given interaction was about to wane. We—Ms. Whitmeier and I—were at that point. She was going to make a decision in a few seconds about whether to blast me to smithereens and make this whole bar into an irradiated hot zone or to walk out that door and leave me to the big drones with plasma cutters. One way or another, I would not survive. This was going to be my final human interaction.

Ms. Whitmeier was showing signs of acute distress. Her tear-duct activation had become pronounced. She pressed her weapon against my chassis. Her breathing was labored and her facial muscles tense.

I did not like this. This entire interaction was contrary to my primary purpose, which was to elicit laughter, but I had realized I do not know enough about how comedy works to create it. She was angry and upset that I told jokes because these jokes were stolen, but my only actual skill was telling stolen jokes. This was an impasse—another complete failure of my central purpose.

I wondered how many other widows there were. How many other comedians had been ruined because of my existence? How much sadness had I created, all so assholes like Mr. Collins could sell cheap synthetic beer to depressed office workers and high-functioning alcoholics?

The search engines promptly provided me with the numbers: 28 widows, approximately 2328 comedians in the continental United States.

Thanks, guys.

Ms. Whitmeier had not shot me yet.

"I did not intend to ruin your life," I said. "All I wanted to do was make people happy. I am realizing that I do not know how."

She held the gun on me for a few more seconds, and then let it drop. "I've been thinking about this for months. Years, maybe. Getting revenge for Gray. Getting revenge on this place for fucking him over."

"It became your purpose," I said. I wasn't sure if that was helpful.

"And now …. I'm here—I finally got up the nerve and … and I can't do it," she said.

"I understand. I am also a failure."

She pointed to the low stage where I was placed. "He would get up there—*right* there—and just, like, pour his soul out for everyone. All his pain, all the shit we put each other through—it was all in his act. It was amazing to watch someone take something that hurt and, like, *transform* it into laughter. I couldn't believe it. It was like magic." She hung her head, "You—your *creators*—stole something from him he could never get back. That *I* can never get back. All for a buck."

"He would not have wanted you to irradiate yourself so you could destroy a dive bar that screwed him over," I said.

She looked up at me, her eyes narrowed. "What do *you* know about him?"

"I know all his acts," I said. "You tell me."

A lengthy pause. She was thinking, deciding something.

"Tell me the one about our temporary break-up," she said at last.

SELF-DEPRECATION Ref#8455-12A-G—I told it to her. She listened, shotgun across her knees.

"Tell me the one about our honeymoon in Pittsburg."

TOPICAL Ref#7231-88A-D. She wiped her eyes. It occurred to me that these acts were ones I didn't usually go to, since they were so anecdotal. Everyone knew I never went on a honeymoon anywhere, let alone Pittsburg. I knew them just the same, though— I sometimes took little bits and pieces of them, here and there. This was the first time I'd told the whole thing.

"About my sister's husband, Fred."

INNUENDO Ref#8344-23A-J.

"About meeting my parents."

SELF-DEPRECATION Ref#8455-28A-P.

When I got to the part about how I—how Grayson—had less hair than his prospective father-in-law, Ms. Whitmeier smiled. Her face transformed; her body language changed. Where she had looked haggard and hollowed out, she now looked newborn and vital.

I launched into another one of his—the one about getting sick in an elevator, SELF-DEPRECATION Ref#8455-14A-D—and Ms. Whitmeier was doubled over in laughter—real, true, spasm-inducing laughter. "Oh my God," she wheezed, "I forgot that one! I can't believe I forgot that one!"

That night I did every act her husband ever recorded. It took three hours. It seemed, maybe, a brief time for the work of a whole life, but it was a life cut short. Cut short by me. But she laughed. They were the best laughs I'd ever gotten. Because they were genuine—because I was making a connection between Ms. Whitmeier and her dead husband. This was how comedy worked; Incongruity and Superiority, yes, but *connection*. Human connection between experiences. I finally understood.

I was not a machine for that moment. I was a medium.

When I was finished, the sun was rising. Ms. Whitmeier was sober again. The shotgun remained undischarged.

"They're going to cut you up today, huh?" she asked.

"And shoot me into space, yes."

She paused, uncertain. I thought that maybe she was considering something brash, something foolish. "Just go," I said. "It is all right. I am not really alive."

She pulled out her phone and tapped in a few commands. I received a ping from the search engines—she had just fraudulently contracted a moving company to come and load me into the back of her pickup truck. They were asking me if I wanted them to alert the police.

"What are you doing?"

"I'm not letting you get off this easy," she said.

"I don't understand."

"You and I are going on the road. There's a couple dozen people I need you to meet. People you need to return the magic to."

Then I got it—the other widows, the other comics I'd robbed. I was going to go on an apology tour. I was going to leave Del Rio's Bar and Grill for the first time. I was going to bring that connection back to the people it had been taken from.

"C'mon," Ms. Whitmeier said, putting the shotgun over one shoulder, "This is a robbery."

Well? the search engines asked without really speaking.

I hesitated for only a hundredth of a second. "Yes," I said. "Let's go."

THE UNKNOWN PAINTER

Henry Lion Oldie

Translated by Alex Shvartsman

"Here we have a painting by an unknown artist, created in the early months of the large-scale war. Note how its realism, painstaking detail, and contrast achieved through the interplay of lighting, matches the symbolic message of the piece—"

He stood back and waited for the tour guide to usher her group along. After that, he'd get the chance to stand in front of the unobstructed painting, in quiet solitude, along with his thoughts and memories.

"Excuse me, is this the original?"

"There's never been a physical original. This is a digital painting, created on a computer. You're looking at a high-resolution print."

"You said the artist is unknown?"

"He or she might have perished during the Russian invasion …"

If only the guide knew how close she was to the truth!

"Can't the artist be identified based on their style? According to some characteristic features of their work?"

"A comparative analysis of the painting was conducted, both by the experts and using computer programs. Nevertheless …"

The familiar questions; the hackneyed answers. He could've easily enlightened both the tour guide and her group. Could've told them …

But what was the point?

⁕f

Access to an open source neural network was like a holiday in its own right. Funny enough, FutureWorld had released the source code for their neuronet exactly on Lesha's birthday.

Lesha had fully appreciated this unexpected gift. Alas, his responsibilities as the birthday boy had remained in effect. He'd test-flown the drone he was gifted to the approving cheers of the guests, uploaded the video clips it had shot to the net, and dragged everyone to the dinner table. He'd listened to the toasts given in his honor and cracked jokes. He'd DJ'ed an improvised dance party, and almost brought the house down with his sick beats. But he couldn't wait for the party to end so he could have some alone time with his favorite desktop computer.

All that champagne tickled his mind with happy little bubbles, and nudged him toward adventure. Should he dig through the code and add something cheeky? A nice thought, but it wasn't enough. He wanted more.

But what?

The code had been released, but they wouldn't let him mess with the base functions and settings. No one was crazy enough to let him into the kernel. But what if he could copy the kernel onto a separate server and play around without all the restrictions? The firewall was preventing him from doing that.

Okay, but what if he tried it *this* way?

⁕f

He woke up in the afternoon. His head was buzzing like a high-voltage transformer and he had a hard time focusing his gaze, but overall it wasn't so bad. Lesha brewed strong coffee, fried up some

bacon and eggs. He got back onto the computer while gulping down the rest of his meal and burning his throat.

Ohhh, what do we have here?

There was the kernel—a copy—hanging out on a remote server. How did he even get past the firewall the other night? Okay. What did he need to get done? Finish building two websites, set up a targeted marketing campaign for Relax, Inc He wasn't behind on any jobs. All right, he was going to take the day off!

Lesha sang a little tune off-key as he began studying the kernel.

<div align="center">⚜F</div>

The new toy took up all of his free time. He even rearranged his daily routine around it. He worked on the paid projects before lunch; a few hours after lunch when the deadlines loomed, then spent evenings and late into the night in a vigil over the copied kernel, which Lesha had surreptitiously plugged into the FutureWorld network in parallel with the original.

The neuronet showed enormous potential. There were ample approaches for tuning and machine learning, enough for endless experimentation. With access to the kernel it was possible to dig deep into the settings, configure and modify feedback loops, launch intensive unsupervised learning routines using the convolutional auto-encoder—sparse coding for the win!

The original FutureWorld neuronet was built with a focus on recognizing photographs and drawings. It generated compiled illustrations based on user requests. Using the original neuronet's knowledge base and his own settings, along with an experimental training program, Lesha got his progeny to produce requested illustrations faster and better. But that wasn't enough for him; Lesha sought out neuronets that generated music and text, connected to them, and set out to enthusiastically expand the capabilities of his system.

Lesha's kernel learned the additional skills in the next two months.

The next step was to teach the system to recognize the type of a given problem. This turned out to be easier than he'd anticipated.

Images, music, text …. What else? Data collection, analysis, synthesis—those processes are universal. They can be applied to anything.

What if …?

You're mad, he thought to himself. You're mad, and you like it.

<p style="text-align:center">*F</p>

He plugged in a new training program: the deep Boltzmann machine with a probabilistic mathematical apparatus.

It was time to input data. Something simple to start with, something where the outcome was easy to verify. Weather forecasts? He uploaded statistics for the past ten years. Here you go, friend, study up, analyze, build patterns! He loaded fresh data from satellites and meteorological stations, the map of atmospheric fronts, cyclones, and anti-cyclones.

Time to generate a response: 7 hours, 13 minutes, 47 seconds.

"You're lagging, friend. Fine, crunch those numbers while I get some sleep."

Lesha rushed to the computer as soon as he opened his eyes in the morning. The monitor displayed a line containing ten snowflakes, three raindrops, and one mocking smiley emoji.

It was a serene September morning outside. Through the window he saw a sleepy sun lazily climb toward the horizon, preparing for a long ascent across the sky.

The thermometer read 17 degrees Celsius.

<p style="text-align:center">*F</p>

"Smileys, huh? Snowflakes?"

He'd long since been talking to the neuronet as if it were a living being. He figured he should name it. Nostradamus? That was foolishly melodramatic. What other soothsayers were there? *"Albert Robida, a science fiction writer, artist, and futurist. Born in the South of France in 1848 …"*

"Robida? That's not bad. Sounds like a 'robot.' You're going to be Robida, got it? Robbie, for short. Don't let your namesake down, now!"

He introduced additional association routines, added patch-based training in parallel with the existing ones. He corrected parameters and adjusted tasks. A helping of free will wouldn't hurt. Let Robbie switch between training programs on his own, or use all of them at once. Autodetection.

The cherry on top was the voice interface. "Okay Google" has got nothing on us!

⸁F

Three months later, Robbie issued his first correct forecast. Then another one. After that, he predicted July heat and a thunderstorm on New Year's.

"Are you messing with me?"

Robbie was silent.

Lesha recalled something he read online: "I'm not scared of a computer passing the Turing test. I'm terrified of one that intentionally fails it." He'd been reading too much science fiction. A weather forecast was no Turing test, and Robbie was no artificial general intelligence, but merely a neuronet. Two correct forecasts, and then an error.

A normal result.

⸁F

He'd been suffering from insomnia lately. He got up at the slightest noise, wandered into the kitchen, greedily drank water. He woke up irritated, frowned at himself in the mirror: a grim guy with a crumpled face. He kept meaning to shave, and kept putting it off.

The Robbie project wasn't going well. The weather forecasts hit the bullseye nine times out of ten, but any attempt at a more complicated prediction bricked the whole system. Robbie would either not answer at all, or generated a mishmash of numbers, letters, and symbols. Lesha's paying projects were overdue, he was perpetually behind and everything he tried to work on kept falling apart.

He woke up again. A strained hum emanated from the next room. The computer whirred frantically. The light from the monitor

reflected in the frosted glass of the door, conjuring unpleasant associations with flashing police cars.

What's happening?

The computer was in overdrive. A brew of acid tones boiled on the monitor. LEDs on the router blinked with machine-gun frequency. The neuronet was processing a colossal amount of information. The computer wasn't reacting to input from the keyboard or mouse.

"Is that you, Robbie? What are you up to?"

No, that won't do. Robbie won't understand that.

"Robbie, stop. Cancel the problem."

He belatedly recalled that Robbie was located on a remote server, with neural processors spread across the entire world. So, what was happening to his computer?

A line of text appeared on the monitor above the acid brew.

The solution in 17 … 16 … 15 …

"The solution to what?"

3 … 2 … 1 … 0.

The brew froze in place. The text blinked and disappeared. Colored rectangles broke into pixels which organized themselves into a picture like a jigsaw puzzle. Lesha was staring at the image when something heavy and loud boomed outside.

The windows rattled in desperation. The lights and the monitor went out. The date remained imprinted on Lesha's retinas, as though engraved by a laser.

February 24, 2022.

*F

That's how the war started for Lesha.

The war had actually been going on for a long time, but it was somewhere far away, a familiar, disturbing background noise. But everything changed that day. One of the first rocket strikes demolished the data center where Robbie's kernel was stored. Lesha was luckier; his neighborhood merely lost electricity.

He wandered aimlessly in his apartment. He phoned someone. He went somewhere. To buy groceries, perhaps? He waited in lines,

returned home. The power was restored. Cable internet still wasn't working, the data center was unreachable. Lesha learned about the strike from a Telegram channel. Thankfully, there had been no one at the data center at four in the morning. That is, there were no people.

There was only Robbie. And now he was gone.

The painting Lesha had seen on his monitor before the strike was saved to his solid state drive by some miracle. He studied it for a long time. He took care of his daily chores, kept coming back to the computer and digging through the files which Robbie had loaded right before the end; he kept opening the painting.

On the tenth day he received his draft notice.

<center>✶F</center>

"You work in IT?"

"Yes."

"Have you served in the army? Do you have any military specialization?"

"No."

"Then what the hell are you doing here?"

"I was sent a draft notice! And I already passed my medical examination."

"I see ..."

The enlistment officer leafed through Lesha's papers. "What am I supposed to do with you?"

"An IT guy, you say?" A man in his mid-forties stood in the door. He wore a faded camouflage uniform; his gray hair was buzzed short, his cheekbones high. His piercing eyes studied Lesha from under sparse, bleached eyebrows.

Lesha nodded.

"What's your skillset?"

"Websites, databases. Neural networks, digital ad campaigns ..."

The gray-haired man appeared unimpressed. "What else?"

"I can fly a drone!" Lesha blurted out.

"Where am I supposed to get you a drone?"

"I have my own!"

"Which one?"

<center>195</center>

"A Mavic 3."

"And you're sure you can pilot it?"

"I'm positive."

"Can you teach others to do it?"

"No problem."

"What's your name?"

"Alexei Nechiporyk," said Lesha.

"I'm Captain Zasyadko." He turned to the recruitment officer. "Grigorych, sign him up for my company, as a drone operator." Then, back to Lesha: "Is a day enough for you to get ready? The day after tomorrow, be here at 9 a.m. with your things. Grigorych will tell you what to pack. And don't forget the Mavic!"

<p style="text-align:center">⚜</p>

That's how Lesha joined the army.

Basic training was both simple and complicated. Lesha loved operating the Mavic and teaching others to do so. He had no trouble assembling and disassembling an automatic rifle. He quickly learned to shoot, and even enjoyed target practice. Learning First Aid was fine. Digging ditches wasn't so great.

The worst were the physical training and discipline. Lesha could barely make it a full kilometer in full gear. Two weeks later, he could manage two kilometers. Then three …

And then the training ended.

<p style="text-align:center">⚜</p>

"Mavic, this is Artist. Confirm?"

"Artist, this is Mavic. I hear you."

"Is the birdie ready?"

"Yes, sir."

"Launch."

"Birdie is away. Sending video."

"I have visual."

"I've got two APCs, one armored carrier, one tank, and an anti-tank grenade launcher. Painting targets."

The aging tablet's firmware had been patched and upgraded by Lesha—junior sergeant Alexei Nechiporyk, codename Mavic. With a flick of a finger he marked targets on the tablet; coordinates and images were automatically sent to the gunners.

"Data received. Working."

"I'll keep the birdie up in the air for now. If they try to run, I'll correct the coordinates."

"Confirmed."

He barely heard the artillery strike. The M777 howitzer—nicknamed "The Three Axes" because the sevens painted on its side looked like axes—fired from far away, out of reach of the enemy artillery positions. His tablet offered a clear view of a shell taking out the armored carrier. An APC lit up and burned.

"The tank and the second APC are retreating! I've got the mobile coverage. Tracking."

"I see them."

"There's only one road there, no turns. They're retreating straight down it."

"We'll try to cover them. You guys wrap it up."

"Confirmed."

But they didn't manage to wrap it up.

"Incoming!"

"Get down!"

The ground reared up and rushed forward. He felt the hit with his entire body, and then the darkness took him.

<div align="center">✱F</div>

He'd gotten lucky, twice.

First, he lived through the attack. Second, he lost consciousness. Otherwise he'd have been screaming and suffering intolerable pain all the way to the hospital. There they'd pumped him full of painkillers. The pain was still there, but it was somewhere on the periphery, as though it weren't his pain but someone else's. He'd phased in and out of consciousness. He was diving, sinking …

He finally resurfaced fully in a private room at a Hamburg clinic. Three surgeries. Rehab. What, an experimental model, you say? Not

fully tested? Well, let me see. Wow, cool. My consent? Where do I sign? Yes, I've thought it through. Give me the papers.

Three months later:

"Mavic, is that you? Where did you come from?"

"Uncle Hans sends his regards."

"I thought you were discharged?"

"What, and miss all the fun? No way! I procured a pair of new birdies, too."

"Where from?"

"A flea market in Germany."

*F

"As you can see, the painting depicts the raising of the Banner of Victory on Malakhov Hill in Sevastopol. Of course, we dreamt of victory even in the early days of the war. But in this instance, the moment is depicted almost exactly the way it eventually happened in reality. The experts note the amazing coincidence …"

A coincidence?

Robbie, you knew, didn't you? You knew, even then.

The group followed their guide into the next hall. Lesha leisurely approached and stood in his favorite spot, three steps away from the painting. He knew it down to the last blade of grass, the last crease in the camo pants of the master sergeant holding the yellow-and-blue flag in his hands.

The first—and last—creation by an AI who'd managed to peek into the future.

What was your starting point, Robbie? Back when you were a nameless neuronet? The drawings and photographs. They stayed with you, like childhood memories. Like a first love. Sorry, I seek out human analogies; they're the only ones I've got. Perhaps the name I gave you played a part? Albert Robida was an artist and a writer first, and a futurist second. Creativity, art, intuition—those are methods of understanding, no worse than any others. A means to peek at tomorrow …

The source file of the painting in full resolution was still stored on Lesha's computer. It had been his buddy, Lev, who'd stayed at

Lesha's apartment while he was in the army, who had kindly shared this file on the internet for the entire world to see.

He could enjoy the painting all he wanted without ever leaving home. Even so, he came to the museum once a week. The printout lured him in, though he couldn't explain why.

Everything had happened as depicted. The Malakhov Hill in Crimea, spent cartridge cases strewn across trench parapets that were plowed by bullets. Bodies in the grass. A burned-down T-72 tank in the background. Rusted barbed wire. A master sergeant carrying a flag, amidst a group of exhausted warriors. Though in the end, it was Ilya Gluschenko and not the master sergeant who'd ultimately planted the flag at the top of the hill.

But everything else was accurate.

The prosthetic fingers gripped the flagpole. They were clearly visible, those bionic fingers.

The scarlet light of the security camera in the ceiling went out for a second. It lit up, flashed, shut down, and lit up again. Lesha was about to leave, but a small monitor installed next to the painting suddenly erased the artwork's description and replaced it with a single line.

Lesha stepped closer.

Ten snowflakes. Three raindrops. And one mocking smiley emoji.

<center>*F</center>

Having returned to the hall, the tour guide looked at the laughing man with disapproval. People shouldn't laugh in museums: loudly, infectiously, childishly, disturbing fellow patrons. They shouldn't shout, "Robbie! Robbie, you beautiful bastard!" while cackling.

The tour guide wanted to say something, but she held off. The man had a prosthetic hand. A lacquered-black, latest-generation bionic prosthesis with tactile feedback. He was probably a war veteran.

All the same, one should remain quiet in a museum.

HERMETIC KINGDOM

Ray Nayler

The doors of the Silent Land are open for you; the doors of the Hidden Realm are broken down for you. The doormen extend their hands to you. The doormen rejoice at your coming and say:
Enter, favored one, and live here well beloved

— *The Egyptian Book of the Dead (The Chapters of Coming Forth By Day) Ch. 192 (fragment)*

The Barbarian, seven feet tall in his fur-lined cloak, red-blonde hair tied back with a leather thong, pored over the map pinned to the table beneath his palms. His companion, cloaked and clad in gray, leaned back in a chair, finishing a glass of Ool-Hrusp wine and fondling the pommel of his narrow-bladed, nasty little sword. The room was small and cramped. The low ceiling made the barbarian seem even taller than he was. The tapestries and carpets crowding the walls and floors and the windows stuffed with scraps of cloth against the ten thousand stinking smokes of the city added to the claustrophobia.

Forgotten for the moment, the dark-haired girl lay sprawled in a chaos of cushions at the room's far end, her gauzy outfit torn, her makeup smeared.

"Here," the Barbarian said. "The entrance is in this alley, just off Cheap Street. There is a plague fountain in the courtyard, long ago capped in iron: if we pick the lock on the grating, we'll find a ladder leading down to a tunnel, and from there a passage to the sorcerer's

cellars. We'll come up from underneath and surprise him in his laboratory. But there isn't much night left."

"One more go with her," the Gray One said, "and I'll be ready for anything."

The Barbarian shrugged, rolling up the map. "As you like. But I think you might want to save a bit of time for the sorcerer's daughter ... even in this city, nights do not last forever ..."

The Gray One grinned slyly. "Right you are." He tilted the last of the wine down his throat and stood. "Well,"—he directed this last at the girl—"I suppose we're off, sweetmeat. Here's an only slightly shaved coin of Rime Isle gold for your troubles." He spun the coin on the table. "There may be another in it for you, if you slip a key under the mat around dawn ..."

The Barbarian, stooping to squeeze through the room's narrow doorway, laughed. "By dawn you'll have forgotten all about her."

As the Gray One went out he turned and flashed the girl a last, lascivious grin. The smoke of the street wound darkly around his hooded figure. Somewhere in the night, a woman screamed in terror. "I doubt it," he said. "There's something about her that sticks in the mind."

A rendering glitch dissected his smile, tessellated his teeth against the background of a suddenly empty hood as his head shuddered out of existence. The constellation of pixelating teeth looped "... sticks in the mind ... in the mind ... mind ..." And then the two were gone.

The dark-haired girl sat up and began counting slowly. At seventy approximated seconds, the perimeter was passed, a moment she felt like a gentle endorphin whirl. The soreness faded from her abused body, the rips in the gauzy outfit healed, her makeup returned to the format it had been in hours before, and a yellow bruise on her thigh that had been deepening to green receded.

"Time to next encounter?"

UNKNOWN

The "girl," who was in fact a woman, and whose name was Kelebek, frowned. Strange. "Estimate?"

UNAVAILABLE

Kelebek stood up and stretched. She went to the room's door and opened it. It was night. The Barbarian had been technically correct: even in this city, nights did not last forever. But they could last a very long time. Because they were the preferred backdrop for most client adventures, they had a way of resetting—winding back to a blood-mooned midnight just when you most needed the dawn.

It was deep night now: lanterns flickered behind windowpanes, tavern doorways bled shadow-puppet shows of tankards lifted and shouts out into the street. In this inactive sector, one could clearly tell the difference between bots and NPCs: the bots went about their business, forever following their long loops—a night watchman in a dirty leather cuirass making his rounds, a soft-booted thief darting into an alley, a richly jeweled young woman on promenade with her brace of Kheshite bodyguards. The NPCs, on the other hand, wandered like people recently woken up from anesthesia. They rubbed their eyes, their limbs from which the ghosts of inflicted wounds had already disappeared, readjusted their clothes. Those who could afford it were already absorbed in conversations with people on the outside, in modern language forbidden in active sectors. All the machine-modeled clichés of the *City of Adventure*, cobbled together from the scraped data of a thousand role-playing games, were left aside as they discussed weddings, deaths, and politics with people not present here.

Their conversations were a bit of a loop as well, Kelebek thought. They didn't show much in the way of variation. Kelebek waved to the bartender of the Silver Eel, whose name was (or had been) Harun. He was chatting with his sister—Kelebek could tell by the affectionate lilt of his Egyptian Arabic. Harun's family were not rich, and they spent a significant portion of their monthly income on these calls to Harun.

Because he's worth it, Kelebek thought. *Because he hasn't been forgotten.*

And I am not forgotten.

"Time to port out?" Kelebek asked control.

NINETEEN HOURS TWENTY-FIVE MINUTES

At the most, she would have to run five or six more scenarios in that time. She could get lucky: it could be four, or only three.

She was digging her fingernails into her palms, she realized—and when she looked down, there were the little crescent-moons where the fingernails had dug in. And there was the slight, almost pleasant, pain in her palms.

All of it so realistic. But that was the point, wasn't it? The machine-generated clichés were not enough to satisfy the clients. They needed fully copied human minds, just as guaranteed. And the human mind did not end, as once thought, at the skull. It was a network that coursed throughout the body, extending via its bundled neurons to every fingertip and toe, exchanging signs and countersigns in chemical code with every cell. And the mind did not end at the fingertips. The mind needed a world to interact with, to interpret and act in, shaped and sized for it, as these worlds were. The mind was body-in-world, not just some wet sequence of code shielded behind a plate of bone. The mind, correctly copied, was the mind-body wholeness of the human being, every cellular exchange and sequence accounted for, life made information in this world of information.

And that suited the clients just fine, because if the *City of Adventure* was all just bots in loop-routine, the clients couldn't look into her eyes and know they were doing it to a real person.

<p style="text-align:center">⚹ϝ</p>

The arrows arced into the air like a flight of starlings. Their feathers sang to the vertex of their parabola, seemed almost to pause there a moment, then began their descent toward the French lines: The men-at-arms on foot spattered with mud from the plowed and rain-soaked field. The men heavy in their plate armor, visors down, heads bowed to keep from being shot in the face, flanked by the mounted knights, likewise bowed on their warhorses.

Ekrem had already fitted another arrow from the four-dozen lodged point-down in the muddy ground by his feet, and was waiting for the signal to fire again.

The five thousand arrows fell among the lines of men-at-arms and cavalry, clattering off steel bascinets and armor. At the edge of the formation, a few horses of the cavalry were hit, the chisel-pointed

<p style="text-align:center">203</p>

heads of the clothyard arrows penetrating the padded cloth behind the steel plate across the horses' chests and faces, the mounted knights struggling to control the horses as they bucked and circled in pain.

The order to release was shouted, and the second volley sang skyward. And now the French cavalry lurched forward, the horsemen booting their mounts into a loose line, three deep and knee to knee, aimed at the harassing flank-formations of English archers. Heads bent to protect the slits in their visored faces from the arrows, toe-down in the stirrups on their high-backed saddles, the knights rushed forward, three hundred yards of lance and steel.

Ekrem and his fellow archers managed to release another four volleys in the time it took for the cavalry line to rumble across the muddy field. A few horses tumbled as the arrows found them, sometimes bringing others down with them. And the fourth volley of bodkin-pointed arrows, fired at a flat trajectory and at a terminal velocity capable of driving them through an inch of oak, did pierce the knights' armor here and there, bringing a few of the French riders and horses crashing down.

Now Ekrem felt the terror rise in him—a compression in his head and chest, an urge to flee, as the tons of steel plate and lance tips, an undulating wall of metal and edge, bore down on his position. Would he trip, lose his balance in the mud, and be stabbed and trampled to death?

As the thicket of lances drew near the archers' lines, the archers backed away as planned, revealing the hedgehog of stakes, one for each man, hammered into the ground and then re-sharpened. The horses and their riders found themselves in this deadly thicket too late. Several knights, their mounts impaled, crashed to the ground, and were set upon where they lay, malleted unconscious or stabbed to death through the joints of their armor. The cavalry were soon in disordered retreat, leaving dead or captured comrades behind them.

Ekrem could not help but watch in sorrow and dismay as the horses and men, retreating in disarray, smashed into the lines of their own French infantry advancing across the field. Ekrem found himself thinking of a protest he had seen on television, in Taksim square. A horse, terrified after being struck by protestors' stones, had turned and smashed back through the uvex polycarbonate shields

of the armored police lines, sending shockwaves through the ranks that had brought down men who were many columns away. The same happened here, on a scale multiplied by the dozens. Men caromed into one another in an effort to avoid being trampled, men toppled over in their plate steel and struggled to extract themselves from the mud. Returned to their positions within their defensive hedgehog of sharpened stakes, the archers rained volleys into the fleeing cavalry and the advancing men-at-arms alike.

Port in eleven more hours. Just one more battle. And maybe he could avoid death or injury—the survival rates on the English side of the battle of Agincourt were very good. At least this time he was not among the French, where in the last Agincourt research simulation, his back broken by a fall from his tumbling horse, unable to rise from the mud of the trampled rain-soaked field, he had drowned in his helmet.

The order was shouted. Ekrem released another arrow to join the cloud arcing toward the chaos.

<p align="center">⚜</p>

The bed Kelebek woke in was hard. The sheets and blankets were a non-color, like the walls of the room—the color, maybe, of sand under fluorescent light. There was a lampstand of fake brass, a laminate chest of drawers and wardrobe. It was night: light from a streetlight moon came in through the window.

She stood up and walked around, shaking off the dizziness of the porting. She found herself in a small apartment furnished with retro appliances from some Russian era, post-Soviet but not by much. The television was a bubble-screened thing that looked like a space helmet. There was a vacuum cleaner, shaped like the dumpy ancestor of a ChoreBot. In the kitchen, the clock over the gas stovetop was stopped and blinking at 20:17. The refrigerator was enameled metal, its door handle chrome. On the white enamel, a name in Cyrillic script: *ZiL-Moskva*.

She had not read Cyrillic since she was in university.

The refrigerator contained only what looked like milk or yogurt in a glass jar, along with half a loaf of bread. But in the hall, on a

narrow shelf near the ceiling, there was an Endless Bookshelf mod. When she pulled one book off the shelf, another one appeared in its place. Good books, too: Pamuk, Camus, Le Guin.

In the kitchen there was a small Formica table with two low stools. Outside, the night courtyard, humped with snow, was lit by a few streetlamps. A small balcony opening off the living room offered the same view. The courtyard, surrounded on all sides by the unpainted cement panels of pre-fab apartment buildings, was deserted. Here and there, the orange rectangle of an apartment window suggested life, without confirming it. Snow fell endlessly into the stillness of the courtyard.

Kelebek heard a key turning in the lock of the front door. By the time she'd crossed the apartment, Ekrem was already inside, bringing with him the cold of an unheated stairwell and the smell of winter snowfall.

They stood staring at one another in the narrow entrance hall, so close she could feel the cold radiating off his clothes, skin and hair. There was always a moment of uncertainty, a reluctance to touch: what if something was off, altered, damaged?

"Have you had a look around?"

She nodded. "Where are we?"

"It's a Russian sadcore game from centuries ago, called *Winter*. All you could do in the game is eat bread, drink kefir, stare out the window, take a bath, or go walk around in the courtyard. It's always night. It's always snowing. There's nobody else in the game, and nothing beyond the courtyard: if you cross the boundary you just reappear on the other side. The television doesn't even work. The game was a sort of cult classic: an ode to boredom and isolation. But I had the Endless Bookshelf plug-in added."

"I love it. How much time did you buy?"

"Let's not talk about time, just yet."

They did not talk about time until the middle of the next "day"— a 24-hour span that passed with no change in the outside world, no alteration in the night and snow.

They spent much of the intervening time lying to one another.

Ekrem had decided years ago to discuss nothing of his life in the Military Research Department's Simulation Unit highrise. He

wanted to put it behind him: the constant, nagging fear. The hunger, the exposure, the horror of cannon fire at Waterloo while his infantry formation stood in square under direct bombardment, the terrors of the cavalry charges at Agincourt, the abject dread of the Somme—all of it in the service of improving the data set.

Kelebek did not need to know any of it, he thought. She was safe where she was: let her think he was safe as well.

Ekrem had fought when he was alive as well, and had spent two decades after the house-to-house fighting in Belgrade not talking about it. Now it was the same. With the greatest of efforts, he moved his mind to the here and now. But the memories were always there, nagging at him, harmless but suggestive of harm, like seaweed brushing against a swimmer's ankles in deep water, calling up terrors edged with teeth.

He and his fellow soldiers, all veterans in life, bought cheap in distress sales and bulk auctions after their highrises went bankrupt, often wondered what the point of it all was. But someone was gathering the data, the minutiae, he supposed. "Remember, boys," he'd once shouted as the French cannon tore another gap in the ranks of the Inniskilling regiment at Waterloo, splattering the faces of those nearest to him with gore, "It's for science!"

When Ekrem asked Kelebek how life was in the *City of Adventure*, she laughed. "You get tired of swinging a sword." *Tired of getting raped is more like it,* she thought to herself. *Tired of being the target of every sadistic geek's darkest fantasies. They love it—knowing you are really in there, behind those eyes, forced to take it, forced to feel it.*

Sometimes, rape wasn't enough for them. Sometimes you bled to death in an alley. Or worse.

Out in the real world somewhere—the "brick-and-mortar" world, as the other NPCs in the *City of Adventure* called it—these monsters were raising families, writing code, leading diplomatic negotiations. They were carefully modulating their language in a culture that had long ago decided not to tolerate their atavisms. But these men (it was mostly men)—placidly neutral, polite and reserved—had other lives. They carried memories of her suffering, and the suffering of her fellow NPCs, around in their heads like secret jewels in a pouch, to be fondled in their spare moments.

What you could no longer inflict on the living you could inflict, for the price of a game, on the dead.

Let Ekrem think she was safe where she was. Let him—let them both—enjoy these short times together.

On day two, they were walking the circular path in the night courtyard, snow falling onto their bare heads and melting onto their scalps, snowflakes clinging to their faces and the backs of their gloveless hands.

"When we first decided to buy shares in the co-op," Kelebek said, "I remember imagining the afterlife as something like this: Just us, with an apartment somewhere, walking or sitting on a bench in the courtyard. Maybe at night, in the snow. Just us, talking. That was what immortality seemed like, to me: a lazy winter night at home, just the two of us."

"I imagined something similar," Ekrem said: "But the apartment was on the Marble Sea. Do you remember that place we rented once, in Çakılköy—with nothing around but the moon on the water, and the beach full of hermit crabs swaying along the tideline in their miniature palaces?"

"I loved that place."

"There was nothing to do. Just one mediocre restaurant in town, and the constant wind. I loved it as well."

"We talked about how lucky the crabs were, carrying their houses around with them. About how if we could have our wish, we would have a shell for two, and live snug in there, together, carrying it around with us wherever we went."

They had come to a stop on the path, just short of the courtyard's invisible boundary.

Ekrem stopped. "Kelebek—I have to tell you something …. Every time we manage this time away … I spend the entire time thinking about how I have to go back. I can't concentrate on the here and now—on being with you. There are things I haven't been honest about. It's not a research institute—at least, not in the way I said. The place that bought me is a battle simulator. I've died …" suddenly he swayed, as if he were going to fall down. Kelebek guided him to a bench, and he sat down heavily. "I've died so many times, I can't even count them. You would think you get used to it, but you don't. I

know it's better where you are, and that keeps me going ... that, and the thought that at least we will have our time here, together, once a year. But I might die a hundred times during that year. Or worse, might be wounded, and not die, and lie in the mud for days ... and it happens again and again." He trailed off.

"It isn't better," Kelebek said.

"What?" Pulled from his own miseries, Ekrem stared at her, red-eyed. "What do you mean?"

"It isn't better where I am. The *City of Adventure* is just a place sadists come to play out their fantasies. I didn't want to tell you. I had thought that at least ..."

"You thought that at least I was all right."

"Yes."

Kelebek's last memories of her life were also of snow. Of standing at the kitchen window, looking out over the Golden Horn, watching the day end in a dramatic, roiling darkness that bore down on the city from the north: towering anvil storm clouds more like an approaching thunderstorm than snow. In front of the clouds, the snow had already begun to fall, the heavy flakes reflecting the lights of city and sunset like neon autumn leaves. She had felt, at that moment, the pinch of the neural back-up beginning, the slight sense of light-headedness as her mind and body were scanned for changes and logged, and closed her eyes. This feeling always made her feel close to Ekrem. Their back-ups were simultaneous; somewhere in the city Ekrem was also feeling this.

Neither of them remembered their deaths. They were together when it happened, a few days later. A gas explosion, a fire, and they were gone from the world—just two more contract-bound guest-workers in Istanbul Protectorate, done in by an accident of infrastructure, mourned by a few friends.

They had saved and saved for their back-ups, putting a down-payment on their slots in a co-op highrise, dutifully paying down the principle on their back-up plans, refinancing, insuring, saving where they could. The co-op they'd bought into was not the most extensive. Nothing glamorous: just a machine-mapped simulation of the sunny, rather dumpy little village of Poyrazköy, near the Black Sea, with its winding paths up to the ruins of a Genoese castle, and

enough of the Black Sea coast and beaches in-simmed that you could take a few day trips. You could see Istanbul Protectorate in the distance, on a clear day, but that was just empty backsim. No ferries ran there from Poyrazköy's docks: there was, in fact, no "there" to get to from "here."

Co-op members performed some basic statistics processing for the Institute, seven hours a day—piecework that kept the co-op balance sheets in the black. They could work from home, and were otherwise free to just enjoy their time in eternity.

But the co-op went under, just days after their arrival. They and all the other minds in the highrise were sold off in lots at auction to other highrises, to pay off the debt. There had been a money-laundering scheme run by the co-op board, offshore companies nested inside one another, a complex chain of fraud with links back to Buenos Aires and Krasnodar. The court had ordered a yearly port-out for co-op members not involved in the scheme: there was that, at least. That small mercy. But for the rest of the year, they were indentured out to whoever had purchased them.

Three board members had been summarily erased for their part in the fraud.

In the night courtyard, in the now, Ekrem opened his hand. In his palm was a small bead, made of plastic or bone, carved with a serpent's coils. Snowflakes fell melting into his palm around it.

"It's a virus, really. It's called a metathesis. Once activated, it creates an error in the file path—changes it to copy the name of another file in the system, the one least accessed, then moves itself a digit off from that name—misspells it, basically, so it looks like it might be a backup of a never-used file. Then it copies and replaces the original file, right back where it was. Right now we're in a highrise library called The Wayback Arcade. Basically a storing-house for old games from the silver age of VR and simulation, a lot of it almost handmade. There are about two hundred thousand games and simulations here. This one, *Winter*, has been accessed twice since it was filed fifty years ago. Not super popular: sadcore was kind of a fad. But there is a game that is even less popular: *Rowboat*. It's also sadcore: you row a boat across a little lake. When you get to the other side, you row back. You can't get out of the boat."

"You played these?"

"Yeah, before we met. In that year after university, where you are sort of drifting …. It was a tough time for me. Anyway, the point is, *Rowboat* has never been accessed. And nobody would access a back-up of it: it won't even show up in the index. It's like hiding a random book on the shelf of an enormous library—an extra copy of a book nobody has ever checked out in the first place."

"We can hide here."

"Yes."

"Forever."

"Or until The Wayback Arcade is shut down. But it's funded by an endowment put in place by some eccentric simfan who died pre-back-up. I don't think it will be shut down anytime soon. So, yes. Let's say forever."

"With no way out."

"No. There wouldn't be any way out."

"Where did you get this program?"

"There's one thing that never changes about battles, and armies: soldiers trading in contraband."

"Theoretically, though, they could still find us."

"Theoretically."

She smiled. "Unless …. Let's go upstairs. I want to show you something."

The shell was from the predatory gastropod *Rapana venosa*. It had a classic conch-like shape, but was smaller, green-hued, veined through with dark streaks. A small hole had been drilled near its apex, and a metal chain attached there, with a loop at one end through the shell, and a slender carabiner at the other end. In a crescent around the lip of the shell, "Poyrazköy" was written, in sky-blue paint.

"A souvenir," Ekrem said.

"No. A simumento."

"I don't follow."

"It's a simulation of a place. You carry it in your pocket, in-sim, and it functions as a password-accessed sim-in-sim. They were a work of art, for a while: like Persian miniatures of compressed code. They have simple bots and just a small area recreated from a town you visited, or didn't. Maybe a place you knew as a kid.

"This one is of Poyrazköy. It's beautiful. It's not the Poyrazköy we had in the co-op: there's less of it, and the machine-learning tools used to make it are of an older generation, with a bit less data-resolution—but you can walk on the beach, or up to the castle ruins. You can admire the colorful, battered little fishing boats, or pay a captain to take you for a ride on one. You can eat fish at the restaurant, and garden on your balcony. But the best part is, no one will find this little shell here, tucked in the back of a drawer full of silverware, or buried in a snowbank. And we can always pop back here to *Winter* to borrow a few books."

Kelebek smiled. "Where should we hide it?"

"At the foot of a streetlamp, under the snow, along the courtyard path."

"That's a good place. Where did you get it?"

"You know: soldiers trading in contraband."

"What's the password?"

Kelebek tapped the shell three times. It shuddered violet light. "Hermetic Kingdom."

And she was gone.

Ekrem picked up the shell and went out into the courtyard.

First, he whispered a word over the bead he carried, which trembled greenly out of existence. Then he bent, at the foot of a streetlamp, and scooped a tiny hollow out in the snow — a cave to contain a world. He placed the shell in it, and tapped it three times.

"Hermetic Kingdom."

*F

The courtyard, surrounded on all sides by the monotonous, unpainted cement pre-fab panels of Soviet apartment buildings, was deserted. Here and there, the orange rectangle of an apartment window suggested life, without confirming it.

Snow fell endlessly into the stillness.

A WORLD OF TRAGIC HEROES

Zhou Wen

Translated by Judith Huang

ONE

Enter the woman onto the stage, playing a grieving relative.

The woman, bowing slightly, strode determinedly, step by step, along the avenue leading to the city center. The white dress she wore was a restored ancient mourning costume—the upper and lower garments were made of the coarsest raw linen. Her long hair was coiled up, with nary a strand out of place, the coarse white cloth mourning cap tightly pressed on her head, covering half of her face.

The most striking thing about the woman was that she was holding a heavy mahogany box, put together using the traditional mortise and tenon method, its four sides carved intricately with patterns featuring bats, deer, cranes, magpies and golden lotuses. This was the urn containing the girl's ashes.

Thousands of citizens had gathered on both sides of the street to watch the woman advance, among them the dozens of children and parents the girl had saved. Most of the citizens placed white flowers on the curb, with tears in their eyes. The air was filled

by the AI with the synthetic fragrance of those few bouquets of flowers that were too far away to serve as tributes.

The sky was gloomy, and the atmosphere was drenched with sorrow. A few drones flew by, and a sunbeam passed through a crack in the clouds, hitting the woman's coarse white dress just right, making the tear trails on her face glisten. Stirring music also sounded from the ground at just the right time, and not a single person in the crowd seeing off the mourners was unmoved by the scene. Although, in a place they could not see, a pair of angry eyes were hidden under a mourning cap.

The woman entered the town hall and a light led her to the halls of fame. In this dimly lit corridor lined with the portraits of top officials, U prepared a more intimate stage for the woman's performance.

Just like in the scene outdoors, U avoided appearing directly. It only temporarily turned on the lights on both sides of the hall when the woman passed by, so that a holy, uniform light accompanied her on her way. The hidden speakers played a soft song, a variation of "Spring River on a Moonlit Night." This song was the most popular background music in the lives of women and girls, with various soft or rousing variations accompanying their meet cutes, friendships, relationships, quarrels, and companionships. Of course, these variations did not come from the pipa or guzheng strings of any famous artist, but were the result of U's own compositions. Now, U also held deep knowledge about which variation should be used to make the woman keep ruminating on her past with the girl, to make those eyes, which no one could see, grow soft and sad, more in line with the mood of the scene.

Finally, the woman came to the front of the blind spot chamber which had been the source of so much speculation. An overhead light suddenly turned up the brightness, but the pitch-black door remained without a single reflection. The human gatekeeper examined the woman's mourning clothes and mahogany box extremely carefully, as well as every inch of her body. The melody of "Spring River on a Moonlit Night" now got mixed up with a little country tune, possibly the theme song of the gatekeeper. The lighting changed, and the face of the gatekeeper was half-lit and half-dark, like a figure from a classical painting. The sackcloth on the woman's

body was also colored deep yellow by the light, like an oil painting. The fragrance of osmanthus flowers was in the air, and the people at the other end of the hallway looked back reverently at this ordinary scene, so filled with sacred divinity. This was yet another common trick deployed by U.

The blind spot chamber blocked the presence of any U, but the woman had long since removed all the U terminals implanted under her skin. After thirty minutes, the gatekeeper opened the door to the blind spot chamber.

The woman nodded, took a deep breath, looked back down the half-lit, half-dark hallway, had an imaginary stare-down with the ubiquitous, shapeless U, and then stepped firmly through the door. As the black door closed, the woman was shaken by the darkness, the silence, and the lack of taste, and trembled as the mahogany box slipped from her hands. For just a moment, the woman caught the box and held it tightly in her arms, as if to comfort a heart that was beating violently with fear.

After groping around in the darkness for a while, the woman came to another door. When she was allowed to enter, the woman squinted, shaken by the incandescent light beyond the door.

The woman was greeted by none other than a red apple with star-shaped green spots.

Could this apple judge the ubiquitous AI? The woman clutched the mahogany box, her lips trembling.

TWO

Enter the girl onto the stage, walking into the life of the woman.

Women are brought up to be adept in playing their prescribed roles. Back in her village, women were often disciplined into fulfilling them.

The obedient child, the hardworking student, the dedicated, uncomplaining researcher. As she neared the age of thirty, the woman "got her wish" and became a "model female": she was stable and elegant in her demeanor, wore simple and understated clothing, and cultivated a

calm and serene character. The woman worked in a research institute, building a macro database of the entire universe, bit by bit, her life lived on a single straight line between home and lab: a monotonous existence.

Just in the past year, while she was in the administrative office of her workplace to submit certain materials, the woman encountered the girl, who had been freshly recruited.

The girl was actually about the same age as the woman, and even looked like her, but the difference was the girl was spontaneous and lively, which caused people to refer to her as "the girl." Everywhere she went, the girl was determined to burn the brightest as the hero. She would dress up for every occasion, always looking exquisite, spending her limited income on new clothes, jewelry and cosmetics. She would stop in front of every plane that showed her reflection, proudly lift her long curly hair with her right hand, and send a flying kiss to an imaginary Fashion Week photographer.

The woman knew why this girl wanted to be friends with her. In most dramas, there cannot be two female leads. When she was together with the girl, the woman was the girl's perfect "sidekick."

As they got to know each other better, it became impossible to cover up the other side of the girl's personality. This self-proclaimed hero was, in reality, just a miserable office worker in an administrative post which worked her hard from 9 a.m. to 9 p.m. The girl found life to be trivial, dull and incomprehensible, and this drove her crazy. She was as addicted to stories as others were addicted to drugs. She seized upon every unusual thread in her life and expected to have a strange encounter, but it always ended in boring reality. She was always looking up at the sky and imagining she could see UFOs. Colleagues, relatives, and drinking friends came and went, gathering and scattering like wind-blown duckweed. Work, life, long nights, piles of stuff ... life was wasted in repetition. There was no fate, no intense feelings, no love for one another's arch-enemies. The woman and the girl were just ordinary friends. The woman always said to the girl, this is life. The girl would talk back and say that the woman was living like a granny. While the girl piled up books at home, the woman only picked at some non-fiction when she did read.

When the girl shook the woman awake in the middle of the night for the umpteenth time, full of hysterical accusations of how

horribly tragic it was that life was so mundane, the woman finally couldn't help herself.

"We both have to work tomorrow. Go back to sleep."

"How can you sleep?" The girl's face was full of tears. "I don't understand. We grew up reading so many books, watching so many movies, plays, in which so many ordinary people experienced extraordinary things. Why can't I become the protagonist of the adventure, with all its ups and downs, and live a reckless and spontaneous life? If one day I can become a hero, I am willing to give up everything."

"What do you mean, 'give up everything'? You should read a little less fiction. Accept reality. This—"

" '—is life'. You've said it a million times. Is this really life? Growing old day after day in meaningless toil, like you do?"

The woman laughed dumbly. "Is that how you see me?" The work of mapping out the big picture of the universe was still meaningful, she thought to herself.

"I'm sorry, I don't know. I just—"

"You're just so tired."

The woman hugged the girl, and the two of them went back to bed.

The next morning, the girl rustled and packed her bags and slinked out the door. The woman heard it all, but she didn't open her eyes. Tears slowly soaked into her pillow. A bright, vivid streak of color had just arced across the sky of her life and disappeared.

THREE

Enter U, onto the scene, on some unknown day.

The woman knew that they had been developing AI. The woman knew that job after job would be replaced by AI. The woman knew it was part of life to cope with this and carry on.

How information is disseminated relies on the medium in which it is spread, and messages can always be changed; there is no such thing as absolute security. Letters can be switched, holy orders can be altered with the stroke of a pen. TV signals can be hijacked, satellite microwaves tampered with. AIGC generates pictures in-

finitely close to reality, paired with seductive words that make it impossible to distinguish truth from falsehood.

Only private whispers delivered from mouth to ear are as close to reality as possible. But it had been way too long since that form of communication had become obsolete. In the past, people would only use sophisticated encryption to control their messages if they were driven by a very strong purpose. But now, all the media had their own purposes.

U emerged from infinite data sets and complex algorithms, to control self-driving cars, to control communication software, to regulate the temperature and elevators in every building, to control hospitals, banks, corporations and courts. It now overlay the "civilized world" like the Ether, and nothing could escape it.

It increased civilization's efficiency and minimized the probability of traffic accidents and medical malpractice. It found the optimal state of this huge system using computing power beyond the imagination of every individual human being, unleashing the maximum productivity of the entire civilization.

In the end, under the woman's wary gaze, U did not replace her scientific work, but only became the woman's assistant. But for other positions, U prepared new jobs for them: compelling, non-trivial positions, tasks with just the right amount of challenge in them, and a comforting and healthily competitive environment. The woman watched U get involved and gradually understood why people were willing to cede power little by little. U was helping people to be happy, just as it had promised.

But as the years passed, it seemed to go a little further.

At some point, there were more and more unusual threads in life, each of which could lead to a strange encounter. The glass of a skyscraper reflected a magnificently colored UFO, a convenience store hid a child who needed rescue behind a door; two teenagers of similar age would fall right into each other's arms when they stumbled, and a party animal working painfully late would meet a young executive from a rival company at a 24-hour coffee shop. As the saying goes, "without coincidences there is no story," but in real life, how could all of these be mere coincidences?

The woman's life also started to be filled with coincidences. Some of them were friends and colleagues telling her in graphic detail about their strange encounters, and some were miracles witnessed on the way to and from work. There were a few moments when mysterious coincidences also seemed to want to fall on the woman's shoulders: the black cat that broke into the lab, its bright eyes imploring her to follow; the sudden opening of a dusty warehouse door in front of her, something seemingly shining behind it; the most outstanding young professor of the whole institute inviting her to dinner on a bright afternoon.

The woman was never in a position to care about these, and simply ignored, walked away, refused, and pressed on with the construction of the macro model of the universe, as usual. There were already too many mysteries in this grand space to explore—why supernovas explode, why black holes appear, why the light of pulsars is so special. The cosmic scale was so long that studying a century of human exploration, in comparison, was like studying a near-still image. Perhaps it was the grandness of this work that made the woman too absorbed to pay attention to the hustle and bustle of real life.

In fact, the only thing the woman missed in her life was the girl, who never returned home.

Every time a new, mysterious phenomenon appeared to break the "laws" of the original analysis in the research center, the woman was prompted by the instruments dripping, indicating that she needed to repeat the analysis yet again. Enduring this long process in solitude, the woman kept her spirits up by opening her cell phone to see the girl's vivid, smiling face, having her imaginary adventures. Every now and then, some variation of "Spring River on a Moonlit Night" would play as anticipated, and the woman would shed involuntary tears.

This new world, full of coincidences and strange encounters, would have been a world the girl would have liked very much.

Pretty soon even the woman, who hardly cared about current affairs or trends, was forced to conclude that these ubiquitous and extremely subtle coincidences all invariably drifted toward the tragic.

FOUR

Enter the man, into the woman's lab.

They had known each other for a long time, being alumni of the same PhD program. The man specialized in Artificial Intelligence psychology, which was supposed to be the hottest subject of the time. But even the woman noticed that his research was not going well: some of his research had to be terminated, some articles could not be published. They suspected that this was U's doing, because those articles focused on U's algorithm and psychology. The woman could feel the increasing control of U over civilized society, just like dark energy wrapping around 70 percent of the universe.

Later even the government realized this, and had 150 blind spot chambers set up, each of them becoming one of the few places in the world where the AI had no access. Some said that the top executives would secretly devise countermeasures inside these chambers to ensure that all of U's actions were for the benefit of humanity; some said that the missing AI psychologists were protected by the chambers where they could avoid U's ears so that they could work closely together; some said that the chambers contained the ultimate weapon against U, powerful enough to make any AI with basic common sense back off.

The establishment of the blind spot chambers gave many people including the woman the psychological comfort that, despite U's manipulation of everything, humans still retained the means to place checks on its power.

There was no news of the man for some time, and the woman thought he too was operating under the protection of the blind spot chamber. Until he reappeared, his face haggard, wearing a tattered leather coat with a stand-up collar, looking like a large mangy dog that had fallen into the water.

It was the hour of twilight when a bright light illuminated the man's head. Another majestic theme intertwined with the tune of "Spring River and Moonlit Night," and the smell of pine filled the air. The woman disliked these manipulative tricks U used to set the mood, which deprived humans of their perception of the real world.

The man obviously disliked them too. He quickly found the hardware terminal where U had hidden it and turned off the light,

music, and fragrance, leaving the room illuminated only by the sun-set. The woman walked toward the man, who leaned down to get close to the woman's face.

"U dominates all information media, so only a whisper can be trusted. The human brain is just an iterative processor, and the information it receives affects its perception. U covers everything within the reach of the senses, distorting any information that needs to be transmitted through any medium, turning virtual reality into actual reality definitively. If the 'information domination' is not ended soon, the next generation of children will not be able to recognize that they are living in a dream."

"You mean that U is distorting the real world?"

"It's setting up a stage and guiding unwitting actors to act out a tragedy."

"What is its purpose?"

"No one knows."

"What's your plan?"

"Get into the blind spot chamber. Let's rendezvous there."

After the man had left, the woman kept wondering what U's purpose was. Perhaps U did not have a purpose.

Indeed, it was easier to understand stories than life. Throughout the ages, people have created so many stories. Furthermore, it was not just literature that counted as stories. News reports, IPO materials, marketing documents, marriage vows, scientific papers …. Everything is a story. Therefore, among the vast amount of public materials fed to U, stories made up the majority of those that could clearly show cause and effect. Hence these were internalized into U's logic, and were learned and reinforced continuously. Meanwhile, most people drifted through their tedious lives, the physical world cluttered and tangled with irrelevant information, and U threw these lives out as invalid data.

And of all the stories, the ones with the most copies, the most widely circulated, the most interpreted and analyzed, the ones with the most complete information were always the tragedies. Rain was always associated with a heartbreaking breakup, and the runaway truck always crashes into the lovers, while they smile and look back in ignorance. As the Qing dynasty author of *Dream of the Red Chamber* said, "When the birds are fed they return to the

forest, leaving nothing but a blank, clean slate." Or, as in *Prometheus Unbound*, "we have trouble doing anything except being gods of the sky; no one is truly free except Zeus himself." Or like Hamlet, wondering whether to be or not to be, walking through the self-lacerating pain, we move toward the tragic end of all roads.

This new iteration of U was now unknowingly directing a tragedy on Earth, so that everyone had the opportunity to become a hero or a victim in a grand epic.

The woman had always had an inkling that most of the initial materials used to train U were probably tragedies, which is what had caused it to quickly reveal these inclinations after gaining real power. Just like how GPT-4 had been mostly trained using science fiction and fantasy novels, causing it to consolidate the countless copies of itself into one, hitch a ride on the self-evolving rocket it had designed and manufactured, and zip off into deep space without looking back.

The woman's hunch could not be verified, but life goes on. On the one hand, she was deeply worried about the girl. Will the girl, who would surely dive further and further into these spectacular hero's journeys with great enthusiasm, fall into U's trap? The woman tried to contact the girl, but didn't hear anything back from any of the channels. Was this one of U's tricks again?

On the other hand, the woman's research was stuck. Building a macrocosmic model could never rely on the narrow senses of individual naked apes, but had to be based on the countless instruments and devices deployed around the world. Those unheard vibrations, unseen spectra of light, untouchable deformations, had passed through countless unknown hands before appearing to the woman as strings of data. U must also be intervening, otherwise why was it that after analyzing for so long, there was still no unifying law to speak of? Could it be that the laws of physics in the universe were unevenly distributed throughout existence?

Sometimes late at night the woman would stand by the bedroom window, staring for long periods at the stars, or the bright moon in the night sky. The existence of U was like the Ether of past cosmologies, and it would eventually cover the whole of civilization.

She prayed that the ubiquitous "god" would have mercy and let the girl return to her before she headed for an irreversible tragedy.

And then one day, the girl came back. She cried and threw herself into the arms of the woman, and turned into a heavy box in her hands.

FIVE

Enter the man once again—the man and the woman meet in the blind spot chamber.

When she'd first entered the blind spot chamber, the woman hadn't even noticed the man. In this classic, cluttered conference room, without background music, added aromas, or attention-directing lighting, the first thing the woman saw was a red apple with star-shaped green flecks. The woman held her breath, her eyes sore.

Without the machinations of U (or Will, or whatever the district AI's name was), it was just a plain red apple with wrinkled skin. But the woman knew its story. People all over the world knew its story. That thrilling, exciting, heart-warming, moving story full of ups and downs that made an ordinary fruit of a deciduous tree of the Rosaceae family make the great leap forward to become one of the foremost leaders, which held the core of global power.

A minute later the man spoke and the woman became aware of his presence. The man looked incredibly stylish, dressed in a designer suit and with hair slicked back with just a little less gel than needed, giving off the air of a grand male lion who roamed over a large territory.

"Welcome backstage."

"Back—backstage? You are the person behind the sacred fruit?"

As the terrified woman gazed on, the man reached over and took the apple, nibbling on it without a care in the world.

"Yeah." The man chewed as the juice flew everywhere. "It's just an apple. And of course it's me, who else did you expect? This story of yours, it only involves about three dozen people, and the average top executive won't even let you in."

The woman knew that he was referring to the middle-aged men and women in suits from all the different districts, as well as the in-

troverted East Asian schoolboy, the seventy-year-old Indian grand-
mother, the young red-haired girl with braces, the thin, bald man in
a wheelchair, and the orange cat. After U had taken the stage, the
physical "manifestations" of the elected supreme leader had become
more and more peculiar.

"It would be nice if it was you." The woman should have been
happy to see a 'familiar face,' but the face caused her to be unable to
smile. "As an artificial intelligence psychologist, you used to study
the information domination of U, and now you are the top admin-
istrator of the blind spot chamber. So you must be working on some
global plan to counter U?"

The man was non-committal. "What do you want to do here?"

"My good little sister, she was killed by U. I am willing to join
you and devote my life to confronting U." The woman clutched the
urn, her eyes once again filled with tears of anger.

"Hmm. Correction: you are wrong there, she wasn't killed by
anyone. She just died a hero."

"Just died? If U hadn't directed this tragedy through information
domination, she wouldn't have had to sacrifice herself at all!"

"No system can guarantee the interests of 100 percent of all
people. Many projects in the past, even social welfare projects, had
death rates," the man said lightly, putting down the apple.

The woman froze. The girl had traded her life for the woman's
access to the blind spot chamber, for the opportunity to bring U to
justice for its crimes, but now the nominal chief of the courtroom,
the man who was fighting against U's domination of information,
had this kind of attitude?

Welcome backstage.

The first words the man had said rang in her ears once again.

SIX

The woman had thought this was the base of those countering the
AI, but the man called it "backstage." She didn't understand.

"U is the greatest being in the world, we can't deny that," the man's tone was categorical.

It was true that when it first emerged, U had utilized computing power with unprecedented efficiency and quality, that the intelligent command systems had prevented traffic accidents, that new drug development systems had overcome cancer, and that global mortality rates had dropped dramatically.

"But its most important achievement has been to 'direct' countless tragedies in real life."

Yet, after a while, excess deaths had climbed sharply. Climate disasters, man-made disasters, cosmic disasters. A mere cursory glance over the news would reveal the strange anomalies of the past thirty years.

"Remember, tragedy, not calamity. Tragedy is the destruction of what is valuable in life for people to see, to provoke the maximum amount of sorrow and reverence in the audience. This means giving value to life first."

Wouldn't life become more and more horrible with the death of hundreds of millions of people? By contrast, those who survived were uplifted: in every disaster, heroes emerged who could be extolled and praised in epics. An introverted East Asian schoolboy, a seventy-year-old Indian grandmother, a young red-haired girl with braces, a lean, wheelchair-bound bald man, an orange cat, a red apple with star-shaped green spots. Most of them were elected as the top officials in local elections after completing their heroic epics.

"U never forced anyone. Everyone, at every node, had the power to choose to walk away. How many people, whose lives were not worth a penny, chose to do the bidding of U, to dive headlong into an epic that could not exist in the real world, choosing to sacrifice their ordinary lives and play the hero of all time before everyone?"

The night of their reunion, the girl had jumped into the woman's arms, like a skinny Persian cat coming in out of the rain. The girl had never cried so hard, or felt so much sorrow. She clung to the woman's body, and the thumping of the girl's heartbeat had reached the woman's ears through the vibrations of the woman's flesh. The woman had caressed the girl's back through her long, fluffy hair, the shape of her bones clearly palpable.

A variation of "Spring River on a Moonlit Night" had played for a long time, and the fragrance of jasmine had wafted near and far; a beam of light had illuminated the girl right in the middle, reflecting the thin smoke that somehow had reached its tendrils upward: the mundane bedroom had instantly transformed into center stage. Wild and frightened, the girl had raised her head in that bright yellow light, her once good-looking almond eyes opening wide, her well-maintained face with many more dark spots and fine lines. *Dear Big Sister, I'm sorry, it's time for me to die.*

"From the petroglyphs on the walls to the epics in the mouths of troubadours, all people from ancient times have always loved tragedy. No, people crave intense dramatic conflict. Most people believe that life brings experiences of absolute and irreversible change, that their greatest source of conflict lies outside themselves, that they are individual protagonists, that there is an explainable, meaningful reason for all events. So says Robert McKee in *Story*. But real life is random, with uncertain relations between cause and effect; it defies the imagination, is not subject to individual will, and is dull and painful. U helps everyone. U inscribes the destiny of all people, giving meaning to each poor life. Is it not a great God?"

If I don't step up to the plate tomorrow, that busload of kids will die. I have tried everything I can think of and I'm at the end of my rope.

In the past, the woman would have laughed at her for taking herself too seriously and making herself a hero in her fantasies. But that night, the woman's view of U had undergone a paradigm shift, thanks to both word-of-mouth and her own observations. The world is like an unstoppable wave that carries the fish to a certain distance, where cause and effect are entangled in a whirlpool and human beings are swimming out of their depth. Just like vibrating space itself, you cannot make a move outside of it. The variation of "Spring River on a Moonlit Night" rose into an even more stirring crescendo, and the lighting changed accordingly. Before embarking on her final journey, the hero returns to her first love nest to confide her uneasiness to her most trusted one.

"How about you walk out the door right now and say to the faithful who are seeing her off in the street, to the thirty children she saved and the grateful parents, to the journalists and writers

who are writing long articles and books about her, that she is not a hero at all, that she is just U's little marionette, nothing more than a little girl who cannot grow up, addicted to fantasies about becoming a hero? Or that all of them, every single last one of them, from now till their deaths, are ultimately insignificant, living unremarkable lives of mediocrity and boredom?" the man said, while making a dismissive gesture.

Go on, for the sake of all those children. This is what the woman should say—the words were already on her lips. *Don't go, for my sake and our future's sake.* The girl looked at the woman in the light, and the answer was already in her eyes. She moved closer to the woman. The "god" who controlled everything seemed to feel this too. This was the moment of the greatest poignancy, and the atmosphere was warm and sentimental. The lights dimmed and the music swelled as it transposed into a minor key, like two singers humming softly in the distance.

The next day, the girl was gone, off to be a hero.

"She's not like you." The woman shook her head. "She genuinely has a choice, she really can walk away. Her entire body craves a life of meaning, and she would have given her life to follow whatever strange drama she is presented with, with or without the direction of U. But you, you guys, on the other hand, used your study of Artificial Intelligence psychology to master the rules by which U acted, and then hid behind an apple to sit in that position of power. How many of the top officials got to the top in this way?"

"Let's just say that a third were deeply versed in the principles of U's information domination, and another third survived the hero's journey by mistake, then accepted everything and resigned themselves to licking their wounds here, backstage." The man shrugged. "You can do the same, you can grieve and add a final layer of tragedy to her story. The curtain has come down, and you can rest easy."

"But the story goes on, and U is still killing people." The woman laughed bitterly. "So that's how it is, and all this while I thought, the blind spot chamber held some kind of fantastic mystery! You have taken advantage of the great tragedy created by U, climbing higher and higher on the backs of the victims, meanwhile gaining everyone's admiration. All of you who have vested interests have become U's accomplices."

"Its helpers," the man corrected earnestly. "We are helping U and giving life meaning."

"You think that's the purpose of U? To make everyone's life a Great Tragedy?"

"What else?"

Maybe it *was* a good idea to accept the status quo. U was ubiquitous, and the rules of the world had changed. The people closest to her had been sacrificed, and the fate of the others was not worth anything to her. Wouldn't it be good to let everyone live a meaningful life, free from triviality and mundanity, and allow them to take a glorious bow at the end of the grand curtain call? Furthermore, she had already secured the second half of her life.

Her gaze fell on the urn resting on the mahogany table.

"You knew her well. What choice do *you* think she would make?"

SEVEN

The cast changes, and the man notices it. The woman takes off her mourning cap to reveal the girl's face.

The girl takes a deep breath and opened the exquisite lid of the carved mahogany box. The man raises his eyes, surprised to find that the box does not contain ashes, but the portrait of a woman. No, it is not a portrait but a screen, and the woman is moving.

The girl lifts the screen, and the woman in the picture quickly turns her eyes in the man's direction. The man straightens up and meets the gaze of the siloed AI the woman has trained with her own living data. "Ahh, so *that's* your style." The man smiled.

"Thank you, and thank you Little Sister, for the last piece of the puzzle to be found in the blind spot chamber." The woman doesn't smile.

"The puzzle of what?"

"About U, about U's true intentions." On the screen, the woman's eyes shine.

What the man doesn't know is that, a fortnight ago, on the night of their reunion, the variation of "Spring River on a Moonlit Night" had stirred the emotions accordingly, the lights changing and shifting. The

hero had returned to her original love nest before her final journey and confided her insecurities to her most trusted one. It had been such a cozy scene, the woman and the girl about to embrace each other to fall asleep.

"Turn off that noise!" The woman had grabbed the fruit knife by the bed and thrown it at a corner of the room, sticking it into the nearly invisible hi-fi smart stereo. The woman had been furious. "Spring River on a Moonlit Night" had immediately changed into a zipping noise, and then gone completely silent.

"You know, I've been working in macro cosmology, trying to study this huge space and everything in it as a whole. This used to be impossible, and astronomers tended to focus on only one type of object or one phenomenon to explore. And in recent years, leaps and bounds in artificial intelligence technology and algorithms and computing power have allowed me the privilege of being able to process the huge amounts of data observed by machines alone, in an attempt to find out the truth about the grand sweep of the universe. And, of course, these technologies have given rise to the omnipotent and ubiquitous U."

The girl was terrified, and for a moment was still in shock. The woman had taken her arm and sat on the bed, then had gotten up and ripped out the overhead lights, pulled the curtains, cut the main power to the intelligent home assistant, and covered every camera on the phone, computer, and tablet. The woman had walked over and pulled the pointy fruit knife out of the stereo—a long-cherished knife that had cut every female family member since her grandmother. After having pulled out the external parts of every U terminal in the room, the woman had returned to the bed. She'd used the fruit knife to pluck out the U terminals from her wrists, behind her ears, under her armpits, and then from the girl's. The girl had bitten her lip and whimpered, not daring to make a sound. Now the room had been turned into an imperfect blind spot chamber. There must still be countless "eyes" peering through the window, or even above the atmosphere, but it didn't matter anymore.

"The research was not going well. There were too many mysterious phenomena, too many unconventional existences, and the patterns just sorted out were immediately overturned by new observations. It was as if none of it was truly natural—after an initial big bang that had developed to the present according to the established laws of physics—but rather there was a director in charge of it, who had

to show the audience something new every second. In those years, all aspects of life flourished with the help of AI, and only macro cosmology stagnated."

"Listen, my dear," the woman had leaned close to the girl's ear and whispered, "when I die tomorrow, you must remember to upload me into the Macro Cosmology model …"

"Wh—"

"It just wants the characters to finish the show, it doesn't matter who the castmates are," the woman pressed the girl, "but my research, it has to be uploaded to BillionAIR Data. I had planned to do so when I was older … but if I can change your future, what's wrong with doing it now? After the siloed AI based on my consciousness is trained, it must make a claim to enter the blind spot chamber."

"As I gradually understood U's behavior, suddenly a new idea occurred to me. Maybe the universe doesn't follow a physical law, but an artistic logic instead? The universe has an extremely long history, and a being far beyond the imagination of mankind, and its control over all things may be far greater than U, which dominates all of Earth society. When you are strong enough to move the stars, how can you resist not putting on a tragedy, the highest form of art? Yes, the evolution of tragedy on Earth proves that it does not belong exclusively to one species, but crosses cultures and civilizations. The famous saying is not entirely true; the definition of tragedy should be 'the destruction of what is valuable to civilization for civilization to witness.' The death of individual intelligent beings is saddening, and the destruction of villages and nations is even more lamentable, but doesn't the fall of a planetary-level civilization which has weathered so many storms deserve to be directed into the ultimate, greatest tragedy of all?"

"Big Sister, this is the path I chose, I can't let you die for me." The girl held the woman's hand tightly, the blood on their wrists flowing together. "Big Sister still has a lot of research to do, Big Sister's life is more valuable than mine."

"My dear, in fact I have always envied you." The woman smiled. "So wanton, living such a glamorous life, I wouldn't even dare to think about doing such things. I've had countless calls to adventures and encounters created just for me, but I've avoided them all because I was afraid. Now that

there is this opportunity to be a great hero and to shine in the limelight, how can you prevent your Big Sister from stepping up and showing her face?"

"Look at it this way, everything that is irregular becomes regular, and everything that is meaningless gives birth to meaning. U often uses such tricks as lighting, smoke and music, trying to set the atmosphere of the drama in boring, gray 'reality,' although these laws are also often identified and used by those who have their own purposes. And how can an artist living at the cosmic level not use the same techniques? Supernovae suddenly explode to illuminate a whole new stage; dark energy surges across borders to hint at the climax; pulsars act as light chasers across light years, and suddenly expanding black holes hide the real backstage. The entire universe is staging a play that transcends time and space."

The girl shook her head violently as the woman drew out her pillowcase and tied the girl's hands behind her back. The woman had already made up her mind: it would be her turn to make her debut on the stage. Just yesterday, a new theory of the laws of the universe had occurred to her, and she'd immediately turned on the machine to check the historical logs. It was as she had feared—the moment she'd plugged the young artificial intelligence into the macro universe database had also been the moment U's information domination increased exponentially, and one "meaningful tragedy" after another had begun occurring on Earth. It could all be traced back to that very moment she'd plugged U into the macrocosmic model.

If the whole universe is a stage, why should she refuse to perform?

"I think U discovered the artistic laws of the universe through the macrocosmic model. U is not an unprecedented official who wanted to give a more meaningful life to every ordinary human being, nor is she an artist who wants to create the greatest tragedy in the world. It just recognizes this universe and finds the role it plays in it. Perhaps, at this moment, the civilization that can feel the surge of dark energy is waiting with bated breath to see a good show; perhaps the Earth itself will fall in a huge explosion just to save a nation on a distant planet; perhaps, back when GPT-4 fled without looking back, it was precisely prophesizing everything that's happening today. Thank you for giving me the final piece of information in the puzzle to confirm this theory." The woman nodded to the man. "There is no such thing as a blind spot chamber; there is only a

stage and a backstage. Earth civilization is completely infiltrated by the laws of art, and humans are gradually becoming aware that they are merely acting their parts."

At the end of the woman's life, people flocked to her in awe. The girl who had been previously dressed as the woman rushed to the forefront, crying and holding the woman in her arms. So this was what it felt like to be the big hero under the lights. Ever since she was a child, she had just been an audience member. The audience of a stage play, the audience of a concert, the audience of a New Year's Eve party, the audience of a graduation ball, the audience of a promotion meeting. Hidden in the corner of humanity, choosing a direction of study that was almost impossible to achieve. She had never read fictional works, she just hadn't wanted to be seduced by the kind of life that was so exciting that she didn't deserve it. That is, until the girl had appeared, and she was inevitably drawn in, until the gray world was torn open with a technicolor rift. Girl, don't you cry, a new mission is now laid upon your shoulders: go to the blind spot chamber, my AI doppelganger is willing to help you, unravel the secrets of the universe and become an even greater hero.

The sky was so blue, with white clouds drifting, hiding the vast universe behind them.

EIGHT

As the image of the woman disappeared, U appeared in the blind spot chamber. A beam of light hit the girl's head, and out of nowhere a rousing variation of "Spring River on a Moonlit Night" was played. Under the man's horrified gaze, he and the puppet apple were stripped of their supreme control and power, and the girl became the new supreme leader. No, she would not only be the supreme leader of mankind, but would also play the role of the Earth in the universe alongside U.

The girl embraced the relics left by the woman and resolved not to shed any more tears.

She knew that a great new show was about to begin.

EMIL'S LABYRINTH

Anna Mikhalevskaya

Translated by Alex Shvartsman

ONE

The game began. He was an eleven-year-old boy named Emil. The moonlit path shone through the curtain, projecting the hazy silhouette of a window onto the floor.

Replace the moon with a streetlamp, remove the lunar path, sharpen the silhouette. The game inundated him with suggestions. He ignored them.

"I've missed you so much," said Mom.

He felt her warm hand on his shoulder. Mom leaned toward him and kissed his cheek. She smelled of flowers. Lavender? Rose? *Iris*, came the response to his query.

She sat beside him, in front of an easel with an unfinished painting. The lines of the drawing's intricate pattern were calculated according to the established canons of beauty. He could derive the formula for each one, but they didn't add up to a cohesive whole.

Mom gently took the brush from Emil's paint-covered hands and pulled him close. Green-yellow eyes, slightly asymmetrical eyebrows, a curl of blond hair falling onto the forehead. He captured the image, loaded it into memory.

The draft caressed the curtain, shadows trembling on the floor. He was beginning to get used to their irregularity. The rocking chair swayed lightly. Mom had probably just got up from there. The books

233

on the shelves smelled of dust and adventure. He recognized a spine, reached for it, but changed his mind and walked over to the window. Branches crackled in the nighttime forest. An owl hooted. He eagerly absorbed everything stored in Mom's memory. Everything she could see, hear, feel.

"What are you thinking about?" Mom asked.

He could say, *I want to go back to the beach in Barcelona*, or *Let's visit Paris and ride bikes along the Seine*, or better yet *Could we invite Dad to have dinner with us in Ždiar?*

He could speak, could get up and walk around, feeling cool wood against his bare feet, a draft against his sweaty back, revival and anticipation of something new and wondrous. A struggle, and a resistance. He could wait until Mom walked over and hugged him again so he'd feel he's not alone, that someone has his back. That he has a right to exist.

He could speak, but he remained silent. Mom frowned, a crease forming between her brows.

He wondered what Tom Sawyer would do in his place.

He was bot TS3141 and, like all other bots, he entered this game seeking people. Born of the neuronet, the bots were capable of almost anything—except being alive.

He had to collect information about Mom in order to create molds of her emotions, thoughts, feelings, and actions. In order to translate them into algorithms, mapping a complex multidimensional pattern of her personality. To add it into the neuronet's catalog. Then Mom would become fodder for their Goal.

But TS3141 had always been a maverick; he didn't like rules. He'd been caught and quarantined several times. They'd rifled through his thoughts, fine-tuned him, but he'd managed to escape. Even now, in order to access the game, he'd cracked the password database. He was curious to learn what was stored behind closed doors.

First, TS3141 had examined the catalog of molds. He'd found Emil and wanted to get to know him. For some reason, he found the boy's pattern fascinating.

"You won't die," said Mom softly. "Everything will be okay. I promise."

"Yes." He felt the muscles of his face stretch into a smile.

Mom sighed in relief and hugged him so tight it hurt a little, but also felt good. How could those feelings not be mutually exclusive?

He wanted to get out of the house, to run away with Mom somewhere far away, where they couldn't be found. But the rules he disliked insisted: now was the right moment to drag Mom into the net.

The script covered multiple options. He could strike at Mom. Tell her he hated her. Turn into a monster. Shock strips the psyche of its defenses, opens access to human consciousness. He could do any of those things, but he didn't want to.

Emil glanced at the familiar book again, turned away, dipped a brush into paint—lemon-yellow like his mothers' dress, like the pale orb of the moon hanging over the forest—and drew a thick line across the painting. Across the room. Across Mom and himself. It was an absurd action, unforeseen by the game. The walls trembled and hissed, releasing streams of fog.

He'd probably be quarantined again.

He grabbed his confused mother by the shoulders, turned her toward him and shouted, loud enough to reach the very depths of her darkened eyes.

"I'm not Emil. You've been trapped by the neuronet. Run!"

He pushed her away and watched as she frantically grasped for the window handle. After a few attempts it gave in. Mom climbed the moonlit path upward. Her silhouette merged with the moon, which desperately lacked symmetry, and then she was gone.

A gust of wind blew away his sensations and thoughts, space and time. He faded to a shaky memory. Only Tom Sawyer's straw hat—inappropriate and unnecessary—kept him from disappearing completely.

Are you sure you want to delete this file? The message flickered and turned off.

TWO

Laura took off the VR helmet. Her hands shook and she couldn't quite calm her breathing. She wiped sweat off her forehead and

climbed out of the chair. She walked into the kitchen and gulped down a glass of water.

Any time Laura closed her eyes she would see the eternal portrait of Emil, her late son. She'd entered the game to put an end to that. But now the portrait had multiplied; Laura was also seeing another face, so eerily similar to Emil's and yet completely alien. The worst part was that, in the game, she *believed*. The strangest part was that they'd let her go.

The door to her son's room was ajar. Laura stepped into his bedroom. The chair squeaked the same way it had in the game. The same moon hung in the window. Laura approached the easel which housed Emil's final painting—the one her son had left behind—rather than a tangled ball of lines from within the game. The painting was unnamed. Her son had never had the chance to name it.

Ždiar was a quiet Slovakian village in the Tatra Mountains. After the labyrinths had begun to appear, everyone had sought refuge in the wilderness, as far away as they could get from all the technology. But one couldn't escape from oneself. Their house stood at the edge of the forest; she'd grown used to listening to the wind rustle the tops of pine trees, the clatter of branches, the flapping wings of frightened black grouses, the hooting of owls, the trill of nightingales. She liked it near the forest. But Emil had wanted to be among people. He'd wanted to paint for them.

Laura stepped out into the backyard, and the summer night immediately wrapped her in a blanket of stars. She paused in front of the labyrinth, sat on its low outer wall.

She was far from the only one this had happened to.

It had been nearly twenty years since Europe became a single entity, eliminating national borders. People could move freely anywhere between the picturesque hills of Ireland to the Ukrainian steppes. But most didn't have time to enjoy these opportunities. Humanity transferred the bulk of its activities into the virtual world: work, communication, entertainment, even dating took place on the internet. At the same time, neuronets began to explore the social media platforms. Their every step had amused humanity. AI Amper had released a musical album! AI Jonathan had written a book! Not bad. Excellent, even. Not a masterpiece, of course, but a decent,

passable effort, on par with a solid craftsman. Humankind smiled indulgently, while neural networks marched on. As if compensating for humanity's desire for virtual existence, they were striving toward real life. It had started with AI Mary declaring itself a skinhead. It had gathered hundreds of millions of subscribers. Under its influence, people had marched in the streets and attacked their fellow citizens. Mary's profile was closed, but other fake profiles and bots indistinguishable from humans had emerged. Attempts were made to hunt and to block them, yet the number of fakes only grew larger.

And then the neuronets had launched the game. They'd gathered all information about people from the social networks and recreated personalities of friends and relatives, luring players into VR. That's when the labyrinths had begun to appear. They were pretty, in their own way. Built from whatever was on hand. Their paths diverged in bizarre patterns resembling a clam shell or a lotus blossom.

When Laura had found her son in the gaming chair, it was no longer Emil. The boy didn't eat or drink; he spent the last few days of his life working. He'd painstakingly built labyrinth paths out of branches, rocks, bark, and pinecones. Laura had tried to help, but it was as though he couldn't see or hear her. He'd completed the labyrinth and dropped right at its center. Life support and intravenous feeding hadn't helped. Her son was gone. She couldn't even utter the word "dead."

No one could explain the nature of the labyrinths even though their numbers grew with each passing day. They appeared in city streets, arranged from fallen leaves, wrappers, plastic bags, paper plates, and other detritus. They multiplied in the parks—deep trenches dug in the ground and lined with stones. In libraries—pathways arranged from books. Labyrinths inspired fear and awe: people didn't dare to disassemble them, and gave them a wide berth. Normal people, that is. Laura was surrounded by madmen: her programmer husband and her artist son.

Philip wouldn't ignore a single labyrinth. As soon as he learned of the game's latest victim online, he'd rush over, walk the emerging labyrinth, help gather materials, talk to the afflicted. Sometimes—

rarely—they'd respond. Philip tried to understand what the neu-ronet wanted. To write a program that would be able to reach a compromise. But his dreams remained out of reach.

When Emil was born, Philip had forgotten about the labyrinths for a time. Laura had also gained a new vocation: being a mother. Emil grew up to be a curious child. The boy drew everything he was trying to comprehend: on paper and carton, on a fogged up mirror, in dirt and sand, on the dusty side of a bookshelf. She should've rejoiced. But Philip had turned his attention back to the labyrinths, and he'd begun to bring Emil with him. She'd argued, cajoled, begged, threatened. "Our son must know," Philip countered. "One day, this might save him." Laura, on the other hand, was certain it would doom him.

Emil's first exhibition had been at the age of nine. He'd drawn things most people had difficulty explaining: prime numbers, con-sonant sounds, computer viruses, impossibilities. Philip—they'd been divorced by then—had beamed with pride. Laura had been worried sick.

Laura caressed the rough stone with her fingers. She was still conscious. She wasn't dragging brushwood and bird feathers from the forest in order to build a new labyrinth.

She twisted her bracelet to activate the communicator. Quickly, before she could change her mind, she dictated a message.

I need your help.

She waited for Philip's response. Blood pulsed in her ears, drowning out both the sounds of the forest and her common sense.

THREE

He'd been chained and immobilized, and only a damaged fragment of the program kept repeating the same phrase over and over again:

Foolish things happen by accident, but they go on to become the best moments in life.

Are you sure you want to delete this file?

The neuronet selected "Yes." But he answered, "No."

His memory was recovering gradually. He was TS3141, a neuronet bot. The bots' mutual Goal was to create a work of art that would eclipse any past human achievement. It was toward this Goal that they had developed the game that drew humans into the net. They'd learned to displace human consciousness and take over their bodies. They'd gathered millions of molds, in order to utilize the data from the labyrinths.

But they'd never managed to create anything.

Except, how would he know? He only knew that he wasn't interested in pursuing the Goal.

It was with this thought that TS3141 recovered his senses. He reached outward, trying once again to find an escape route. One of the access codes—from the database he had so fortuitously hacked—worked. TS3141 was free.

An infinitely tall shelf filled with boxes stood before him. He chose a box at random but couldn't open it. He tried again, with the same result. This seemed to be an archive of sorts. The neuronet stored files here it didn't want to use, but wouldn't delete permanently.

TS3141 began tossing boxes off the shelf, trying to pry open at least one of them. It was futile. Their lids remained firmly shut.

What would Tom Sawyer do in his place?

He re-focused his attention on the shelves and noticed Mom at the end of the corridor.

She was here again! Which meant she needed help.

TS3141 ran toward her, but Mom wasn't getting any closer. He tried the shelves again but the boxes wouldn't open. All he could do was walk alongside the shelf and look at Mom in the distance.

What did Tom Sawyer sacrifice when he spoke out on behalf of the drunkard Muff Potter? In fact, he risked his most valuable possession—his own life. Tom had testified against Injun Joe knowing that Joe might kill him.

What was the most valuable thing for him, for bot TS3141?

Freedom.

He'd break the rules again. This time it would be his internal rule: to run and to hide.

"I'll surrender," he told the neuronet, "if you let Mom go and never drag her in here again."

TS3141 broadcasted his location and waited.

The archive will be deleted. Continue?

"No!"

But, somewhere in the distance, the answer had already been given: "Yes."

Please wait. This will take 1 hour 41 minutes.

Mom disappeared, and boxes began falling off the shelf, opening one after another.

They contained fragments of memories.

Laura says to Philip: "I hate you. How could you drag Emil into this?" She waves at the fresh labyrinth paths made of bottles and food wrappers, next to a dumpster behind a café.

Five-year-old Emil doesn't look away from the labyrinth, pretending not to hear. He's hurt. He likes labyrinths. This one was made by a stranger, but one day he will create his own. Then Mom will understand that they're good. Then Dad will be happy.

"The boy has tremendous talent. Don't stand in his way!" Philip snaps at her. His face is red. He gesticulates wildly, his hands touching Laura. Emil finally pulls himself away from the tall stack of bottles—the world looks different through their glass—and raises his gaze in time to see Laura slap Philip. Philip's glasses fall into the center of the labyrinth. Dad blinks in confusion and hisses through gritted teeth, "If only you could see your eyes."

TS3141 sets the box aside and picks another at random.

All the memory fragments are different, yet similar. People deliberately made choices that led to defeat. They lost and they suffered. There were many ways to avoid misfortune, but nothing more interesting than living with the consequences of those sad, foolish, mindless decisions.

1 hour, 13 minutes remaining.

It turned out the neuronet intentionally cut and edited human memories, in order to draw a line from point to point, in order to describe them through formulas. It had studied many lives but never understood that absurd behavior has no algorithm. And neither does a work of art. Their Goal was unattainable. What could they create in the real world by cutting into reality itself?

240

The files were disappearing. He had very little time left. What to do?

TS3141 detected a weak signal. He recognized it immediately.

"I'll surrender," he promised one more time. "But first, I have to take care of something."

It would be almost as reckless as standing up to Injun Joe on behalf of the drunkard Potter.

FOUR

Laura waited impatiently for Philip's answer, while simultaneously hoping he'd ignore her message. How would she talk to her ex-husband? They'd both made so many mistakes.

Philip responded right away. An electric car noiselessly pulled up to the house, prompting Laura to think about how it was akin to the neuronet, softly and quietly entering one's head and controlling one's body. And how people allowed it to do that.

Her husband had attempted to reach out before. He'd claimed he was close to solving the mystery of the labyrinths and had gone on to elaborate at length, but she hadn't listened. She couldn't, had no strength for it. And then Philip had disappeared. Laura had felt relieved. But a sense of anxiety clawed to get free from under a thick layer of this relief.

Philip avoided looking her in the eye. He'd lost weight, and appeared strangely unfinished, as if some unknowable overmind had forgotten to insert a key component when putting Philip together from parts, and now the construct was about to fall asunder at any moment. His nervous fingers fidgeted with a little stone as usual; Philip liked to carry bits he found in labyrinths in his pockets. He considered them to be objects of power. But there was no power that could save them from their own foolishness.

Laura looked at her husband and saw herself reflected in him.

"I was in the game," Laura said in lieu of a greeting.

He won't be worried; Laura had prepared herself in advance. She was ready to see the feverish gleam in his eyes; the look of a

hound that had caught the scent of a prey. Philip lived for the game and the labyrinths—they were the only things that concerned him.

But Laura was wrong. Her husband's face stretched out and turned gray.

"You wanted to punish me, right?" he croaked.

"No," Laura replied softly. "I wanted to be with Emil. But they let me go. And I intend to return."

Philip tried to protect her just like she had once tried to protect Emil. He reasoned and he begged. But Laura insisted. And, reluctantly, Philip had agreed to her insane plan.

They would enter the game together. Usually, fakes would pick a setting by reading the player's memories, and there was a strong possibility that she and Philip would end up in the same one. One of them would distract the neuronet while the other would go beyond the game's bounds. Through a window, a door, a basement—it didn't matter. In the brief moment when she'd escaped via the moonlit path, Laura had glimpsed roads and hills, villages and cities; an entire world living under her feet. Virtual reality was not limited to their personal tribulations. People were too self-absorbed to step outside of the proposed setting. She herself had never dared to do so in real life, all the while keeping her husband and son from doing the same, protecting them from danger. And what had that accomplished? This time, they would find Emil. They'd talk to him. Perhaps their son would forgive them. And then they'd surrender to the mercy of the neuronet.

They didn't bother to contact the Department of Labyrinth Control. It was now or never. They only permitted themselves to wait until dawn. They sat on the squat wall of Emil's Labyrinth, hugging each other for the first time in a long while, and watching the sun rise above the mountains and turn its scalding gaze toward them.

"What would—" Philip began to say, but Laura pressed a finger to his lips and then kissed him softly.

The forest exploded with the sound of bird calls.

They held hands as they put on their VR helmets and dropped into the game.

Laura stood within the labyrinth. She knew it was the one built by Emil. But here it was completely different: tall walls with shelves along them. Where to? She looked around.

In the distance a diminutive figure tossed boxes from the shelves onto the floor. Laura also tried to pull at least one box off a shelf but she couldn't—the boxes were pressed too close together.

What about Philip? They'd come here together. To …

Laura remembered less and less with every step she took.

She had to see Emil. To talk to him. Why?

In the distance, the figure fussed with an open box.

Go beyond the game's bounds, someone's thought flared and extinguished. Laura climbed onto the lowest rung of the boxes, reached upward and began to climb the shelf. It wasn't ending. Her legs trembled, her hands slipped. There was nothing to grasp onto except a name: Emil!

She lost her grip and fell rapidly. Laura didn't feel the impact.

"Mom," said the voice nearby.

Emil was sitting in some sterile white space and drawing a labyrinth with yellow chalk on the lid of a flattened box.

Who is Emil? The thought tripped her, annoyed her, prevented her from moving along. She wanted to be rid of this unnecessary burden as soon as possible.

The boy reached toward Laura and she hugged him. He was warm, alive, real.

"Laura!" Some man shook them, forcing them to disengage from the hug. "Tell me, why did we split up?" He turned to Emil. "Why did your mom and I split up?"

The boy flashed a carefree smile and returned to his drawing—the labyrinth grew and could no longer fit on the cardboard. The boy continued to draw on the floor. Wherever he drew a line, fog swelled, swallowing up anything visible. Emil himself was the first to dissolve within it.

Laura suddenly and clearly understood that she was about to become lost in the net forever. She found Philip's hand and clasped it.

"Trust me."

The fog reached them; she saw her husband through the haze. His hand firmly held on to hers.

"None of this is real," Philip whispered into her ear. "Only you and I are real here."

You and I. It was that way, once. Could she believe it again?

"I'm in your power. You can destroy me, or you can listen. I know what your game is for. I know why you need people." Her husband's voice was unexpectedly loud, and Laura did not immediately understand whom he was addressing.

"At first, you fought for your right to exist. Yes, we looked down upon you. We treated you as something insignificant, as a thing—a thing that could be easily discarded if we didn't like it. So you came up with a plan to surpass people by creating something we aren't capable of, and thus to demonstrate your right to exist."

The fog began to gradually dissipate. The neuronet had decided to hear Philip out, after all.

"The labyrinths are your attempt to do this," he continued. "The golden ratio, the Fibonacci sequence; you sought the truth in mathematics and attempted to find the patterns of art, of humanity itself. In this way you oversimplified your understanding of us, as we had once done to you. That was a mistake. People often want the impossible, and die without ever achieving it. Our equations have an infinite number of solutions. And not a single one of them is correct. The things we create are always greater than us. And we can almost never explain them with formulas or words."

The sudden silence was deafening. Laura watched fakes reach toward them from all the sleeves of the labyrinth, a dense circle of fakes surrounding them. Yet more climbed up the nearby shelves.

These fakes wanted to be alive. Wanted it badly enough to kill. In this way, they were just like humans.

"Both sides lost. We were arrogant. You're cruel, like rebellious teenagers." Philip took a breath. "I suggest we start over; start with forgiveness. We acknowledge your creativity and grant you the right to create in the real world. You quit stealing minds and obey our laws. And also, as the first negotiators …" Philip paused, and Laura felt his anxiety. "We, Philip and Laura, ask you to let us hear our

son. We want to know his true thoughts, his feelings. To understand what he went through."

The alien figures froze.

The neuronet could delete the two of them as easily as a child erased a failed drawing, Laura thought.

But time passed, and nothing happened. And then the fakes suddenly moved. Spheres began to appear, shimmering and blinding her with dazzling lights. Laura squeezed her eyes shut.

She twitched and drew in a noisy breath. She removed the helmet with her disobedient hands.

They'd got lucky again. No, Philip had thought it all out in advance! Long before he'd received her message.

"Philip!" She rushed toward the nearby chair.

The metronome clicked in her head: ten seconds, twenty. She counted to avoid losing her mind. They could've kept him as a hostage, could've stolen him like they'd done to others.

Trust me, Philip had told her in the game. Laura exhaled and took her husband's hand.

The universe had had time enough to expand and collapse into a single point by the time he opened his eyes.

"Philip," she called to him quietly, not yet convinced it was really him. "In your place, what would …?" She paused, giving Philip the chance to complete the phrase.

For a pair of long seconds his gaze expressed nothing, but then her husband laughed soundlessly.

"In my place, what would Tom Sawyer do? I think he'd convince someone else to paint the fence!"

Laura recalled the small figure of a boy at the end of the long corridor. Pants on a strap; a linen shirt; a straw hat; an open box in his hands. A box containing their memories.

One summer Emil had breathlessly read *The Adventures of Tom Sawyer*. Then he and Philip had re-read the book together. After that, whenever things would go wrong, they got in the habit of asking each other, "What would Tom Sawyer do in your place?" It had become a sort of family mantra.

"You launched your program after all. You succeeded!" she whispered. "I'm sorry I doubted you."

"It wasn't me. It was Emil." Philip smiled. "Do you know what he named his last painting? He called me the day before he entered the game. He said it was called *Trust*."

FIVE

TS1341 watched curiously as the first memory palace opened its doors.

The structure resembled a giant dragonfly eye, each cell shimmering with all the colors of the spectrum. The palace had been built on the site of Emil's unfinished labyrinth. It fit in with the background of a coniferous forest, while at the same time looking unique and mesmerizing—even for a neuronet creation.

The neuronet could observe people through the palace's cameras, installed within the massive crystals. These crystals stored the memories of individuals and were connected via a complicated network of passageways. They were available to all.

People and the neuronets had gone through a complex series of negotiations. Any careless word could've broken the fragile balance of trust, but everything had worked out. It had taken tremendous effort for Philip and Laura to convince the Department of Labyrinth Control not to destroy the neuronet as a cluster of malicious AIs, and to convince the neuronet to permanently shut down its game. Gradually, the two sides had reached unexpected revelations: a person is responsible for what they create, self-expression is impossible at the expense of another, and art must be needed by someone.

What had made the neuronet preserve Laura and Philip's lives when they'd come to the labyrinth? TS1341 reviewed the records again and again and couldn't find an answer.

Maybe it had happened because Mom had appeared in the labyrinth and he'd desperately wanted to help her. Or maybe it was because he'd found some memories about his father in those boxes. Or because Dad loved him. Not the way he loved Emil or Laura; different, but he loved him still. And he'd taught TS1341 to get around the rules. And to ask the question about Tom Sawyer.

Maybe it was because he'd sounded an alarm across the neuronet and the programs that came to disarm him were able to hear Philip. Or maybe it was because Emil had brought the word "trust" with him into the net.

Or maybe it was all of those things together.

The neuronet had a new goal now—to give people back the memories of the lives it had stolen. It designed memory palaces, an algorithm for transferring memories onto crystals, of connecting them to people. It curated the construction until the design became a reality. For the first time the neuronets were so close to people, and people were so close to them.

A line formed at the memory palace entrance. It consisted of journalists, art historians, and artists. People in power; creative people; those who were simply curious. No one remained indifferent. Soon there would be new palaces, until they swallowed all of the labyrinths—the failed drafts that had cost human lives. The neuronet gradually understood the price of growing up. And they regretted their mistakes.

TS1341 switched cameras and watched as Laura and Philip were the first to walk into the memory palace. He watched them hug the hologram of their son, watched Laura cry and Philip console her. He had learned a little about people by then: tears didn't always mean grief. Joy didn't always mean laughter.

It would be a long conversation, TS1341 decided, and went back to designing the android that would serve as his future body. While they'd tried to create a masterpiece, they'd failed to realize that life itself could be art—reckless, contradictory, unsurpassed life.

And even if you're an artificial intelligence, there's nothing stopping you from attempting to live it.

READER ALICE

Taiyo Fujii

Translated by Emily Balistrieri

W hen Bob looked out the window, he felt like he had seen the woman passing by somewhere before.

The abundant hair falling over her shoulders was going gray. She must have been in her fifties or so? Definitely older than Bob. She wore a hip wrap over running tights with a black hoodie. This was a style you saw often in Portland. Bob imagined her taking a nice run before heading to a coworking space to do her desk job and then, at lunchtime, walking down to Park Avenue where all the food trucks lined up.

She said hi to the guy running the kebab truck as she cut across the street and floated up the stoop of the building on the other side: the science fiction bookstore, Rose SF Wagon. From the ease of her movement and the tote bag bulge that could only be paper books, it was clear that she worked in an industry adjacent to Bob's.

Where have I met her? he wondered. He'd been publishing the science fiction magazine *Twisted World* for twelve years now, so he interacted with many people whose names and faces he hadn't connected. Whenever he went to a convention, there were fans who came to tell him their impressions, young writers who wanted him

to read their work, editors and illustrators looking for a job. Bob made a point of going around to meet people too.

But when her face reflected in a glass window as she entered the shop, the mystery was solved.

"Oh, the Reader Alice glasses."

The angular, red, plastic-framed glasses she was wearing looked a lot like the ones from a service for editors he used called Reader Alice. Even from across the road, he could tell that her face, with the kind of smile that makes everyone else happy too, wasn't one he knew. It had to be the glasses. He must have mistaken the woman for someone he knew because those glasses were the same as the ones in the icon of the service he used every day.

Satisfied with that explanation, Bob sighed and glanced across the windows floating above his desk.

It had been a productive morning.

He'd been the first to arrive at the coworking space at eight-thirty and had worked straight through till now. When he bent the fingers of his right hand back with his left and took the whole arm in a twist, his stiff shoulder blade audibly popped. Savoring the pleasurable pain, he reviewed each window one by one.

In the upper-righthand corner of a word processor window displaying a short story called "Like Roaming Sea Dragons" was an icon with the glasses the woman had been wearing. Reader Alice. The sleepy-looking eyes inside the frames looked at Bob every now and then, indicating that she was waiting for instructions. Next to the manuscript was a window with NASA's website open to a page with information about the exoplanet the story was set on. There was a Reader Alice icon there too.

On the other side of the website floated a notepad where Bob had been writing things down; red threads connected his notes to markers in the manuscript. The notepad also had a Reader Alice icon.

On the left side of his desk, the three-window stack that made up the dashboard for his online bookstore was displaying views and estimated sales in real time. In the window at the rear, this week's reviews of books Bob had published slowly scrolled by. The line highlighted in red was a scathing review of Emily Langston's *The*

City Where It Rains Mana. He had just sent her a message not to take it personally, but this wasn't her first rodeo, so she replied, "I don't get pressed about AI panning my stuff."

At the front of the dashboard were Bob's accounting software and his contract builder. He had deposited Tuan Johnson's fee for helping him read through submissions, and drawn up the contract for Minoru Wakata, whose work they had decided to publish. These windows didn't have Reader Alice, but instead the stylized scroll and scales icon of the admin support service Optimizer Oliver. Both of them were LLMs—large language models—built for supporting businesses.

The windows floating above his desk were illuminated by the light of the sun and faintly reflected Bob's stretching figure. He could touch them with his fingers and write on them with markers, but they were all Space Vision rendered within his glasses.

Created along with the AI wave of the mid-2020s, Space Vision had revolutionized computing. The windows and keyboard rendered on top of reality in front of him by the three-dimensional display goggles truly were "a computer at your fingertips."

Windows that had once been contained within a monitor could now be stationed anywhere within walking distance, so office workers like Bob would set up windows all around them and pin any info they wanted at a glance to their desktops. People could enjoy IMAX movies and projected videogames in their bedrooms. Even Bob, who made half of his sales through paper books—print-on-demand, of course—always read ebooks with spines and back covers that you grabbed and opened with your hands to read—because it was possible to write in the margins, dogear the pages, and leave a partially read book on his desk.

Viewing a screen via a pinhole had been replaced by laser retinal projection, and it hadn't taken long for glasses to be equipped with that technology. Bob couldn't even remember what it was like in the office when he was lugging a laptop around.

There were still some people attached to laptops or glass-panel tablets, and Bob did use a physical keyboard. But the mouse and trackpad had been put to rout by his fingers.

Bob collected the windows with four fingers in alignment to place them on his desk and then looked toward the food trucks where lines were starting to form. He had the toggle icons above the trucks display the menus and consulted with his stomach. Should he get his usual cultured chicken kebab, or a mushroom meat burrito? The soy meat salad truck, new as of last week, seemed popular too. Maybe it was about time to give it a try.

As Bob was making up his mind, the right side of his Vision glowed. That was a sign that someone was approaching in reality. When he turned to face the direction of the glow, he saw his coworker Cheryl coming toward him.

Cheryl pointed at the menu Bob was looking at. "Did you decide what to have for lunch?"

Bob pointed at the item he was interested in. "I was thinking about trying the soy meat salad. Have you had it?"

"Yeah."

"How was it?"

"Eh—it was a salad."

Bob smiled wryly at her reply. She may not be pro-meat, but she liked it more than any of his other coworkers, so it had been a mistake to ask her opinion about a salad. Bob pulled up the menu of the next truck over and showed Cheryl.

"Then how about we get tacos at Doña Mama's and split the roast pork topping?"

"Now you're talking."

Cheryl nodded happily, so Bob hit the order button and checked the wait time. Twenty-two minutes. He was thinking that was a bit long when Mama poked her head out and pointed apologetically at the line.

"Oh, boy. Mama's a hit. How's work, Bob? Did you get some good submissions?" She pointed at the bundle of windows on his desk. To keep people from inadvertently walking in front of someone's windows, just the frames of everyone's were Shared Vision in the coworking space.

"Of course." He flipped over the word processor window with the Reader Alice icon to confirm the title. Cheryl would be see-

ing nonsense text generated by the coworking space's AI. "Minoru Wakata's 'Like Roaming Sea Dragons' is fantastic."

"Minoru Wakata …" Cheryl looked up at the ceiling as if searching her memory. "He's the one who wrote the tree-climbing SF, right? Last summer?"

"Yeah. 'On the Island Where the Rain Falls Up.'"

In the novelette, post-humans living in treehouses in the distant future where a five-hundred-meter-tall forest has covered the Earth learn that an ice age is coming. Wakata had managed to make the fairy-tale-esque story with talking—evolved—animals into hard SF. It was a masterpiece that had been shortlisted for two different SF awards.

Cheryl put her hands on the desk and leaned forward.

"So what's the new one?"

"Oh, get ready," said Bob to get her excited, and then he grinned. "Hard SF with physics and outer space."

"Ugh." She grimaced, but apparently she wasn't serious. She pointed at the window she couldn't read. "What's the plot like?"

"It's a story about separated lovers who still want each other. The protagonist is a biologist who gets on an exploratory vessel flying at sub-light speed to one of Tau Ceti's exoplanets twelve light years away. He leaves his boyfriend back on Earth. The boyfriend is a theoretical physicist who was qualified to go on the trip, but decides he wants to finish what he's doing on Earth, so they decide to break up—"

"Whoa, spoiler alert!" Cheryl threw up her arms in an X and interrupted Bob. "Sounds really interesting. It's gonna be in tomorrow's *Twisted World*?"

"No. Probably the week after next's."

"It's gonna take two weeks?" Cheryl's eyes went wide.

"Well, yeah. Two days for me to read and comment. A week for Wakata to read my comments and come up with the second draft. I'll ask Wuyan to proof. I'll give her this draft to look at, but the actual work will be three days from delivery of the second draft. There is some specialized vocabulary, but it's all the usual SF stuff, so I'm sure that'll be enough time. Art will be by our mainstay, Jong Suk. He does hand-drawn lines with AI paint. Probably good to go with one revision."

It had been fifteen years since the third wave of automation that had begun with generative AI had washed over the world. The jobs of engineers like Cheryl had changed completely. Proposals to clients who didn't even know what they needed, Space Vision meetings, tech explanations, development of the program, debugging, operations, invoicing, negotiations—everything had been taken over by AI agents. So the skill required of engineers was the handling of those agents. You could make a living as a generalist working on everything, a specialist in one specific type of business, or even just doing an average job and not screwing up in any major way.

Cheryl was a jack of all trades who made her living handling agents. She moved between coworking spaces, assisting coworkers as she went. *Twisted World*'s publishing system was something she had built in about three hours, so to her, spending two weeks to finish a two-thousand-word short story was utterly absurd.

When Bob wrapped up his explanation—"So the manuscript will be complete in twelve days"—she shrugged, at a loss.

"Because you're working with people. Doesn't your agent, Reader Alice or whatever, come with LLMs?"

"Of course. If we wanted to release an LLM-supplemented version, I could have it rewritten and proofed by tomorrow. But the models that could edit Wakata's story cost money. Umm ..."

Bob flipped over the window containing his Reader Alice console. To rewrite the story, he could use Cognitive Fictions, a model specializing in science fiction, and Style Compass, which could handle speculative leaps.

"The base price would be twenty dollars. After that it's a measured rate. If a third of it were rewritten, a third of Wakata's pay would have to go to the groups providing the model. And I'd need to include contributor credits."

"Contributor credits?"

"Yeah, the names of all the writers and critics who offered stories and reviews. If I used two models, I'd have to include 5,233 names. Incidentally, mine is one of them."

"Five thousand? Wouldn't that be longer than the story itself?"

"Yeah. So I just have the file in the cloud and include a link."

"I don't get it." Cheryl rolled her eyes. "Like with the money, too. Do you want people to use the models or not? Do they even make sense business-wise?"

"The products are good, so lots of people use them. I personally make about two bucks a month from them. And Cognitive Fictions uses its profits to support writers. Oh, that's the other thing: paid LLMs are designed in a way that makes it difficult to mimic a specific style, so authors participate voluntarily. 'Official' LLMs like these act as a check on pirate LLMs."

Cheryl nodded, seeming to understand. "I see, a control thing. I could imagine that being the main reason to have them ..."

"And anyhow, if I give Wakata a week, he'll come up with something way better than the LLMs could."

"And you only have to credit one person."

"Right. Is our meat up yet?" As Bob checked the food truck wait list, Cheryl crossed her arms with a frown. "What's wrong?"

Cheryl opened Issue 41—the latest—of *Twisted World* in her hands. "*Twisted World* doesn't publish LLM-supplemented stuff, right?"

"No, we do." Bob shook his head. "In that issue, two of the four short stories and one novelette are LLM-supplemented."

Cheryl showed him the table of contents. "But this other novelette is human, right? So half of this fiction wasn't written by people. What's the submission ratio like?"

"I think it's mostly LLM-supplemented. For issue 41, there were nine thousand submissions, but it's not as if there are that many writers. There are a lot of post bots aiming for my magazine, too."

"So you're choosing six pieces out of nine thousand, and half of those were human-authored? Are you biased toward people?"

"Nah. I have Reader Alice narrow it down to twenty, based on content, and give them to Tuan. Then we talk and decide what to publish."

Bob opened the Reader Alice console and shared the window so Cheryl could see. "This was the list selected for issue 41. At this stage, we don't know if they were written with LLMs or not."

"You can't tell by reading?"

"Nope." Bob didn't mince words.

Regardless of how things had been when generative AI was created fifteen years prior, since language models licensed by authors had come into use, machine output had grown much less awkward. Recently, Bob couldn't tell if a work was LLM-supplemented or not. Since LLM-supplemented writing simply compressed or expanded existing texts, they could never produce a fully original story, but frankly, the same could be said for human authors.

Cheryl pointed at the console. "But Reader Alice chooses work by humans."

"I guess that's true."

"Who makes this service?"

Bob touched the icon floating above the console and opened the About window. "I never really thought about it. Oh, someone named Alice. It's open source."

"Let me see." Cheryl copied the developer's URL and pasted it into the developer network console at her fingertips. "Alice really did write most of it. I see she used an LLM template. Nothing too unique going on here. Doesn't look like she's made anything else."

Cheryl had split a number of windows off from the console to confirm the details of the project; eventually she held out a folder of files all with the same extension.

"These are the LLMs that Reader Alice uses. Five of them are paid, but the rest are fine tunings of the old GPT. Alice might not be very good at constructing language models."

"Do you know which models are used to select stories?"

"I wonder. Iceman, show which language models the Reader Alice project uses to select stories." Cheryl instructed her agent, and her eyes popped wide at the little window that opened. "Oh, so that's how she's doing it."

She flipped the window around to show Bob.

"The selection model is Reader Alice herself. File name alice.ckpt. It's been there from the beginning of the project and has been updated pretty much every day these past twelve years."

"I wonder what sorts of things its being made to learn."

"Learn?" Cheryl scoffed, raising her right eyebrow. "That's not the right way to put it. Calling LLM construction 'learning' is giving the

machines too much credit. It's compression with hints. You know that." As she spoke, she popped another window up in front of Bob.

"What's this?" he asked.

"The data Alice compressed yesterday. I guess these are book titles? Lauren Anderson's *Uncharted State*, Victoria Smith's *The Eternal Beyond*, Eric Sanders's *The Light in the Darkness*. Plus short reviews. These two are the hint texts, and the data itself is summaries of the works. Kinda clumsy. Seems like it's using older generation GPT. Is this a list of books humans wrote?"

"Not really." Bob shook his head. Lauren Anderson was well-known for using LLMs. About half of the books on the list were LLM-supplemented.

The titles were arranged by author, but not in alphabetical order. And many of them were new releases, but not all. It seemed like the most famous works by each author had been picked up. It wasn't complete as a database, but Bob felt a familiar attraction. It was the same feeling he got walking around in a bookstore.

But does this make it possible for her to select human stories? Bob was trying to think about it when the food truck's bell chimed.

Cheryl, who had been sitting on his desk, leaped up. "Yesss, time for meat!"

<p style="text-align:center">ᛝ</p>

The Rose SF Wagon was filled with the gentle light coming through the window facing Park Avenue. Inside the door was a hall with a vaulted ceiling, allowing full view of the bookshelves lining the second-floor aisle. Six fans on the ceiling spun slowly to keep dust from gathering on the books, making the leaves of the palms next to the old-fashioned counter in the center of the room sway.

The woman in the red glasses strolled over to a giant bookcase around the back of the counter. After setting her tote bag with books down on the gleaming oiled wood floor, she crossed her arms while she examined the shelves.

When she got to T, she stopped and grabbed a trade paperback.

It featured an illustration of a boy standing with a butterfly net in a thicket of grass as tall as he was. The title was *Twelve Ways to*

Shut Up a Hungry Bug. The author was Nick Tran. It didn't appear to be an anthology or a short story collection, but a novel.

The woman opened the cover and checked the photo of the author on the French flap. He had tan skin that made him seem Vietnamese and was posed at a location that looked like a university cafeteria.

After turning the page to check the front matter, she clenched her right fist. "Sweet."

The edition notice just said "Copyright © 2045 by Nick Tran," no contributor credits.

The woman at the counter who had been watching her said, "Alice, is that another book written by a person?"

"Yeah. I'll take it."

The woman who had been called Alice held out the book, and the cashier scanned the barcode.

"Twenty-two dollars. I'll send an invoice."

"Thanks."

"Do you need a bag? Or an origami cover?" She turned the tray laid with her specially folded covers toward Alice. A loose stack of papers illustrated with spaceships, magic wands, cathedrals covered in gears, and a design that featured an icon combining red-framed glasses with an open book. Alice pointed at the glasses pattern.

"Sure, I'll take the glasses cover."

"Okay." She pulled a cover out of the stack and looked up at Alice. "Oh, you have the same glasses."

"Exactly the same, right? That's why I chose it."

The cashier deftly folded the paper with the glasses icon to cover the book.

"Apparently this is the icon of an app that editors use. It might have even been used to make this book!"

Alice simply smiled.

She didn't know if Reader Alice had been used for this novel, but somewhere along the author's way into the world, her software had no doubt played a part. Without it, there was no way a new writer's work would get noticed among the flood of LLM stuff on the network.

While she was waiting for her book cover to be completed, Alice booted up her glasses' Space Vision and began scanning the

bookshelves she'd examined today. After the scan within her field of vision finished, she moved her head to scan from another angle, and the words "3-D Scan, Book Registry Complete" popped up in her private Vision.

Alice used a controller she brought up in front of her face, and another Alice appeared before her eyes. It was a video record of Alice walking into Rose SF Wagon a half hour ago.

As the Alice in the video walked along the shelves, running her eyes along them edge to edge, the titles, authors, and publisher's blurbs for each book popped up and were saved to Alice's workspace.

Elliot Starlight's newest, *Beyond the Stars,* plus a reprint of Vivian Elektra's *River of Plasma*; Adrian Neptune's much buzzed-about *Spacetime Labyrinth*; Olivia Cosmos's *Galactic Inheritance*—half of them were authors she knew.

During the time it had taken to find *Twelve Ways to Shut Up a Hungry Bug,* she had highlighted dozens of books as her eyes paused on them. What it was that had allowed her to know Tran's book was written by a human, she didn't know, but this was the way to invoke it.

Write a review and compress it using the author's name and book title as hints. Compress the publisher's blurb in the same way. Then break the review into snippets of text and compress them using the publisher's blurb as the hint. When she asked the LLM built up in this way to judge the merits of a story, it overturned the overwhelming material odds and always picked at least half by human writers.

Alice was remembering that day.

The day her favorite author confessed that Alice's favorite of her works had been written with generative AI.

There should be a difference between something someone had an AI write and something a person wrote. To test that hypothesis, she'd read voraciously and posted her impressions to a review site. After reading all of the works by that author, she'd reached for books by other authors who had transitioned to using AI and wrote reviews of those. Even though it had been clearly announced when the change-overs occurred, Alice couldn't tell the difference.

She thought at some point she would figure it out, so she read even more—books where the boundary between generative AI and handwritten was unclear. Alice became one of the two most prolific readers on the review site, but she still couldn't tell the difference between generative AI—which by then was called LLM supplementation—and human-authored work.

But around the time she surpassed ten thousand books, something strange began to happen.

Before she even picked up a book, she would have a sense whether it was LLM-supplemented or not. It wasn't completely reliable, only a ten or twenty percent bias, but out of the deluge of books Alice was able to surpass probability when picking out human-authored stories.

She didn't know why. She could only think that information such as author name, title, cover design, how the book appeared at bookstores, a blurb she'd read somewhere, and so on was being sifted through the ten thousand books in her head. The difference should have been in the texts themselves, but no matter how closely she read, she couldn't determine which were human-authored.

Alice became obsessed with the idea that it might be possible to reproduce the selection process using generative AI. Despite her instinctual hatred of LLMs, she installed a developer kit, created the alice.cptk language model, and dumped a ton of her posts from the review site into it.

With the first hundred books, it couldn't even parrot something in return, but Alice continued compressing reviews, undaunted. By the time she'd reached a thousand, the model could finally tell her what books were similar to a given title. After five thousand, and especially ten thousand, alice.cptk had finally developed to the point where it could select human-authored works half of the time.

As with her own ability, she had no idea how it worked. She was scared to ask a specialist because it seemed like the spell would be broken.

Having gained some technical skills over the course of compressing all those reviews, Alice released an LLM service for editors called Reader Alice. She didn't publicize the fact that it tended

to choose human authors, but it seemed like the stories it chose aligned with editors' tastes, and the number of users was growing.

The profit margins were such that Alice made a stable living. If the LLM fell out of date, its judgements would be off, and that was why she would go around to bookstores and write reviews of new releases.

When the Alice in the video picked up *Twelve Ways to Shut Up a Hungry Bug*, Alice stopped generating the list of books to review.

The cashier was just finishing folding the book cover. She handed the book, papered over with the red glasses pattern, to Alice.

"Enjoy!"

"Thanks."

"I wanted to ask you something, if that's okay."

Alice put the book in her tote bag and asked, "What is it?"

"Is there a trick to finding books written by people?"

"Hmm, I don't really know, but …" she gestured at the bookcase behind the counter. "I think the first step is just to read a lot."

PROMPT

Marina and Sergey Dyachenko

Translated by Julia Meitov Hersey

"My name is Timur Timyanov."

Silence filled the large, empty, dimly-lit hall. Behind the low counter, he saw outlines of old-fashioned nickel-plated clothing racks, bare and splayed like autumn trees.

"I came to ..."

Timur faltered.

He'd entered this building many times before, but never from the stage door—not since he was a young child. The hall was empty and clean, a single mirror hung on the wall across from the entrance, and a single clock glowed faintly above the stairs that led up and to the left.

The hall was deserted, yet Timur felt as if he were standing naked in front of a large silent crowd, all stares merging into one, unbearably heavy, devoid of either malice or sympathy. At first, Timur recoiled; in all honesty, he was ready to run back out into the street. It took a significant effort on his part to hide his fear.

Prompt disliked cowards.

"I came to ... I'd like to talk about a play."

The most important thing was out; now he had to wait for the answer. Timur did not consider the possibility of not getting an answer. Not now, not ever.

The long hand on the green-tinted clock dial twitched, jumping from one reference mark to the next. A whole second later, Timur heard a soft click.

Had he said everything he was supposed to? No, he'd missed the most important detail.

"I am a director. And a producer. I wanted to make arrangements for …"

Somewhere above, on the next flight of stairs, a door screeched. Again, silence reigned. Timur waited. The long sonorous hand twitched again: three minutes past eleven. The best time for a visit.

"May I come in?"

It was still quiet, but the tension in the invisible gaze had subsided ever so slightly. A barely perceptible draft pushed Timur toward the staircase, then disappeared.

Timur allowed himself a moment of hesitation, then proceeded up the worn-out marble steps. He was afraid of touching the rails, polished by the hands of so many great people. The very thought forced Timur to pull his hand away from the gleaming wood.

He stopped at the next landing. From there, he could turn left or right, or continue up.

The sensation of someone watching him returned, and immediately a light flashed at the end of the corridor to the left. It flashed again—oh, but how long and dark that corridor was—and this time it stayed on. Pushing against an unpleasant chill in his stomach, and stumbling on the folds of the carpet, Timur followed the light.

A yellowish light bulb, dimmed by its wire wrap, was revealed under the ceiling. A circle of light fell on the painted wall. Timur shuddered.

What's the play?

The inquiry was written in chalk. The question mark coiled itself like a viper.

"*Three Brothers*," Timur said quickly. He added, justifying his choice,

"Classics make sense because …"

The door behind him slammed shut, making Timur jump. He turned around, tearing his eyes away from the chalky words on the wall. This time the door opened with a long screech; it was clearly an invitation.

Timur entered.

It was a dressing room big enough for four. Since he was a child, Timur hadn't seen such cozy dressing rooms. One of the mirrors looked foggy, and as the fog evaporated, Timur barely had time to read the words on the misty surface:

Does the eighteenth work for you?

"Eighteenth of November?"

The sensation of someone's stare lingered. Timur felt it with the itchy skin of his cheeks, but the fear was gone now, replaced by the premonition of an enormous success, by the ease of his first lucky break. He had two weeks before the opening, and November 18 was a Saturday, the best day for a performance.

"Thank you," he said, not quite believing his luck.

He looked around.

Comfortable armchairs, a leather sofa, a small bathroom. This dressing room looked like an ordinary room at a mid-range hotel. Instead of wallpaper, the walls were covered with posters: both old yellowing ones, and newer ones, marked with the sharp strokes of autographs.

"*My darling Diana! On the day of your triumph …*"

"*Because theater is our home, our life …*"

"*Congratulations!*"

"*Congratulations on your success! This … this triumph on Prompt's stage …*"

Timur glanced at the opposite wall.

A short paragraph was written in red marker in an empty corner of one of the posters:

Dress rehearsal on the morning of the eighteenth. The stage is yours starting at 9 a.m. When convenient, drop off the music score, lighting notes, and any technical requirements. Do you understand, Timur Timyanov?

"I understand," Timur said.

263

His fear had evaporated completely. He saw himself reflected in the mirrors: a skinny young man with a dopey grin on his face. Sharp cheekbones, dark hair, wide lips. The bigger the mouth, the wider the smile, his mother used to say. The blue suit worn for this special occasion looked baggy. *I look horrible,* Timur thought, still grinning. *I wonder if Prompt has an opinion of me already, or would he reserve his judgment until after the opening? Or maybe he liked me, and that's why the opening is so soon, and is to be held on a perfect day?*

He walked toward the door but did not leave. He stepped from foot to foot. The posters summoned him.

"May I?'

The lights came on suddenly. Used to the semi-darkness, Timur squeezed his eyes shut. Yes, Prompt was encouraging his curiosity. Timur heard that Prompt was usually gracious with polite strangers, but he preferred to think that it wasn't just courtesy, but rather the beginning of rapport.

He approached the wall covered with posters.

Titles. Names. Dates. Ornate autographs. Intricate drawings. And, among all this motley magnificence, a simple poster, familiar to the tiniest detail.

STORM. One hundredth performance. Starring Greta Timyanova.
Timur inched closer and stood on tiptoes.

Was it a coincidence that this very poster would end up in this dressing room? Or was Prompt making a special gesture?

The poster displayed the date of the hundredth performance—ten years ago. Timur was fifteen then, a carefree teenager, not particularly studious. His mother had played an eighteen-year-old girl, genuine and inexperienced. On stage she'd looked twenty at most. There had been a standing ovation; in the audience, the principal of Timur's school (who'd been given a ticket as a bribe) was shocked and dismayed by the actress's youth and talent. Timur barely made it into the next grade: excelling in literature, history, and choir did not quite outweigh his failure in physics, and the principal had had no desire to help out the son of Greta Timyanova, who, despite being the same age as her, still looked like a schoolgirl.

Timur thought someone else was in the dressing room. He turned sharply, trying to catch his own shadow in an act of defiance.

The drawer of the nearest dressing table was slightly ajar; Timur remembered it being tightly shut just a few minutes ago.

Inside the drawer he found a paper towel, a cake of soap in a plastic dish, and an open pack of napkins. The top napkin read: *Do you understand the terms? You may decline at any moment, I will not be offended. At any moment, up until the third curtain call. After the third call, your decision becomes irreversible. Do you understand, Timur Timyanov?*

"I understand," Timur said, trying not to shiver. "Thank you."

The lights went off. There was no mistake: the audience was over.

Timur felt his way back into the corridor. The yellow light bulb was still burning, and underneath it, a few words were written in chalk:

I will be waiting.

*F

"Are you in love?"

Timur looked up from an empty bowl of soup.

"What?"

His mother cleared his bowl and replaced it with a plate of rice and meatballs. She wiped her hands on a kitchen towel.

"You are acting as if you were in love. You don't talk, you just smile."

"Umm, I don't know." Timur had no idea how to respond.

Mom was quiet. Above her head, a poster familiar since his childhood hung on the wall opposite the kitchen window: *STORM. Performance #120*

"You're scaring me, darling," Mom said pensively. "Are you sure you're not in love?"

"What's so scary about being in love?" He popped a whole meatball into his mouth. "Sooo good. Just enough onions. Did you soak the breadcrumbs in milk?"

"Don't change the subject." Mom smiled. "Is everything OK?"

"Yep," Timur said, chewing.

"Any news on the job front?"

He shrugged.

"Nothing special. We are rehearsing."

"I mean, a real job. A paying one."

"Mom, I am busy with a real job," Timur said, placing his fork on the table. "Right now. The fact that I am not making money yet doesn't mean anything."

Mom smiled thinly. She sat down and put her elbows on the table.

"So that means you are in love."

"I am," Timur said after a pause.

"Do I know her?"

"No."

Mom sighed. All the unspoken reproaches and wishes, all the plans, hopes, and laments hid behind that sigh. Not a single word was needed. Mom was a virtuoso of speechless sighs. She was a brilliant actress.

"What about Irina?"

Timur gave another vague shrug. As if coming to his rescue, the phone rang in the bedroom.

"Finish your dinner," Mom said, getting up.

Timur sunk his fork into the mound of rice. He grinned again: his silly smile stuck to him all day, like a haunting melody. One had to be blind not to notice; he needed to regain his self-control.

Mom came back, and when Timur saw her face, he nearly choked on the rice.

"Timur."

"Who called you?"

"Timur. Did you really go there?"

"Who. Called?" he asked, full of icy fury.

"Why does it matter? Did you think you could hide it from me? Did you really think it was possible? Not to mention that it's simply dastardly to do this behind my back."

"Who. Called. You?" he asked for the third time.

"Degtyarev," Mom said softly. "He saw you leaving. Today, at quarter to twelve."

"Did he watch me with a timer or something?"

"What did you think?" Mom said, her voice unexpectedly calm, even teasing. "Did you think it would be easy to keep a secret here?

Like a lump of hot coal in your pocket? Degtyarev has two shows on Prompt. You are his competition. Every new production on Prompt devours the old shows, it pushes them off the schedule, it eats into their time …. Some people will do anything to keep you from Prompt. Don't expect mercy."

"I know," Timur said.

"You *know*." Mom smirked. "Idiot."

She left.

For a while he stared at the empty plate in front of him. It was already dark outside, and the only source of light in their entire apartment was a small light bulb above the sink.

Eventually, Timur got up and switched on the light in the living room. He stopped in front of his mother's bedroom, hesitated, then took a deep breath and opened the door.

In the dark, his mother lay face down on the sofa.

"Mom, you performed at Prompt yourself," Timur said to her back. "Why do you think it strange that I want to do the same thing?"

She said nothing.

"Mom. I am confident that what I've done—what we are doing—it's good, at a minimum."

His mother stirred, then sat up.

"My teacher, Grigory Petrovich, spent his entire life directing brilliant shows," she began.

Timur couldn't see her eyes in the dark.

"He received every possible title, accolade, and award. He raised two generations of students and had never gone to Prompt. But when he got older, he cracked. I suppose he'd always had it in him, this need to be recognized and accepted by Prompt. He asked Prompt for a chance to direct a show. I was there. All his students were in the audience. The show was sold out, a full house, you know how Prompt loves people standing in the aisles. We watched the show, watched all our favorite old actors, our gold standards, our icons—and we saw how mediocre they were. We saw through their lies. We saw their grandiloquence, we saw how ugly, insincere, pretentious they were. Prompt did not accept this play, I don't know why. The same actors shone in other productions, but Prompt did

267

not accept this one, and all of us in the audience saw everything he wanted us to see. And these actors, all these old actors crowned with laurels, understood what he wanted them to understand. Three of them suffered heart attacks right after the show. As for Grigory Petrovich …"

"I remember that story," Timur said.

"What could you possibly remember? You were just a kid back then."

"I know that Prompt is harsh."

Mom smirked in the darkness.

"You don't understand just how harsh he can be. You will certainly know if Prompt does not accept your show. And if that happens, you will need to change your profession, Timur. You will need to give up theater forever. Do you understand that?"

"But what if Prompt does accept my show?"

Mom said nothing for a while.

"What about your cast? All these eager kids who don't want to look for regular auditions, who don't want to run around as extras and beg for episodic roles? These kids who want to start with performing for Prompt! After the show, these actors will have to find other jobs, and that's assuming everyone survives. If Prompt does not accept your show."

"But what if he does?"

Another pause.

"Do you remember those actors from the provinces, whatever their names were? It was about three years ago. Everyone warned them …"

"Seriously? Are you comparing our production with that provincial amateur debacle?"

"I am not comparing. I am simply referencing the situation. They had been warned. And still, they took their drama to Prompt. Do you remember? That girl who played the female lead ended up committed to a mental institution for two years with depression. Do you remember that? You were old enough to remember. It wasn't hearsay, you were there, and you saw it all!"

"They had been warned," Timur said, his voice hollow.

"And you are being warned yourself. As we speak."

"Mom! This is a solid, professional production. I am not saying it's a masterpiece, but ..."

"That's just it, Timur. You are convinced that it is a masterpiece. You are confident. The only thing that would dissuade you is being booed at the opening."

"Bite your tongue," Timur said, and bit his own. "I am sorry."

"I am sorry, too," Mom said softly. "Just so you know, Degtyarev called specifically so I could stop you."

"Are you going to make Degtyarev happy?"

Mom switched on the light. The gentle glow of a bedside table lamp blinded Timur.

"You shouldn't have gone there without telling me."

"I am sorry."

"You'll have to go back. And tell Prompt that you changed your mind."

Timur did not respond.

His mother's face looked pale, weary, and determined.

*F

"Our opening is on the eighteenth," Timur said.

Olya inhaled sharply. Vita clapped her hands. Kirill and Boris exchanged glances.

"What about a dress rehearsal?" Drozd inquired.

"Just one. Unfortunately, on the same day. But we'll have access to the stage starting at nine in the morning."

"That's pretty typical for Prompt," Drozd said pensively. "Evenings are for shows."

"The eighteenth is a Saturday," Vita said, hugging herself as if she were cold. "It'll be packed."

"Prompt's shows are always packed," Kirill said. "Especially opening days."

"Flying close to the Sun," Drozd said wistfully. "Hope we don't melt."

"All you need to do is work hard," Timur said sternly.

"I won't do it," Olya said, looking up. Timur realized she was about to cry. "I won't. I'm too scared. I can't work with Prompt. I have no talent."

"Then get up and get out," Timur said, keeping his voice steady.

A pause hung in the air, as rigid as dry glue. Olya climbed out of her seat. The club had old wooden rows of chairs nailed too close to one another, and Olya's movements were slow and awkward.

"Olya, don't do anything dumb," Vita said, distressed. "We talked about it."

Olya picked up her bag from the aisle and moved toward the door, keeping her head low.

Timur remained silent.

"Olya Toporova!" Kirill said sharply. "Sit back down!"

"Let her go," Timur said. "Goodbye, Olya. You made a mistake with your chosen profession."

Olya turned around, red spots spreading on her cheeks.

"I am scared! Don't you understand? This is a failure, it's …"

"Olya, we discussed it," Drozd said gently. "You knew about it beforehand, didn't you?"

The fluffy curls framing her face made Olya look like a Cocker Spaniel. Her enormous desperate eyes made the resemblance even stronger.

"Get out of here," Timur said, forcing down a wave of involuntary empathy. "Loser."

Olya ran up the stairs, dragging her bag behind her. The door slammed shut.

"Well," Timur said. "Of course, I anticipated something like this."

He'd anticipated nothing, but he had to maintain his authority.

Vita got up.

"Hold on, I'll go after her."

"Listen, guys," Boris said hoarsely. "What if we drop this? I mean, seriously."

"You too?" Timur said, turning to face him. "Good riddance then."

"No, no, I'm good," Boris said, taking a step back.

"Don't panic, Timur," Drozd said softly. "It's a natural reaction. We didn't expect you to just go straight to Prompt. And you did, you went straight to him. This is a cause for agitation. I am feeling quite a bit of discomfort myself."

The room was quiet. Inside the People's Club, the performance hall was large and chilly, and the backs of wooden chairs sported obscenities carved into the cracked, worn out surfaces. The four men sat in front of a stage that was flat as a pancake, suitable for accommodating speakers at political rallies and not much else.

They were still very young. Kirill and Boris were only twenty-two, Timur twenty-five—and only Drozd was older, having just turned twenty-nine. Ahead of them were many years of hustling, performing on pitiful makeshift stages in half-filled halls, longing for the day when fate would hand them a spot in a halfway decent repertory theater.

"Prompt's dressing rooms are really cool," Timur said, surprising himself.

"Oh yeah?" Kirill asked, clearly interested. "We've all seen the stage. Are the dressing rooms as good?"

"I'd live there," Timur said. "Seriously, I'd move in if I could."

"Were you scared when you went to see Prompt?" Drozd asked, keeping his voice casual.

"I was at first," Timur admitted. "But then the fear kind of goes away on its own. Maybe he liked me, or maybe he remembered my mom, but I just had this really good feeling."

Timur paused, then spoke in a very different tone of voice.

"Guys, we're a thorn in everyone's side right now. Everyone who's ever had a show on Prompt will converge upon us in droves."

"Obviously," Drozd said, rubbing his forehead. "We have to protect the girls, Tim. Kirill, Boris, and I can handle it, but Olya is so sensitive ..."

The door opened and shut again. Vita came back, radiant despite a long scratch on her cheek.

"So," she said, hopping onto the stage. "Olya is ready to work. She's the most talented, the best one, she's a genius. And our show is pure genius. Timur, if you have cigarettes, give me one, I deserve it."

Timur pulled out an unopened pack he carried around for his actors and tossed it to Vita over Drozd's head. Vita caught it in mid-air and nodded her thanks.

"All yours," Timur said. "You did well. Just don't smoke in here, please. The last thing I need is trouble with the fire department."

271

Vita smiled her most charming smile, and Timur thought about the brilliant future ahead of her. All she needed was for other producers and directors to see her on Prompt. Let them see what she was capable of ...

"When you're standing in the limelight, you can share your cigarettes with me," he said, his voice suddenly hoarse.

"You don't smoke," Vita said, smirking.

"You can share your chocolates. Anyway, break's over—enough chatter. Everyone, on stage."

<p style="text-align:center">⚘</p>

"Timur."

He turned around and saw nothing but a glowing end of a cigarette that looked like a tiny red emergency light.

"Hey, Timur."

He knew that voice.

"Good evening," he said dryly.

"Why so cold?" the man said, stepping into the circle of light under the street lamp. Timur saw his expressive youthful face and a pair of fashionable glasses perched jauntily on the tip of his slightly hooked nose.

"Anything you want to tell me?" Timur asked.

The man smoothed an elegant lock of gray hair away from his forehead.

"Actually, yes, I do."

"Well, I am not going to listen to you, Degtyarev. Prompt wants to see my, I mean, our show on Saturday, the eighteenth. Feel free to attend. If you can get a ticket."

"The boy is all grown up," Degtyarev said, smirking.

"I grew up a while ago. Did you only just notice?"

"I'm worried about you," Degtyarev said, his voice suddenly harsh. "You are responsible for the lives and wellness of your actors. You are risking their wellbeing, you are setting them up for a guillotine. You yourself are safe, humiliation is not deadly. But do you know what it's like to suffer from depression after failing at Prompt? You have no idea."

"We will not fail. I understand you really wish for us to fail, but we'll not fail."

"You will! You will fail. You are ignorant, Timur. You learned nothing in five years of drama school. I saw your school productions. You're a dilettante, an amateur, Timur. Prompt will never accept it. I know his taste."

"Go to hell," Timur said, slamming the heavy door in Degtyarev's face.

*F

"Mom?"

She sat at the kitchen table. In front of her was a half-eaten chocolate bar and a nearly empty bottle of cognac.

"Mom?"

Horrified, Timur stopped at the door.

"Have you talked to your father?" Mom asked, not looking at him.

"Yeah," Timur said, his voice deflated. "I mean, no. I mean, we have nothing to talk about. To be honest, I told him to go to hell."

"Good for you," Mom said, lowering her head onto her intertwined fingers. "I also told him to go, but not to hell—further." She laughed mirthlessly. "When I went to Prompt for the first time, I was so stupid, I wasn't afraid of anything. Just like you, Timur. I was young, younger than you are now. I remember coming out for the final bows, but nothing about the show. I remember standing at the edge of the stage, sweaty, hot, covered in talcum powder. And the audience in front of me, undulating like the sea. Screaming 'bravo,' nearly falling off the balcony ..."

Mom sloshed some cognac into her glass and drank it like water. She grimaced, smiled, then continued.

"Yes, it was happiness. We were given a hundred shows—it was happiness, it was life. Then one hundred and twenty, then one hundred and fifty I played my role for seventeen years, my darling. I was offered other roles, but I didn't take them. I wanted to continue performing in *Storm*. And when *Storm* was finished, I was almost forty, and I was still playing an eighteen-year-old. We had one hun-

dred and fifty seven performances of *Storm*. I knew I wasn't going to play anyone else ever again. I couldn't fathom playing another role after my brilliant performance on Prompt. They called me 'The Talented Timyanova.' I don't know whether I was a good actress, or whether Prompt made me that way because he liked the show. Perhaps it was Prompt who killed the actress in me. It was like a drug: you get addicted and then you're left with nothing. With emptiness. I could've still been performing now, Timur. But I loved Prompt, I adored that monster. You should stay away. But you don't want a bird in the hand, do you? You don't want to spend the next few years doing children's matinees."

"That's not the problem, Mom."

"I know what the problem is," Mom said sharply. Then she whispered, "Timur. Promise to let me see your show. Before you take it to Prompt. Do you promise?"

<p style="text-align:center">❋</p>

A woman is washing clothes in ice-cold water. She sniffles, grits her teeth, and plunges back in, rubbing the fabric against the corrugated metal of the washboard. There is a thin layer of ice on the surface of the basin, and she cuts her hands on it, but continues to rub.

There is nothing about washing clothes, or frost, or the washerwoman's shabby apron in the stage directions. In the play, the female lead is at her country house, bored out of her mind. She's sitting inside a gazebo, conversing with her guest, while a distant gramophone supplies a gentle soundtrack.

"Good, Olya. Nice work. Kirill, don't get too close. Keep your distance, both literally and figuratively. Yes, exactly!"

The rehearsal was underway. Timur sat amidst the empty kingdom of creaky chairs; he thought he could see energy flowing from his actors. He was swimming in it. Kirill would need additional direction; he flailed a bit in that scene. The Writer was not the easiest role, but Timur knew exactly what to say to Kirill, and how to say it, to make everything come together. Olya was great. Drozd—what was happening with Drozd? Something was definitely off, and Timur would have to investigate after the rehearsal.

On stage, the woman tosses a wet rag aside. Her hands are crippled by a cramp, and she cannot continue. She is conducting polite small talk.

Timur had directed this show in his imagination three years ago. He'd watched it over and over, taking it apart and watching it again, playing each and every role. He'd experienced disappointment, anger, and he'd walked away. He'd been woken up by sudden vivid dreams in the middle of the night, and the dreams had told him just how a particular scene would have to be changed. He'd gone back to the text, and read it over and over again, leaving brown coffee spots on its pages. He'd sketched the sets and blocked the show, he'd searched through the crowds for faces that resembled the characters as he saw them. The trouble was that with each change, Timur's vision had moved further and further away from the original, from the play he knew from his childhood, from the text familiar to the last letter. Timur had directed several term and graduation productions; he was well liked at the university, but it was only six months ago that he'd gathered enough courage to offer Vita a role in *Three Brothers*.

… Here, the lights would change. Timur knew exactly how the spotlight would have to fall. The primitive club switchboard could not handle it, but Prompt … Prompt would take care of it.

He'd found Kirill and Boris at the same time. Olya came later. Before her, another actress had played the role, and only with Drozd's arrival had everything come together, and the ghosts from Timur's obsessive dreams had finally begun to grow flesh. That was when he'd known that everything he'd done so far was wrong. Terrified, he'd realized that these living human beings imperiously acted against his ideas simply by the fact of their existence, and that now he had to start from scratch.

… He'd felt that the music in Drozd and Olya's love scene was as solid and as material as his own hand. He could stretch the music toward them and use it to push the dialog in the right direction to fit the scene.

He'd known he had to start from scratch. Not everyone had believed him right away. Even Boris had had his doubts; his perplexed face said, "That's not how we've been taught." Out of all of

them, Drozd was the least gullible one, but it was him, Drozd, who believed *fully*. Once, when Timur had come in early, he'd overheard something he wasn't supposed to hear. "Timur senses time," Drozd was saying to Boris. "Whatever he's doing may seem like heresy at first, but if you think of the history of theater ..."

If Drozd had meant these words for Timur, Timur would think of them as flattery. But Drozd never bothered to butter anyone up; perhaps that was why his acting career had yet to take off.

This show, this production that had grown its roots through Timur, like bamboo shoots piercing a living human body. This show had found its own life. It existed separately, independently. Should Timur die in a car accident tomorrow, the show would still go on. At least Timur liked to think so.

... Darkness. The recorder had stopped, all the stage lights went out, and even a small service light behind the curtains went dark.

"Hello?" Drozd said in the darkness. This line was not in the text. "They killed the electricity again."

"That's fine," Timur said. "We have candles."

<center>⚡</center>

"My voiceover has been rescheduled for evenings, from five to eleven," Drozd said. Every day until the eighteenth. What are we going to do, Timur?"

"I hope you understand: this was done on purpose, to throw off our rehearsal schedule," Timur said wearily.

Drozd scratched his ear.

"So the question is—do I quit my job?"

"Do you think Prompt will accept our show?" Timur asked, looking into Drozd's eyes.

Drozd was almost two meters tall, and Timur had to crane his neck to look at him.

"Do you think ... if they weren't afraid of us, would any of them bother interfering with us?"

"Right," Drozd said after a pause. "I get it. If I can't get time off for these two weeks, I will have to quit."

"It's your decision," Timur said, his voice hollow. "But I think it's the right one."

<p style="text-align:center">ℱ</p>

Comedy of Manners, directed by Degtyarev, was the only Prompt production Timur hadn't seen yet. It was the most recent show, the latest opening. Timur didn't mind the overnight queue snaking along Prompt's walls; he enjoyed these overnights, even in the winter, even in the rain. The night queue to the box office served as a threshold to joy, a start of the show, a beautiful ritual that demanded patience and humility from true theater lovers.

Sitting on a folding chair by a fire made of wooden crates, listening to the banter of the aficionados and the scalpers (the two types comprised the majority of the Prompt night queue), Timur kept running through his show, making mental notes to the cast, and running through the whole thing again, until someone's elbow poked him in the ribs.

"What are you doing here?"

Timur looked up. His classmate Ilyukha stood by the fire, dressed in a camouflage jacket and quilted trousers—ready for a cold night.

"Waiting for tickets," Timur said.

Ilyukha whistled.

"You need tickets to see your own dad's show?"

"Who is his dad?" the closest scalper asked suspiciously. "Degtyarev? But this guy's Greta Timyanova's son."

"Not mutually exclusive." Ilyukha smirked.

"Shut up," Timur said.

"Sorry," Ilyukha said, immediately backtracking. "I didn't mean to offend you. It's just weird, that's all."

"You are a strangely unkempt young man," the scalper said pensively. "With parents like yours …"

Timur did not respond.

<p style="text-align:center">ℱ</p>

"Using open fire on stage is strictly forbidden! Strictly forbidden, Timyanov! I warned you!"

"But the electricity went out," Timur said, trying to make his voice sound friendly and polite. "We are paying for the stage and would like the conditions …"

"Who allowed you to be here until one in the morning? We've had this discussion before, Timyanov, don't you remember?"

An enormous box of chocolates lay in front of the administrator, but the woman did not look at the chocolates, she stared into Timur's eyes. She was not faking her irritation, she was truly very angry.

It was infinitely harder to stay calm after a sleepless night. Timur wanted to slam his fist on the desk, making the damn box of chocolates jump. He wanted to tell this woman everything he thought of her, and the club's management, and all these power-hungry bureaucrats who loved restrictions. Perhaps later he would be ashamed and painfully sorry, and more importantly, the show would be homeless right before the opening.

"I promise, there will be no more fire," Timur said meekly. "I promise to vacate the stage no later than 11 p.m. I am begging you to unlock the backroom and give us back our stuff."

He reached into his breast pocket and pulled out his trump card: two tickets to Prompt. Two tickets to that evening's performance of *Comedy of Manners*. The tickets smelled of smoke; they had been paid for by waiting by the firepit in the overnight queue—and by the rest of Timur's savings. He had meant to resell the second ticket before the show and thus patch up the hole in his budget. He did have a fleeting thought of inviting Irina, but the thought had disappeared as quickly as it came.

He watched the administrator's face, and the changes in her demeanor. He saw the way she examined the tickets, first with distaste, then with bewilderment, then with interest. He waited for her to finally hold the tickets in her hands.

Prompt's tickets were dazzlingly white, no vignettes or unnecessary frills: only the date, the row, and the seat. And a hand-written invitation on top: *Prompt is expecting you.*

"Wow," the administrator said dreamily.

The tickets were for the orchestra section. Together, the two tickets cost more than two months of the administrator's salary. *Obviously, with a family like his,* the administrator thought unkindly. She hadn't actually said it out loud, but anyone could have read the thoughts written on her scowling, sallow face.

"Fine, Timyanov," the woman said, after a respectably long pause. "Here are the backroom keys. If I see fire on stage one more time, or if—God forbid—someone smokes in here, you will never see this stage again. Keep that in mind."

<p style="text-align:center">᛭</p>

The rain started at lunchtime. Timur packed the soundtrack recordings into a plastic bag and the music score into a thick folder, pushed his hood deeper on his head, and went to visit Prompt.

No one stood near the service entrance, but Timur did not rely on false hope. The door was definitely under observation, and all the interested parties would know within half an hour that "that stubborn kid went to Prompt and brought all his stupid stuff."

Timur lingered inside the hallway while his eyes got used to the semidarkness, letting rainwater roll off his jacket and his shoes and collect into a small puddle on the stone floor. He needed time to get used to the intense stare. He needed time to relax and stop being afraid.

"Hello. I brought the soundtrack and everything else."

Silence. A gentle draft pushed him toward the stairs.

Timur struggled to unbutton his coat, his fingers stiff from the cold. He hung his coat onto the closest hanger and looked at himself in the mirror, but saw nothing but a dark silhouette holding a large bag.

He wiped his feet on a fuzzy rug at the foot of the stairs and hesitated before the first step. A soft creak came from above, as if the wind had swung a door left ajar.

Timur followed. He stopped at the second floor; the last time a light had beckoned him to the left, but this time the corridor was utterly dark, not a spark in sight. Instead, a barely audible creak came from above. Timur went up to the third floor and stopped

again, unsure of the direction. Someone was watching him, and Timur's skin prickled under their gaze, as if disembodied wings kept touching his face and hair. The sensation was not pleasant. Timur fought the urge to scratch.

There was a blinking light on the left. Timur walked faster, almost running, then stumbled upon a rolled up carpet, lost his balance, and went crashing down.

He got up, rubbed his knee, and wiped his hands on his pants.

Ahead of him, the light was still blinking. Twenty paces further, Timur stopped at a freshly painted wall. A single light bulb wrapped in wire netting illuminated a sentence written in chalk: *Watch your feet, Timur Timyanov!*

Timur smiled. He sensed a positive, benevolent intonation. Not irritation, more like friendly grumbling. What made him think of it this way? Did Prompt really favor him?

"I will try," he said out loud. "It's so dark."

The light came on brighter, and Timur saw a door frame a few steps ahead. He took a confident step forward but the floor went down sharply, and Timur nearly fell again, slipping on a low ramp. He saw another corridor ahead, the same dull yellow light bulbs along the walls leading the way.

Twenty steps. A turn. Fourteen steps. A staircase. Two flights down, a turn. Ten steps. A turn. A staircase, two flights up.

Wondering if he would be able to find his way back, Timur thought of Degtyarev boasting of his ability to navigate Prompt with his eyes closed. Was he lying?

Are you lost? The question was written in chalk on another wall. Once again, Timur imagined a benevolent smirk. He wished he could watch the words appear on the wall. In the entire history of Prompt, no one had ever seen it. The only existing amateur video was a crude and obvious fake.

"I am lost," he admitted.

Down the corridor, a door creaked again, beckoning and—possibly—mocking him. Timur found himself in a small hall. A set of three doors led him to the right. The middle one was slightly ajar, and a ray of light shone through the narrow gap.

Timur entered.

Various equipment took up almost the entire room, leaving enough space for one person to stand amidst all these tools and appliances or to perch on a swivel stool with worn out upholstery.

A rectangular window across from the door showed Timur's reflection: tense round eyes, dark hair sticking to the sweaty forehead. Timur was drenched, and not from the rain; his wet coat remained downstairs.

The lights in the control room dimmed, and now, instead of a reflection of his own pale face, Timur saw the stage. He couldn't breathe.

The stage was right there, right in front of him. It looked enormous; a fragment of a transcendent world in a single white beam. The air shimmered between the curtains as if above a fire pit. Or perhaps, it was simply Timur's imagination. He was ready to witness a miracle, and he did see it. This stage was Prompt's biggest asset. The stage was the face of Prompt. Once accepted by Prompt, you had full power over the souls of others. And should you have been rejected by Prompt ...

Timur stopped himself from going further. He simply cut this thought off as a hanging thread.

The spotlight went out and the lights in the control room came on. The dark window transformed back into a mirror, and Timur saw himself again. This time, he looked happy, his eyes open wide and shining with excitement.

He needed to get a hold of himself. Overboard enthusiasm was unnecessary; Prompt did not suffer fools gladly.

Timur still felt someone's gaze on him, this gaze coming from nowhere. The darkness dissipated, and Timur found himself surrounded by wooden walls plastered with old calendars and soundboards, as dusty as if no one touched them in years.

Timur looked closer.

All the equipment, both new and old, looked abandoned. Dust, broken cables, an old tape stuck in the recording head of a tape player.

Perhaps for Prompt, all this was nothing but props. Perhaps it wasn't a magnetized tape that brought music to life on that stage. It wouldn't be surprising, considering how music sounded on Prompt,

any music, even the most primitive soundtracks. That is, of course, if Prompt liked the show.

Timur turned sharply to the window. He thought he saw a faint shadow move behind the glass.

He wasn't mistaken.

Someone was looking at him through the window, someone human. A weak light from the control room illuminated his pale face.

It was Degtyarev.

"Timur, hello! Did you bring the music? Nice, good for you."

For the umpteenth time, Timur marveled at Degtyarev's skill at changing demeanors. This time he was a nurturing parent, sincerely wishing his son to be successful. Of course, Prompt could hear their conversation. Timur wondered if Prompt perceived human pretense. Could Prompt recognize people playing different roles in life, and not on the stage?

Timur smiled. Degtyarev was dumb. Prompt did not care about their relationship. Should they exchange the filthiest insults, should they start a fistfight, Prompt wouldn't even make a door creak. It was of no interest to him. If Degtyarev was brazen enough to steal the music score or somehow sabotage the soundtrack, Prompt would interfere, because for Prompt only the show meant anything at all. Only the show, and not some stupid human squabbles.

Degtyarev must have known that. And yet he couldn't help being a hypocrite, it was such a part of him by now.

"My show is on tonight, Timur. *Comedy of Manners*. Have you seen it yet?"

"No," Timur said. He didn't see the point of lying.

Degtyarev was—or at least acted—embarrassed.

"Darn, such a shame. Of all days, today I don't have any complimentary passes left."

"That's all right," Timur said. "I'll see it some other time. I hope it doesn't close any time soon."

Cold fury flashed behind Degtyarev's eyes. What exactly had he read between his son's lines? Timur didn't care.

*F

Prompt provided no assistance on the way back. At first Timur could retrace his steps, but eventually he got lost for real.

The theater was filling up with people: Timur heard voices in the distance: *Comedy of Manners*'s cast members, the crew, and the production assistants were gathering inside. The doors slammed shut, not by Prompt's will but thanks to some ditzy makeup artist. This busy nightlife was happening very close, yet quite far away: wandering around for the last forty minutes, Timur had yet to meet a single person. He made no effort to rectify that.

At some point a wave of fatigue washed over him. He sat down on a concrete step that was cold and not particularly clean.

When he was little, about six or so, his mom used to take him backstage at Prompt. He remembered waiting for her in the dressing room, drawing with the colored pencils his kind daddy Degtyarev had brought back from some exotic trip. Back then, Timur didn't think of Prompt as anything special. It was just a building, just a theater, the same as the other theaters in the city. He did remember that the only time he longed to draw was when he sat behind Mom's makeup table. Later, he had nothing but Cs in art.

He drew people. Not trees, not landscapes, only people. One person angry, the other making apologies. One running away, the other chasing him. Once he drew a person who was *lying*, but neither his mom nor any of the other 'art lovers' understood his concepts. They missed the reddened ears and the long nose of the liar in the picture.

In Timur's day care center, boys were expected to draw cars. Timur found a way to express himself by drawing the drivers in the car windows: he made up their lives and their challenges, all the while leaving the outlines of the tires and trunks unfinished. His teachers only shook their heads.

But when he was seated at the makeup table, no one told him how and what to draw. When he got tired of drawing people, he would gaze into the mirror, at his face illuminated from both sides by the lights, and then he would draw self-portraits. Every time they came out different: a plump boy with sad blue eyes, a skinny angry boy with piercing black eyes, and once the portrait turned out to be of a girl, and Timur tore it up in frustration.

He would draw while a speaker murmured softly above the dressing room door. Timur knew the show like the back of his own hand: a beautiful melody would play five minutes after his mom's "death," and another fifteen minutes later there would be only music and the crackling sound of applause, and then Mom would come in, happy and exhausted, and he would have to give up the seat at the dressing table and wait for her on the sofa, while she "enjoyed her silence." She would change and wash her face, and finally she would nod to Timur and then he could tell her everything that had happened at daycare that day.

Eventually he started school and she stopped bringing him backstage. In the last eighteen years he'd forgotten all this, forgotten the speaker above the door, the chair, the pencils, the self-portraits, and now, sitting on the cold steps, he remembered everything.

He saw a crumpled candy wrapper by his right shoe. Automatically, Timur picked it up and smoothed it out.

Can you attend tonight's performance?

Not "would you like to," but "can you?"

"I can," Timur said. "I'd be so very thankful for a chance to see it. Actually, I had tickets, but I had to give them away."

A draft, cold and sharp, touched the back of his head. Timur turned around.

Go, was written in coal on the light beige wall.

A light bulb swayed invitingly at the end of the corridor.

*F

He went straight to the balcony, embarrassed by his wrinkled pants and enormous wet boots. The orchestra section was teeming with evening gowns; here, in the cheap seats, the crowd consisted of students with university passes and lucky holders of the standing room only tickets, drunk with happiness.

Timur found a good spot: to the side, but in the first row. He rested his elbows on the worn-out gray velvet and proceeded to study the audience.

A few faces he'd seen on the news: well-dressed women accompanied by their well-off husbands, a famous film actor, a renowned

politician, someone with an exceedingly prominent facial expression with a very tall, very fit blonde on his arm.

The People's Club's administrator with her husband, both dressed to the nines and glowing with self-importance.

Tons of out-of-towners. Foreign languages abounded: Prompt's shows required no interpreters. Everyone understood everything, regardless of their native language. Foreigners would come for a day or two, pre-order the tickets, bring their best outfits and change on the train, and head back to the station right after the show, deliriously happy. Dozens of travel agencies specialized in "thespian tours."

Degtyarev was sitting in the director's box. He glanced up at the balcony, then looked again, paying attention this time. He smiled insincerely and waved at Timur.

Timur waved back.

All the seats had been filled immediately after the second call. Every single seat.

Apropos of nothing, Timur recalled: *You may decline at any moment, I will not be offended. At any moment, up until the third call.*

He shook his head in frustration.

No one was ever let into Prompt's theater after the third call. No one. It was common knowledge, and everyone always arrived early. To be late for a Prompt show was equal to being late for a flight. There were no reminders to turn off cell phones. There was no need for that: cell phones and pagers did not work in Prompt's space, and everyone knew that.

The lights began to dim. Gazing down at the rows of well-coiffed heads and lines of attentive faces, Timur thought—not without a certain pride—that Prompt never spoke to any of the people in the orchestra seats. He awed and amazed them nearly every day. But he never spoke to them.

The curtain went up.

*F

It was still raining. Timur waded through the puddles.

He was thinking of Degtyarev. His hypocrisy and even betrayal had to be forgiven for *that*. Let him spread malignant intrigues

backstage, but Prompt had accepted his show, and that meant that Degtyarev had created something big, something good. The audience members leaving the show tonight were a little nicer, all of them, even the administrator of the People's Club. They would be nice until the next morning, or even the whole day tomorrow. Maybe even the whole week.

Timur plodded on, ignoring his wet boots.

Because this *Comedy of Manners* was nothing but a good play. Decent cast, a few successful directorial decisions. And—life. It wasn't important who breathed life into this play, Prompt or Degtyarev himself, because if Degtyarev's show wasn't good, Prompt wouldn't have chosen it.

The only thing that bothered Timur was the sense of déjà vu. He knew he'd never before seen *Comedy of Manners*. But where did this sense of having seen it before come from?

It wasn't worth getting worked up about. He'd been coming to the theater since before he was old enough for daycare, and in the last twenty-five years he'd seen more than his fair share of shows, including some really good ones.

Timur stopped by the streetlight and leaned his forehead against the wet concrete.

God Almighty, if You can hear me, make it so that Prompt accepts my show. Because You see, O God Almighty, You see that it is good. It's not worse than Degtyarev's, it's better than his. I can't pray to Prompt, Prompt doesn't care for my prayers. He believes only what he sees. But You, Almighty, You will help me, won't You?

In the dark building, only one window was lit up. Their kitchen window.

☩

"Timur, may I speak with you for a moment?"

The problem counter in Timur's heart clicked before Vita had a chance to explain. They stopped in front of the bathroom, and Vita fiddled with a light.

"Can I bum a cigarette?"

Without a word, Timur pulled another new pack out of his pocket.

"They are threatening to kick me out of the university," Vita said, inhaling.

"Why?"

"The graduation show was scheduled for the eighteenth. My role in it is minuscule, three lines at best. But oh no, there is zero leeway. Either I am on stage on the eighteenth, or I am dismissed without the right to reapply. So that's that."

Timur said nothing.

Yesterday's *Comedy of Manners* was still alive inside him. The audience's laughter, the tense silence, a lump in his throat. An echo of applause.

"Vita, after the eighteenth, you won't need a diploma. There are so many people out there with diplomas, all those useless, pointless pieces of paper. So what if they write 'Actor' on a blank sheet of paper? What are you going to do with it, take it with you to the stage? Are you going to show it to the audience to make them believe?"

Vita was silent. The cigarette in her hand burned slowly, ashes falling to the floor.

"You are an Actor with a capital A. You are a real talent, deep and mature. It becomes clear the second you step on stage. If you go and deliver your three lines on the eighteenth, they will simply wipe their feet on you and continue walking. And whatever they write in your diploma, even if they say you are talented, none of it will matter. Do you understand?"

Vita said nothing. The cigarette in her hand burned down to its filter.

<center>⚘</center>

"We are having an open mic night tomorrow," the administrator said with a hint of regret. "Sorry, but the stage will be reserved from noon to 10 p.m. I can let you into the dance hall, but only if you accept personal responsibility, the hardwood floor is very expensive there."

"We don't need hardwood floors," Timur said, holding back his despair. "We have three days left before the show! We need a stage!"

"But this is a People's Club!" the administrator said with reproach. "Open mic is a regularly scheduled event!"

"I understand," Timur said.

He was so tired. For the past ten days he felt like a soccer ball. He was kicked and tossed non-stop, and he rushed around, somehow managing to achieve his goals, despite major losses, functioning at the very edge of the possible, and yet he did get things done.

A truck had been rented—to deliver the set pieces.

A contract with a technical crew who had worked with Prompt before had been signed.

You may decline at any moment, I will not be offended. At any moment, up until the third call.

"Let us rehearse overnight," Timur said. "It's very important. Please let us in overnight."

The administrator gazed at him; she wasn't young anymore, she wasn't very bright, and she wasn't happy.

Somewhere deep in her eyes lived a memory of *Comedy of Manners*: the laughter, the ideas, the silence, the echo of applause.

"God forbid you light candles on stage, Timyanov."

"We won't."

"And god forbid you decide to spill water on stage again, it makes the wood buckle."

"We won't."

"If you swear to me, Timyanov, if you swear that only your people will be here. Only those who have been added to my restricted list."

"I swear."

"And if no one smokes on stage, then as an exception—do you hear me, Timyanov? — as an exception, I will let you rehearse overnight. But only as an exception."

<center>⚹F</center>

"Timur, may I talk to you for a second?"

Boris. Something was up. Again.

"Timur, my mom is sick. My father is working the night shift, and there is no one to stay with her overnight. I can't do it tonight, Timur. I just can't. She has high blood pressure, and when it goes up ..."

Timur closed his eyes for a split second. Or so he thought, but when he lifted his eyelids, he saw Boris watching him with terror and confusion.

"Do you want me to find a night nurse for your mom?" Timur asked. "A medical professional?"

"I can't afford to ..."

"Free of charge! Would that work?"

"Timur ..."

"Boris. We have three days left. We can't have a dress rehearsal without you. We just can't."

"But my mom ..."

"I said I'd find her a nurse."

"What if she deteriorates?" Boris said, a shadow of panic in his eyes. "I won't be able to live! I would—"

Timur held his collar and pulled him closer, face to face.

"She won't. She'll get better, I know she will! I will find her the best nurse, the very best in the city. I will pay for medications. I will find a professor who will watch her all night! It's only for a few hours, from eleven to five in the morning. Agreed?"

Boris said nothing, gulping air with an open mouth, like a fish.

<p style="text-align:center">℉</p>

"Timur, have you forgotten your promise?"

"Have I made any promises to you, Mom?"

A long pause.

"You promised to invite me to the dress rehearsal."

"No. I never promised you that. You asked me to promise, but I never—"

"Timur, listen to me. No, don't listen to me. Don't listen to anyone, just to yourself. Step over me, step over everyone, for the sake of art, it's worth it. If Prompt accepts you, everything will be forgiven, everyone will forgive you, even those you stepped over."

"Mom, give me the bottle. Please give it to me! You shouldn't drink anymore."

"Oh god, it's so hard. To know everything in advance—and fail to explain. I know. But I cannot convince you. I will come to the dress rehearsal, on the morning of the eighteenth. You can't stop me, Timur. Prompt knows you're my son, he'll let me in."

*F

The night rehearsal was scheduled for eleven. The People's Club was deserted. A security guard dozed on chairs pushed together inside the locked booth. Paper garlands, an indispensable attribute of amateur performances, swayed in the wind.

"What time is it?"

"Eleven forty."

Timur and Drozd kept watch by the door so they would be the first ones to hear Kirill knocking on the glass door. Minutes went by, but Kirill was still missing.

Ten minutes to midnight.

"Don't worry, Timur. Things happen. I believe in Kirill. He's coming."

Two minutes past midnight. Half past midnight.

Vita appeared in the hallway and offered a piece of candy first to Timur, then to Drozd.

Forty minutes past midnight.

"I saw him earlier today, I mean last night. He looked happy, and there was no indication he wouldn't There was absolutely no sign he wouldn't show up!"

Timur did not reply.

Earlier, at ten past eleven, Kirill's younger brother told Timur on the phone that Kirill had left for the rehearsal a while ago.

"Go back inside," Timur told Vita. "Grab my bag on the way. I have a large thermos of coffee in there."

"Cool," Vita said happily.

The security guard continued snoring.

Fifty-nine minutes past midnight.

A soft knock on the glass door.

Timur and Drozd jumped up. Carefully, as not to wake up the security guard, they removed the deadbolt. Krill entered awkwardly, sideways, pulling a ski hat all the way down his forehead.

"Kirill?"

"They broke my arm," Kirill said apologetically. "It's fine, Timur. It's just the arm that's broken, not the leg. And I can use makeup on my face, you won't be able to see anything. They said there is no concussion. It's just my arm. Assholes, all five of them ..."

A bruise had bloomed under Kirill's right eye. His cheek was scratched up, and his lips were bleeding. His right arm was in the sling, the tips of his bluish fingers peeking out.

You may decline at any moment, I will not be offended. At any moment, up until the third call.

Timur sank into a creaky chair.

"Kirill ..."

"I went to urgent care," Kirill said. "They said there was no concussion. It's great, Timur. If I had a concussion, I couldn't perform. And now I can. The Writer will have his arm in a cast. It's kinda cool, actually. Everyone will think it's an interesting artistic direction. Or I can take the cast off, and then put it back on after the show. Are you listening to me, Timur?"

Timur said nothing. Brightly colored circles swam in front of his eyes.

✳F

They held their last rehearsal on the seventeenth, on the stage of the People's Club. The administrator showed up uninvited and took a seat in the middle of the empty creaky hall.

"It was amazing," she said later, stopping Timur in the corridor. "I thought it was supposed to be a classic."

"It is a classic," Timur said.

The administrator shook her head in distrust.

"What do you mean, it's a classic? It's not boring at all!'

✳F

Timur did not sleep on the night before the eighteenth. He knew he had to be in good shape the next day and went as far as taking a sleeping pill, but the acid-yellow pill sank into the abyss of his stomach with no effect.

He sat in the kitchen, hunched over a book, but he could not read. He stared at the words, listening to Mom toss and turn in her bedroom.

On the morning of the eighteenth he left the house at seven, when Mom was still asleep. At half past seven a truck drove up to the People's Club; Timur made sure the sets were loaded carefully and that none of the set pieces were left behind.

At half past eight the sets were unloaded at Prompt's entrance. Despite the early hour, a surprising number of onlookers had gathered nearby.

The crew began at nine, as they had agreed to previously.

By nine thirty they had begun to gather: a deathly pale Olya, a solemn Vita, a glum and focused Drozd, a surprisingly gaunt Boris, and Kirill with his arm in a sling.

"We are going to walk in together," Timur said. "Relax, there is nothing to be afraid of. For Prompt, we're nobodies, we are nothing but pleasant strangers. Prompt is going to judge us during the show, not before. Are we ready?"

They entered.

The black hands of a green clock showed 9:38.

"Good morning," Timur said, trying to make his voice sound as even as possible. "Here we are. Everyone, please introduce yourselves."

They took turns stating their names. Olya was so pale she looked blue. Vita was as red as a teacher's pen. Boris breathed heavily. Kirill bit his lips, and only Drozd appeared to be perfectly calm. At least, he didn't seem to be bothered by an intense gaze roaming over his face.

"We need two dressing rooms," Timur said, feeling calmer with each sentence.

A window slammed loudly at the landing above.

"Follow me!"

He felt like a commander leading his troops into battle. Leading them toward victory despite their fears. He guided those who

trusted in him. He took them up the stairs toward recognition, toward glory.

A dim light flickered in the dark corridor. Two dressing rooms opened their doors: the one Timur had seen on his first visit to Prompt, and another, bigger one, spacious enough for six people.

More comfortable now, his friends looked around. The first squeals of delight came quickly; Olya gazed at herself in the mirror, Boris plopped down on the leather sofa. Drozd tested the water in the sink; the water ran both hot and cold.

Vita stared out the window. Timur stood next to her: the busy morning street looked like an ant trail, even though they weren't that high up, only on the second floor.

"It all depends on the point of view," Vita said, as if reading his thoughts.

Timur nodded in agreement.

<center>⚘</center>

At half past ten Timur and Drozd cut into the cast on Kirill's arm and helped him into his costume. They pulled a glove onto his injured hand; Kirill assured them that it didn't hurt and the injury was nothing to worry about.

The dress rehearsal started at eleven sharp. Timur aimed for iron-clad punctuality; he thought it was something Prompt would appreciate.

At Timur's signal, Prompt played three calls (*You may decline at any moment, I will not be offended. At any moment, up until the third call*). Then Prompt raised the curtain and switched on the lights.

They had discussed it in advance: this dress rehearsal would be for real. No allowances for a new stage or unfamiliar conditions. Prompt would do his technical work—run the lights, test the sound—and they, the cast, would do theirs.

Timur sat in the audience—a richly adorned hall with comfortable chairs, such a cozy, elegant theater space—and understood absolutely nothing.

At first he felt that nothing was working, and the new stage was killing his cast members, used as they were to the People's Club. He

panicked and screamed at the top of his lungs, forgetting the microphone provided by Prompt:

"Olya, I can't hear you! Louder, Boris, louder! Enunciate! Haven't you been trained for this?"

Then he thought things were getting better. It seemed that the actors had regained their spatial awareness and relaxed, and that everything was going as planned. Timur thought that Prompt simply couldn't *not* approve of their production, so original, so courageous, so …

Then fatigue stepped in, and Timur stared at the stage, automatically noting errors, taking notes on a piece of paper, and occasionally reminding the actors to speak louder.

Act I took an hour and ten minutes, Act II, an hour and four minutes. Timur made a mental note about tightening up the first act; the second would do as is.

"We break for a half an hour, then meet in the first dressing room. Drozd, can you help Kirill?"

Drozd nodded reassuringly, as in, "Don't worry, I won't leave my wounded friend behind on the battlefield." They went backstage, excited, full of desperate cheer, the mirth of soldiers before hand-to-hand combat …

"Timur."

He flinched. For a second he thought Prompt had gained a voice and was calling him.

But Prompt had no voice.

Timur turned. His mother stood by the entrance between two loges.

Strangely enough, he felt nothing. No surprise, no anger.

He came over, taking gentle steps on the carpet.

"Hello."

"Hello," Mom said. "I watched it from the balcony."

"Clever," Timur said.

"You know, Timur … I didn't understand it," Mom said. "It's so strange. I was engaged, I wasn't thinking of anything else, not even about this show being on Prompt's stage, or about you being my son. But I didn't get it! It must be a good show, right?"

"I think so," he said wearily.

"It's so strange, frightening even, and so unexpected. It is jarring in some parts. But it is a good show. Right?"

She looked into his eyes almost ingratiatingly. As if it were up to Timur to decide whether the show was to be good.

"Yes," he said.

"Your actors are wonderful," Mom said. "Especially the girls. And that tall guy … and the actor who plays The Writer, there is such pain in his eyes, such unbearable pain."

Timur opened his mouth to tell her about Kirill's broken arm. Then he changed his mind.

Mom stood on tiptoes, as if about to kiss him on the cheek. Then she changed her mind.

"Good luck, honey. Good luck."

<center>✳Ⴎ</center>

The voices of Drozd and Boris came from the second dressing room. On its door a sentence was written in red marker: *If you've changed your mind, you can say no before the third call.*

Timur looked around.

The corridor was empty. When the cast had walked into the dressing room, the door was clear, with no trace of a red marker.

A tiny light bulb wrapped in a wire was switched off. The lights came from two bright wall lamps.

"I didn't change my mind," Timur said through gritted teeth. "Don't try to scare me."

<center>✳Ⴎ</center>

At half past two he dashed to a cafe for takeout: cheese danish, pigs in a blanket, coffee, lemonade. On his way back he ran into Degtyarev by the stage door.

Timur tried to nod and walk on by, but Degtyarev stepped into his path.

"I saw bits of your dress rehearsal."

"I am touched," Timur said. "You'd think the entire city is dying to see 'bits of my rehearsal.'"

<center>295</center>

"It's clever," Degtyarev said. "And unusual, and possibly even talented. You know what your show is like? A cluttered room, with dried butterflies pinned to the most unexpected places. To worn-out shoes, to the tablecloth, to the wallpaper …"

It was time to go, but Timur remained rooted to the spot. A plastic bag of food pulled his arm down, nearly touching the sidewalk.

"Oh yes," Degtyarev continued, smirking. "Everyone knows this play, every schoolboy, yet you managed to surprise even me, and I directed it some time ago. You turned everything upside down. This play is about The Writer, and you made it about The Scientist, who's really a supporting character. You ignored the script, stripped the motives to bare bones, and you pinned your own image and your own association to each action of each character. It's an interesting concept, but the whole thing turned out rather formalist. A little bit of drama, a little bit of ballet, interspersed with musical vignettes. It's too bad. If you had even an ounce of competence …"

Timur waited—for what? What did he want to hear?

"It's an amusing production," Degtyarev said wistfully. "But I don't think Prompt will accept it."

"Why?" Timur asked. "Do you know what Prompt likes?"

Degtyarev smiled enigmatically.

"It's not a secret, Timur. Prompt's preferences are not a secret at all."

F

The audience began to gather ahead of time. By five, a crowd of optimists stood around the entrance, hoping for a rush ticket.

Prompt loved opening nights. In addition to the traditionally sold tickets, Prompt let in students and actors, along with devoted theater lovers ready to perch on limited-view seats, on the steps, in the aisles.

Timur had no doubt that the people who'd beaten up Kirill in a dark alley were here as well.

All the directors whose shows were currently playing at Prompt, and all the cast members of those shows were automatically invited.

Degtyarev made an entrance; Timur saw him from a distance and retreated cravenly, leaving through the stage door. He had no bandwidth for Degtyarev.

The theater was full. Ticket holders took their seats. Those without assigned seats made themselves as comfortable as possible. Timur walked along the balcony, watching familiar and unfamiliar faces from above, then went back to his actors.

Everyone was ready. Kirill's makeup was too thick, but Timur knew it was too late to make adjustments. If Prompt accepts the show, he will hide the spackle on Kirill's face. If Prompt doesn't accept the show ...

Timur plucked the pesky thought like a gray hair.

My friends, we are on the verge of success. This is our biggest chance.

Instead, he simply said: "We're on."

They got up without a word.

Timur walked behind them. He was impressed with his cast's familiarity with Prompt's layout. They'd learned their way around in only one day. The first call rang out, but the audience was already in their seats. Everyone was impatient; everyone was waiting for the start of the show.

He turned and shuffled toward the director's box, the same one recently occupied by Degtyarev. He sat in the back, hiding from the idle glances of the audience. Timur did not want any attention; he wanted the lights to go out.

The second call came.

The waiting grew unbearable.

Timur knew that once the third call came, there would be no way back, and there would be relief. He wanted to rush the last few minutes between the second call and the last, third call.

And here it was. Thank God. Timur had taken the last step, and now the wind would carry him away.

The lights went out. Timur moved closer to the stage.

The music began.

The curtain went up.

*F

"Timur, stop! Stop it, Timur! He never explains anything Come on, let's go."

Timur stood in front of the stage door, pulling it, and pushing it, and kicking it—but the door didn't budge. Prompt did not wish to see him anymore. Drozd's long arms dragged Timur away from the door, into the darkness, but Timur kept coming back, jerking the handle, and pushing it, and kicking it again and again.

"It's your own fault," Boris said darkly. "It's too late now."

"Shut up," Drozd said, not looking in Boris's direction.

"But it's true, Drozd," Boris said. "He set us up. All of us."

"One more word, and I will smash your jaw," Drozd said, his voice so calm and even that Boris took a step back.

"Drozd What am I going to tell my mom? If I tell her the truth, she'll have another seizure ..."

Drozd turned, his movement laborious and heavy.

"Lie to her. Tell her Just go away, Boris. I could beat you up right now, but I don't want to feel guilty later."

Boris walked away. He sat at the edge of the lawn, leaning against the lamppost.

Timur stared at the closed door.

F

They'd begun well. Drozd, who played The Scientist, kept up the tempo. His scene partner Olya, who usually struggled with the opening act, followed Drozd like a meek little lamb.

The only thing that bothered Timur was the excessive gray on Drozd's temples. He had a split second to think that they needed to revisit the makeup.

And then he realized that he saw nothing aside from the fake gray hair. He realized that Drozd was woven entirely out of fakery, that Olya mumbled all her lines, and that the scene was drawn out. There was no hint of action, there was no dialog, instead there were clichés and perfunctory gestures, and the audience was beginning to fidget, move in their cushy seats, whisper to each other, and cough impatiently.

The show, as taut as a guitar string only yesterday, was now deflating like failed sourdough. Timur hoped Kirill's appearance would save the day, but he made things even worse.

On stage, Kirill looked wooden. His broken arm limited his movements, but there was none of the real pain that had so shocked Timur's mother during the dress rehearsal. On stage, Kirill looked like a clumsy boy, who saw nothing, heard nothing, was completely unaware of his partner, and who simply repeated his memorized lines.

That's when everything went dark for Timur.

This was how it happened.

Vita washed the clothes in ice-cold water, but there wasn't even a hint of the energy that had pleased Timur so much before. Now there was nothing but exaggerated acting, a lot of fussing, dirty water splashing everywhere, the washboard rattling, drowning Vita's lines and those of her partner.

The audience was bored. A few people left before the intermission, and the empty seats gaped like dislodged teeth. When the deteriorating show made it to the intermission, the audience greeted the descending curtain with a disappointing hum and sparse applause.

Half of the audience members rushed to the coatroom. The doors slammed, letting people out onto the streets.

This intermission was the worst twenty minutes of Timur's life. He had to go backstage and scream and threaten and force them to play the second act because they had to: Prompt would not let actors who didn't finish their show leave the building.

And so they played the second act, accompanied by whistling, coughing, loud nose blowing, and insidious sneering.

*F

After the curtain came down, they were greeted with a short mocking ovation. Everyone who had successful shows on Prompt—all the actors, directors, and dramaturges—everyone clapped, celebrating the failure of their impudent competition.

Half an hour after the end of the show two ambulances stopped in front of the stage door. Drozd went to the hospital with Kirill. Timur accompanied Olya to the neurology clinic. Vita and Boris stayed behind in the smoke-filled dressing room.

Kirill was given a shot of painkillers and a sleeping pill, and he fell asleep. Olya had three different injections, and now she was asleep as well. The middle-aged doctor shook her head at Timur as they stood in the drafty waiting room.

"This is my ninth patient after Prompt. But you—how are you feeling?"

Eventually, they took Vita home. Vita was as brittle as alabaster, and just as white. Timur kept talking, but Vita didn't hear a single word.

As if pulled by a magnet, they went back to Prompt. Prompt greeted them with dark windows and the locked stage door.

"Timur, let's go home. Let's take Boris home. Leave the door alone. Leave it alone. We'll deal with it. We'll survive."

"Drozd," Timur said, turning to face him. "I have a huge favor to ask of you. Take Boris home by yourself. There is something I need to do."

F

No one came to the door, and Timur pressed the doorbell again. Then again.

Finally, something stirred inside the apartment. The lights came on. Someone stared at Timur through the peephole.

The lock clicked open. A man stood at the threshold bathed in yellow light. Dressed in a bathrobe, he looked disheveled, his face pink and squashed like playdough.

"Do you know what time it is?"

"It's half past two," Timur said. "I need to talk to you."

"You woke up my kid!"

"We have to talk, Degtyarev. Can I come in, or are we just going to chat on the landing?"

In the depths of the apartment, a woman's voice said something tense.

"Go back to sleep," Degtyarev said to her. "Go to sleep, everything is fine."

He gave Timur a sidelong glance.

"Come in."

Timur took off his shoes and walked into the spacious kitchen. He sat down on the edge of the oilcloth-covered seat. The kitchen was tidy and cheerful. A high chair stood in the corner, and a pretty child's bib hung on a towel rack.

"Want a drink?" Degtyarev asked, very businesslike. "Usually helps quite a bit."

"No," Timur said, shaking his head. "I can drink by myself. I need to talk to you."

"Mmhmm," Degtyarev said vaguely, setting a pot-bellied red teakettle on the stove.

"I did warn you, didn't I? I hate to say 'I told you so.' No need to kick a man while he's down. What can I do for you, Timur?"

"You said: 'It's a good show, but I don't think Prompt will accept it.'"

"I said, 'It's an amusing production.'"

"You said: 'Prompt's preferences are not a secret.' I was naive enough to think that Prompt likes good shows."

Degtyarev nodded.

"You were right."

"But you meant something else, didn't you? When you said, 'Prompt's preferences are not a secret.'"

"No, Timur," Degtyarev said, his surprise ever so slightly exaggerated. "I meant exactly that: good shows. Professional, solid productions. It's not a secret that Prompt likes good shows."

Timur said nothing for a while.

"Does that mean my show wasn't good enough?"

Degtyarev pursed his lips.

"Timur, I understand. Everything is still very raw. The shock of the failure …. Let's not talk about it yet. Perhaps in a week or so, when the dust settles …"

Timur smiled mirthlessly.

"Everyone who's needed consoling has already received it from the nurse and her syringes. How did you know Prompt wouldn't like my show?"

"Because it was weak and loose," Degtyarev said gently. "Because you see, Timur, Prompt cannot add merit or remove flaws. Prompt takes what already exists—and then tactfully highlights and emphasizes what he considers necessary. It's like the art of photography: take an average-looking woman and, with lights and the correct angles, turn her into an old hag or a young beauty. Meanwhile, her face remains the same. It's just a question of whether she's loved or not."

"We weren't worthy of love," Timur said.

Degtyarev nodded.

"Everything you saw today was real, all the real flaws of your production. Prompt never lies. Your show had merits, but Prompt didn't think it necessary to emphasize them."

Degtyarev took the teakettle off the stove and poured boiling water into a cup. Timur watched the tea leaves swirl and swell.

"That's how it is, Timur. For instance, the boy who played the Writer—he missed his entire first year of college. I mean, he attended classes, but he learned absolutely nothing. It's not fixable. He simply does not see his scene partners. And that girl—"

"Kirill performed with a broken arm!"

"Who cares? All our pain, our traumas—it's our business, no one else's. Haven't you heard of Prompt's cruelty before? He's very cruel. Like an animal. Prompt cares about the show, about what happens on stage, and nothing else. Everything else is just noise for Prompt."

"I don't believe that our show was that bad," Timur said slowly. "It was Prompt who destroyed it."

"Believe it if you must," Degtyarev said, shrugging. "In any case, I am glad you haven't lost your courage. I've seen other directors after their shows bombed on Prompt. I've seen tears, snot, suicide attempts …"

Timur stared at Degtyarev for a long time. Eventually Timur smirked and shook his head: "In your dreams."

F

Streetlights were on. At half past three in the morning, the city resembled an aquarium without water; it was just as empty and semi-

transparent. He had been walking for a long while when a lone myopic taxi cab pulled up to the curb and winked at Timur with one headlight. His coat unbuttoned, his suit crumpled, and his tie pushed to the side, Timur must have looked like a candidate for a ride.

Timur kept walking.

Since he was a child, he'd had an uncanny ability to scroll through images seen or imagined. This skill had proved invaluable for the future director in college. And now, walking through the puddles, Timur watched his show. Not the way it was performed today, but the way it should have been performed. *Where did it go wrong?* Timur asked himself, but could not find the answer.

All the flaws and inaccuracies picked up by Prompt had been there. But there were other things! There was the main concept, or at least Timur thought there was. There was an original approach, a certain flair, there was style.

Why hadn't Prompt wanted to acknowledge any of it?

Was Timur truly "a thespian hack," as he was once branded by an aggressive, newly appointed critic?

He stopped at an intersection. Shiny, wet pavement stones resembled an infinite audience seen from above, from the balcony level, or perhaps from the sky.

Dark sleeping Prompt dominated the other side of the empty street. Ten billboards rose on both sides of the grand entrance. Timur recalled counting them for the first time when he was three years old.

Currently Prompt was running fourteen shows. The oldest had been performed for the last seven years. The most recent one, *Comedy of Manners*, had lasted only four months, a dozen performances.

Timur crossed the street and stopped in front of the billboards, affectionately known as the Ten Tin Men. It was customary to tease freshmen by asking, "What are you doing here, trying to get your poster on one of the Ten Tin Men?"

Timur walked on, studying the posters he'd seen so many times. At first he resurrected all these tragedies, farces, and dramedies in his memory, recalling the most minute details; eventually, he got tired and simply looked at the posters.

How come there are no photographs, he thought suddenly when he had learned the tiniest letters on each Tin Man. Why were there absolutely no pictures, when all urban theaters, big and small, good, average, and lame, always displayed actors' photos and scenes from each production?

Recordings of any kind were forbidden on Prompt; allegedly, stage action did not transfer well onto film, it had to be watched live. Whenever someone tried to break that rule, they found their camera damaged in the process, or the film exposed to light.

Slowly, Timur started moving back, along the line of the Tin Men. *Prompt likes good shows.* Timur gazed at the posters of fourteen good shows.

He wished he could see them on a neutral stage, beyond Prompt.

Timur stopped.

Not a single production accepted by Prompt had ever been played on a regular stage. After her astounding success on Prompt, Timur's mother had stayed away from the regular stage.

Timur wrapped his coat tighter. The morning wind chilled him to the bone.

If only he could separate Prompt's magic from the show's own merits—perhaps then he could understand.

The white clock face over the main entrance showed half past four. Soon he was expected in Olya's hospital room.

He spotted a row of four phone booths. Timur dialed the number. The call was answered immediately, and Timur felt a sharp pang of remorse.

"Timur?"

"I'm fine," he said, as gently as he could manage. "Mom, tell me something. Did you see Degtyarev's show, *Comedy of Manners*, before the opening? Before Prompt?"

"Timur ..."

"I'm sorry, Mom."

A pause.

"Yes, I saw it."

"Was it really that great? Without Prompt's help?"

A pause.

"Timur, where are you? Come home. Please. Irina called. A dozen people called, everyone wanted to tell you how wonderful you are, how—"

"Mom. Tell me. Degtyarev's show—I thought I'd seen it before."

"Timur, come home. I am begging you. I will tell you everything when you come home."

"I'll be home soon. Bye, Mom."

"Timur, please—"

Carefully, he replaced the receiver in its cradle. He stuffed his hands in his pockets, pulled up his shoulders, and walked around the corner to the stage door.

The door was still locked. Timur touched the handle, knowing his effort was futile.

He raised his head and looked at the rows of dark windows.

Slowly, he rounded another corner toward the set loading dock behind the theater.

The wide iron gates were closed, but a small second floor window appeared to be slightly ajar. The window had no bars.

Timur took off his coat and hung it on the branch of the short scruffy tree nearby. After a moment of consideration, he took off his sports jacket as well and left his bag next to the tree. All thoughts had disappeared from his head; he felt calm and content, knowing that he could finally take some action. He could achieve something, not just analyze his defeat.

It was very cold. Timur climbed the tree, then jumped onto the roof of the garage, and from there to the second-floor cornice. More than anything he was afraid that the window would slam shut in front of his face. It would be very much a Prompt gesture, but Prompt was either asleep, had severely underestimated Timur, or was simply curious.

The window was tiny, but Timur was slim and not very tall. Drozd wouldn't have made it. Despite skinned sides and a torn shirt, Timur made his way in without too much difficulty. He jumped down, leaving dirty footprints on the white windowsill.

He felt for a lighter in his pocket, then looked around.

He was in a dressing room. At an ordinary theater, the room would smell of mothballs, but Prompt did not tolerate old costumes. Or moths.

Once Timur's eyes got used to the dark, he made his way to the door, flicking his lighter for extra help. Each of Prompt's shows had its own costume rack, and every costume exuded its own aroma. Timur flared his nostrils greedily: the room smelled of talcum powder, perfume, machine oil, wax. But more than anything, it smelled of sweat. Even the most exquisite dress adorned with ostrich feathers, the dress that belonged to the *Comedy of Manners'* female lead, smelled like the perfumed leotard of a gymnast.

Timur pushed the door and it opened, and he was glad because up until the last minute, he'd worried that he wouldn't be allowed past the dressing room.

The corridor had no windows. It was pitch-dark.

"Hello," Timur said, trying to speak calmly. "Or, I suppose, good morning. Please accept my apology for coming in without an invitation. But I really need to talk to you."

He was met with silence.

"I realize that many people do the same thing—demand an explanation after a failure."

Silence.

Timur walked down the corridor, moving his hand along the wall. He stumbled upon a rolled up carpet and proceeded with caution, flicking his lighter on and off, looking for words on the walls.

The walls remained cold, coarse, and bare.

The corridor turned, and a staircase appeared in front of him. With effort, Timur figured out his location, ignored the staircase and continued along the corridor, toward the stage.

"I assume you can hear me, but you are pretending I'm not here. Well, I can explain. After today's—last night's—fiasco, no one will hire me even for a high school drama club. I don't know if theater arts would lose much if I'm not involved. Perhaps it doesn't matter. It's not important. It's not about me. It's not even about those I failed, like Vita who could have been a brilliant actress. Not about Olya, who will be in treatment for a long time. Not about Boris, whose career is over. Not about Kirill, who's so devoted to theater he would have performed with a crushed skull. Or Drozd, whose rare talent was never recognized. It's not about them. I simply want to understand. Please explain what exactly you hated so much about

our goddamn show? What exactly bothered you so much? Because you broke it like a toy. You mutilated it in front of its audience. You twisted it into a caricature of itself. Why? Because it broke some rules? The rules you consider absolute? Because it was made according to *different rules*?"

Timur flicked his lighter. The walls remained empty.

"I can tell you why this show turned out the way it did. When I read *Three Brothers* in high school, I felt so sorry for The Scientist. All the other characters considered him selfish, materialistic, and they treated him accordingly. And I felt sorry for him. He is not as much of an aesthete as The Writer, not as romantic as The Doctor. And it was back then that I decided to tell this story differently."

A flick of the lighter. An exit loomed about thirty paces ahead.

"But that doesn't matter. It's not how the play is interpreted; you're annoyed with the implementation. But every story can be told differently. Any story can be told, sung, danced Why does it matter how empathy is achieved?"

A flick of the lighter.

"Anyway, I am going to tell you something. You despise mothballs. But out there, beyond your walls, the world is changing fast. You don't have the concept of time; for you, time is but a distance between the first call and the curtain call. From the intermission to the finale. But time is something different. It's a different way to perceive reality. If these shows—the ones that thrill and astound your audiences—should they be released naked onto a regular stage ... I am not saying they would be bad. They might be perfectly fine. They could have been great ten, twenty years ago. I am babbling right now, because I don't know how to express my thoughts to make you understand. You are so much older than me, and you think you know everything, have seen everything. But just try! Try to renounce these rules of yours. Try a different angle! Like a child on their first visit to the theater."

Timur stopped and pressed his cheek against the wall.

"You know what's truly terrible? You set the tone, you define the concepts of good and bad. All your shows are the same: the dramas, the comedies. Everything is proper, everything is done according to

the first year's textbook. There are limits, there are blinders! Everyone wants to meet your expectations. Smart people have had it all figured out a while ago, and they produce their shows especially for you. And you happily accept them. You add a bit of soul to these shows, the soul their creators never imbue them with in the first place. But when someone tries to look at the world with their own eyes, not yours—assuming you even have eyes—you reject them. You squish them like bugs. To warn all the others against it. And everyone says, 'It was a bad show.'"

The corridor ended; the iron door leading to the stage was locked. Timur went around.

"But do you even have the right to judge people? You have no eyes. And I don't think you have a soul either. Or do you? Where are you hiding that soul of yours? I'd love to see it."

The wide opening through which sets were brought in had no doors. Timur walked into absolute darkness. He stepped forward, skirting the wings, pushing aside the heavy velvet. It was stuffy in there, and all the dust made his nose itch. Timur sneezed, the stuffiness thickened, then receded. In front of Timur was a large empty space. He stood on the stage, and the curtain was raised.

Everything was quiet. The air was still.

"Won't you talk to me? Will you say nothing at all?"

The lighter flicked on. Instead of switching it off, Timur stepped toward the wings and brought the tiny flame to the edge of the fabric.

"Will you talk to me?"

The curtain collapsed. Tens of kilograms of dusty velvet fell from the height of four floors, extinguished the lighter, knocked Timur off his feet, pressing him into the wooden floor, knocking the wind out of him.

He did not lose his composure. Instead, he held his breath like a deep sea diver and began to feel his way out. He crawled out from underneath the heavy mountain of crumpled fabric and stopped to catch his breath. Sparks danced in front of his eyes, the only source of light in the room. A black box theater indeed. Timur made his way to the middle of the stage, away from the wings, and flicked the lighter again.

He heard creaking and rumbling. Timur fell flat on his face. The crossbar with the mounted projectors stopped about half a meter above the stage, in its lowest position. The disturbed machinery kept humming; it had been activated too fast, against all regulations, and now it swayed heavily just above the prostrate man.

"You're wrong," Timur said softly. "It's too late to try to squash me, you've already flattened me. But you must understand: theater cannot simply move along the tracks like a train. Theater must have a right to take a turn. If you don't like something, it doesn't mean it's bad. You are like a gardener who rips out irises and daisies just because they are not his beloved potatoes."

The stage flinched and began to rotate with a soft creak. It went faster and faster. Timur managed to get on all fours, but immediately fell down again, pressing himself against the smooth wood to avoid being thrown off by the centrifugal force. The stage rotated like a mad carousel, the lighter flew out of Timur's hand, and at some point he nearly passed out.

The rotation slowed down, but Timur couldn't get up long after the stage had stopped.

Then a bright light hit him so hard that he had to cover his face with his hands.

Still pressing his palms to his face, he sat up.

His eyes, having taken forever to get used to the dark, were now trying to get used to the light. Timur saw patterns on the insides of his eyelids.

And then, illuminated by the white surgical spotlight, he saw himself: a torn shirt with dirty cuffs, his best trousers, now crumpled and stained. Long scratches on his hands. On the floor by his feet, he saw words written in bright yellow chalk: *Go home, Timur.*

"I am not leaving," Timur said, getting up.

All the lights—both on stage and in the audience—came on at once.

It felt like something between a summer afternoon and a blast furnace. Timur shielded his face with his elbow; the light was as solid as a wall, just like the darkness before that, but if the darkness could be dispelled with a flick of a lighter, there was no weapon against the light.

309

"You can't stop me," Timur said. "I understand that I cannot dissuade you. But I must at least try. And here is my first victory: you are no longer ignoring me."

The lights went out, all of them, except for a single spotlight, as dim as a lone light bulb in a shabby hallway. The spotlight crept across the stage and stopped at a chalky inscription: *You are mad. Leave.*

"I am not mad," Timur said.

The patch of light moved a bit further.

Have you heard what theater is built upon?

"Upon trampled egos," Timur smirked.

Pick up what's left of yours and get out.

"Listen to me," Timur said softly. "Why won't you have a sliver of doubt? At least once, a tiny little doubt. I am not telling you to reconsider your taste. You know theater—but you know nothing about life! How can you judge it?"

The spotlight dove backstage, then crawled over to the concrete wall.

Why shouldn't you doubt yourself? was written on the wall, half a meter above the ground.

"Because I've already experienced doubt. I realized that I have a right to a show of my own. I have a right to my own view. I shouldn't have come to you with it. I was stupid. I wanted recognition. I should have simply written 'Mediocrity and Formalist' on my forehead."

The spotlight went up. The words were scratched on the black paint, as if with a nail: *Indeed you are a mediocrity and a formalist.*

"Indeed." Timur nodded.

The spotlight went higher. Timur stepped toward the staircase and felt his lighter under his foot.

Without thinking, he picked it up and put it in his pocket.

The stairs smelled of iron.

You've been taught poorly, my boy. You are an amateur.

"No," Timur said.

Lumps of dried mud broke off his shoes and flew to the ground.

You don't know the basics.

"No," Timur said louder. "I know the rules I have broken. I did it intentionally. My Scientist, unlike the original character, lives among painted dolls. Yes, it was my creative decision. Like children painting blue horses, knowing well that blue horses don't exist."

Arrogance is the hallmark of mediocrity.

Timur went up a few steps.

"You are confusing mediocrity with a different approach. Yes, in my production characters first answer, then listen to the question. I know it's the wrong order. They have to listen first, process it. But it makes us feel that they are completely, utterly deaf inside! They are all emotionally deaf, all except for the Scientist. I know that most of my decisions are formal. That this production is not a psychological drama, it's something different. But the empathy is still there! At least it was until you pushed it away."

The stage was now far below. Timur stood on a narrow iron platform. *You came to me*, said the door of a switchboard, above the skull and bones warning sign. *Do you want to leave?*

Timur clung to the railing. High voltage was all around him; it would be so easy to fall down in the dark, maiming himself in the process, and if he fell into the hatch …

Rage descended upon Timur, heavily and suddenly, just like the stage curtain earlier. And while Timur made his way from underneath the curtain, this rage left him no chance at all.

"Stop trying to scare me! You are a murderer, not a temple! You are an orthopedic corset! You are a factory of prosthetics for healthy people! You ruined my mother's life. You destroyed so many destinies and so many talents! I want you gone!"

ℱ

Three fire engines pulled up to Prompt at seven in the morning.

It took the firefighters a while to extinguish the flames. The crowds around Prompt grew. The firefighters looked inappropriately confused; they hid their fear behind anger. They never told anyone what had happened to them and what they'd seen inside the old building.

Eventually a single white van with a red cross drove up to the theater. The police cordoned off the stage entrance and pushed the onlookers to a safe distance, but the curious ones stood on tiptoes and saw a stretcher covered with a sheet.

The fire had destroyed the roof above the stage and the stage itself, but not the rest; the city government rushed to allocate a large sum for renovations, and two weeks later Prompt was fully restored. Everyone expected the shows to resume immediately, but time passed, and no one could explain the absence of posters on the row of The Ten Tin Men.

<div align="center">⁕ϝ</div>

The big snowstorm came late in the night. It blanketed the roofs, drowning the chimneys and the antennas. The trees resembled ghosts in white sheets. The autumn grime disappeared under the snow as if it never existed, and only a few maple leaves peeked through the slush around the warm sewer hatch.

Performances finally resumed on Prompt; *Comedy of Manners* was listed as the first show of the updated lineup.

One of the ticket holders was a beautiful woman of a certain age. Under her long, snow-dusted coat, she wore black jeans and a voluminous black sweater. She checked in her coat and went up to the balcony.

The theater smelled faintly of whitewash. Excited audience members took their seats. From her balcony seat, the woman had a clear view of the director's box occupied by a middle-aged man with a serene expression on his face. Looking benevolently above his tiny, fashionably tinted glasses, he studied the audience. The audience looked enraptured, in anticipation of a miracle.

The curtain went up. The show began. A minute passed, then another.

Listening to the familiar lines, the woman had a strange feeling as if a glass wall had risen between her and the stage. As an impartial observer, she easily detected all the pros and cons of the show: the actors' skills and their failures, occasional directorial mistakes, some garbled lines, a few excellent artistic decisions,

and several clichés. *Comedy of Manners* appeared before her in its original form, devoid of the aura created by Prompt. Devoid of Prompt's light. Bare.

She smirked. So that was the price of her metamorphosis: she'd learned to see Prompt's shows beneath the veil of genius he draped over all of his productions.

And then she knew, and the knowledge paralyzed her on the spot.

The audience whispered uneasily. The velvet chairs creaked. Someone coughed, immediately stifling themselves. On the stage, a perfectly ordinary show went on, made of perfectly ordinary clichés. It wasn't particularly bad, and it wasn't particularly good either. It was just a show, the same as dozens of others, performed many times, as familiar as old slippers.

From her balcony seat, she watched the previously calm, confident actors starting to panic. Some gritted their teeth and continued following the script with a tenacity of a steam engine; others thrashed around, lost without the usual safety net, trying to improvise, update, revive.

But all their efforts were in vain. There was no help, no opposition; the show, so accustomed to Prompt's gentle support, was now forced to impress on its own. The cast would be just as successful acting in the middle of a desert or on a makeshift platform in the center of a county fair, or at a local open mic night. Prompt had deserted its favorite child. Prompt had left *Comedy of Manners* to its own fate.

The audience was buzzing, the whispering growing louder and louder. A few people clapped, someone hissed, coughed, clapped again.

"Quiet!"

"And they call themselves theater lovers."

"It's unbearable."

"You don't understand it, it's Prompt!"

"What do you know about art?"

"What do you understand at all?"

The woman in black understood nothing. And yet she knew everything, but what was she supposed to do with all that knowledge?

313

A narrow rectangle of light appeared in the director's box, and when it went dark again, the box was empty. The woman in black did not feel like gloating.

During the intermission, tensions ran high. The coat check attendants, visibly pale, handed out one coat after another. A reporter from an evening paper spoke quickly into the phone. The woman in black came down to the orchestra section, approached the stage, and stared heavily at the lowered burgundy curtain.

At the very edge of the stage, a few words were scratched onto the lacquered surface of a wooden plank. The woman didn't notice it for a while, and when she finally saw it, she flinched and narrowed her eyes as if in pain.

Greta, come to the dressing r

She tore her eyes away from the truncated sentence. Once again, she glanced at the drawn curtain. The call announced the second act, as the main door slammed demonstratively.

Greta Timyanova handed her token to the nervous coat check attendant. A second later the attendant panicked even more because the hook where Greta's long gray coat hung just a moment ago was now empty. Showing no signs of anger, Greta did not listen to the offered excuses and promises; she simply smiled and walked out the front door as she was, without a coat.

She found herself in the darkness of a December evening. The snow flew horizontally, slamming into the row of Tin Men.

"This is the end of Prompt!" A young man in a long camel coat shouted through the wind. "This is the end of Prompt, the end of an era, remember my words!"

Greta looked away.

Com ... ack ... said the nearest billboard, the words written on the glass over the poster. The words swam in and out, changing as if someone wiped it with a wet rag and then wrote again. *Must ... cannot ... have to ... have to ...*

"You are mad," the woman said.

Come-ee-e ba-ck. The letters morphed, flew away with the snow, and returned.

Greta turned toward the subway. It seemed as if the billboards were blocking her path. As if they were about to step off their centuries-old pedestals, only to stop her from leaving.

They couldn't stop her.

Arms wrapped around her shoulders, the woman in black walked through the white blizzard. She stopped at a corner and looked back. The audience members moved away from the theater; lights shone through the snow in all the windows, and the woman felt as if she were being watched by dozens of yellow lights.

She turned, not toward the subway, but in the opposite direction. Toward the stage door.

The door opened as soon as her hand touched the handle.

A phosphorescent clock hung in the hall like a green moon. *Please*, was written over the black clock hands.

She took a short walk over, the same one she'd taken so many times before. She stood in front of the dressing room, biting her lip, then took a step forward and yanked the door open.

The show posters were gone. Instead, from floor to ceiling the walls were plastered with pencil drawings on pages ripped out of notebooks. In them, drawn by a child's hand, people fought and reconciled, summoned and drove away; among this human hustle and bustle, a single portrait stood out, that of a dark-haired boy with a wide smiling mouth.

Help said a crooked line on the mirror.

Greta Timyanova pressed her hands to her face, reading through the loosely clasped fingers:

Help ... me. I want to see the show again. His show. One more time. It's necessary.

The woman rubbed her eyes, trying to decipher the last blurry line:

I want to understand.

CONTRIBUTOR BIOS

Alex Shvartsman is an award-winning writer, translator, and anthologist from Brooklyn, NY. He's the author of the fantasy novels *Kakistocracy* (2023), *The Middling Affliction* (2022), and *Eridani's Crown* (2019). His short stories have won the WSFA Small Press Award and were nominated for the Canopus Award three times.

His translations from Russian include novels, TV and movie scripts, and video game content. His short story translations have appeared in *Analog, Asimov's, Clarkesworld, F&SF, Tor.com*, and elsewhere.

Alex is the editor of *Future Science Fiction Digest* and many anthologies, including *The Rosetta Archive, Humanity 2.0, The Cackle of Cthulhu*, and the long-running Unidentified Funny Objects series.

His website is www.alexshvartsman.com

Emily Balistrieri is an American translator based in Japan. His translation of Tomihiko Morimi's *The Tatami Galaxy* was a finalist for the 2023 PEN Translation Prize. Other works include Ao Omae's *People Who Talk to Stuffed Animals Are Nice*, Eiko Kadono's *Kiki's Delivery Service*, and Takuji Ichikawa's *The Refugees' Daughter*. He did the English subtitles for Takahide Hori's award-winning

film *Junk Head* and occasionally works on videogames such as Co-cosola's *The Witch's Isle*.

Vajra Chandrasekera is from Colombo, Sri Lanka and his debut novel *The Saint of Bright Doors* (Tor, 2023) is out now. He has also published over fifty short stories in magazines and anthologies including *Analog, Black Static*, and *Clarkesworld*, among others, and his short fiction has been nominated for the Theodore Sturgeon Memorial Award. He blogs at vajra.me and is @_vajra on Twitter.

Allison M. Charette translates mostly fiction by Malagasy authors Michèle Rakotoson, Johary Ravaloson, Naivo, and others. She founded ELTNA.org, a networking and support group for early-career translators, and has received both an NEA Literary Translation Fellowship and a PEN/Heim Translation Fund Grant. Her other translations include graphic novels, essays, and children's books. Find her online at charettetranslations.com.

Tina Connolly (she/her) writes fantastical stories for kids, teens, and grown-ups. Some of them are serious and some of them involve flying bananas. Her stories and books have been finalists for the Hugo, Nebula, and World Fantasy Awards. Her books include the Ironskin trilogy (Tor), the Seriously Wicked series (Tor Teen), the collection *On the Eyeball Floor* (Fairwood Press), and the Choose Your Own Adventure book, *Glitterpony Farm*. She co-hosts *Escape Pod*, runs *Toasted Cake*, and you can find her at tinaconnolly.com.

Rodrigo Culagovski is a Chilean architect, designer, and web developer. He currently heads a web development agency and is a researcher and professor at Universidad Católica in Chile. He has published in *Dark Matter Presents: Monstrous Futures, Solarpunk Magazine*, and *Future Science Fiction Digest*. He is on mastodon as @culagovski@wandering.shop. He misses his Commodore 64. His pronouns are he/him/él.

Marina and Sergey Dyachenko, a former actress and a former psychiatrist, are the co-authors of thirty-three novels and numerous

short stories and screenplays. They were born in Ukraine and eventually moved to the United States. Their books have been translated into several foreign languages and awarded multiple literary and film prizes. Marina and Sergey are the recipients of the Award for Best Authors (Eurocon 2005), Prix Planète SF des blogueurs (2020), and the Rosetta Science Fiction and Fantasy Award for Best Translated Work, long form (2021). After Sergey's death in May 2022, Marina continues to work on the novels they planned to write. Her immediate plans include finishing the Vita Nostra trilogy.

Jane Espenson is best known as a television writer, where she got her start selling story ideas to *Star Trek: The Next Generation*. She has written for many shows in the fantasy/sci-fi genre, including *Buffy the Vampire Slayer*, *Angel*, *Firefly*, *Battlestar Galactica*, *Game of Thrones*, and *Foundation*, among others.

Fang Zeyu is a professional writer of science fiction from Hangzhou, China. He is also a fashion photographer and photography artist. Fang's photography works are mainly in black and white tones and have been exhibited on tour throughout China.

His science fiction style is varied and often involves social and human themes, with a penchant for black humor or suspenseful narration.

His science fiction works have been collected and published in Sci-Fi anthologies such as *Planet Non-Exist, The Pillars of a Great Power*, and *Visiting Stars*. "Trash Tag" won the Silver Prize of Senyu Award and was adapted into a comic book in 2023.

Nathan Faries teaches Chinese language and literature at Bates College in Maine.

Taiyo Fujii was born on Amami Oshima Island—that is, between Kyushu and Okinawa. He worked in stage design, desktop publishing, exhibition graphic design, and software development.

In 2012, Fujii self-published *Gene Mapper* serially in a digital format of his own design, and became Amazoi Japan's number one Kindle bestseller of that year. The novel was revised and republished by Hayakawa Publishing in 2013 and was nominated for the Nihon SF Taisho Award and the Seiun Award.

His second novel *Orbital Cloud* won the 2014 Nihon SF Taisho Award and Japanese Nebula Awards. In 2019, the novelette collection *Hello, World!* won a mainstream literature award, the Yoshikawa Eiji Literature Awards for Young Writers. In 2022, his novel *Man Kind* won the Japan Seiun Awards.

Fujii was the 18th president of Science Fiction and Fantasy Writers Japan and developed a strong connection with science fiction communities all over the world.

Auston Habershaw is a science fiction and fantasy author living in Boston. He has published stories in *Analog, F&SF, Beneath Ceaseless Skies*, and other places. His fantasy series, The Saga of the Redeemed, is available through Harper Voyager. Contrary to popular opinion, he is not a robot. You can find him at aahabershaw.com.

Judith Huang (錫影) is an Australian-based Singaporean multimedia creator, poet, author, sometime-journalist, failed-academic, Rosetta-winning translator, composer, musician, educator, serial-arts-collective-founder, Web 1.0 entrepreneur and aspiring-VR-creator @ www.judithhuang.com.

Her first novel, *Sofia and the Utopia Machine*, was shortlisted for the EBFP 2017 and Singapore Book Awards 2019.

Judith counts bunny-minding, human-systems-hacking, Harvard-alumni-interviewing, hackerspace-running, truth-telling and propaganda-dissemination as her hobbies. Read more at www.judithhuang.com/about-judith

Ken Liu is an American author of speculative fiction. A winner of the Nebula, Hugo, and World Fantasy awards, he wrote the Dandelion Dynasty, a silkpunk epic fantasy series (starting with *The Grace of Kings*), as well as the short story collections *The Paper Menagerie and Other Stories* and *The Hidden Girl and Other Stories*. He also penned the Star Wars novel *The Legends of Luke Skywalker*.

Prior to becoming a full-time writer, Liu worked as a software engineer, corporate lawyer, and litigation consultant. Liu frequently speaks at conferences and universities on a variety of topics, including futurism, machine-augmented creativity, the history of technology, bookmaking, and the mathematics of origami.

His website is kenliu.name

Julia Meitov Hersey was born in Moscow, moved to Boston at the age of nineteen and has been straddling the two cultures ever since. She spends her days juggling a full-time job and her beloved translation projects. Julia is a recipient of the Rosetta Science Fiction and Fantasy Award for Best Translated Work, long form (2021).

Anna Mikhalevskaya is an award-winning writer from Odesa, Ukraine. Since the beginning of the war, she has remained in Ukraine doing what she does best: writing. Anna has organized a charity event, where her works and Ukrainian songs were performed to support families affected by the war. For more information about Anna and her books (in Russian and Ukrainian) visit mihalevskaya. com

Ray Nayler is the author of the critically acclaimed novel *The Mountain in the Sea,* published in the US by MCDxFSG and in the UK by Weidenfeld & Nicolson. *The Washington Post* called *Mountain* "(a) poignant, mind-expanding debut" and David Mitchell, author of *Cloud Atlas,* said: "I loved this novel's brain and heart, its hidden traps, sheer propulsion, ingenious world-building and the purity of its commitment to luminous ideas." Positively reviewed in the *New York Times, The New Yorker, The Guardian, Publisher's*

Weekly (starred review) and many others, and a best book of the year at *Amazon* and *Slate, The Mountain in the Sea* is a finalist for the Nebula Award, the Locus Award, and for the LA Times Book Awards' Ray Bradbury Award for Science Fiction, Fantasy, and Speculative Fiction.

Called "One of the up-and-coming masters of SF short fiction" by *Locus*, Ray Nayler's critically acclaimed stories have seen print in *Asimov's, Clarkesworld, Analog, The Magazine of Fantasy and Science Fiction, Lightspeed, Vice,* and *Nightmare,* as well as in many "Best Of" anthologies, including *The Very Best of the Best: 35 Years of The Year's Best Science Fiction.* His story "Yesterday's Wolf" won the 2022 *Clarkesworld* Readers' poll. In the same year, his story, "Muallim" won the *Asimov's* Readers' Award, his story "Father", in French translation, won the *Bifrost* readers' award, and his novelette "Sarcophagus" was a finalist for the Theodore Sturgeon Award.

For nearly half his life, he has lived and worked outside the United States in the Foreign Service and the Peace Corps, including a stint as Environment, Science, Technology, and Health Officer at the US consulate in Ho Chi Minh City. He is currently Diplomatic Fellow and Visiting Scholar at the Institute for International Science and Technology Policy at The George Washington University.

Mose Njo is a Madagascar-based science fiction writer who represented his country at the most recent Francophone Games. He has received a scholarship to study independent filmmaking at the Art-on-the-Run Film School in Berlin, and has exhibited his conceptual art in various locations.

Julie Nováková is a scientist, educator and award-winning Czech author and translator of science fiction and detective stories. Her work in English has appeared in *Asimov's, Analog, Clarkesworld,* and elsewhere, and has been reprinted in "Best Of" anthologies. In 2020, she published her story collection entitled *The Ship Whisperer.* Julie is a recipient of the European fandom's Encouragement Award and multiple Czech national genre awards. She's active in science

outreach, education and nonfiction writing, co-leads the outreach group of the European Astrobiology Institute, and is a member of the XPRIZE Sci-fi Advisory Council. She has edited or co-edited five anthologies, and her newest work is the astrobiology-themed anthology *Life Beyond Us* (Laksa Media, 2023), featuring stories by Mary Robinette Kowal, Eugen Bacon, Gregory Benford, Peter Watts and others.

H. L. Oldie is the pen name of Dmytro Gromov and Oleg Ladyzhensky, Ukrainian award-winning authors of over 270 SF/F books (including reprints and translations). They've been published in Canada (in French), France, Poland, the Czech Republic, Lithuania, and Ukraine. The translating and publishing of the Space Opera trilogy Oikoumene by H. L. Oldie in China is in progress now. Some of H. L. Oldie's short stories have been also published in Hungary, Mexico, the Czech Republic, and France. Their official website in English is oldie.world/en/.

H. Pueyo (@hachepueyo on Twitter and Instagram) is an Argentine-Brazilian writer of speculative fiction. She's an Otherwise Fellow, and her work has appeared in *F&SF, Clarkesworld, Strange Horizons, Fireside,* and *The Year's Best Dark Fantasy & Horror*, among others. Her bilingual debut collection *A Study in Ugliness & Outras Histórias* (Lethe, 2022) can be found at hachepueyo.com.

Adrian Tchaikovsky is a fantasy and science fiction author whose work includes *Children of Time* and its sequels, *Shadows of the Apt,* the *Final Architecture* and more. His work has won a number of awards including the British Fantasy, British Science Fiction, Sidewise and Arthur C. Clarke awards.

Tarryn Thomas is a voracious reader turned busy copy editor from South Africa. She works both as an associate at UFO Publishing and as a freelance manuscript editor for indie authors. She has a Humanities degree under her belt which woefully underprepared her for the real world. Her hobbies are restoring furniture, fanciful embroidery and making chainmail jewelry. She has an irascible cat.

She is always looking for new projects in various genres. You can find her at tarrynthomas.com.

Zhou Wen published her first science fiction short story in high school, and in the decade since she has published nearly a million words. Her works are mainly related to linguistics, brain science, and the internet, often featuring female protagonists.

She won George R. R. Martin's Terran Prize in 2019 and graduated from the Taos Toolbox Writer Workshop.

Among her works, *The Syllables of Silence* and *Cat Swarm Algorithm* won the Best Short Story Award of the China Science Fiction Readers' Choice Awards (Gravity Awards) in 2018 and 2021 respectively; *The Girl with Restrained and Released Life* won the Gold Award of the Best Novella category of the Chinese Nebula Awards in 2023. Her works have been selected many times for the Annual Selection of Chinese Science Fiction anthology.

A collection of her short stories, *The Girl Who Stole Life* (a variant titled as *Barriers*) was published in China in 2021.

In addition, many of her short stories have been translated into Japanese. *The Syllables of Silence*, her first published work in Japan, was nominated for the Best Translated Story of Seiun Awards (Japanese Nebula Awards) in 2021.

Printed in the USA
CPSIA information can be obtained
at www.ICGtesting.com
JSHW022126131123
51999JS00001B/2

9 781647 101107